Ancient Art in Bowdoin College

Ancient Art in Bowdoin College

A DESCRIPTIVE CATALOGUE OF THE WARREN AND OTHER COLLECTIONS

Kevin Herbert

Harvard University Press

CAMBRIDGE · MASSACHUSETTS · 1964

Distributed in Great Britain by Oxford University Press, London

Publication of this volume has been aided by
a grant from the Ford Foundation.

Library of Congress Catalog Card Number 63–19138

Printed in the United States of America

DVABVS MARGARITIS SPLENDIDIS
ALTERI PARENTI, ALTERI CONIVGI

Preface

THIS book was written to serve a variety of uses. For the interested scholar it is a *catalogue raisonné*, with objects mainly arranged by culture and type, in chronological sequence, and with technical data and references appended to each item. For the undergraduate in residence at the College it offers a text with references for the study of the ancient art in the Walker Art Building. And for the lay visitor to the galleries it can be a guidebook which will increase his understanding and enjoyment of the various exhibits. The wishes of the donors, the excellence of their gifts, and the primary role of this art as a study collection in a collegiate museum all imposed upon the writer the obligation of preparing the book to fulfill the triple but not always commensurate ends of scholarly publication, undergraduate education, and general information for the wider public. The result is therefore something more than a catalogue in the usual sense.

It is a privilege and a pleasure to record here my thanks to all those who assisted me in these studies. Two of these debts require especial notice. To Sir John Beazley of Oxford University I am most grateful for very generous permission to use his notes on portions of the sculpture, terracottas, pottery, bronzes, and gems in the Warren Collection. The attributions of Attic Black-figure and Red-figure to various painters, to give but one example, are his. For some years prior to World War II Sir John had a separate catalogue of this collection in preparation, but he was forced to abandon the project in 1941 and never afterward found the opportunity to return to it. I am also greatly indebted to the trustees of the Warren Memorial Foundation for a liberal subvention in aid of publication of the book. In this matter President James S. Coles of the College and the Honorable Robert Hale, an officer of the Foundation, were most helpful.

For countless hours spent in stimulating discussions about the collections I sincerely thank my former teacher, Professor Sterling Dow of Harvard University, and my former colleague and friend, Mr. Richard Wadleigh, Curator of the Collections of Bowdoin during 1960–61. Dr. Cornelius Vermeule, Curator of Greek and Roman Art in the Museum of Fine Arts, Boston, first suggested the need for this book and was most helpful on numerous occasions, and Dr. William Stevenson Smith, Curator of Egyptian Art in the same museum, very kindly read the chapters on the Mesopotamian and Egyptian collections. My former colleagues, Professors Nathan Dane II, Philip Beam, and Carl Schmalz of Bowdoin, also rendered various courtesies and assistance which were much appreciated. Messrs. Stephen Merrill and James Pierce separately produced certain of the photographs, Mr. Merrill being responsible for all the terracottas and some of the sculptures, Mr. Pierce for all the painted pottery, bronzes, and some of the sculptures. All other photographs were made by the writer. For her admirable patience and efficiency a special note of thanks goes to my wife, who prepared the typescript for the book. Lastly, I wish to express my thanks to the officers of the Bryant Foundation of Springfield, Vermont, and of the Danforth Foundation of St. Louis, Missouri, for grants which enabled me to pursue some of my studies in the Widener Library of Harvard University.

The reader should note that three types of reference are used in the book: abbreviated titles, which refer to books or journals frequently cited and which are fully described in the list at the beginning of the book; short titles, which refer to works listed at the end of the introductions to the various classes of artifact; and full titles, which include all works not in either of the previous two categories. An asterisk indicates that the object is illustrated. Because the reproduction of epichoric and cursive forms of the Greek alphabet would increase printing costs, the standard Greek font has been used throughout. For the same reason all ligatures and monograms have been resolved wherever they appear in the coin legends. Furthermore, the introductions to the various classes of art are indebted mainly to the appended bibliographies. These sections and bibliographies were prepared primarily for the student and layman, though it is possible that in given instances the scholar will also find them useful.

A book such as this is obviously the result of a cumulative process. Apart from the relatively few published articles on objects in the collections it is based upon the data accompanying the artifacts at the

time of accession, supplied by Edward Warren, John Marshall, or John Beazley, among others, upon the notes that curators such as Henry Johnson or G. Roger Edwards may have added, and upon the occasional letters of various scholars who over the years have offered opinions on individual objects in the collections. With the exception of signed letters, all of which are acknowledged under the separate entries, this information is now set forth anonymously in the catalogue files of the Walker Art Building. For the opportunity to draw upon this fund of fact and opinion I am very grateful, but I also recognize my sole responsibility for the accuracy of all the data and commentary as it appears in this volume. There is also, of course, much in the descriptions and commentary which appears here for the first time. The book, written in Brunswick while I was a member of the faculty of Bowdoin, was completed in November 1961, and since that time only minor bibliographical additions have been incorporated in the text.

In conclusion I wish to note that early in the course of these studies I fancied myself as among the select "one or two people not yet born" for whose enlightenment and pleasure Edward Warren, in his letter of January 1916, claimed to devote his gifts. But now by this work I am most pleased to expand infinitely the numbers of the happy few, who even so will still remain a very select group.

K. H.

Washington University,
St. Louis, Missouri,
May 1963

Contents

Abbreviations

ABV — J. D. Beazley, *Attic Black-figure Vase-painters* (1956).

AG — A. Furtwängler, *Die antiken Gemmen*, 3 vols. (1900).

AJA — *American Journal of Archaeology*, 1897 —.

ARV — J. D. Beazley, *Attic Red-figure Vase-painters* (1942). New edtition in process.

ARVS — G. M. A. Richter, *Attic Red-figured Vases. A Survey*, rev. ed. (1958).

Att.V. — J. D. Beazley, *Attische Vasenmaler des rotfiguren Stils* (1925).

BM Bronzes — H. B. Walters, *Catalogue of the Bronzes, Greek, Roman, and Etruscan, in the British Museum* (1899).

BM Terracottas — H. B. Walters, *Catalogue of the Terracottas in the Department of Greek and Roman Antiquities, British Museum* (1903).

Bronzes — Winifred Lamb, *Greek and Roman Bronzes* (1929).

BSR — *Papers of the British School at Rome*, 1902 —.

CAH — *Cambridge Ancient History* (1923–1939). New edition in process.

Casson, *Catalogue* — Stanley Casson, *Descriptive Catalogue of the Warren Classical Collection of Bowdoin College* (1934).

Catalogue général MC — *Catalogue général des antiquités égyptiennes du musée du Caire* (1901 —).

Cesnola Collection — J. L. Myres, *Handbook of the Cesnola Collection of Antiquities from Cyprus. Metropolitan Museum of Art* (1914).

CJ — *Classical Journal*, 1905 —.

CRR — E. A. Sydenham, *The Coinage of the Roman Republic*, rev. by G. C. Haines (1952).

CVA — *Corpus Vasorum Antiquorum* (1922 —).

DABF — J. D. Beazley, *The Development of Attic Black-figure* (1951).

Dar.-Sag. — C. Daremberg and E. Saglio, *Dictionnaire des antiquités grecques et romaines d'après les textes et les monuments* (1877–1919).

Das Glas — Anton Kisa, *Das Glas in Altertume*, 3 parts (1908).

Descriptive Catalogue — *Descriptive Catalogue of the Art Collections of Bowdoin College* [4] (1930).

Die Typen — Franz Winter, *Die Typen der figürlichen Terrakotten*, 2 vols. (1903).

DNM — Neils Breitenstein, *Catalogue of Terracottas, Cypriote, Greek, Etrusco-Italian, and Roman. Danish National Museum* (1941).

Encic AA — *Enciclopedia dell'arte antica classica e orientale*, 4 vols. (1958 —).

EVP — J. D. Beazley, *Etruscan Vase Painting* (1947).

EWA — *Encyclopedia of World Art*, 6 vols. (1959 —).

Figurines Louvre I — S. Mollard-Besques, *Catalogues raisonnés des figurines et reliefs en terre-cuite grecs, étrusques, et romains I. Musée National du Louvre* (1954).

GPP — R. M. Cook, *Greek Painted Pottery* (1960).

Griechische Plastik — L. Alscher, *Griechische Plastik*, 4 vols. (1954 —).

GRJ — R. A. Higgins, *Greek and Roman Jewellery* (1961).

Gr Painting — Martin Robertson, *Greek Painting* (1959).

Gr Pottery — [E.] A. Lane, *Greek Pottery* (1948).

Gr Sculpture — R. Lullies and M. Hirmer, *Greek Scultpure* (1957).

Gr Terracottas — T. B. L. Webster, *Greek Terracottas* (1950).

H — Height.

Handbook — G. M. A. Richter, *A Handbook of Greek Art*, rev. ed. (1960).

Hellenistic Age — M. Bieber, *Sculpture of the Hellenistic Age*, rev. ed. (1960).

Hesperia, suppl. II — R. S. Young, "Late Geometric Graves and a Seventh Century Well in the Agora," *Hesperia*, suppl. II (1939).

HN — B. V. Head, *Historia Numorum* [2] (1911). New edition in process.

IBC — W. Wroth, *Catalogue of the Imperial Byzantine Coinage in the British Museum*, 2 vols. (1908).

IG — *Inscriptiones Graecae* (1873 —).

Illustrated Handbook — *Illustrated Handbook of the Bowdoin College Museum of Fine Arts in the Walker Art Building* (1950).

JDAI — *Jahrbuch des deutschen archäologischen Instituts*, 1886 —.

JHS — *Journal of Hellenic Studies*, 1880 —.

Kourion — J. H. Young and S. H. Young, *Terracotta Figurines from Kourion in Cyprus* (1955).

L — Length.

Lawrence-Cesnola Collection — Alexander Palma di Cesnola, *The Lawrence-Cesnola Collection. Cyprus Antiquities Excavated by A. P. di Cesnola* (1881).

Lewes House Collection — J. D. Beazley, *The Lewes House Collection of Ancient Gems* (1920).

Lex. Myth. — W. H. Roscher, *Ausführliches Lexikon der griechischen und römischen Mythologie* (1884 —).

MR — P. Jacobsthal, *Die Melischen Reliefs* (1930).

MMA Bronzes — G. M. A. Richter, *Greek, Etruscan and Roman Bronzes. Metropolitan Museum of Art* (1915).

The Mummy — E. A. Wallis Budge, *The Mummy: A Handbook of Egyptian Funerary Archaeology* [2] (1925).

Myrina — D. Burr, *Terracottas from Myrina. Museum of Fine Arts, Boston* (1934).

NC — H. G. G. Payne, *Necrocorinthia* (1931).

Numismatique constant. — Jules Maurice, *Numismatique constantinienne*, 2 vols. (1908, 1911).

OB — Obverse (of coins and tesserae).

OCD — *Oxford Classical Dictionary* (1949).

RE — *Real-Encyclopädie der klassischen Altertumswissenschaft* (1893 —).

Répertoire — S. Reinach, *Répertoire de la statuaire grecque et romaine*,[2] 4 vols. (1904–1908).

RIC — H. Mattingly, E. A. Sydenham, and C. H. V. Sutherland, *The Roman Imperial Coinage*, 5 vols. in 7 parts (1923 —).

RV — Reverse (of coins and tesserae).

ABBREVIATIONS

Salaminia — Alexander Palma di Cesnola, *Salaminia: The History, Treasures, and Antiquities of Salamis in the Island of Cyprus* (1882).

Sammlung Warren — K. Regling, *Die griechischen münzen der Sammlung Warren* (1906).

SCE — E. Gjerstad, et al., *Swedish Cyprus Expedition*, 4 vols. in 8 parts (1934 —).

Sculpture and Sculptors — G. M. A. Richter, *Sculpture and Sculptors of the Greeks*, rev. ed. (1950).

Sculptures MMA — G. M. A. Richter, *Catalogue of Greek Sculptures. Metropolitan Museum of Art* (1954).

SEG — *Supplementum epigraphicum graecum* (1923 —).

Shapes — G. M. A. Richter and M. J. Milne, *Shapes and Names of Athenian Vases* (1935).

SIG — W. Dittenberger, *Sylloge Inscriptionum Graecarum*,[3] 4 vols. (1915–1924).

T — Thickness.

Terracottas BM — R. A. Higgins, *Catalogue of the Terracottas. British Museum* (1954 —).

Terracotta Lamps — O. Broneer, *Corinth IV, 2: The Terracotta Lamps* (1930).

Tonreliefs — H. von Rohden and H. Winnefeld, *Architektonische römische Tonreliefs der Kaiserzeit*, 2 vols. (1911).

VA — J. D. Beazley, *Attic Red-figured Vases in America* (1918).

VAM Catalogue of Textiles — A. F. Kendrick, *Victoria and Albert Museum Catalogue of Textiles from Burying Grounds in Egypt*, 3 vols. (1920–1922).

Vase MFA — L. D. Caskey and J. D. Beazley, *Attic Vase Painting in the Museum of Fine Arts, Boston*, 2 parts (1931, 1954).

Vases MMA — G. M. A. Richter and L. F. Hall, *Red-figured Athenian Vases in the Metropolitan Museum of Art*, 2 vols. (1936).

W — Width.

Ancient Art in Bowdoin College

I

Historical Introduction

THE beginnings of the collections of ancient art at Bowdoin can be dated to the arrival in 1860 of five large and impressive Assyrian mural reliefs from the palace of King Ashurnazirpal II (885–860 B.C.). These works were the gift of Henri Byron Haskell, M.D., Bowdoin 1855, a medical missionary at Mosul in Mesopotamia. Like a number of other Americans serving in the Middle East at that time, he was attracted by the monumental art which the great Layard had excavated at Nimrud and Nineveh in the previous decade, and after some difficulties he acquired and shipped home to his college a representative selection of these reliefs. Ironically, however, the Bowdoin officials viewed their arrival more as an unwanted burden on their limited resources than a gift of lasting significance, for the shipping charges which they had agreed to bear proved much higher than originally estimated. The size and great weight of the tablets also gave trouble in the absence of a suitable place for their display, but the north entry of the chapel, newly completed in 1855, was eventually devised as a gallery of sorts in which to exhibit them.

The nearest thing to a museum possessed by the College at that time was the Sophia Walker Gallery, a room set aside in the chapel in honor of the mother of Theophilus Wheeler Walker, who in 1850 had given a sum of money toward the completion of the structure. It was here that the Bowdoin (1811–1826), Boyd (1852), and Thatcher (1855) collections of paintings were displayed, but in the decades after the

Civil War the crowding of the growing collections in this small room and the presence of the huge reliefs in the entry made it plain that the chapel could not long serve as both a museum and a place of worship. Again the generosity of Mr. Walker initiated a solution, for shortly before his death in 1890 he expressed the intention of providing funds for an art building at Bowdoin. In the very next year his two nieces, the Misses Mary Sophia and Harriet Sarah Walker, determined to erect such a structure in memory of their uncle and in accordance with his wishes. The letter of gift to the College was made on September 1, 1891. Designed by Charles Follen McKim and modeled on the Loggia dei Lanzi and the Pazzi Chapel, the Walker Art Building is thought by many critics to be one of the most handsome of its type in the country. Upon the dedication of their magnificent gift in June 1894, the sisters also gave the new museum over forty items of Greek and Roman glass and pottery, thereby gaining the additional distinction of being the founders of the classical collections. By far the most important of their gifts on that occasion is a large Attic red-figured pelike, or wine jar, an excellent example of late fifth century style.

The construction of so excellent an art building north of Boston soon caught the attention of a number of patrons who in their various ways determined to contribute to the growth of its collections. Yet not everything received was worthy of the name of art. For example, in the early years of the museum plaster casts of sculpture and reduced bronze reproductions represented Greek and Roman art in the galleries. If to the contemporary eye viewing old photographs these versions appear worse than useless for purposes of instruction or appreciation, it must be remembered that in the years prior to the first World War almost every American museum depended upon such pallid devices to convey some idea of classical art. That major museums like Boston and New York and smaller ones like Bowdoin now display superb to respectable originals in every category of ancient art is a tribute to the energy and foresight of a small number of collectors and curators in the years between 1890 and 1930. These scholars and patrons came to their tasks very late in the day, if one considers the historical development of the Louvre, the British Museum, or the great Italian museums, and thus in the light of their problems and accomplishments these men are most deserving of our praise and admiration. One of them, Edward Perry Warren, was the leading collector of the period, and was especially remarkable because of his equal devotion to the causes of a major and a collegiate

collection, those of the Museum of Fine Arts, Boston, and of the Walker Art Building at Bowdoin.

The first donor to add to the classical collection established by the Walkers was George Warren Hammond, a successful paper industrialist, who gathered American and ancient artifacts as an avocation. In a letter to the curator, dated May 27, 1897, he offered the College parts of his collection with "the hope and expectation that they will be a nucleus that will induce others to send their collections, already made or to be made in the future, to Bowdoin College." His gifts included ancient coins, pottery, glass, bronze objects, Egyptian funerary pieces, and a Greek inscription. With the exception of the inscription, none of these pieces today is of great significance either for art or scholarship, but Hammond's expressed desire to attract others to contribute to the collections was to find early fulfillment through the gifts and efforts of three quite different men: Hammond's nephew, E. P. Warren, Professor Henry Johnson of the Class of 1874, and Dana Estes of Boston.

Estes, in company with Charles E. Lauriat, was one of the first American book publishers to offer the reading public the standard works of European novelists and historians. He later established his own book house, Dana Estes and Company, and as his fortune prospered he traveled to Asia, Europe, and Africa, collecting antiquities of many kinds. Some of this material eventually was presented to the Peabody Museum in Cambridge, Massachusetts, and in 1902 Bowdoin received some or all of that part of the Lawrence-Cesnola Collection from Cyprus which Estes apparently had acquired in the last decade of the nineteenth century. The Estes Collection includes Egyptian grave stelae and funerary articles, Roman glass, and Cypriot inscriptions, pottery, and terracotta figurines. The figurines range in time from the Archaic to the Hellenistic periods, and though most of them unfortunately consist only of heads, their number, provenance, and variety make them a significant collection. The pottery, chiefly of the Archaic period, and the inscriptions, in Greek but of the Roman period, also help to illustrate the culture of ancient Cyprus. Lastly, two grave stelae inscribed with hieroglyphics are among the most important objects in the Egyptian collection.

Henry Johnson joined the Bowdoin faculty in 1877 as instructor in modern languages, but his greatest and most enduring work was to be in the field of art rather than literature. In addition to his teaching duties he served as Curator of the Art Collections for many years and later

was appointed first director of the museum, a position he held until his death in 1918. During his tenure the museum came of age as the new art building both required and received gifts of many types and periods. One of the most useful of these was Johnson's own excellent collection of classical coins, which in part came to the College in 1919 by bequest and later was augmented by purchase. These coins number over 130 pieces and range in time from fifth century Greece down to the late Roman Empire. Valuable as this gift is, Johnson's most important accomplishment was not as a collector but as adviser and confidant to Edward Perry Warren concerning his plans for establishing a comprehensive collection of classical objects at Bowdoin. Their surviving correspondence indicates that the two men were in complete harmony concerning this extraordinary plan and that Warren also trusted Johnson's ability to put these gifts to best advantage. Even though the greatest part came to the College after Johnson's death, Warren's letters show that the inception and beginnings of the scheme were formulated many years before 1918. It is safe to say, therefore, that without Johnson these generous plans for the collections might never have matured in the manner they did.

Edward Perry Warren was born on June 8, 1860, the son of S. D. Warren, a prosperous New England paper manufacturer. After leaving Harvard without a degree, he emigrated to England, where he established his permanent residence and later took a B.A. from Oxford in 1888. Warren was early attracted to ancient Greek literature and art, and so completely did Hellenic ideas appeal to him that he determined to devote his life and considerable fortune to these studies and to the collecting of classical art. As a first step in his remarkable plans he acquired Lewes House, Sussex, in 1890, and began gathering there a select and companionable group of men who at his expense were to pursue their studies and share their interests. For varying periods during the next two decades and beyond, a succession of friends, clients, and scholars lived a life there which combined discourse and study with good fellowship in an English country setting. It might at first sight seem that such a program could only result in a great waste of time and money, as certain members of Warren's own family believed, but many have testified to the charm and spirit of Lewes House in those days, to the work begun or completed there, and to the beauty of the art which it contained. Chief among those whom Warren enlisted was John Marshall, a fellow Oxonian and classical archaeologist of brilliant

mind but difficult temper. Their relationship quickly ripened, however, into a unique *philia*, or friendship, which in its happiest period united their energies in a remarkable quest for Greek art. The Van Branteghem sale in Paris, in May 1892, was the scene of their first major purchases, and their diplomacy, bargaining skill, and expert knowledge on this and later occasions quickly established their reputation with the dealers. The way was thus prepared for the second step in Warren's grand plan of action, to make the best of the objects in his possession available to the American public.

Though the dominant mercantile ethos of the New England of his day rendered life there impossible for him, Warren did not desert the area by his leaving. Greek art, which to him represented order, masculinity, and beauty, could help to improve the tone of that society, and so he began negotiations with the trustees of the Museum of Fine Arts in Boston for the sale of the choicest objects of his present and future acquisitions. Though many obstacles had to be overcome, a working agreement was eventually arranged, and in 1895 Warren and Marshall began a program of systematic collecting of classical antiquities for the museum which continued for the next decade. In order to conserve his own resources, Warren charged the museum cost plus 30 per cent for each object, a most generous stipulation on his part since it in no way reimbursed him for the great expense of effort and money involved. The two collaborators now acted with such vigor and judgment that by the turn of the century they were pre-eminent in the hazardous and demanding business of acquiring the best of Greek art then available. The agents of the British Museum, the Louvre, and Berlin were unable to compete with them, while all of the chief private collectors in Europe had either died or retired from the field. Their methods were simple and their skills compelling. At auctions or in private showings they bought only the best and were always prepared to pay high prices. Marshall, though he published very little, was one of the most acute scholars of his time, and he was especially adept at exposing forgeries in terracottas and other categories. Warren, on the other hand, never considered himself an archaeologist, but he was a perceptive and learned, if not bookish, man. More importantly, he complemented the scholarship of his friend by his steady and foresighted manner, which organized each campaign and kept the ultimate goal always in view despite distractions from every side. This is not the place to describe the works of art which eventually went to Boston as a result of their efforts, but three

outstanding examples of sculpture should be named here: the supremely lovely head of a girl from Chios, the Bartlett head of Aphrodite, and the so-called Boston Throne. Apart from a visit to the museum for a personal inspection, the reader can best study these and the other larger works in L. D. Caskey, *Catalogue of Greek and Roman Sculpture in the Museum of Fine Arts, Boston* (1925). Of the 134 pieces described there, 107 were obtained with the cooperation of Warren and Marshall, and this number is but a small part of the total in all classes of art which came to the museum through them. In his report for 1904 the president of the museum acknowledged the comprehensive and noble character of the collection, adding that in the process the two friends and their assistants had expended "such an amount of time, money, and patience directed by great knowledge, that it is difficult to believe the happy combination could ever exist or recur." In fact, the felicitous arrangement came to an end in that very year, and it is certain that similar opportunities will never be seen again in our time.

A change in museum policy was foreshadowed in 1899 when land was purchased on the Fenway as a site for the present building. By 1904 the trustees had decided that no more money could be allotted for the purchase of classical antiquities because of the needs of the construction fund, and thus the great decennium of acquisition came to an end. For Warren the tragedy of this shortsighted policy was twofold. With the market completely under his control and his organization at the height of its effectiveness, he was forced to suspend operations and was left with much of his capital invested in some very costly objects intended for the museum. Perhaps even worse, Marshall and he now began to drift apart because of the resulting inaction, and within two years his friend had married, moved to Rome, and accepted a position as purchasing agent for the Metropolitan Museum of Art, an office he retained until his death in 1928. Close upon these misfortunes came a bitter legal action initiated by Warren in 1909 against his brother Sam. Though he was justified in bringing the suit, which concerned his share of the family's fortune, the sudden death of his brother during the hearings caused a breach in the family that was never again closed. There can be no doubt that as a result of these events the years 1904 to 1909 were the unhappiest in Warren's life.

With characteristic resilience and tenacity he now entered on a third phase of his work on behalf of Hellenism. The end of systematic collecting had only reduced, not terminated, these activities, for Boston

continued to acquire important classical objects from him in the years 1910 to 1928, but he also now began making outright gifts to selected museums and institutions of higher learning. Beneficiaries included Harvard, Chicago, Heidelberg, and Bonn among the universities, and the British Museum, the Louvre, Vienna, and Boston among the museums. Three institutions, however, were especially favored with gifts: the museum of the University of Leipzig, the Ashmolean Museum of Oxford, and Bowdoin. Leipzig received its collection primarily in honor of Professor Franz Studniczka, an old friend, and the Ashmolean was similarly enriched because of all that Oxford had meant to Warren as an undergraduate and afterward. Yet Bowdoin, the only undergraduate institution among the major recipients, and with no claims of personal loyalty, ultimately received almost 600 separate objects to form a collection that in size and quality appears to be first among all of Warren's donations. The reasons for this generosity are many and not always obvious. As early as 1903 Warren had established a summer residence at Westbrook, Maine, and so he was undoubtedly aware of the needs of the new Walker Art Building a few miles to the north. Yet this condition was only one of many factors influencing his decision.

Warren's surviving correspondence with Professor Johnson and others gives a partial view of his intentions in making these gifts to the College. In a letter of November 13, 1912, he told Professor Johnson, "This year having an unusually good opportunity to make up a small lot of classical antiquities, I am sending them to Bowdoin College. They are not the first pick, since first pick went to Boston by way of purchase, but Boston did not have all that was good." A few years later, in a letter of December 15, 1915, to the curator, Miss Curtis, he said, "I had been sending some things to Bowdoin, but now I became more systematic. I can't hope to provide more than a good little illustrative collection of antiquities . . . things that would help a student . . . the said student would doubtless know the collection in Boston, and the Bowdoin collection would only be his apparatus." Finally, in a letter of January 19, 1916, to Professor Johnson, he candidly expressed his hopes for the collection: "I'm afraid I'm not much for the evangelization of American youth by art. Art is inevitably for the few, and a museum is a lighthouse to rescue these from unhappiness. It is a traitor to the modern cause lodged amid utilities for the succour of renegades. Hope of a better future lies in these records and protests of the past . . . My humble and delightful work for Bowdoin is meant for one or two people

not yet born." These passages reveal a practical and essentially modest man of aristocratic temper, and one not given to mincing words. On the one hand he rightly recognized that the best had to be made available to the great museum in Boston, but by his vision and taste he was also able to create a smaller collection that is a perfect example of its kind. It also seems likely that the excellence, if not the very existence, of the Bowdoin collection derives in a sense from the frustration of Warren's hopes for Boston following the decision of 1904 and from his consequent concern for the educative function, if only for the happy few, of college and university museums. Bowdoin and the other institutions of learning, in effect, became the beneficiaries after the withdrawal of Boston.

The painted pottery is perhaps the best part of the Warren Collection, for it contains many excellent individual pieces and has at least one example of nearly every major type and style in the history of this class. The care and devotion of the donor in preparing this special corpus over the course of many years is truly laudable. The figurines, the gems, and the coins are close seconds in this competition, proof of Warren's belief that good collections of vases, coins, and figurines were the only avenues available to most American museums for complete and representative collections of Greek art. There are also some excellent individual objects among the stone sculptures, but there is not sufficient distribution of the pieces among the various periods and perhaps too many of the objects are statuettes. Nevertheless, the sculptures, augmented by the gifts of other donors form a very respectable collection for a collegiate museum.

For his devoted services and achievements in the cause of classical art, Warren was elected an honorary fellow of Corpus Christi College at Oxford in 1915, no small distinction at that time for an American and one who was not a research scholar with a long list of publications to his credit. Bowdoin recognized its debt when it granted him an honorary L.H.D. in 1926. He died in London, December 29, 1928, and in *The Oxford Magazine* for January 24, 1929, J. D. Beazley published a brief but perfect eulogy of the man, his character, and his work. In speaking of the Bowdoin collection, Beazley seems to question the wisdom of making these gifts to an undergraduate institution in so relatively isolated a location, but then he answers these objections with Warren's own argument: "A coin, a gem, a vase, a statuette, would speak of Greece in the heart of Maine; and sooner or later there would be a

student whose spirit would require them. There was no hurry: an acorn in the forest." If the collection in Boston is today recognized as Warren's major accomplishment, the collection at Bowdoin is most certainly his *opusculum aureum.*

The gift of classical or other objects to a college or university museum places them before the most promising of observers, the student. As tangible remains of a more distant time, such works serve as a necessary supplement to the purely literary, philosophical, or historical studies of the past. They are a physical corrective for the abstractions of these other pursuits and a valuable reminder that such peoples as the Greeks and Romans also lived in a particular time and place. No printed text used in the classroom, accurately as it may reproduce the original manuscript of a Sophocles or Lucretius, can effect that feeling of immediacy to be found in the presence of the work of the ancient potter, sculptor, or coroplast. A few Athenian or Byzantine coins turned in the palm and closely examined can teach much that is beyond the powers of any modern commentary to convey. And apart from this developing sense of the ancient world in its totality, the student can better understand a period or people through its art. The Periclean Funeral Oration in Thucydides is a testimony to the greatness of Athens, but the reliefs of the Parthenon and many lesser works of art speak equally well of the values of that society. Similarly, if the pages of Virgil or Tacitus tell much about the Roman character in all its ranges, the study of late Republican and Imperial portrait sculpture can add to that understanding. For these and many other reasons Bowdoin has been most fortunate in having such patrons as Haskell, the Walkers, Hammond, Estes, Johnson, and especially Warren. And for the same reasons it is also fair to claim that, within their limits and so far as any of the works of man are lasting, the classical collections are "a possession forever."

BIBLIOGRAPHY OF THE CLASSICAL COLLECTIONS AT BOWDOIN

President's Report: Bowdoin College Bulletin (1892 —). The *Reports* contain notices of accessions, but without details in most instances.

J. D. Beazley, Warren catalogue lists I–II, *President's Report* (1923–24) 47–54, for 73 gifts given in 1923; list III, *President's Report* (1924–25) 48–60, for 90 gifts given in 1915. These lists do not by any means treat all of the objects in the Warren Collection.

L. C. Hatch, *History of Bowdoin College* (1927) 447–456.

Descriptive Catalogue of the Art Collections of Bowdoin College [4] (1930). This is the last relatively comprehensive catalogue of the museum.

Stanley Casson, *A Descriptive Catalogue of the Warren Collection in the Walker*

Art Building (1934). This long out of print booklet of but 16 pages does not treat the vases or the terracottas, and only summarily discusses the other categories.

Osbert Burdett and E. H. Goddard, *Edward Perry Warren: The Biography of a Connoisseur* (1941). Appendix IV, "An Appreciation of the Bowdoin Collection," by Warren himself, is on pages 414–419.

An Illustrated Handbook of the Bowdoin College Museum of Fine Arts in the Walker Art Building (1950). This catalogue offers a summary treatment with illustrations of a few selected objects of the classical collections.

Kevin Herbert, *Terracotta Figurines in the Walker Art Building*, Bowdoin College Bulletin no. 335 (1960). This monograph examines 20 illustrated pieces and also has a brief history of the collections.

Kevin Herbert, "The Bowdoin Painter," *The Walker Art Museum Bulletin*, vol. I, no. 4 (1962) 3–10. This article examines the Attic Red-figured vase painter of the early fifth century before Christ, so named because two of his lekythoi, or oil flasks, are now at Bowdoin.

Kevin Herbert, "Greek and Latin Inscriptions at Bowdoin College," *American Journal of Archaeology* 66 (1962) 381–387, pls. 104, 105. This article discusses 11 inscribed stones and other objects.

Metropolitan Museum of Art Library Catalogue, 25 vols. (1960). This work deserves notice here because it will serve as an indispensable bibliographical aid in the study of the Bowdoin collections.

II

The Mesopotamian Collection

THE major objects in the Mesopotamian collection are five large Assyrian slabs with figures in low relief and cuneiform inscriptions, the gift in 1858 of Dr. Henri Byron Haskell. The collection also contains a fragmentary relief of the head of King Ashurnazirpal II, a Babylonian cone with cuneiform inscriptions, and an Assyrian cylinder seal.

The Assyrian reliefs are among some 73 such pieces in the United States which come from the North West Palace at Calah, now Nimrud, of Ashurnazirpal II, king of Assyria from 885 to 860 B.C. These sculptures lined the walls of the throne room and other chambers of the huge palace, which measured about 105 yards square. In general, they treated of the hunting and military prowess of the king and of the important role of the date palm in the life of the country. Nineveh and Calah were destroyed by the Medes in 612 B.C., and the latter city then remained hidden beneath the rubble until Austen Henry Layard began excavating there in 1845. He discovered the North West Palace in 1848.

The reliefs from the palace at Nimrud are important in the history of art because they represent the first narrative work in stone on a large scale. Like the Homeric poems, however, the maturity of their style indicates that these reliefs were the fruition of a long process of development. The hypothetical location of the reliefs in the throne room of the palace gives us some idea of the effect these panels had on the contemporary visitor. The reliefs were arranged in an upper and lower register, separated by the cuneiform Standard Inscription, translated

below. On the south wall, beginning at the left, two upper panels showed Ashurnazirpal hunting wild bulls and lions. Beneath them were two complementary panels of the king pouring libations over a dead bull and lion. In the next sequence the upper panels depicted the storming of a fort and the shooting of enemies swimming a moat, the lower slabs the king reviewing a procession of captives. A door on which appeared bull colossi and winged genii intervened at this point, and then followed a number of slabs which are now missing. Nine other slabs from the far right end of this wall also survive, showing battle and camp scenes of the type described above. The figures were originally painted black for beard, hair, and pupil of the eye; white for the eyeball; and red on the king's headdress and sandals. Above the slabs, the walls and ceilings were brilliantly colored in blues, reds, black, and white. The combined effect of the symmetry and massiveness of the reliefs, the repetition of the inscription, and the vividness of the colors must have impressed upon the ancient visitor the notion of the power and invincibility of the Assyrians.

The history of the Assyrians and their cities of Ashur, Calah, and Nineveh on the upper Tigris River falls into three periods. The first was one of development and long struggle by this Semitic people against the Babylonians, Hittites, Egyptians, and others from about 2500 to 1000 B.C. In the second age, from about 1000 to 745 B.C., Assyria became a world power under the able leadership of rulers like Ashurnazirpal II, who in addition to building the great palace at Calah also displayed talent as an imperial executive and military leader. Under him and his successors the Phoenician cities were made tributaries and control of Mediterranean trade routes was secured. The third and great period of the Empire, 745 to 612 B.C., saw hegemony over the entire Middle East established by such warlords as Tiglath-pilaser III, Sennacherib, and Ashurbanipal, and it was in this time especially that Assyria became forever identified as a cruel and destructive military power. When it came, the decline and collapse of the Empire was precipitous. Nineveh was destroyed by the Medes and Babylonians in 612 B.C., and by the end of the seventh century the Assyrian nation no longer existed. Though the creative legacy of the Assyrians is small, their achievements in architecture and in low-relief sculpture of the type at Bowdoin are of great importance.

The Standard Inscription, translated by D. D. Luckenbill, appears on all the reliefs:

Palace of Ashurnazirpal, the priest of Ashur, the favorite of Enlil (Bel) and Urta, the beloved of Anu and Dagan, the strong one among the great gods, the mighty king, king of the universe, king of Assyria; son of Tukulti-Urta, the great king, the mighty king, king of the universe, king of Assyria; (grand)son of Adad-nirari, the great king, the mighty king, king of the universe, king of Assyria; the valiant hero, who goes hither and yon trusting in Ashur, his lord, who is without a rival among the princes of the four quarters (of the world); the wonderful shepherd, who fears not the battle; the mighty flood who is without a conqueror; the king who has brought to subjection those who were not submissive to him, and has brought under his sway the totality of all peoples; the mighty hero who tramples on the neck of his foes, treads down all enemies, and who shatters the power of the strong; the king who goes hither and yon trusting in the great gods, his lords, and whose hand has conquered all lands, who has brought under his sway all mountain (regions) and has received their tribute, taking hostages and establishing his might over all lands.

When Ashur, the lord who called me by my name and has made great my kingdom, intrusted his merciless weapon unto my lordly power, I overthrew in battle the widespreading hosts of the Lulumê. With the help of Shamash and Adad, the gods, my helpers, I thundered over the hosts of the Nairi-lands, Kirhi, Shubarê, and Narib, like Adad the destroyer. (I am) the king, who, from beyond the Tigris to Mount Lebanon and the Great Sea, has brought in submission at his feet the whole land of the Lakê, (and) Suki, as far as the city of Rapiku, whose hand has conquered (the territory) from the source of the river Subnat to the land of Urartu (Armenia). From the pass of Kirruri to the land of Gilzani, and from beyond the Lower Zab to the city of Tilbâri, which is above the land of Zaban, from Til-sha-Zabdani, Hirimu, and Harartu, the fortresses of the land of Karduniash (Babylonia), I have added to the border of my land, and (the inhabitants of the countries) from the pass of Babite to the land of Hashmar I have reckoned as peoples of my land. In the lands which I have brought under my sway I have appointed my governors, (and) the performance of service (I have laid upon them).

Ashurnazirpal, the exalted prince, who fears the great gods, the powerful lord, conqueror of cities and mountains to their farthest borders, the king of lords, who consumes the wicked, who is crowned with splendor, who is fearless in battle, the unsparing leader, the destroyer of opposition, the king of glory, the shepherd, the protector of the (four) quarters (of the world); the king, the word of whose mouth destroys mountains and seas, who by his lordly attack has forced mighty and merciless kings from the rising to the setting sun to acknowledge one rule.

The former city of Calah, which Shalmaneser, king of Assyria, a prince who went before me, had built, that city had fallen into ruins and lay prostrate.

That city I built anew, and the peoples whom my hand had conquered, from the lands which I had brought under my sway, from the land of Suki, from the whole land of Lakê, from the city of Sirku which is on the other side of the Euphrates, from the farthest border of the land of Zamua, from Bit-Adini and the land of Hatte, and from Lubarna, (ruler) of the land of Hattini, I took and I settled them therein. The ancient mound I destroyed, and I dug down to the water level; I went down 120 tipke. A palace of cedar, cypress, juniper, boxwood, mulberry, pistachio-wood, and tamarisk, for my royal dwelling and for my lordly pleasure for all time I founded therein. Beasts of the mountains and of the seas of white limestone and alabaster I fashioned, and set them up in its gates. I adorned it, I made it glorious, and put copper hooks all around it. Door-leaves of cedar, cypress, juniper, and mulberry I hung in the gates thereof, and silver, gold, lead, copper, and iron, the spoil of my hand from the lands which I had brought under my sway, in great quantities I took and I placed therein.

There are two reliefs in Boston from the North West Palace. On one a winged genius raises the right hand in salute while holding a cere-monial baton with the left (inv. no. 81.56); on the other a winged genius is seen pollinating the sacred tree (inv. no. 35.731). The Standard In-scription appears on both slabs. For Assyrian reliefs in the Metropoli-tan Museum, see Charles Sheeler's work listed in the bibliography, below.

BIBLIOGRAPHY

A. H. Layard, *Nineveh and Its Remains* (1954) plan iii, for an outline of the North West Palace at Nimrud.

E. A. Wallis Budge, *Assyrian Sculptures in the British Museum* (1914).

A. T. Olmstead, *History of Assyria* (1923).

D. D. Luckenbill, *Ancient Records of Assyria and Babylonia* I (1926) 171–173, for the translation of the Standard Inscription; reprinted in no. 7, below, pp. 5–7.

C. J. Gadd, *The Stones of Assyria* (1936).

E. F. Weidner, "Die Reliefs der assyrischen Könige," *Archiv für Orientforschung*, suppl. 4 (1939).

Charles Sheeler and others, *The Great King, King of Assyria: Assyrian Reliefs in the Metropolitan Museum of Art* (1945).

J. B. Stearns and D. P. Hansen, *The Assyrian Reliefs at Dartmouth* (1953).

H. G. Güterbock, "Narration in Anatolian, Syrian and Assyrian Art," *American Journal of Archaeology* 61 (1957) 62–71.

G. Furlani in *Enciclopedia dell' arte antica classica e orientale*, 4 vols. (1958 —) s.v. "Assiria, Arte."

R. D. Barnett, *Assyrian Palace Reliefs* (1960).

THE MESOPOTAMIAN COLLECTION (1–9)

1. *Terracotta cone inscribed with cuneiform characters.* The translation of the text reads as follows: "To Ningirsu, mighty hero of Enlil. Gudea, ensi of Lagash. The correct thing to make — splendidly the Ninnu temple of the divine white stormbird he built and restored."

Babylonian work. About 2150 B.C. L, 0.115 m. Diam. of head, 0.045 m. Gift of the Misses Walker. Acc. no. 1894.3.

The translation of the Sumerian cuneiform text, as well as a transcription of it, was made by Miss Edith Porada, editor of the corpus of Near Eastern seals, in a letter of August 26, 1946.

Lagash, together with Ur and Erech, was one of the principal cities of the Sumerians in southern Babylonia during the third millenium B.C. Under the reign of Gudea, the *ensi*, or governor, the city saw its golden age and the classical period of Sumerian sculpture and literature. Gudea considered his greatest achievement to be the rebuilding of the great temple to his god Ningirsu, the remains of which form a large mound on the northern edge of the city. Many cones with the same inscription as that on the Bowdoin terracotta were found by the French excavators of the site in the late nineteenth century. See E. de Sarzac, *Découvertes en Chaldée* I (1887); P. Handcock, *Mesopotamian Archaeology* (1912) 111–112, pl. viii.

2.* *Chalcedony cylinder seal with intaglio of a hero fighting a winged bull.* The hero on the left prepares to strike with a sword held in the right hand. With the other hand he seizes a foreleg of the monster, which stands erect on its hind legs. In the field are a star and crescent, and behind the man are two stalks. Beneath the feet of the monster is a small animal. The cylinder is drilled through lengthwise. PL. V

Assyrian work. About 900–700 B.C. L, 0.043 m. Diam., 0.009 m. Warren Coll. Acc. no. 1913.52.

Casson, *Catalogue*, no. 92.

The scene shows the struggle between the god Bel and the dragon, which has been interpreted as a representation of the cosmogonic myth of the war between order and disorder. See W. H. Ward, *Seal Cylinders of Western Asia* (1910) 197–212, esp. figs. 572, 580, and 584; H. Frankfort, *Cylinder Seals* (1939); Edith Porada, *Mesopotamian Art in Cylinder Seals of the Pierpont Morgan Library* (1947); and Edith Porada, *Corpus of Ancient Near Eastern Seals in North American Collections: The Pierpont Morgan Library Collection*, 2 vols. (1948).

3.* *Crystalline gypsum slab with low reliefs and cuneiform inscriptions.* Two griffin demons facing the sacred palm between them are shown fertilizing date blossoms with date spathes held in the raised right hand. Each holds a bucket in the left hand which may contain pollen. The demons have eaglelike heads crowned by upright feathers. The nearer wing of each is folded down, the farther is upright, and each wears a fringed garment which leaves one leg bare to the knee. The palm stem rises between sepals to its crown at the top, and around the stem are courses of undulating water in this highly stylized representation. These courses, which represent irrigation canals, form volutes at regular intervals on the stem, which in turn may represent whirlpools. Many palmettes grow at the junctions of the canals. The stem of the tree itself is marked by a chevron pattern to distinguish it from the water courses. The inscription is across the upper half of the stone. PL. I

Assyrian work. Of the reign of Ash-urnazirpal II (885–860 B.C.), H, 1.338 m. W, 2.128 m. Haskell Coll. Acc. no. 1860.1.

Descriptive Catalogue, 107, no. 487.

This relief was from the lower register of a panel which perhaps came from room I of the palace. All the slabs from this chamber with one exception are similar: in the upper register of each are kneeling winged demons fertilizing the sacred tree; in the center is the Standard Inscription; and in the lower register are the griffin demons fertilizing the sacred tree. See Layard, *Nineveh and Its Remains*, 313; for a complete example of this type in New York, see Sheeler, *The Great King, King of Assyria*, pls. v–vii; on the origins and role of the griffin demon, *ibid.*, 32; cf. Barnett, *Assyrian Palace Reliefs*, pl. 7.

4.* *Crystalline gypsum slab with low reliefs and cuneiform inscriptions.* A winged, bearded genius facing right holds a date spathe in the raised right hand and a bucket in the left. He wears a miter with triple bull's horns and a heavy pendant earring. The nearer wing is down, the farther one up, and the forward leg is bared to the knee. In the girdle under the right arm are inserted two daggers and a flywhisk, the handle of which is in the shape of a horse's head. His inner and outer garments are heavily fringed and he wears a bracelet and armband on each arm. The inscription cuts across his waist. The relief is in excellent condition. PL. II

Assyrian work. About 885–860 B.C. H, 2.185 m. W, 1.485 m. Haskell Coll. Acc. no. 1860.2.

Descriptive Catalogue, 107, no. 488; *Illustrated Handbook*, 15, fig. 1.

This and a similar figure facing left may have been magically anointing the king, who stood between them; at least from the amount of space left on the right it does not appear that the sacred tree was involved. The type of miter seen here is found as the headgear of the Mesopotamian gods as early as the middle of the third millennium. The position of the wings and the bared leg is used in the reliefs of the demons and genii to indicate their swiftness and freedom of movement. See Sheeler, *The Great King, King of Assyria*, 23, and pl. 1.

5. *Crystalline gypsum slab with low reliefs and cuneiform inscriptions.* Two figures, whose countenances are mutilated, stand facing to the right. The one on the left is a winged, bearded genius who holds a date spathe in the raised right hand and a bucket in the left. He is garbed in the customary manner; see No. 4, above. He appears to be anointing the figure on the right, a bearded functionary who stands with the right hand raised in a salute. Before him he holds a bow in the left hand, and he wears a sheathed sword on the left hip. His long coat covers both legs to the ankles. The inscription covers the lower three quarters of the slab. The stone was defaced in the upper right corner by someone attempting to imitate the style of the profiles.

Assyrian work. About 885–860 B.C. H, 1.675 m. W, 1.980 m. Haskell Coll. Acc. no. 1860.3.

Descriptive Catalogue, 107, no. 489.

The figure on the right appears to be the keeper of the king's bow. There are similar reliefs in London (British Museum, inv. nos. 124564–6) showing winged, bearded genii magically anointing the bearers of the king's cup and bow. Cf. Barnett, *Assyrian Palace Reliefs*, pls. 30, 31.

6. *Crystalline gypsum slab with low reliefs and cuneiform inscriptions.* A winged, bearded genius facing left holds a date spathe in the raised right hand against a blossom of the sacred tree. He is garbed in the customary manner; see No. 4, above. Behind him

are the palmettes of another sacred date palm. The inscriptions cut across the middle of the slab.

Assyrian work. About 885–860 B.C. H, 2.315 m. W, 1.855 m. Haskell Coll. Acc. no. 1869.4.

Descriptive Catalogue, 108, no. 490; *Illustrated Handbook*, 15, fig. 2.

7.* *Crystalline gypsum slab with low reliefs and cuneiform inscriptions.* The king stands in profile to the right, dressed for the hunt. He is armed with a sword on his left hip and with two daggers in his belt on the right side. His upraised right hand holds a cup and his left rests on a bow. Behind him stand two figures, both eunuchs, one holding what may be a riding crop, the other bearing a parasol. Before the king remain two hands of what was a chamberlain. The right hand holds a flywhisk over the king and the left the customary napkin. At the bottom of the slab are the remains of two lines of an inscription. PL. III

Assyrian work. About 885–860 B.C. H, 0.965 m. W, 0.790 m. Haskell Coll. Acc. no. 1860.5.

Descriptive Catalogue, 108, no. 491.1, and facing plate; *Illustrated Handbook*, 15, fig. 2; Olmstead, *History of Assyria*, fig. 58, facing p. 104.

The inscription at the bottom proves that this scene came from an upper panel in two registers, with the Standard Inscription between them. The smaller scale and finer execution of this relief suggest that it was designed for a private royal apartment. Though the relief shows no dead quarry, it may be part of a bull- or lion-hunting scene, with the king taking refreshment after the hunt. See Gadd, *The Stones of Assyria*, 212–213, 243.

8.* *Crystalline gypsum fragment of the head of Ashurnazirpal in low re-* *lief.* The fragment comprises the head and beard of the king in right profile. Over the forehead is a band on which there are traces of white. The eye is white, with black for the pupil. The beard is rendered in a series of stylized curlicues with a series of vertical lines near the bottom. PL. IV

Assyrian work. About 885–860 B.C. H, 0.350 m. W, 0.180 m. Warren Coll. Acc. no. 1906.4.

Descriptive Catalogue, 108, no. 491.2.

Ashurnazirpal II was one of the earliest of the Assyrian warrior kings whose conquests extended westward to the Mediterranean. He also established the system of control of the outlying provinces through Assyrian governors, a method that was later to be used with such success by the Persian kings. Excavations of his palace and temple at Calah have unearthed numerous reliefs and records of his conquests. See Olmstead, *History of Assyria*, 81–109, figs. 44–61.

Although the treatment of hair and beards of both the king and his genii in the reliefs of this period is much of a type, an attempt at individual portraiture has been observed. In the present instance, for example, the rounded, drooping nose, the thin, severe lips, and the intensity of the gaze all indicate no stylized type, but an individual who must, of course, be the king. Thus this portrait with its stylization of physiognomy serves as a good example of the limitations and rigidity of Assyrian realism in this period. See Sheeler, *The Great King, King of Assyria*, 28.

9. *Crystalline gypsum fragment of a cuneiform inscription.* Four lines of text are preserved. The top and left side are intact.

Assyrian work. About 885–860 B.C. H, 0.114 m. W, 0.100 m. T, 0.050 m. Haskell Coll. Acc. no. 1860.6.

III

The Egyptian Collection

ALTHOUGH the Egyptian collection is neither extensive nor endowed with many outstanding pieces, it does contain a sufficient variety of funerary objects to stir the imagination. These artifacts particularly reveal the intense concern of the ancient Egyptian with his gods, death, and the afterlife, matters to which he devoted a great amount of his substance and thought. His varied and seemingly contradictory religion can be grasped only by recognition of its polytheistic and pluralistic nature. Each divinity tended to possess limited functions, each myth limited insight, yet all were simultaneously powerful and valid.

In the beginning the various gods were often local deities, such as Ptah at Memphis, Osiris at Busiris, and Bast at Bubastis, and many of them were identified with different animals. Thus Horus was the hawk, Anubis the jackal, and Thoth the ibis. This fact, so puzzling to us and so often misinterpreted, probably derived from an awesome regard for those characteristics of animal life which set it apart from human existence. The inscrutability and unchanging reality of the animal world gave it a status in Egyptian eyes that eventually found full expression in the religious art of the country. The complexities of Egyptian religion, however, do not stop with this phenomenon, as one example should demonstrate. Horus the hawk was a sun god, but in this role he was often identified with Amon, another sun god of importance. The chief myth about Horus tells how he avenged the murder of his father, Osiris, by the wicked Set after countless trials and with the help of his mother, Isis. Finally, in the Hellenistic period, he often takes the form of the

chubby infant Harpocrates with the fingers of the right hand held to his mouth (see No. 22), and in various other forms he was identified as Heracles, Eros, or Apollo.

The Egyptian concern with the afterlife is forever identified with the monumental pyramids of Cheops and his successors and with the custom of mummification (see Nos. 12, 15, and 16). Each pharaoh built his own pyramid at great cost of treasure and labor in order to safeguard his elaborately preserved corpse for all time. The pyramid of Cheops, for example, was the largest and the oldest, being 768 feet square at the base and 482 feet high, containing some 2,300,000 blocks of limestone of an average weight of 2.5 tons each, and requiring the labor of an estimated 100,000 men for 20 years. The practice of mummification aimed not merely to preserve the body from decay, but, more importantly, to maintain the personal identity of the deceased. In the process the viscera, but not the heart, were first removed, fatty tissue was then dissolved by immersion of the corpse in a solution of salt or natron for a period of weeks, and finally the completely desiccated body was covered with a resinous paste and carefully wrapped in bandages. A ritual was then performed over the mummy, designed to restore its vital faculties, and a funerary banquet was prepared to give the deceased physical sustenance.

The first noteworthy period of Egyptian history is that of the Old Kingdom (2680–2258 B.C.), during which the three colossal pyramids and the great Sphinx were built at Gizeh and the various plastic arts developed and flourished. In the last two centuries of the third millennium the central authority slipped away to provincial barons, but the pharaohs of the Middle Kingdom (2040–1786 B.C.) regained their power, conquered Nubia, and fought in Palestine. Secular literature, architecture, and the arts all prospered in this period. The next two centuries saw a second time of disintegration, marked by the rule of the nomadic Hyksos, but the rise of the New Kingdom (1570–1085 B.C.) signaled the beginning of the greatest period of Egyptian history. Noteworthy figures of Dynasty XVIII are the conqueror Tuthmosis III (1504–1450 B.C.), who annexed Palestine, Phoenicia, and Syria; the diplomatic Amenhotep III (1410–1372 B.C.), who ruled at the apogee of prosperity; and the heretic Akhenaten (1372–1355 B.C.), who sought to establish the monotheism of the sun god Aton. Dynasty XIX (1342–1197 B.C.) also stands out for the monumental Ramesside art created at Karnak, Abu Simbel, and Medinet Habu just before the final period of decline

began. The Assyrians overran the country from 671 to 663 B.C., but Psamtik repelled them to begin the Saitic period (663–525 B.C.), a time chiefly marked by conventional imitations of earlier forms of art. Then came the unbroken ages of foreign domination: the Persian period (525–332 B.C.), the Greek, under the Ptolemies (332–30 B.C.), the Roman (30 B.C.–A.D. 324), and the Byzantine, or Coptic (A.D. 324–640). The ancient history of Egypt ends with the Arabic conquest of the seventh century.

Objects of especial interest in the collection include the following: two inscribed funerary stelae (Nos. 10–11), the handsome face from a mummy cartonage (No. 12), a collection of *shawabti,* or respondent figurines (No. 18), a tiny silver statuette of the god Harpocrates (No. 22), a bronze statuette of the cat-headed goddess Bast (No. 23), and the collection of Coptic textiles (Nos. 53–61).

A note on the dating of the Egyptian artifacts must be added here. Many of the smaller objects are common tomb decorations which have come to Bowdoin without information about provenance or details of excavation or acquisition. It appears that most of these pieces belong to the Late Period of Egyptian art, a lengthy span that can be extended from the beginning of Dynasty XXI (1085 B.C.) to the end of the Ptolemaic period (30 B.C.). However, in the absence of pertinent data, it seems wise not be attempt dating these objects at this time. In all other cases, however, where data is on file or where parallel material has been found, dates are given.

BIBLIOGRAPHY

Catalogue général des antiquités égyptiennes du musée de Caire (1901 —).

E. A. Wallis Budge, *The Mummy: A Handbook of Egyptian Funerary Archaeology* [2] (1925).

H. Frankfort, *Kingship and the Gods* (1948); *Ancient Egyptian Religion* (1948).

J. G. Milne in *Oxford Classical Dictionary* (1949) s.v. "Egypt under the Greeks and Romans."

J. Vandier, *Manuel d'archéologie égyptienne,* 3 vols. (1952 —).

W. C. Hayes, *The Scepter of Egypt,* 2 vols. (1953 —).

K. Lange and M. Hirmer, *Egypt: Architecture, Sculpture, Painting in Three Thousand Years* (1956).

J. A. Wilson, *The Culture of Ancient Egypt* (1956).

A. H. Gardiner, *Egyptian Grammar* [3] (1957).

William Stevenson Smith, *The Art and Architecture of Ancient Egypt* (1958); *Ancient Egypt as Represented in the Museum of Fine Arts, Boston* [4] (1960).

S. Donadoni in *Enciclopedia dell' arte antica classica e orientale,* 4 vols. (1958 —) s.v. "Egiziana, Arte."

Larousse Encyclopedia of Mythology (1959).
H. W. Müller in *Encyclopedia of World Art*, 6 vols. (1959 —) s.v. "Egyptian Art."

THE EGYPTIAN COLLECTION (10–67)

10. *Funerary stele of alabaster with three incised figures and with hieroglyphics in the field.* The stone, curved at the top, is chipped and worn. On the right is the figure of the dead man and behind him his son. In the center is an offering table with food on it and adorned by a lotus flower. On the left is the god Ptah holding the *usr* scepter, a symbol of strength.

From Upper Egypt. Dynasty XIX (1342–1197 B.C.). H, 0.215 m. W, 0.170 m. T, 0.055 m. Estes Coll. Acc. no. 1905.17.

In a letter from Cairo dated April 9, 1904, R. Huntington Blanchard interpreted the hieroglyphics: the name of the deceased is Hou-i-nefer, son of Kaenhu; the child of the deceased is named Aahotep.

Ptah was worshiped from the earliest period at Memphis. He is usually represented as a mummified figure, his body wrapped in mummy strips, and his head tightly bound. Only his hands remain free for him to hold a scepter, which unites the emblems of life, stability, and omnipotence. He was regarded at Memphis as the shaper of the world and the father of gods and men. See Frankfort, *Ancient Egyptian Religion*, 23–24.

11. *Funerary stele of alabaster with four incised figures and seven lines of hieroglyphics.* On the right side stands the dead man facing a triad of divinities on the left: Osiris, Horus, and Isis. The lower half of the stone is covered by the hieroglyphics. When found, the stele was battered and friable, but it has since been restored.

From Akhmim (Panopolis). After Dynasty XXII (950–730 B.C.). H, 0.450 m. W, 0.330 m. T, 0.068 m. Estes Coll. Acc. no. 1905.18.

The translation of the text was made by Dows Dunham, now curator emeritus of the Department of Egyptian Art, Museum of Fine Arts, Boston, in a letter dated May 29, 1936, given line for line:

1. An offering which the King gives to Osiris, foremost of the Westland, great god, lord of Abydos, and Ptah-
2. Sokar-Osiris, great god, lord of the Secret Place (?), and Anubis upon his hill, who is in the place of embalming, lord of the necro-
3. polis, that they may give invocation-offerings of bread, beer, cattle, fowls, wine, wine (?), incense, ointment (?),
4. clothing, offerings, and food, every good pure sweet thing for
5. the spirit of Osiris, the Priest (?), Scribe of Accounts, Nesi-pa-maj, deceased, the son of the same (i.e. man with the same titles), Wedja -Hor, deceased,
6. the son of the same, Nesi-pa-maj, deceased, son of the same, Hor-resuet, and born of the Lady,
7. the High-Priestess of Min, Pas-herjneterj, deceased: he shall not be destroyed for ever and ever.

See *The Mummy*, 439–450, for the development of the sepulchral stele in Egypt.

12.* *Mummy cartonage consisting of a face and a very deep headpiece.* The face is painted in gilt, with the eyelids and eyebrows in black. The eyes themselves consist of agate, white with black for irises. Over the forehead are two horizontal rows of pastic ornamentation of various shapes: circles, disks with spokes, figurines, and asplike shapes. On the top are two large plastic shapes, one a large winged scarab, the other a circular seal with the figure of a bird. The top also has much painted decoration in pink, red, brown, green,

and yellow. This includes flower motives and a scene with an altar, on each side of which is a votary and animal gods. Though broken behind the face on the right side, the covering is in excellent condition. PL. V

New Kingdom or later. H, 0.300 m. W, 0.250 m. T, 0.360 m. Gift of E. E. Kern. Acc. no. 1917.12.

During the Old Kingdom the features of the dead were painted on the outer mummy wrappings, but in Dynasty XI (2040–1991 B.C.) the face and wig were painted on cartonage, a molded casing made of layers of linen, mucilage, and plaster. This headpiece was then placed upon the head of the mummy. The custom of using cartonage masks continued until the Ptolemaic period, and from this method was early evolved the style of the anthropoid coffin. See W. R. Dawson in *Encyclopaedia Britannica* (1961) s.v. "Mummy"; *The Mummy*, 221–222.

13. *Mummy cartonage consisting of head and chest.* The face and neck are painted in gilt, the eyes and eyebrows are black. The hair is rendered as a series of dark blue and buff bands curving over the head and down the shoulders. Plastic beads were attached at the neck. The covering is broken over the forehead and is smeared with resin in places.

New Kingdom or later. H, 0.430 m. W, 0.260 m. T, 0.095 m. Hammond Coll. Acc. no. 1898.42.1.

See Hayes, *The Scepter of Egypt* II, fig. 189, for a mask of similar styling.

14. *Three fragments of mummy cartonage.* They consist of a pectoral and two pieces made of horizontal strips joined at both ends by verticals. The pectoral, which is completely covered in gilt, has two large convex bosses at the upper corners. The object is much smeared with resin in its present condition. The other two decorations are painted in gilt, red, green, and yellow.

They are adorned with a variety of raised geometric patterns.

New Kingdom or later. Pectoral: H, 0.260 m. W, 0.400 m. Second piece: H, 0.475 m. W, 0.225 m. Third piece: H, 0.280 m. W, 0.225 m. Hammond Coll. Acc. nos. 1898.42.2–4.

15. *Mummified human head.* The slightly open mouth shows the teeth to be in very good condition. The nose is somewhat flat, but not Negroid; it may have been broken in life.

New Kingdom or later. H, 0.205 m. W, 0.125 m. T, 0.180 m. Gift of Mrs. Lucien Howe. Acc. no. 1929.5.

The process of mummification, which aimed at the preservation of the body from decay and at the protection of the personal identity of the deceased, varied greatly from period to period in Egypt. The most elaborate methods were employed during the Late Period, the entire process occupying as much as seventy days. See G. E. Smith, *The Royal Mummies. Catalogue général MC* (1912); *The Mummy*, 201–215; R. J. Forbes, "Mummification," in *A History of Technology*, Charles Singer and others, I (1954), 266–270.

16. *Mummified hawk.* The bird is still completely covered in mummy wrappings save for the beak and claws.

Late Period. H, 0.385 m. Donor unknown. Acc. no. 1931.12.

In the Late Period large quantities of various sacred animals were mummified by the Egyptians. The ibis, falcon, owl, and other birds have been found, the crocodile was the most popular reptile, and cats and dogs were also especially common. See C. Gaillard and G. Daressy, *La Faune momifiée. Catalogue général MC* (1905), for mummified animals of all types.

17. *Mummified animal, apparently a kitten.* The animal is completely swathed in wrappings.

Late Period. H, 0.175 m. Donor un-

known. Acc. no. 1931.13.

See No. 16, above. On the role of the cat, see V. Langton, *The Cat in Ancient Egypt* (1940).

18. *Forty-three faïence shawabti, or respondent figurines.* The figurines stand in mummy wrappings covered with hieroglyphics. Their hands are crossed on their breasts, holding a hoe and a crook. The colors range from deep blue to gray.

H, 0.045–.175 m. Hammond and Estes colls. Acc. nos. 1898.44.1–18 and 1905.25.1–25. The individual figurines cannot now be identified according to donor.

These figurines were placed by the score in tombs to act as substitutes for the dead man in the afterlife should he be called upon to do hard labor. The inscription addressed the figurine and ordered it to step forward for duty should any of the forty-two judges of the underworld require the dead man to work in the fields or do other tasks of this type. See *The Mummy*, 251–258, pl. 20; Frankfort, *Ancient Egyptian Religion*, 118–119.

19. *Faïence shawabti, or respondent figurine.* The figure stands tightly swathed in mummy wrappings from the hips down. His two hands, which are freed from the winding sheet, are crossed over his breast. In the left he holds a whip, in the right a crook. His head is bare and he has the customary chin beard and long hair. The color is a light greenish-blue. The lower part of the figure is covered with hieroglyphics.

H, 0.150 m. W, 0.038 m. Gift of William W. Lawrence. Acc. no. 1958.15.

See No. 18, above.

20. *Upper part of a bronze statuette of Osiris.* The figure is broken off at the waist. The god wears the crown of Upper Egypt, a dome-shaped hat

with a papyrus tuft in front, and holds his hands crossed over his chest. In his hands are a crook and a whip. The crown has a flat extension on both sides. The surface of the metal is much corroded.

From Cyprus. Ptolemaic period. H, 0.115 m. Estes Coll. Acc. no. 1905.29.

Osiris was a god of fertility who, after his murder by his brother Set, ruled in the underworld as judge of the dead. With his wife and sister, Isis, and their son, Horus, he formed an important trinity, which later was worshiped in Greece and Rome. The Greeks identified him with Dionysus as a fertility god and with Hades as god of the underworld. See G. Daressy, *Statues des divinités. Catalogue général MC I–II* (1905–06) 66–115, pls. 12–21; *The Mummy*, 361–363; T. A. Brady in *OCD*, s.v. "Osiris."

21. *Iron statuette of Osiris.* The god wears the crown of Upper Egypt and holds scepter and whip in his hands, which meet on his chest. The body is flat and boardlike.

Late Period. H, 0.115 m. Hammond Coll. Acc. no. 1898.46.

See No. 20.

22. *Silver statuette of Harpocrates.* He wears the uraeus on his head and a necklace over the shoulders; he also has wings. The index finger of the right hand is to his lips, and he holds a cornucopia in his left hand and arm. At his feet to the left is a small quadruped, in the center a tortoise, and to the right a stick around which a serpent is coiled. He stands on a small rectangular base.

Greek work. Ptolemaic period. H, 0.030 m. Warren Coll. Acc. no. 1915.52.

Casson, *Catalogue*, 14, no. 108.

Harpocrates is the name given by the Greeks to the god Horus in the form of a chubby child, who invariably has his finger held to his mouth. He was

born, according to the mythologies, after the murder of his father, Osiris, and consequently had to suffer many trials before achieving revenge on the wicked Set. He was variously identified with Heracles, Eros, and Apollo. See G. Daressy, *Statues des divinités. Catalogue général MC* I–II (1905–06) 40–65 pls. 8–12; *The Mummy*, 378–381; T. A. Brady in *OCD*, s.v. "Horus"; S. Donadoni in *Encic AA*, s.v. "Horus."

23. *Bronze statuette of the cat-headed goddess Bast.* The goddess holds a sistrum in her right hand and an aegis of the sun goddess Sekhmet in her left hand up against her bosom. There is also a basket on her left arm. There are holes in both ears for the fitting of earrings, which are lost. Her dress is ornamented with an incised vertical herringbone design, and she stands on a low plinth, with a spur for insertion into a mount below. There is a reddish deposit on part of the figure.

Dynasty XXII (950–730 B.C.) H, 0.082 m. Warren Coll. Acc. no. 1923. 39.

Casson, *Catalogue*, 14, no. 102.

The cat was the sacred animal of Bast, the local goddess of Bubastis, a provincial capital in Lower Egypt. As a result, the goddess was represented with a cat's head, though originally she had been depicted as a lioness. With her consort, Ptah, and their son, Nefertum, she formed a divine triad, and she became a great national divinity when about 950 B.C. Bubastis became the capital of the kingdom. She was a goddess of pleasure, music, and dancing, and many great festivals were celebrated in her honor. See G. Daressy, *Statues des divinités. Catalogue général MC* I–II (1905–06) 250–253, pls. 50–53; *The Mummy*, 372–374; S. Donadoni in *Encic AA*, s.v. "Bast."

24. *Five faïence amulets with jackal heads, representing the god Anubis.* The god in each instance is standing and holding in his hands what appears to be a bird. The amulets range in color from deep to light blue. Each object has two holes, one at the top, the other at the bottom, for fastening the amulet to the mummy.

H, 0.035–.050 m. Estes Coll. Acc. nos. 1905.31.1–5.

Anubis presided over embalmings in the earliest dynasties. From this role he developed into the *psychopompos*, or conductor of souls, who, like Hermes, brings the dead before the judges of the underworld to weigh their souls. See G. Daressy, *Statues des divinités. Catalogue général MC* I–II (1905–06) 138–149, pls. 29–31; *The Mummy*, 362–365; S. Donadoni in *Encic AA*, s.v. "Anubis."

25. *Faïence amulet with the jackal head of the god Anubis.* The object is colored blue.

H, 0.040 m. Hammond Coll. Acc. no. 1898.44.1.

See No. 24, above.

26. *Two glazed clay amulets.* No. 1 is in the shape of two small jars joined together. It is colored blue and black. No. 2 is in the shape of a crude herm. It is colored light blue.

Said to be Egyptian. No. 1: H, 0.041 m. W, 0.020 m. No. 2: H, 0.035 m. W, 0.015 m. Johnson-Chase Estate. Acc. nos. 1958.43.1–2.

27. *Four faïence figurines representing the four sons of Horus, the warders of the viscera of the dead.* The figurines are delineated in outline only, both sides being flat and unmarked. The identities therefore are possible only from the profiles of the heads: the human-headed Imsety, the hawk-headed Qebhsnuf, the jackal-headed Duamutef, and the dog-headed Hapi. There are holes at the top and bottom of each figurine. Two of the figurines are broken at the waist, and all are blue in color.

H, 0.062 m. Estes Coll. Acc. nos. 1905.31.6–9.

Horus appointed his sons to watch over the heart and entrails of Osiris, and from this mythical beginning these gods became the official protectors of the viscera of the dead, which from the time of the Old Kingdom were customarily removed from the corpse to be preserved in four jars. Imsety guarded the liver, Qebhsnuf the intestines, Duamutef the stomach, and Hapi the lungs. See *The Mummy*, 240–245 and figs.; 369.

28. *Faïence amulet of the god Osiris.* It consists of an upright column with four horizontal bars at the top, and it represents the spinal column of the deity. The color is blue.

H, 0.033 m. Estes Coll. Acc. no. 1905.31.10.

The Egyptians wore a variety of charms as protection against injury or evil of any kind. The present amulet is called a *tet* and is described in chapter 155 of the Book of the Dead. See *The Mummy*, 306–308.

29. *Faïence amulet of the god Horus in the shape of a hawk.* The figure wears a crown and there is a loop at the back for suspension. The color is dark green.

H, 0.042 m. Hammond Coll. Acc. no. 1898.44.2.

See *The Mummy*, 267.

30. *Faïence amulet of the god Horus in the shape of a hawk.* The figure wears a crown, and there is a loop at the back for suspension. The object is broken at the head and at the feet. The color is light blue.

H, 0.028 m. Estes Coll. Acc. no. 1905.31.11.

31. *Faïence amulet in the shape of a papyrus column.* The color is blue.

H, 0.045 m. Estes Coll. Acc. no. 1905.31.12.

This amulet was supposed to bestow the vigor and charm of youth upon the wearer. See G. A. Reisner, *Amulets. Catalogue général MC* (1907) nos. 5394–5437, pl. 2; *The Mummy*, 314–315.

32. *Faïence amulet in the shape of a papyrus column.* The color is blue.

H, 0.053 m. Estes Coll. Acc. no. 1905.31.13.

33. *Square faïence medallion of the god Bes.* The god is flanked by two birds. His legs depend directly from his head, which is in frontal view. A projection on the top is drilled for suspension. The color is blue.

H, 0.030 m. Estes Coll. Acc. no. 1905.31.14.

Bes was the buffoon among the gods, but under the New Kingdom his stature increased and he became the patron of many domestic activities. He protected pregnant mothers, presided over the toilet of women, and acted as the guardian of sleep and defender against evil spirits and dangerous beasts. See G. Daressy, *Statues des divinités. Catalogue général MC* I–II (1905–06) 181–196, pls. 39–41; *The Mummy*, 368–374; S. Donadoni in *Encic AA*, s.v. "Bes."

34. *Four faïence amulets of the uzat, or sacred eye.* All these charms are drilled through for suspension. The colors are various shades of blue.

H, 0.020–.030 m. Estes Coll. Acc. nos. 1905.31.15–18.

The *uzat*, at first thought of as the right eye of Horus the Elder and later as the right eye of Ra, was worn to protect the person against ghosts, physical harm, or the curses of one's enemy. See G. A. Reisner, *Amulets. Catalogue général MC* (1907) nos. 5740–5811, pl. 5; *The Mummy*, 316–318.

35. *Faïence pectoral scarab with attached wings.* The color of the body

and wings is blue to bluish-gray. The wings have incised lines to indicate feathers. Each wing has three small holes, one at the tip and two at the roots. Opposite the latter on the scarab proper are corresponding holes for the attachment of the wings. There are also holes at the top and bottom of the scarab. The wings are at present attached to the body by four sets of tiny beads.

W, 0.150 m. H, 0.058 m. Johnson-Chase Estate. Acc. no. 1958.16.

The *scarabaeus sacer*, or dung beetle, was the sacred scarab of Egypt. From earliest times the beetle was the source of interest and symbolism, and in Egypt it was associated with the sun god and with resurrection and death. In the third millennium B.C. the scarab appears carved on stones for use as seals. In later times it was also made of metal and faïence, and was put to many decorative and religious uses. Scarabs were buried with mummies, for example, and were used to commemorate weddings and other important events. See *The Mummy*, 271–306.

36. *Large scarab of black quartz.* The bottom is flat and unmarked. Holes are drilled at the front and back of the figure, but do not go through.

L, 0.042 m. W, 0.031 m. Hammond Coll. Acc. no. 1898.47.1.

37. *Four small scarabs.* Three are of faïence, one of light green stone. Two of the faïence scarabs have hieroglyphics on their undersides, the third a geometric pattern of a rectangle and cross. All are drilled through.

L, 0.013–.015 m. Hammond Coll. Acc. nos. 1898.47.2–5.

See P. E. Newberry, *Scarab-shaped Seals. Catalogue général MC* (1907).

38. *Bronze mirror with decorated handle.* The round handle has a two-faced head at its top. The most prominent feature of the faces is a large,

spreading nose. The hair is rendered as a series of incised bands over the forehead and down the sides, where it ends in curls. The foreheads are decorated with the uraeus.

From Abydos. H, 0.235 m. W, 0.100 m. Estes Coll. Acc. no. 1905.38.

39. *Bronze mirror.* The object is oblong and has a thin extension which was fitted into the original handle, now missing.

W, 0.150 m. H, 0.140 m. Extension, 0.075 m. Estes Coll. Acc. no. 1905.31.

See Smith, *Ancient Egypt*, 121, 173.

40. *Bronze counterpoise.* The surface is oblong and the handle wide and flat. Some pieces of woven fabric are stuck to the surface.

W, 0.115 m. H, 0.080 m. Handle, 0.135 m. Estes Coll. Acc. no. 1905.32.

See Hayes, *The Scepter of Egypt* II, 252, fig. 153, for a similar object.

41. *Painted wooden shuti, or two plumes, with curved tops.* The colors are red, cream, and light and dark green. The back is plastered.

H, 0.130 m. W, 0.058 m. Estes Coll. Acc. no. 1905.33.

These feathers were worn in the *atef* crown by Ptah-Seker-Osiris, the triune god of the Egyptian resurrection. See *The Mummy*, 322.

42. *Three necklaces.* The glazed beads are of many shapes: oblong, round, disk, and arrowhead. Their colors are blue, green, yellow, and black. Some of the beads are of colored glass, others of glazed stone.

Estes Coll. Acc. no. 1905.39.

Beads of this type are a commonplace in Egyptian tombs. See *The Mummy*, 266–270.

43. *A string of multicolored beads.* The beads are round, disk-shaped, and tubular, and are blue, yellow, green, and black in color.

Johnson-Chase Estate. Acc. no. 1958. 17.1

44. *Necklace.* It consists of a blue faïence *uzat* and disk-shaped beads of brown, buff, and blue.
Johnson-Chase Estate. Acc. no. 1958.17.2

45. *Diorite bowl.* The lips curve inward, and the bottom is flat.
Said to be predynastic and from Abydos. Diam., 0.145 m. Estes Coll. Acc. no. 1905.34.

46. *Porphyry bowl.* The lip has a ridge on the inside, and a fragment of it is missing.
From Abydos. Diam., 0.185 m. Estes Coll. Acc. no. 1905.35.

47. *Alabaster bowl.* The lip is plain and the bottom is rounded.
From Abydos. Diam., 0.170 m. Estes Coll. Acc. no. 1905.36

48. *Alabaster flask.*
Said to be of Dynasty XXIV and from Abydos. H, 0.180 m. Hammond Coll. Acc. no. 1898.41.

49. *Oblong soapstone dish in the form of a swan.* The neck of the swan forms the handle; it describes a circle with the head resting on the side of the bowl. The rounded underside has incised decorations in zigzag and hatched patterns. The legs appear in low relief and are tucked under the body. The bowl itself is moderately deep.
Said to be of the New Kingdom. L, 0.153 m. W, 0.060 m. Gift of John Hubbard. Acc. no. 1927.32.

50. *Glazed terracotta lamp.* The large, round handle is pierced and on a line with the long, narrow spout at the other end. Both the spout and filling hole are funnel shaped. The filling hole, in the center of the body, pierces a raised figure of a frog. The remainder of the top surface has small knobs. The frog and top of the handle are glazed yellow, the rest blue.
Said to be from Thebes. L, 0.095 m. Diam., 0.055 m. Hammond Coll. Acc. no. 1898.2.

51. *Glazed bowl.* Two small protuberances are pierced for suspension. The lip is raised slightly from the body. The color is blue.
Said to be from Thebes. Diam., 0.043 m. Hammond Coll. Acc. no. 1898.3.

52. *Bronze amphora.* The sides rise vertically from a round, pointed bottom. A raised band encircles the neck, and two round, pierced handles rise from the lips. There is a large hole in one side.
Said to be from Thebes. H. 0.085 m. W, 0.025 m. Hammond Coll. Acc. no. 1898.48.

53. *Textile roundel.* Of black wool on a linen backing, it has an interlacing geometric design picked out in white. The backing and the roundel are somewhat tattered.
Coptic work. From the Fayum, Egypt. Third or fourth century A.D. Diam., 0.120 m. Backing: L, 0.255 m. H, 0.130 m. Warren Coll. Acc. no. 1915.6.
Cf. *VAM Catalogue of Textiles* I, pl. 27, no. 187.
The basic principle of weaving is the formation of a pliable plane of threads interlaced at right angles. In Greece the weighted-warp loom was used, on which the threads of the warp were suspended from an upper bar and weighted at the bottom. Two horizontal rods were inserted through these vertical threads in such a way that the weft thread on the shuttle might pass alternately over and under them. Weaving progressed downward, the weft being driven upward by a comb. In the first century B.C. the two-bar

loom was introduced into Rome from Egypt; this was a device which could be used vertically or horizontally. If a pattern was desired, a system of leashes and heddles was employed. In this work no people of antiquity surpassed the Coptic artists of Egypt. See *Encyclopaedia Britannica* (1961) s.v. "Weaving, Hand"; "Tapestry," pl. ii, and the extensive bibliography there; R. J. Forbes, *Studies in Ancient Technology* IV (1956) 192–251, with detailed bibliography; *Handbook*, 369–379, fig. 436. For general surveys of Coptic art, see L. Guerrini in *Encic AA*, s.v. "Copta, Arte," and W. F. Volbach in *EWA*, s.v. "Coptic Art."

54. *Textile fragment.* It has a square panel with tapestry decorations and part of a border, all on a linen backing. In the panel a horseman is encircled by a cable design, all in dark brown on a white ground. The border consists of vine and leaves in white on a dark brown ground.

Coptic work. From the Fayum, Egypt. Fourth or fifth century A.D. W, 0.255 m. H, 0.220 m. Warren Coll. Acc. no. 1915.10.

Cf. *VAM Catalogue of Textiles* I, pls. 16, no. 69, and 17, no. 150.

55. *Linen tunic.* It is decorated with embroidered flower designs in blue. The embroidery is around the collar, over the shoulder, and down the garment, front and back, in vertical panels on each side extending about a quarter of the length of the garment. A small embroidered flower in purple is also on each side in the lower corners, and a flower pattern is at the edge of each sleeve.

Coptic work. From the Fayum, Egypt. Fourth to sixth century A.D. H, 1.005 m. W, including sleeves, 1.600 m. Warren Coll. Acc. no. 1915.2.

Cf. *VAM Catalogue of Textiles* I, pl. 1, no. 1.

56. *Linen cloth.* It is decorated with interwoven lines in blue and white and embroidered flowers in green, rose, yellow, brown, blue and white. One original edge is preserved.

Coptic work. From the Fayum, Egypt. Fourth to sixth century A.D. H, 0.540 m. W, 0.550 m. Warren Coll. Acc. no. 1915.3.

57. *Textile fragment of a roundel.* In tapestry weave are a man and lion in variegated colors on a black ground. The whole is surrounded by a border of wave pattern.

Coptic work. From Egypt. Fifth or sixth century A.D. Gift of John Hubbard. Acc. no. 1927.1.

Because of favorable climatic conditions a mass of tapestry fragments have been found in Egypt dating from the fourth to the tenth century A.D. They consist mostly of garment trimmings and parts of pillows. Wall hangings are far less frequent. Many of the designs indicate a connection with the cult of Osiris and were used on burial robes because of their symbolic relevance to a life after death. Among them are the following themes: the vine; the amphora, often with a vine growing out of it; nude women and youths; birds and animals, especially the lion and the hare. See *Encyclopaedia Britannica* (1961) s.v. "Tapestry."

58. *Textile fragment of a border.* In tapestry weave are pairs of birds on each side of a tree. There is a geometric design along both edges in light brown and white against a dark brown ground. The birds and trees are in light brown, with details in rose, green, and white, all against a rose ground. An ornamental design in the center is in the same colors as those of the birds and trees.

Coptic work. From the Fayum, Egypt. Fifth or sixth century A.D. L, 0.230 m. H, 0.085 m. Warren Coll. Acc. no. 1915.5.

59. *Large textile fragment.* It has geometric designs arranged in a lattice pattern. The warp is in natural color, the weft in deep red. Designs are inlaid in white. One original edge is preserved.
Coptic work. From the Fayum, Egypt. Fifth or sixth century A.D. L, 0.330 m. H, 0.250 m. Warren Coll. Acc. no. 1915.9.

60. *Textile fragment of a border.* It has a vine in rose on a dark blue ground.
Coptic work. From the Fayum, Egypt. Fifth or sixth century A.D. L, 0.185 m. H. 0.060 m. Warren Coll. Acc. no. 1915.7.

61. *Textile medallion.* In tapestry weave is a man in the center. Animals, trees, and geometric designs are in the field. The border consists of a leaf design. The figures and designs are in green, light brown, and rose, picked out with black and on a rose ground. The medallion has a frayed linen backing.
Coptic work. From Egypt. Sixth or seventh century A.D. L, 0.195 m. H, 0.165 m. Warren Coll. Acc. no. 1915.8.
Cf. *VAM Catalogue of Textiles* III, pl. 15, no. 692.

62. *Linen cloth.* There are embroidered geometric designs in blue at each end.
Arabic work. From the Fayum, Egypt. Thirteenth or fourteenth century A.D. L, 1.880 m. W, 0.880 m. Warren Coll. Acc. no. 1915.4.

63. *Tall unglazed pitcher.* It originally had a high verticle handle and tall narrow neck, but these are now missing. A small tubular spout projects from the shoulder, below which in black glaze is a design containing Christian symbolism of an undetermined meaning.
From the Fayum, Egypt. About the

sixth century A.D. H, 0.270 m. Diam. of base, 0.063 m. Gift of Arlo Bates. Acc. no. 1916.5. Formerly in the Cairo Museum.

64. *Fragmentary bowl.* The base, part of the bowl, and part of the lip are preserved. The base is heavy and slightly concave, the lip offset. There is a light yellow glaze on a white slip over all except the inside of the base. Graffito designs consist of two concentric lines around the inside of the lip. A medallion in the center of the interior is made of abstract curvilinear lines surrounded by a border of scrawls.
From Kom-es-Shukaifa, near Alexandria. Of the Arabic period. About the twelfth century A.D. H, 0.070 m. Diam., 0.130 m. Gift of Arlo Bates. Acc. no. 1916.1.
Nos. 63–66 all derive from excavations conducted by George A. Reisner and Oric Bates in 1908. In technique and decoration these fragments are very similar to Byzantine pottery of the same period. See D. M. Robinson, *Olynthus* V (1933) 285–292, pls. 204–208. After the end of Byzantine power in Egypt in the seventh century, Islamic artisans continued to employ some of the styles and patterns of their predecessors. See A. J. Butler, *Islamic Pottery* (1927), and D. Talbot Rice, *Byzantine Glazed Pottery* (1930).

65. *Fragmentary bowl.* Part of the base, part of the bowl, and the lower edge of the lip are preserved. A dark yellow glaze covers a buff slip. The decorations consist of crossing bands interspersed with scrawls. The inside of the base is unglazed.
From Kom-es-Shukaifa. Of the Arabic period. About the twelfth century A.D. H, 0.035 m. W, 0.090 m. Gift of Arlo Bates. Acc. no. 1916.2.

66. *Fragmentary bowl.* The base and part of the bowl are preserved. On an orange glaze in graffito design is a

starfish in the center of the bowl. There are scrawls between the tentacles, and the whole has a circular border of concentric lines and splotches.

From Kom-es-Shukaifa. Of the Arabic period. About the twelfth century A.D. H, 0.035 m. W, 0.110 m. Gift of Arlo Bates. Acc. no. 1916.3.

67. *Fragmentary bowl.* The base and part of the bowl are preserved. The inside of the bowl has a green glaze, the exterior orange. The bowl is decorated with graffito designs of curvilinear forms and scrawls with a border of two lines on each side.

From Kom-es-Shukaifa. Of the Arabic period. About the twelfth century A.D. H, 0.035 m. W, 0.105 m. Gift of Arlo Bates. Acc. no. 1916.4.

IV

Sculpture and Reliefs

THE first extant statues of the Greeks are dated not earlier than 650 B.C. and give evidence of Egyptian and Mesopotamian influence. The earliest most common type, the *kouros*, or standing youth, reveals its origin from a quadrangular block of stone, for the head is cubic, the features are carved in flat planes, and the body is four-sided and rigidly straight. But during the course of the Archaic period (650–480 B.C.) Greek artists demonstrated a revolutionary talent for breaking away from the formalized past and developing a naturalistic treatment of the human body. By the beginning of the fifth century B.C. the nude *kouros* had acquired a measure of grace and mobility in accord with the realities of anatomy, and its fully clothed female counterpart, the *kore*, revealed the first mastering of the problems of drapery. In both types the face itself is now quietly but charmingly expressive. The forms other than substantive sculpture, such as reliefs, grave stelae, and architectural decoration, also show similar advances in technique, especially in the elementary foreshortening of lines in reliefs to create a sense of depth.

In the first part of the Classical period (480–400 B.C.) some of the greatest works of Greek sculpture were created. Casting in bronze became the favored mode, which gave rise to such masterpieces as the Charioteer of Delphi (ca. 470 B.C.) and Poseidon from Artemision (ca. 450 B.C.). These two works show the rapid advances made in the representation of action and in problems of composition, for the Charioteer stands with his weight equally distributed on both feet, but Poseidon stands poised and ready to hurl his trident. The subtle and dramatic

interrelation of figures was also superbly treated in the pedimental sculptures of the Temple of Zeus at Olympia (ca. 465–457 B.C.). The latter part of the Classical period is summed up in the achievements of Phidias and his colleagues in the pedimental sculptures and in the reliefs on the frieze and metopes of the Parthenon (ca. 447–431 B.C.). The dynamic unities of the pediments and frieze, the representation of strong emotion in the combats of the metopes and of an inner composure in the other figures, and the mastery of anatomy and garments are but some of the qualities which make these elegant works immortal.

Technical versatility and the rise of individualism in the fourth century combine to produce a somewhat emotional and self-conscious sculpture, which charms if it does not inspire. The Hermes holding the infant Dionysus (ca. 350–330 B.C.) by Praxiteles and the bronze Boy from Marathon (ca. 340–300 B.C.) show the histrionic side of the period, the Chios head of a Girl (ca. 320–280 B.C.) its dreamy, introverted aspects. Portraiture begins in the second half of the century by treating the great literary figures, and later includes famous rulers. The naturalistic tendencies of this period come to complete fruition in the Hellenistic age (ca. 300–30 B.C.), with its growing emphasis on realism in modeling and movement and in the full range of human emotions and conditions. Representative of the baroque side of this time are the stupendous frieze of the altar of Zeus and Athena at Pergamon (ca. 197–159 B.C.) and the grandiose Laokoon group (ca. 60–30 B.C.).

By the beginning of the first century B.C. the new wealth of the Roman conquerors had created a market for originals and copies of Greek statues of all types. Because of the subsequent loss of most Greek originals, our own knowledge of Hellenic sculpture now directly depends upon the great numbers of reproductions made in the late Republic and Empire. Greek techniques adapted to the needs of Italian tradition also produced the typically Roman historical relief. Representative examples are the triumphal procession with the spoils of the Temple of Jerusalem on the Arch of Titus (82 B.C.) and the continuous spiral band of 2500 figures depicting the Dacian Wars on the Column of Trajan (ca. 114 B.C.). Decorative wall reliefs and sepulchral reliefs were other types of art that found popularity, but the characteristic and most important of Roman achievements was in portrait sculpture.

Native realism, based on the custom of keeping the death masks of ancestors, blended with Greek idealism to produce variable currents in the history of Roman portraiture. The style of the Late Republic is dryly

realistic, but in the Augustan age an idealistic treatment of Augustus himself parallels the older manner in other heads. After a time of formalism under the Julio-Claudian emperors, naturalism returned as the official style of the Flavians and Trajan. The philhellene Hadrian and his Antonine successors, however, reinstated Greek classicizing tendencies, but in the political and military chaos of the third century artists favored a simpler treatment of portraits for the most part. Finally, the last phase of this form is reached with the frontal and rigid figures of the fourth century.

The best of the Bowdoin sculptures show a nice balance between Greek originals, Roman originals, and Roman copies. The head of a man from Cyprus (No. 68) illustrates the Archaic treatment of hair and beard in stylized ringlets. Though there are unfortunately no fifth century originals, a fragment of a woman's face (No. 91) is a copy of a work done about 460 B.C., and another Roman copy of a male torso (No. 87) follows the style of the latter part of the period. The fourth century is represented by Roman imitations of a standing youth (No. 97) in the Praxitelean manner, and a torso of the Leaning Satyr (No. 86), originally created by Praxiteles. Hellenistic works are two small horses' heads (No. 74), a statuette of a youth in the manner of Lysippus (No. 77), and a large relief of the sleeping Heracles (No. 75). The list is completed by three Roman portraits: the head of a boy (No. 84) and the head of a man (No. 83), both of the early Imperial period, and a head of Antoninus Pius (No. 100). The last head is the best piece of sculpture in the collections and is probably also the best known, for it has appeared on loan at a number of exhibitions.

For the bronze reproductions, life-size and in reduced scale, and for the plaster casts of classical sculpture in the possession of the Walker Art Building, see pages 14 and 21–26 of the *Descriptive Catalogue*. Two of these figures, the bronze Demosthenes and Sophocles, are in the niches in the façade of the museum, north and south respectively of the main entrance. All other reproductions are now in storage, on loan to various academies, or on display in certain classrooms of the college.

BIBLIOGRAPHY

Anton Hekler, *Greek and Roman Portraits* (1912).
G. M. A. Richter, *The Sculpture and Sculptors of the Greeks*, rev. ed. (1950); *A Handbook of Greek Art*, rev. ed. (1960) 45–172.
L. Alscher, *Griechische Plastik*, 4 vols. (1954 —).
R. Lullies and M. Hirmer, *Greek Sculpture* (1957).

M. Bieber, *The Sculpture of the Hellenistic Age*, rev. ed. (1961).
J. J. Bernoulli, *Römische Ikonographie*, 2 vols. in 4 parts (1882–1894).
E. Strong, *Roman Sculpture from Augustus to Constantine* (1907).
F. N. Pryce in *Oxford Classical Dictionary* (1949) s.v. "Sculpture, Roman."
M. Milkovich, *Roman Portraits. A Loan Exhibition of Roman Sculpture and Coins from the First Century B.C. through the Fourth Century A.D. Worcester Art Museum* (1961).

SCULPTURE AND RELIEFS (68–108)

68.* *Limestone bearded head* (from a statue). The beard and hair are rendered in small stylized curls. Much of the forehead and the lower part of the beard are missing, and the tip of the nose is battered. PL. VI

From Cyprus. About 550–500 B.C. H, 0.325 m. W, 0.190 m. Warren Coll. Acc. no. 1923.116.

This head represents the Sub-Archaic Cypro-Greek style, in which Oriental conventions, chiefly Assyrian and Egyptian, begin to disappear as the natural forms are more clearly rendered. The distinctive feature of this period in Cypriot sculpture is the treatment of the hair and beard in regular rows of curls. See *Cesnola Collection*, 202–203; *SCE* IV, pt. 2, 117–122, pl. xvi. For summaries of all aspects of Cypriot art in antiquity, see P. Bocci in *Encic AA*, s.v. "Cipro," and Erik Sjoqvist in *EWA*, s.v. "Cypriote Art, Ancient."

69. *Limestone head of a man* (from a statuette). The figure wears a high pointed cap. The almond-shaped eyes are raised and flat. The back is flat and unworked.

From Cyprus. About 550 B.C. H, 0.084 m. W, 0.045 m. Estes Coll. Acc. no. 1902.39.

Salaminia, 12–13, pl. viii.

Cf. *Cesnola Collection*, 161, fig. 1061; *SCE* III, pl. vi, no. 166; IV, pt. 2, pl. xi.

70. *Limestone head of a flute player* (from a statuette). The stylized hair is brushed back from the forehead in vertical waves. A strap for the support of double flutes passes below the ears and around the back of the neck; in front of the ears a strap rises at right angles to the other strap and disappears under the hair. There are traces of red on this strap and also of light brown on the forehead. The eyes are almond-shaped and protuberant.

From Cyprus. About 550–500 B.C. H, 0.112 m. W, 0.075 m. Estes Coll. Acc. no. 1902.15.

Illustrated Handbook, 16, fig. 4; *Salaminia*, 93, fig. 87a; *Lawrence-Cesnola Collection*, unnumbered pl.

This head belongs to the period of Archaic Cypro-Greek style, mainly with Western influences. See *Cesnola Collection*, 160–164, no. 1070; *SCE* IV, pt. 2, 109–117, pls. xi–xiv.

71. *Marble statuette of Cybele on a throne*. The goddess wears a high polos and a Doric chiton. Over the chiton is a himation, draped over the left shoulder and drawn across the back, under the right arm, and across the lap. In her right hand she holds forth a patera, and in her lap lies a small lion. The left side of the statuette is unfinished, and a light brown encrustation completely covers the stone.

Greek work. About 425–300 B.C. H, 0.175 m. W, 0.095 m. T, 0.093 m. Warren Coll. Acc. no. 1927.2.

Casson, *Catalogue*, 5, SW–24; *Illustrated Handbook*, 17, fig. 4.

Cf. *Sculptures MMA*, no. 127, pl. xcvii, a–c. Cybele, the great mother-goddess of Anatolia, is primarily a di-

vinity of fertility and of wild nature, symbolized by her attendant lions. By the fifth century her worship had extended to Greece, where she was associated with Demeter. Cf. G. Lippold, *Handbuch der Archäologie, III: Die griechische Plastik*, pt. 1 (1950) pl. 67, no. 2, for a relief of a mother-goddess of the same period. For a general survey of Greek art, especially of sculpture, see R. Bianchi-Bandinelli in *Encic AA*, s.v. "Greca, Arte."

72. *Limestone head of a woman* (from a statuette). The hair is drawn back to a knot on the crown of the head. The mouth is slightly smiling. The surface is much scarred.

From Cyprus. Fourth century B.C. H, 0.065 m. W, 0.045 m. Estes Coll. Acc. no. 1902.38.

Salaminia, pl. viii, no. 11; *Lawrence-Cesnola Collection*, unnumbered pl.

Cf. *SCE* III, pl. clxii, nos. 517, 522.

73. *Marble right hand of a woman* (from a relief). Part of the drapery of the figure is preserved, drawn around the wrist and held by the fingers. The relief may come from a grave stele. The marble is Pentelic.

From Attica. Fourth century B.C. L, 0.185 m. T, 0.056 m. Warren Coll. Acc. no. 1927.12.

Casson, *Catalogue*, 4, SW–17.

The art of relief sculpture on sepulchral stelae reached its highest development at Athens in the late fifth and early fourth centuries B.C. Cf. *Gr Sculpture*, pls. 177–180, 182–185, 191, 192, 196, with commentaries.

74. *Two marble horses' heads* (from a relief). No. 1 preserves the head and upper part of the neck. It is worked on both sides, though the lower part of the left or inner side is only roughly chiseled. The mouth is open and the mane hogged. A drilled hole on the sheared underside is modern. The right ear and part of the mane are missing. No. 2 preserves the head but very little of the upper neck. The left or inner side is only roughly chiseled. The mouth is open and the mane loose. A drilled hole on the sheared underside is modern. The lower jaw is missing.

Greek work. About 300 B.C. No. 1: L, 0.190 m. H, 0.075 m. W, 0.065 m. No. 2: L, 0.160 m. H, 0.060 m. W, 0.061 m. Warren Coll. Acc. nos. 1915. 36.1–2.

Casson, *Catalogue*, 5, SW–22, –23.

The two heads probably come from a chariot group in high relief on a sarcophagus. The style of the sculpture is reminiscent of the equine heads in the reliefs on the north and west friezes and the east pediment of the Parthenon. Cf. *Gr. Sculpture*, pls. 147–150, 167; P. E. Corbett, *The Sculpture of the Parthenon* (1959) pls. 16–25, 32, 36, 40. On the treatment of the horse in Greek sculpture, see *Sculpture and Sculptors*, 111–112, and for heads contemporary with the Bowdoin horses, cf. those on the Alexander sarcophagus in Constantinople, *ibid*, fig. 748.

75.* *Fragment of a marble relief depicting a sleeping Heracles.* He is surrounded by Erotes stealing his club and wine. Part of the edge is preserved on the right. Heracles lies on a rock sleeping, with his right arm raised and his drinking cup in his left hand. His lionskin is spread beneath him and hangs over his left forearm. Beyond his right thigh is what appears to be the trunk of a tree. Of the Erotes, one has buried his head and arm in the drinking cup, while a second is departing with an oenochoë on his back. Two others are lifting the club, one having gotten under it to support it on his back, the other holding the upper part of it with both hands. The surface is somewhat corroded. The stone is now encased in plaster. PL. VII

Greek work. From Florence. Hellenistic period. H, 0.915 m. W, 0.765 m. Warren Coll. Acc. no. 1906.2 The relief

was formerly fixed in the wall of a Florentine villa, but additional information is not available.

Casson, *Catalogue*, 3, SW–5.

A fragment of a similar relief, though not a replica, is in the Villa Albani in Rome. Only one of the children is preserved; he has mounted a ladder and plunged his head into the cup, a kantharos. These two reliefs probably go back to an original, or two closely related originals, of the Hellenistic period. Cf. T. Schreiber, *Hellenistische Reliefbilder* (1894) pl. 30, no. 1, for the Albani relief. For bronze statuettes of the drunken Heracles in New York and Baltimore, see *Hellenistic Age*, 140, figs. 577–580.

76.* *Fragmentary marble statuette of Aphrodite.* The head, most of the right arm, and the left arm below the elbow, as well as the right foot and other small fragments, are missing. She stands with her left elbow resting on a high pillar, with her weight fully on her right leg. The left leg is bent at the knee. Drapery is arranged around the left shoulder. On the one side it falls down along the pillar and on the other it is drawn behind and around her to be caught between the knees. She is otherwise completely nude. The stone is covered with a brownish deposit.

PL. VIII

Greek work. Hellenistic period. H, 0.455 m. W, 0.170 m. Estes Coll. Acc. no. 1904.1.

Illustrated Handbook, 18, fig. 9, where the piece is incorrectly ascribed to the Warren Collection.

This statuette follows in the twin paths of the Cnidian Aphrodite by Praxiteles, the first convincing execution of the attractive female nude, and of the Capitoline Aphrodite, a somewhat later and much more voluptuous treatment of the nude. Cf. *Handbook*, figs. 187, 212, 213; *Hellenistic Age*; figs. 24–31, 34–39. For a short survey of the goddess in classical art, see A. De Franciscis in *Encic AA*, s.v. "Afrodite."

77.* *Fragmentary marble statuette of a youth.* Both arms below the shoulders and the head to the base of the neck are missing. The right leg below the knee and all of the left are also missing, as are most of the male parts. Erosion and chipping have scarred the front of the body. The weight of the figure was placed fully on the right leg. The remains of three fingers show on the left hip, indicating that the left arm was held akimbo. The entire surface has a glossy sheen, the result of a cleaning with acid. Lastly, there is a drilled hole in the back of the right thigh.

PL. IX

Greek work. Hellenistic period. H, 0.420 m. W, 0.120 m. Warren Coll. Acc. no. 1913.60.

Casson, *Catalogue*, 4, SW–11; *Illustrated Handbook*, 19, fig. 10. The description in the latter is confused.

Cf. *Sculptures MMA*, no. 52, pl. xlv, for a similar figure. This figure may represent a satyr, Narcissus, or Hermes. Casson calls it a Young Satyr in the tradition of Lysippus. Cf. *Répertoire* II, 135, no. 4; 102, no. 3; 150, no. 7, for examples of the various possibilities.

78.* *Marble head of Zeus or Heracles* (from a statuette). There is a fillet around the head, the whole of which is very well preserved. The beard is full and round.

PL. IX

From Telmessus in Asia Minor. Hellenistic period. H, 0.110 m. Warren Coll. Acc. no. 1908.8.

Casson, *Catalogue*, 4, SW–13.

Cf. *Sculptures MMA*, nos. 129–131, pls. xcviii, xcix. Casson thinks that this head is in the Lysippian manner. On Lysippus and his influence, see *Hellenistic Age*, 30–57; A. Giuliano and S. Ferri in *Encic AA*, s.v. "Lisippo."

79. *Marble head of Heracles* (from a statuette). The head has curly hair, a round, curly beard, and a mustache. The forehead is deeply furrowed and the eyes deep-set. The neck is heavy

and the muscles prominent. The surface is worn.

Greek work. Hellenistic period. H. 0.110 m. Warren Coll. Acc. no. 1927. 17.1.

Casson, *Catalogue*, 4, SW–15.

Casson suggests that the figure may represent Poseidon and places it in the Lysippian tradition. But the anguish of the countenance seems better suited to Heracles. Cf. *Hellenistic Age*, figs. 82, 83.

80. *Fragmentary limestone face of a waterspout in the form of a lion's head.* On both sides of the mouthspout are cuttings whereby the object was perhaps fastened to a water drain.

From Cyprus. Hellenistic period or later. H, 0.078 m. W, 0.060 m. Estes Coll. Acc. no. 1902.40.

Salaminia, pl. x, no. 10.

81. *Marble portrait head of a middle-aged man* (from a relief). The head is about two-thirds life-size, in high relief, and was probably intended as a portrait of an individual. The hair is curly but the forehead is bare to the crown. Both forehead and face are deeply lined. The head is broken away at the point of juncture with the background, which was on the figure's left side and was probably part of a tombstone.

Roman work. First century B.C. or A.D. H, 0.230 m. W, 0.125 m. Warren Coll. Acc. no. 1927.19.

Cf. L. Goldscheider, *Roman Portraits* (1940) pls. 2–4, 12, 14, 25, 28, 34.

The initial stimulus to the development of Roman portraiture is to be found in the custom of preserving the death masks of ancestors. Out of this tradition grew a style of native Italian naturalism, which was later modified by the idealizing tradition of the Greeks. Late Republican portraits, for example, are dryly realistic, but Augustan heads show Greek influences. See

F. N. Pryce in *OCD*, s.v. "Portraiture, Roman," with references.

82. *Marble fragment with flowers in relief* (from the wall of a funerary urn). Above, a palmette rests on horizontal fleurs-de-lis. Below, an acanthus is superimposed on a row of beading and a wide band of cable pattern. The background for both the palmette and acanthus is a type of elongated tongue pattern.

Roman work. First century A.D. H, 0.220 m. W, 0.150 m. T, 0.022–.035 m. Warren Coll. Acc. no. 1923.42.

For examples of Augustan and later decoration, see Strong, *Roman Sculpture*, 59ff.

83.* *Marble portrait head, perhaps of the emperor Claudius.* The hair is combed forward. The beardless face is lined and the visage stern. The lower part of the nose is missing, and the left ear, chin, and lower lip are chipped. The neck is quite long and muscular.

PL. X

Roman work. Mid-first century A.D. H, 0.380 m. W, 0.205 m. Warren Coll. Acc. no. 1913.58.

Casson, *Catalogue*, 3, SW–4; *Illustrated Handbook*, 20, fig. 12.

This head bears a resemblance to a portrait type of the emperor Claudius. See Bernoulli, *Römische Ikonographie* II, pt. 1, 327–355, esp. 345–348, and pls. xviii, xxxiv; also E. Suhr, *AJA* 59 (1955) 319–322, with references. Dr. Cornelius Vermeule first noted the similarity of the Bowdoin head to the portraits of Claudius. J. M. C. Toynbee, *Art in Roman Britain* (1962) 123, no. 1, pl. 7, gives all the accepted identifying features of this emperor's physiognomy: the flat crown of the head; the thick, neat hair; the angular bridge of the nose; the folds of flesh around the mouth; the prominent ears; and the powerful and stocky neck, among others.

84.* *Marble portrait head of a boy.*
The hair, which is combed over the
forehead, was reworked over the left
temple in antiquity in order to conceal
damage. The tip of the nose and upper
lip are somewhat battered, and the left
cheek is slightly chipped. The lips of
the small mouth are parted in a half
smile. PL. XI

Greco-Roman work. Augustan period
or later. H, 0.180 m. W, 0.155 m. War-
ren Coll. Acc. no. 1923.111. Formerly
in the Harber and Willett colls. Brought
from Greece by the antiquary Campden
in the seventeenth century.

Casson, *Catalogue*, 4, SW–8; *Illus-
trated Handbook*, 19–30, fig. 11.

Cf. Strong, *Roman Sculpture*, pls.
cvii, cviii; L. Goldscheider, *Roman
Portraits* (1940) pl. 11; M. Pobé and
Jean Roubier, *The Art of Roman Gaul*
(1961) no. 93.

85. *Marble fragment of a winged
Nike* (from a relief). In archaistic style
the figure faces left with wings out-
spread. She holds a phiale in the right
hand, and wears a belted chiton. The
left arm, which crosses in front, is
broken away. The present piece con-
sists of two mended fragments. The
original edges are preserved on all four
sides, but the upper left quadrant is
missing. There are many small chips
on the surface of the stone.

Neo-Attic work. Augustan period. H,
0.310 m. W, 0.280 m. T, 0.035 m. War-
ren Coll. Acc. no. 1913.35.1.

Casson, *Catalogue*, 4, SW–14.

The complete figure is known from
many replicas, both in marble and ter-
racotta reliefs and in sigillata ware.
Nike in them is stepping forward, fill-
ing a phiale held in the one hand from
an oenochoë held high in the other.
This is the only relief in which Nike
appears alone; in the others Apollo,
Artemis, and Leto move toward her, or
Apollo only. All go back to an archaiz-
ing Hellenistic original, which in turn
was based on a fourth century model.
Cf. T. Schreiber, *Hellenistische Relief-*

bilder (1894) pls. 34–36; *Tonreliefs*,
17–19. For examples of the elaborate
draperies in neo-Attic reliefs, see *Sculp-
ture and Sculptors*, figs. 514, 515, 517.

86.* *Marble torso of a satyr.* The
statue is in slightly larger than natural
scale and is preserved from the base
of the neck to the hips. The following
parts of the figure, now lost, were added
in separate pieces and joined to the
body by means of pins: the left shoul-
der, both legs from the hips, two fin-
gers of the left hand, parts of the dra-
pery on the right side of the back and
at the lower left-hand side. The drapery
is an animal skin draped over the right
shoulder and on the left hip. The sur-
face of the whole is dull. The left arm
of the figure was held akimbo and his
weight rested on the right leg. PL. XII

Greco-Roman work. First or second
century A.D. H, 0.830 m. W, 0.510 m.
Warren Coll. Acc. no. 1923.110.

Casson, *Catalogue*, 3, SW–1.

This torso is part of a fine Roman
copy of the famous Leaning Satyr by
Praxiteles. Casson states that this torso
comes from one of the best surviving
copies of the Faun and that it is su-
perior to the best known of them, that
in the Capitoline Museum in Rome. He
notes that the drapery of the Bowdoin
Satyr is easily rendered, and that it was
not heavily cut with the drill, as in the
Capitoline copy. For the works of Prax-
iteles and discussion of the Leaning
Satyr, see T. B. L. Webster in *OCD*,
s.v. "Praxiteles," with references;
Sculpture and Sculptors, 257–267, fig.
51. On the type of leaning figure, see
Griechische Plastik III, 86–98, figs. 28–
32.

Although there is no record to con-
firm the thought, it seems likely that
the donor of this work had it in mind
to honor Nathaniel Hawthorne, a grad-
uate of Bowdoin, and his novel *The
Marble Faun*, by the gift of a sculpture
which symbolically stands at the very
center of this famous story.

87.* *Marble male torso.* The weight of the figure, which is nude, was very slightly placed on the right leg. The marble has a slightly yellowish cast. The surface is chipped and scarred to some degree and there is a crack from the left shoulder to the right hip.

PL. XIII

Greco-Roman work. First or second century A.D. H, 0.485 m. W, 0.295 m. Gift of Mrs. Mortimer Warren in memory of Dr. Mortimer Warren. Acc. no. 1950.3.

Miss G. M. A. Richter, then Curator of Greek and Roman Art in the Metropolitan Museum of Art, stated in a letter of October 12, 1950, that this work is a good Roman copy of a late fifth century piece. Cf. G. Lippold, *Handbuch der Archäologie, III: Die griechische Plastik*, pt. 1 (1905) pl. 68, nos. 1, 2; *Sculptures MMA*, no. 55, pl. xliii, a–c; *Gr Sculpture*, 64, pl. 190, for examples of the original type.

88. *Marble statue of Eros asleep.* The figure reposes face upward, with the left hand brought up beside the head. The right arm extends across the chest, and the left leg is tucked under the right. The right forearm and the toes of the right foot are missing, and the left hand is damaged. The figure rests on a plinth of irregular shape.

Greco-Roman work. First or second century A.D. H, 0.610 m. W, 0.270 m. Warren Coll. Acc. no. 1923.117.

Casson, *Catalogue*, 3, SW–7.

Both this subject and the attitude of the body were often treated in later antiquity. Cf. *Répertoire* I, 442.

89. *Fragmentary marble statuette of Nike.* The figure wears a Doric peplos, overgirt, and is represented as striding vigorously forward with her right leg in front. Small holes at the back edge of the shoulder were probably used to attach wings. Head and arms, which were separately attached, are missing. A few small fragments are missing from the lower part of the body.

Greco-Roman work. First or second century A.D. H, 0.450 m. Warren Coll. Acc. no. 1923.40.

For the type, cf. *Répertoire* II, 380, fig. 5; 388, fig. 2. The figure is a copy of a fourth century B.C. original. See *Griechische Plastik* III, 123–125, fig. 44.

90. *Fragmentary marble statuette of a seated, bearded satyr.* The figure sits on a rock with his mouth half open in an expression of pain. Under his left arm is the neck of a wineskin and against the rock beneath his left leg is a shepherd's crook. He may be extracting a thorn from his right foot. A support beneath the middle of his ribs probably joined his right arm. All of the right arm and leg are missing, as well as the left arm from the biceps and the left leg from the knee.

Greco-Roman work. First or second century A.D. H, 0.425 m. Knee to back, 0.230 m. Warren Coll. Acc. no. 1908.6.

Casson, *Catalogue*, 4, SW–12.

Cf. *Sculptures MMA*, no. 181, pls. cxxv, cxxvi.

91. *Marble fragment of a woman's face.* Most of the left cheek, chin, lips, part of the nose, and the lower left eyelid are preserved. The sculpture is life-size and the marble Pentelic.

Greco-Roman work. First or second century A.D. H, 0.130 m. W, 0.100 m. Warren Coll. Acc. no. 1927.13.

Casson, *Catalogue*, 5, SW–21.

The fullness of the chin dates the original about 460 B.C., according to Casson. Cf. *Gr Sculpture*, pls. 107 and 119, for female heads from the Temple of Zeus at Olympia, built between 470–456 B.C.; *Sculpture and Sculptors*, 74–75, figs. 159–163.

92.* *Fragmentary statuette of Hermes.* The head and both arms are missing, but the left hand remains attached to the hip, indicating that the left arm was held akimbo. The legs are missing

below the thighs. A piece of drapery hangs over the left shoulder and across the small of the back. The marble has a yellow cast to it. PL. XI

Greco-Roman work. First or second century A.D. H, 0.210 m. W, 0.127 m. Warren Coll. Acc. no. 1927.10.

Casson, *Catalogue*, 4, SW–10.

Cf. *Répertoire* II, 149–151, esp. 151, no. 7; *Sculptures MMA*, nos. 125, pl. xcv; 180, pl. cxxiv. This reduced copy is rendered in the manner of Praxiteles.

93. *Fragmentary marble statuette of a satyr.* The right arm was raised and the left held downward. The body is nude save for a skin slung over the left shoulder and under the right. The head, all limbs, and the lower part of the torso are missing.

Greco-Roman work. First or second century A.D. H, 0.180 m. W, 0.125 m. Warren Coll. Acc. no. 1913.56.

Casson, *Catalogue*, 4, SW–16.

The right arm probably either held grapes or was pouring wine.

94. *Fragmentary marble statuette of Aphrodite Anadyomene.* The head, both arms, and legs below the knees are missing. Part of her hair rests on the back of the right shoulder. The completely nude figure stood with its weight on the right leg. The right arm was raised and the left one held at the side. Evidence of a support against the left thigh is to be seen in a large rough area there. The figure is chipped and eroded, especially about the breasts and on the back.

Greco-Roman work. First or second century A.D. H, 0.237 m. W, 0.088 m. Warren Coll. Acc. no. 1930.122.

This is undoubtedly a copy of the so-called Aphrodite Anadyomene, in which the right hand was raised to arrange her hair and the left was holding an ointment vase or mirror. Cf. *Sculptures MMA*, nos. 152–155, pls. cx–cxii, a–c.

95. *Marble breasts of a woman* (from a relief). The left breast is covered, but the right is bare. The garment is girdled just below the breasts and its folds overhang the belt. The piece is broken on all sides.

Greco-Roman work. First or second century A.D. W, 0.145 m. Warren Coll. Acc. no. 1915.65.

Casson, *Catalogue*, 5, SW–18.

96. *Marble torso of an unfinished statuette of Heracles.* The head, the lower part of the right arm, and the legs from the knees down are missing. The stance puts the weight on the right leg, and the left leg is forward. A lion-skin is held over the left arm. The figure is still in a rough state. Much of the surface has a brownish deposit on it.

Greco-Roman work. First or second century A.D. H, 0.210 m. W, 0.132 m. Warren Coll. Acc. no. 1915.53.

The chief interest of this figure lies in its unfinished condition. At the front and back of each shoulder are small, rounded *puntelli*, or measuring points, used by the sculptor in copying this work from another. For methods of work in ancient sculpture and for other examples of unfinished figures from antiquity, see *Sculpture and Sculptors*, 140–148, figs. 433, 436, 437.

97.* *Fragmentary marble statue of a youth.* The head and lower parts of both arms are missing, as well as a section of the lower left leg. The figure is completely nude and stands with the left leg bent. At his right is a tree stump, with the tail of a large snake sticking out of a hole at the bottom. The top of the stump is broken. The stump and the right leg are joined at the thigh and the calf. In place of the missing lower left leg is a metal bar joining the upper portion to the foot. The figure is also broken above the left knee, at the right ankle, and at the lower part of the trunk. The statue stands on a

low base with a molding across the front but otherwise irregular in shape. The penis is also missing. PL. XIV

Possibly Greco-Roman work of the second century A.D. H, 1.035 m. W at shoulders, 0.310 m; of base, 0.455 m. T at chest, 0.160 m. Gift of Nathan Dane, II. Acc. no. 1961.97.

The previous history of this statue is obscure. It was in the possession of a collateral branch of the family of Professor Dane residing in North Windham, Maine, for many years prior to June 1960. Nothing more can be ascertained.

In general, the statue appears to be a refashioning of a Polyclitean model of the type seen in the Antinous at Naples. Cf. H. Bulle, *Der schoene Mensch im Altertum* (1912) 152, fig. 82. For the Doryphorus and Diadumenus of Polyclitus as treated in Roman copies, cf. *Sculpture and Sculptors*, figs. 645, 650. However, there are also somewhat similar statues in Dresden and Florence, which are figures of the Pythian Apollo. Cf. *Répertoire* I, 252, nos. 952, 955, 956.

98. *Fragmentary marble statuette of Athena Parthenos.* The upper half of the figure is missing. She stands with the right leg bent and rests the left hand on the top of her shield, which is on a small pedestal at her side. The hand is all that remains of the left arm. A gorgoneion decorates the center of the shield. The goddess is in a full-length, overgirt tunic. The statuette rests on a high base which may not be ancient.

Said to be from Cyprus. Second century A.D. H, 0.245 m. W, 0.135 m. H of base, 0.065 m. Gift of Mrs. John Mead Howells. Acc. no. 1960.48. Formerly in the Metropolitan Museum of Art.

The quality of the work on this figure indicates it was commercially produced for the mass market. In general it imitates the fifth century Athena Parthenos of Phidias, imitations of which

were common in the period of the Empire. See *Sculpture and Sculptors*, 215–220, figs. 599–604.

99. *Front wall of a marble cinerary urn with reliefs.* In high relief on the left side of the fragment is a woman, whose face is missing, standing in a chariot drawn by winged serpents. She is holding the body of a child over her left shoulder, grasping it fast by an ankle. Her right hand and arm are missing. In the center of the urn is the inscribed name LAMP/ADIVS within a rectangular molded frame. Below this frame is the upper part of a female figure fixed in the ground. With her right arm she is receiving a human figure which is falling headlong toward the earth, and with her left arm she is holding up a cornucopia. On the right side of the urn is a standing male figure, whose head has been lost, in frontal position struggling with two bulls. One of the bulls is to the man's right, and its lowered head is being restrained by the man's grip on its left horn. The other bull, to the left of the male figure, is trying to leap away but is being checked by the man's grip on its right horn. Many parts of the figures are broken away and other portions are badly eroded. But the body of the man and the heads of the bulls are good examples of the undiminished excellence of the relief work on this urn. The base and the rim of the urn are molded.

Greco-Roman work. Second century A.D. H, 0.355 m. Diam., 0.273 m. H of letters, 0.025–.040 m. Warren Coll. Acc. no. 1927.20.

Casson, *Catalogue*, 3, SW–6; K. Herbert, *AJA* 64 (1960) 76–78, pls. 17, 18.

In the article by Herbert, the figures are identified as follows: Medea and her children on the left, Gaea in the lower center, and Jason yoking the fire-breathing bulls on the right. The whole sequence of the reliefs is interpreted as a symbolic rendition of Orphic belief.

Medea in her chariot represents the swiftness of death, Gaea is both the universal mother and the first of the chthonians, and Jason and the bulls embody the vigor of life and revivification. The style of the reliefs suggests a Hadrianic date, but the letter forms and the name Lampadius suggest one of the fourth century A.D. The difficulty is resolved by the consideration that the urn was made in the second but reused in the fourth century. See Herbert, *loc. cit.*, 77–78.

100.* *Marble portrait head of the emperor Antoninus Pius* (A.D. *138–161*). The hair encircles the forehead in curly strands, and the beard and mustache are of medium length. The iris and pupil of the eyes are incised. The tip of the nose is missing and there are chips on the neck, but the head otherwise is in excellent condition.

PL. XV

From Rome. About A.D. 138–150. H, 0.380 m. W, 0.225 m. Warren Coll. Acc. no. 1906.1.

Casson, *Catalogue*, 3, SW–3; *Illustrated Handbook*, 20, fig. 13; R. Delbrück, *Bildnisse römischer Kaiser* (1914) 6, pl. 20; M. Wegner, *Die Herrscherbildnisse in die antoninischer Zeit* (1939) 126, pl. 3; C. Vermeule, *Greek and Roman Portraits 470 B.C.–A.D. 500* (1959) fig. 54; Milkovich, *Roman Portraits*, fig. 20.

Cf. G. M. A. Richter, *Roman Portraits* (1948) nos. 73, 74. Wegner calls this head a free repetition of the Formian type, which was the earliest official portrait of the emperor. Yet in many respects the Bowdoin portrait appears superior to the Formian head as a piece of sculpture. The highly polished, porcelainlike quality of the skin makes a fine contrast with the rough hair and beard. B. M. Felletti-Mai in *Encic AA*, s.v. "Antonino Pio," offers the most recent treatment of the emperor's portraits, but does not mention the Bowdoin head.

101. *Fragmentary marble statuette of Aphrodite.* All of the figure from the waist up is missing. The goddess stands nude on a heavy plinth of irregular shape. To the right at her feet sits a winged Eros astride a dolphin. He holds a whip above his head with the right hand. From the left side of the goddess projects a small stub, probably part of a strut to support the left arm. She may have been arranging her hair.

Greco-Roman work. Second or third century A.D. H, 0.170 m. Base: H, 0.025 m. W, 0.090 m. Warren Coll. Acc. no. 1923.41.

Eros riding a dolphin is a common form of support in nude figures of Aphrodite. There are numerous examples of this type in the museums of Europe, and there is also a type in which the dolphin is the sole support. Cf. *Répertoire* I, 326–335; L. D. Caskey, *Catalogue of Greek and Roman Sculpture in the Museum of Fine Arts, Boston* (1925) 173, no. 96, with the dolphin but no Eros. These figures symbolize the sea birth of the goddess. The Prima Porta statue of Augustus is also accompanied by an Eros riding a dolphin, and in this case the child signifies the descent of the Julian *gens* from Venus. See Hekler, *Greek and Roman Portraits*, pls. 170, 171; B. M. Felletti-Mai in *Encic AA*, s.v. "Augusto."

102. *Marble face of Mithras* (from a relief). The god wears the Phrygian cap over his curly hair. His lips are slightly parted. The face is apparently broken away at the point where it joined the background.

Greco-Roman work. Second or third century A.D. H, 0.093 m. W, 0.070 m. Warren Coll. Acc. no. 1908.19.

Casson, *Catalogue*, 5, SW–20.

Mithras, an ancient Aryan god, the brother of the invincible Sun and the *comes invictus* of man, became the chief figure of a popular mystery reli-

gion in the Later Empire. It found especial favor with the Roman legions because of a strict ethical system and the inculcation of loyalty. The central myth concerned the slaying of a sacred bull by the god in a grotto, and the Bowdoin head undoubtedly comes from a relief depicting this scene. See H. J. Rose in *OCD*, s.v. "Mithras," with references; the standard work is F. Cumont, *Textes et monuments figurés relatifs aux mystères de Mithra*, 2 vols. (1896, 1899).

103. *Marble bearded head, garlanded with vine leaves* (from a statuette). The head is raised upward, and the mouth is half open. The beard and hair have numerous drill holes. The top and back of the head are either roughly finished or damaged, and the lower part of the nose is missing. An unidentifiable appurtenance joins the left side of the back of the head.

Greco-Roman work. Second or third century A.D. H, 0.144 m. W, 0.094 m. Warren Coll. Acc. no. 1923.118.

Casson, *Catalogue*, 5, SW–19.

104. *Marble portrait head of a bearded man.* The face is lined with age. The ears and chin are somewhat battered, and the surface is much weathered.

Roman work. Third or fourth century A.D. H, 0.305 m. W, 0.195 m. Warren Coll. Acc. no. 1913.59.

Casson, *Catalogue*, 3, SW–2.

Cf. L. Goldscheider, *Roman Patriots* (1940) pls. 87, 96, 98, 107, 109.

105. *Marble bearded head.* The hair and beard are elaborately drilled. The hair is parted in the middle and drawn back around the temples, leaving the ears uncovered. The nose was restored in modern times. The marble is gray. The head is larger than life size.

Provenance and date unknown. H, 0.380 m. Warren Coll. Acc. no. 1927.23.

Casson, *Catalogue*, 4, SW–9, notes that this head may be Roman or Baroque work.

106. *Limestone head of a bearded king.* The top of the head is unfinished and has a rectangular hole. A diadem with raised oval forms representing jewels rest on the head. The hair escapes beneath it over the forehead and flows down on both sides to the level of the chin. The features are regular and the gaze is slightly downwards. A thin beard and mustache complete the portrait. The nose is missing.

Gothic work. Thirteenth century. H, 0.155 m. W, 0.145 m. T, 0.130 m. Warren Coll. Formerly in the Fitzhenry Coll. Acc. no. unknown.

Illustrated Handbook, 21, fig. 14.

The head has been identified with a number of schools. Some think it to be from Rheims Cathedral and that it may have been removed during restorations there. Others relate it to the so-called Master of the King's Head of Chartres. See W. Voge, *Bildhauer des Mittelalters* (1958) 75ff. It has also been suggested that the head is Spanish work of the seventeenth century. The hole in the head indicates that it was affixed to a building with an iron clamp and the unfinished top and downward gaze that it was to be seen only from below. For a thirteenth century head of Christ, from Rheims and in the same attitude, see André Malraux, *The Voices of Silence* (1953) 241.

107. *Alabaster head, perhaps of Christ or John the Baptist.* The eyes are closed and the mouth open in the grimace of death. The face is gaunt and bearded, and the hair flows behind the ears and down the neck.

Said to be Milanese work. About the fifteenth century. H, 0.230 m. W, 0.180 m. Warren Coll. Acc. no. 1906.3.

Cf. M. H. von Freeden, *Gothic Sculpture: The Intimate Carvings*

(1962), a similar head in miniature of John the Baptist in death.

108. *Small marble head of an old man.* The man is bald, save for a fringe around the edge and a tuft just above the middle of the forehead. His face is deeply lined and his mouth is slightly open. The nose is battered.

Bought at Naples. Perhaps of the eighteenth century. H, 0.140 m. Warren Coll. Acc. no. 1908.7.

V

Pottery and Vase Painting

BECAUSE the firing of terracotta vases rendered them practically inde-structible, no class of Greek artifact has survived in greater quantity than pottery. The great volume of material thus far dug up presents a continuous narrative of ceramics from Mycenaean to Greco-Roman times, and in the case of the superb Attic vase paintings of the sixth and fifth centuries the pottery also serves as evidence of the development of pictorial art. This latter fact is especially important to art history be-cause, with the exception of a few plaques and stelae, the whole of Greek free painting in panels and murals has been lost to us. The addi-tional fact that the vase painter took his themes from mythology or from the everyday life of the people gives valuable insight into the nature and spirit of the times. But apart from the archaeological and his-torical aspects of these objects, at their best they stand in their own right as individual examples of the Greek talent for reconciling the de-mands of utility, form, and decoration in works which remain a lasting source of aesthetic delight.

In the Neolithic and early Bronze ages a variety of pottery fabrics are found throughout the Aegean world, but about 1400 B.C. a Myce-naean buff fabric with decorations in reddish-brown achieves pre-emi-nence. This pottery imitated Late Minoan ware, using the flowing and undulant lines of plant and marine life for its motives. By the beginning of the first millennium B.C. the decline of Mycenaean gave rise to the Geometric style, in which horizontal bands of devices such as hatched meanders and lattice lozenges cover the entire surface of the pot. In

its later period highly stylized humans and horses in silhouette were also used. Near the end of the eighth century, Oriental influences in the form of floral ornament and various animals marked the transition to a developing black-figure technique at Corinth, in which the subjects are drawn in silhouette on a reddish buff ground and further delineated by incised lines and touches of color. At first, the Corinthian product dominated the market, but by 650 B.C. it was eliminated from the competition by the superior clay, improved techniques, and artistic skill of the Athenian potters and artists. The Corinthian ware was also content with an animal style, while the Athenian was developing the use of human figures in mythological and other contexts.

Though the black-figure technique prospered through most of the sixth century, it was doomed because of its own artistic limitations. Useful for the expression of action, it was unable to convey subtleties of emotion and anatomy, and so about 525 B.C. the red-figure style arose to replace it. In the new technique the figures are in the ground color, internal details are depicted by thin glazed lines, and the background is a black glaze. Where the solid blacks of the earlier style had produced only puppetlike representations of men, the open forms of red-figure solved so many problems of representation that in the first decades of the fifth century the art of vase painting reached its highest level. By the middle of the century, however, free painting on large surfaces was using techniques of perspective, shading, and the portrayal of emotions, which were beyond the scope of vase painting. Two equally futile reactions took place among the artists of red-figure: the mannerists sought to stay the tide by continuing in an elegant, archaic vein, and the muralists tried to bring the scope and drama of free painting within the confines of a vase. Yet by the late fifth century vase painting was no longer a creative activity. Some competent artisans remained, but there were many who turned to the mass production of florid and sentimental scenes designed to sell. A subsidiary vase style of the fifth century, called white-ground, had matt polychrome figures on a white background. They were mainly designed as funerary dedications and most commonly portray mourners standing before a grave monument.

At this point a brief return to the middle of the second millennium B.C. is necessary in order to outline the development of the Cypriot pottery in the collection. Before 1500 B.C. Cyprus had seen a number of native fabrics such as Polished Red ware and Red Slip and Black Slip wares develop and degenerate. Then in the final period of the Bronze

Age, Cypriot fabrics such as White Slip ware competed with Levanto-Helladic imports and wares made on the island by Mycenaean and other artists or local imitators of them. White Slip features decorations such as hatched lines, lattice lozenges, and the like. Levanto-Helladic uses, among other devices, concentric circles and horizontal encircling lines. Between 1000–750 B.C. White Painted ware with geometric decorations was dominant and Black-on-Red ware with concentric circles was popular in the Archaic period. Bichrome Red-on-Buff and Tricolor ware with a red slip, black paint, and details in white were produced between 600–300 B.C.

Attic red-figure ware continued until the late fourth century when painted decoration began to be restricted to floral motives. In South Italy red-figure began about 440 B.C., and for the next century and a half a number of regional schools produced vases ranging from attractive echoes of late Attic work to grotesque and barbarized productions. In the Hellenistic period the potters sought to imitate the visual qualities of embossed metalware, so that painted ornamentation was neglected for a variety of relief decoration. The most widespread of these fabrics is the so-called Megarian ware, consisting almost entirely of hemispherical bowls with molded reliefs on the exterior. The surface was covered with a fired glaze ranging in color from black to red. In the Roman period Arretine ware and later terra sigillata or mold-made pottery continued the Megarian techniques, but the glaze was now a consistently bright red.

Judged by variety, quality, and scope, the pottery, vase fragments, and vase paintings form the most important of the Bowdoin collections. Examples of Mycenaean, Cypriot, Geometric, Corinthian, Attic black- and red-figure, Boeotian, South Italian, Etruscan, Megarian, South Russian, and Roman work are to be found; some of the best-known vase painters are represented; and the objects range in time from the fourteenth century B.C. to the end of the Roman Republic.

One of the most handsome pieces is a tall-stemmed cup (No. 128) of the Late Mycenaean period, decorated with linked whorl shells. Good examples from Cyprus are a large hemispherical bowl (No. 109) and a stirrup vase (No. 111), both of the Late Bronze Age, and two large barrel jugs (Nos. 113 and 115) and a small oenochoë with trefoil lip (No. 117) of the Early Iron Age. An Athenian Geometric pyxis with cover (No. 131), from a wealthy lady's grave, and a Protocorinthian pointed aryballos (No. 134), with a bull and two lionnesses, show the

beginnings of this art in the major Greek centers. Of Attic black-figure vases five pieces stand out: a panel amphora with an amusing and bawdy Dionysiac scene (No. 143), a Little Master lip cup and band cup (Nos. 144 and 146), both superbly proportioned, a striking eye cup (No. 148), and an unusual one-handled kantharos with a plastic lion's head on the inner rim (No. 152).

Attic red-figure ware constitutes the greater part of the collection. Early Red-figure (530–500 B.C.) is represented by cup fragments painted by Oltos (No. 159) and in the manner of Skythes (No. 162). Both preserve the heads of women and are excellent examples of the work of these outstanding artists. Late Archaic Red-figure (500–480 B.C.) includes fragments by Brygos (Nos. 163–164) and the Panaitios Painter (No. 165), an askos by Makron (No. 166), and a lekythos by the Bowdoin Painter (No. 167). The last of these artists was so named by Beazley because of the presence of two of his vases at the college. Over 200 works of this competent artist have been identified in museums and collections here and in Europe. The fragment of the Panaitios Painter, showing a lovely nude at her bath, was recently selected by the British scholar R. M. Cook to illustrate Late Archaic in his comprehensive study of Greek vase painting. From the Early Classical period (480–450 B.C.) there comes a hydria in the manner of the Aigisthos Painter (No. 172) showing a woman making a wreath, intently watched by two youths, a cup with standing youths by the Briseis Painter (No. 175), a fragment by Duris (No. 177), a Nolan amphora by the Pan Painter (No. 185), and a hydria with the rape of Oreithyia by the Niobid Painter (No. 186). The last two of these are very important, for the Pan Painter, a mannerist and one of the greatest exponents of red-figure, shows the deftness of his lines in the youths on the Bowdoin amphora, and the Niobid Painter is one of the first imitators of contemporary wall painting. Classical Red-figure (450–425 B.C.) has an attractive lekythos by the Painter of the Boston Phiale (No. 195), showing a nude dancing girl and her teacher, and a column krater from the school of Polygnotus (No. 196), with Oedipus addressing the Sphinx. From the same period also comes a White-ground funerary lekythos of the school of the Achilles Painter (No. 188), depicting a man and woman before a grave stele. Finally, Late Classical Red-figure (425–400 B.C.) offers a pelike by the Dinos Painter (No. 202) that avoids some of the sentimental excesses of his contemporaries. His figures are firmly modeled and in general show the influence of mural painting.

Two other examples of late fifth century red-figure work are a Boeotian bell krater with cover (No. 212) and an Early South Italian bell krater by the Tarporley Painter (No. 213). The second of these is especially attractive, for this artist fills his Bacchic scenes with handsome youths and stately women. From the late fourth century comes a huge Lucanian nestoris by the Primato Painter (No. 229), so fantastic and tasteless that it commands a certain interest, and an Etruscan stamnos (No. 230), with a sea god, nude maenads, and satyrs. A South Russian bowl with gray glaze (No. 242) dates from the third century and is imprinted on the bottom with a coin mold showing the figure of Tyche wearing a mural crown. A Megarian type of bowl (No. 243) of the second century, having a greenish-brown glaze and decorated with leaves in relief, is an example of the cheap and commercially successful ware manufactured in the Hellenistic period. The last noteworthy example of the collection is a fragment of molded Arretine ware (No. 244), a fine red-glazed pottery which was in general use in the Roman Empire from the first century A.D. onward.

BIBLIOGRAPHY

J. L. Myres, *Handbook of the Cesnola Collection of Antiquities from Cyprus. Metropolitan Museum of Art* (1914).
Corpus Vasorum Antiquorum (1922 —).
E. Gjerstad and others, *Swedish Cyprus Expedition*, 4 vols. in 8 parts (1934 —).
J. D. Beazley, *Attic Red-figure Vase-painters* (1942); *The Development of Attic Black-figure* (1951); *Attic Black-figure Vase-painters* (1956).
[E.] A. Lane, *Greek Pottery* (1948).
F. N. Pryce in *Oxford Classical Dictionary* (1949) s.v. "Pottery," "Terra Sigillata," with bibliographies.
G. M. A. Richter, *Attic Red-figured Vases: A Survey*, rev. ed. (1958).
Martin Robertson, *Greek Painting* (1959).
R. M. Cook, *Greek Painted Pottery* (1960).

POTTERY AND VASE PAINTING (109–248)

CYPRIOT POTTERY

Introductory note: For purposes of the classification of pottery and other artifacts the Bronze Age in Cyprus has been divided as follows: Early Cypriot I–III, Middle Cypriot I–III, and Late Cypriot I–III. When *Swedish Cyprus Expedition* IV, part 1, is published, it will present a comprehensive survey of the Stone Age, which is divided into Pre-Neolithic and Neolithic, and the Bronze Age in Cyprus. In like manner the Iron Age has been divided into five major categories: Cypro-Geometric I–III (1050–700 B.C.), Cypro-Archaic I–II (700–475 B.C.), Cypro-Classic I–II (475–325 B.C.), Cypro-Hellenistic I–II (325–50 B.C.), and Cypro-Roman I–III (50 B.C.–after A.D. 350). The first three

of these periods are surveyed in *SCE* IV, part 2 (1948), and the last two in *SCE* IV, part 3 (1956). For the individual wares, their sequences, and the techniques involved in the manufacture of Nos. 109, 110, and 113–121, consult *SCE* IV, part 2, pages 48–91, and IV, part 3, pages 53–71, and the individual references under each object. For the relative chronology of Cypriot pottery in the Iron Age, see *SCE* IV, part 2, pages 184–208, and IV, part 3, pages 71–81.

109. *Hemispherical bowl.* The neck is high and offset, and a single handle projects from the shoulder. On the top of the lip and extending inside the vase a short way are four bands with horizontal rows of dots. On the neck are vertical bands in black of lattice lozenges and seams. On the shoulder are horizontal bands of lattice work, seams, and lines, and on the body similar vertical bands.

White Slip II (Late Cypriot II) ware. About 1300–1200 B.C. H, 0.277 m. Diam. of lip, 0.225 m; of base, 0.100 m. Estes Coll. Acc. no. 1902.29.

Cf. *Cesnola Collection*, 33, fig. 282; *SCE* I, pl. cxiv, nos. 5, 10, 11.

110. *Tall-necked jug.* The lip slants forward and is notched at the back where the handle joins it. The handle rises above the lip before curving down to a join on the shoulder. A pierced lug stands at the base of the neck in front. The neck and upper part of the body are decorated with alternate bands of black lines and lattice lozenges, a pattern which is broken in front and back by a vertical band of zigzags. The lower part also has this zigzag motive in a horizontal band, and the bottom has a large cross. The handle has a zigzag pattern, too, but much of it is worn away. The bottom is rounded.

White Slip II (Late Cypriot II) ware. About 1300–1200 B.C. H, 0.185 m; of

neck, 0.070 m. Diam. of lip, 0.030 m. Estes Coll. Acc. no. 1902.36.

Cf. *Cesnola Collection*, 34–36, nos. 287–289; 315–317.

111.* *Stirrup vase.* In the center of the top is a false neck from which project two handles; in front is a high spout. The well-rounded body has a narrow, low foot. Red-glazed bands of varying widths encircle the body horizontally. PL. XVI

Levanto-Helladic (Late Cypriot III) ware. About 1200–1050 B.C. H, 0.120 m. Diam. of base, 0.030 m. Estes Coll. Acc. no. 1902.17.

The stirrup vase, first developed in Crete during Late Minoan I and quite common in Late Minoan II, was scarce on the Greek mainland prior to the end of Late Helladic II, after which it became the most popular of vase forms and remained so until the fall of Mycenae. The excellent qualities of the Bowdoin vase indicate that it is a product of Mycenaean artists who went to Cyprus in the Late Helladic period rather than of the cruder native imitators. See *Cesnola Collection*, 45–50, figs. 424, 442; *SCE* I, pl. cxix, no. 7.

112. *Globular bottle.* Twin handles rise from the shoulders and join the neck at its middle. The lip, upper neck, and backs of the handles are glazed. On each side the body is covered with concentric circles. Running down from the handles on each side are horizontal lines set in ladder-fashion.

Levanto-Helladic (Late Cypriot III) ware. About 1200–1050 B.C. H, 0.134 m. Diam. of lip, 0.035 m; of base, 0.035 m. Estes Coll. Acc. no. 1902.32.

Cf. *Cesnola Collection*, 49, fig. 445.

113. *Barrel jug.* The ground is reserved. Narrow horizontal lines surround the lip, and a broad red band is under the lip, with four narrow black lines below, another covering the ridge around the middle of the neck, and a

broad band at its base. Between the middle and the base is a zigzag line. On each side of the body there are concentric circles of varying widths in black, and a band of black lines encircling the body on the shoulders. In the middle zone of both front and back are lattice lozenges. On the outside edges of the handle are broad bands, and in the middle zigzags and a band of horizontal lines.

White Painted I ware. About 1050–950 B.C. H, 0.382 m. W, 0.397 m. Diam. of lip, 0.140 m. Estes Coll. Acc. no. 1902.27.

Cf. *Cesnola Collection*, 78–79, fig. 622; *SCE* II, pl. xci, no. 2; IV, pt. 2, 48–51, fig. iii, nos. 11–17.

114. *Shallow bowl.* The inside is unglazed save for concentric circles of varying widths in black; the sides are grooved and glazed. The underside of the base bears a broad circular band of red, with narrow concentric circles within and around it. On the edge panels of zigzags are placed vertically and bordered by vertical lines. There is a handle on each side.

Bichrome II ware. About 950–850 B.C. H, 0.025 m. Diam. of bowl, 0.185 m; of base, 0.120 m. Estes Coll. Acc. no. 1902.18.

Cf. *Cesnola Collection*, 72, figs. 560, 561; *SCE* IV, pt. 2, 60, fig. xv, nos. 8–11.

115. *Barrel jug.* From the barrel-shaped body rises a thick neck with a ridge around its middle. A two-ridged handle joins the base of the neck to the shoulder. On the inside of the lip are narrow black bands, on the edge of the lip outside a herringbone design. On the upper part of the neck are bands of black and red, and just above the ridge a band of zigzags. A black band is at the base of the neck, and the handle is black with a zigzag pattern down its back. At either end of the body is a cross surrounded by

concentric circles of black, next a red band, and then a reserved band. In each of these are depicted two stylized birds with great claws. Next on each side are more black concentric lines, a red band, and finally at the shoulder a band of herringbone. Across the central zone, back and front, are bands of lattice lozenges running vertically. On one side, above these bands, is a horizontal row of black triangles.

White Painted II ware. About 950–850 B.C. H, 0.365 m. W, 0.295 m. Diam. of lip, 0.113 m. Estes Coll. Acc. no. 1902.28.

Cf. *Cesnola Collection*, 78–79, fig. 622; *SCE* II, pl. xcii, no. 10; IV, pt. 2, 52–53, fig. xiii, no. 6.

116. *Small amphora.* The flaring lip joins a thin, ridged neck, to which two vertical handles are affixed. The body is round and stands on a thin, narrow ring base. Around the lip, inside and out, is a black band. Above the ridge is a broad band, below it two narrow lines encircling the neck. The outside of the handles are black. On the shoulder on both sides are four sets of concentric circles. Just above the middle of the body are seven closely spaced horizontal lines encircling the body.

Black-on-Red II (IV) ware. About 700–500 B.C. H, 0.135 m. Diam. of lip, 0.043 m; of base, 0.025 m. Estes Coll. Acc. no. 1902.30.

Cf. *Cesnola Collection*, 108, nos. 844–850; *SCE* II, pl. cxvi, no. 1; IV, pt. 2, 69–71, fig. xxxix, no. 2.

117. *Small oenochoë.* The handle rises vertically from the shoulder and joins the trefoil lip. There is a narrow black line around the lip, two others at the top of the neck, and one broad line at the base of the neck. At the shoulder on each side is a group of narrow lines encircling the body vertically. In the center of one side is a dot with a circle, and around this four groups of concentric circles. In the center of

the other side is a dot within a smaller circle, and again the four groups of concentric circles. On the front of the vase are four other groups of concentric circles, and below them a large group of concentric bands. PL. XVI

Black-on-Red II (IV) ware. About 700–500 B.C. H, 0.150 m. Diam. of base, 0.035 m. Estes Coll. Acc. no. 1902.32.

Cf. *Cesnola Collection*, 108, nos. 834–839; *SCE* IV, pt. 2, 69–71, fig. xxxix, no. 18.

118. *Small pitcher.* A black band surrounds the flaring lip, inside and out, and two broad bands and two narrow follow on the ridged neck below. Three sets of concentric circles are on the shoulder below which are five closely spaced lines encircling the body just above its middle. The handle is decorated with three sets of horizontal lines on the outside.

Black-on-Red II (IV) ware. About 700–500 B.C. H, 0.085 m. Diam. of lip, 0.035 m; of base, 0.039 m. Estes Coll. Acc. no. 1902.31.

Cf. *Cesnola Collection*, 107, fig. 833; *SCE* IV, pt. 2, 69–71, fig. xxxviii, no. 9.

119. *Small flask.* Black lines encircle the ridged neck and body. The back of the handle also is black.

Black-on-Red II (IV) ware. About 700–500 B.C. H, 0.105 m. Diam. of lip, 0.028 m; of base, 0.025 m. Estes Coll. Acc. no. 1902.34.

Salaminia, pl. xix, no. 22.

Cf. *SCE* IV, pt. 2, 69–71, fig. xxxviii, no. 12.

120. *Pyxis with lid.* The center of the bottom is concave, the sides in outline are nearly vertical, the shoulder is abrupt and wide, and the neck is thick with a narrow, raised lip. The handles rise vertically from the shoulders. The bottom, sides, and shoulders are decorated with encircling red lines. The lid

has concentric circles of the same color.

Bichrome Red II (V) ware. About 600–400 B.C. H, 0.085 m. Diam. of lip, 0.100 m; of base, 0.045 m. Estes Coll. Acc. no. 1902.142.1.

Cf. *SCE* IV, pt. 2, 74–75, figs. liii–liv.

121. *Feeding bottle.* The bottle has a high neck on a round body and a handle rises in high loop across the neck. A short spout juts out from the shoulder. Dark horizontal lines cover the body and neck; there are also lines on the handle and spout.

Bichrome Red II (V) ware. About 600–400 B.C. H, 0.110 m. Diam. of lip, 0.030 m; of base, 0.023 m. Estes Coll. Acc. no. 1902.33.

Cf. *Cesnola Collection*, 107, no. 825; *SCE* IV, pt. 2, 74–75, fig. lv, no. 2.

122. *Spout vase with plastic head of a woman as a false neck.* The head wears a stephane decorated with vertical lines, alternately black and white, on a red ground. White was also used for the eyeballs. Curls over the forehead and twin locks on either side of the neck are applied. The double handle runs from the back of the head to the shoulder of the vase. On the front of the shoulder is a spout 0.065 m in length and 0.019 m in diameter at the tip, which is broken. Black lines run the length of the spout and concentric circles are found on the back and front of the vase. Liquid was poured into the vase through a hole in the bottom which is the mouth of a spout reaching up inside to the base of the neck. By this ingenious device the liquid could not leak out through this hole.

Tricolor ware. About 500–300 B.C. H, 0.265 m. Diam. of base, 0.050 m. Estes Coll. Acc. no. 1902.46.

Salaminia, 275, fig. 269.

Cf. *Cesnola Collection*, 113, fig. 931; *SCE* IV, pt. 2, fig. xxxix, no. 15.

The design suggests the possibility that this vase was used as a pot still for

the distillation and condensation of liquids.

123. *Small cup.* The interior has a reddish ground with decorations of concentric circles in black; the offset lip is entirely black. The body bears horizontal black lines encircling the circumference, with a broad red band around the lower part. The handles are entirely black with two broad vertical black lines extending from them to the base, which is completely black.

Tricolor ware. About 500–300 B.C. H, 0.047 m. Diam. of lip, 0.077 m; of base, 0.026 m. Estes Coll. Acc. no. 1902.24.

Cf. *Cesnola Collection,* 109.

124. *Askos in the form of a pigeon.* The handle is on the back, behind which is a round spout. Traces of black show in a large circular pattern on the breast and as wings and feathers. Two struts support the body on the lower front and simulate claws. The point is mostly worn away.

Tricolor ware. About 500–300 B.C. H, 0.120 m. W, 0.075 m. L, 0.130 m. Estes Coll. Acc. no. 1902.60.

Cf. *Cesnola Collection,* 110, no. 903.

125. *Unglazed pot.* The handle crosses the mouth and terminates at one end in a lion's head in relief, surrounded by rudely incised rays. On the other side just below the lip is a small projecting spout. The wide shoulder tapers to a narrow foot.

Unpainted ware. About 500–300 B.C. H, 0.150 m. Diam. of lip, 0.090 m; of foot, 0.053 m. Estes Coll. Acc. no. 1902.45.

Salaminia, 258, fig. 247.

Cf. *Cesnola Collection,* 118–119.

126. *Unglazed pot.* The handle crosses over the trefoil lip. The thick neck gives way to a round body, which tapers to a small base.

Unpainted ware. About 500–300 B.C. H, 0.290 m. Diam. of lip, 0.115 m; of base, 0.078 m. Gift of Mrs. John Mead Howells. Acc. no. 1960.49. Formerly in the Metropolitan Museum of Art, New York.

Cf. *Cesnola Collection,* 118–119.

127. *Plain bowl.* It has an olive-brown glaze. On the inside there are decorations of vine leaves in white and of incised tendrils. Two concentric circles are on the bottom. The outside is undecorated.

Greco-Roman fabric. About 100 B.C.–A.D. 200. H, 0.055 m. Diam., 0.118 m. Estes Coll. Acc. no. 1902.143.

Cf. *Cesnola Collection,* 120, nos. 988, 989.

GREEK PAINTED WARE AND OTHER POTTERY

128.* *Tall-stemmed cup.* The buff ground is decorated with a brownish-red glaze in a linked whorl-shell motive around the body. A band of glaze encircles the lip and below the motive are six horizontal lines. In the field on one side only are four groups of semicircular patterns of lines and dots in a red glaze. The stem, base, and handles are also glazed in red. PL. XVII

Late Mycenaean (Late Helladic III A:2) ware. About 1350–1300 B.C. H, 0.165 m. Diam. of lip, 0.130 m; of base, 0.065 m. Warren Coll. Acc. no. 1908.4.

The form of this cup is essentially Helladic and is without Minoan antecedents. See A. Furumark, *Mycenaean Pottery* (1941) 56–57; 312, fig. 51, no. 3; on the shape, fig. 17, no. 259. Though the decoration of linked whorl shells has a Late Minoan prototype, there are no Minoan versions which exactly parallel this treatment. The type is popularly known as the champagne cup. See Nicolas Platon in *EWA,* s.v. "Cretan-Mycenaean Art," for a survey of Cretan and mainland art in the second millennium B.C.

129. *Geometric oenochoë.* Around the outside of the lip are two horizontal glazed lines, below which is a row of dots. On the front of the body is a panel of key pattern, on either side of which are three vertical bands of dots separated by vertical lines. Around the lower part of the body are three horizontal lines, and the base is reserved. The back of the body is black, and the handle is decorated with horizontal stripes.

Attic ware. Eighth century B.C. H, 0.058 m. Diam. of lip, 0.053 m; of base, 0.057 m. Warren Coll. Acc. no. 1915. 30.

For oenochoae of similar shape, cf. *CVA Athens* 1 (K. Rhomaios) pl. 4, nos. 1–4. For surveys of this period in Greek art, see E. Homann-Wedeking in *Encic AA*, s.v. "Geometrica, Arte," and Bernhard Schweitzer and Werner Fuchs in *EWA*, s.v. "Geometric Style."

130. *Geometric vase in the form of a pomegranate.* The inside of the bud was originally black; the outside has alternate black and reserved bands. Around the shoulder is a band of triangles with lattice patterns within them and dots between them. Around the middle of the body are a series of panels, separated by vertical lines and bands of lattice pattern, in which alternately there are lozenges with asterisks in the field and swastikas with dots in the field. Below this is another band of triangles with lattice patterns and dots between them. Around the lower side is a frieze of geese and the stem is decorated with black and reserved bands and by a wheel pattern on its bottom. The stem is pierced by a hole.

Attic ware. Eighth century B.C. H, 0.102 m. Diam., 0.090 m. Warren Coll. Acc. no. 1915.15. From the Sambon Coll.

On such pomegrantes, see K. Friis Johansen, *Les Vases sicyoniens* (1923) 28–29.

131.* *Geometric pyxis with cover.* The wide, deep bowl has a thin base and an incurving wall with a grooved rim for the cover. The slightly convex cover has a low, wide knob in its center. A wide band of glaze encircles the knob, and on the outer edge of the cover are bands of diagonals, serpentine lines and dots, concentric lines, and hatched lines. There are two holes on the edge of the cover for suspension cords. Around the upper part of the body is a series of panels, in which armed charioteers alternate with swastikas, dot rosettes, vertical and hatched lines. Around the lower part of the body are two bands of chevrons and wavy lines separated by horizontal lines. The underside of the bowl is decorated with a compass design in the center surrounded by a border of three concentric circles. On the outer edge are swastikas. The inside of the cover and the bowl are unglazed. PL. XVIII

Attic ware. Late eighth century B.C. H, 0.130 m. Diam. of base, 0.230 m; of lip, 0.190 m. Warren Coll. Acc. no. 1913.6.

Pyxides of this type have been found in Late Geometric Athenian graves. See *Hesperia*, suppl. II, 76–87. These boxes with jewelry appear more often in the graves of women, while weapons and drinking vessels are more common in the graves of men. Cf. *Gr Pottery*, pl. 7a; *GPP*, pl. 6; *Gr Painting*, 38–41.

132.* *Geometric trefoil oenochoë.* The neck is tall, the body round. On the neck is a panel in which a horse appears. In the field are a long-necked bird, zigzag lines, and a lozenge. The lip, back of the neck and handle, and shoulder are black. The body is decorated with narrowly spaced horizontal lines, and the base has a wide, black band. PL. XVIII

Attic ware. Late eighth century B.C. H, 0.233 m. Diam. of lip, 0.077 m; of base, 0.088 m. Warren Coll. Acc. no. 1915.42.

See *Hesperia*, suppl. II, 68–71, figs. 43, 44. On the Geometric style, see *Gr Pottery*, 24–25; *GPP*, 14–22.

133. *Geometric mug.* The inside is reserved save for a line in black glaze around the inside of the lip. On the edge of the lip are dots in groups of five. On the outside around the lip is a band of lattice pattern, below which is a panel of water birds. On both sides of this panel are other bands of lattice pattern, and below it is a border of linked oval forms. The high handle has horizontal stripes on it. The bottom is reserved.

Attic ware. Late eighth century B.C. H, 0.087 m. Diam. of lip, 0.065 m; of base, 0.042 m. Warren Coll. Acc. no. 1915.31.

For the shape, see *Hesperia*, suppl. II, 89, fig. 60, grave xviii, no. 2.

134.* *Black-figure pointed aryballos.* A ray pattern runs around the upper part of the lip. On the handle are three vertical stripes and on the shoulder a wave pattern, below which is a band of dot rosettes. In the scene are two lionesses and a bull, with dot rosettes in the field. Below is a band of zigzags, and around the bottom a ray pattern. PL. XIX

Late Protocorinthian ware. About 650–640 B.C. H, 0.067 m. Diam. of lip, 0.030 m; of base, 0.009 m. Warren Coll. Acc. no. 1915.35.

On the pointed aryballos, see *NC*, 17; P. N. Ure, *Aryballoi and Figurines from Rhitsona in Boeotia* (1934) 19–22, pl. 3, no. 91. On the whole subject of Corinthian Black-figure pottery, see *GPP*, 43–62, and for a comprehensive study of all artistic aspects of the period which now follows, see Bernard Ashmole in *EWA*, s.v. "Archaic Art."

135.* *Black-figure alabastron.* On the top of the lip and on the neck are tongue patterns in red and black. On the edge of the lip are dots. In the

scene are two panthers with heads frontal and tails arched over their backs. Between them is a conventionalized double lotus bud. On the bottom is a rosette. PL. XIX

Early Corinthian ware. By the Dolphin Painter. About 625–600 B.C. H, 0.080 m. Diam. of lip, 0.030 m. Warren Coll. Acc. no. 1928.3

On the lotus pattern, see *NC*, 145–146, fig. 52a, b; for the panther's mane, *ibid.*, 285, no. 400, and pl. 23, no. 2. Cf. P. N. Ure, *Aryballoi and Figurines from Rhitsona in Boeotia* (1934) 41, pl. 5, no. 97.6.

136.* *Black-figure alabastron.* The scene shows a youth riding a horse. A tongue design is on top of the lip, shoulder, and bottom; there are dots around the edge of the lip. The decoration is all in red and shading to black because of faulty firing. Part of the lip is missing. PL. XX

Corinthian ware. About 625–600 B.C. H, 0.074 m. Diam. of lip, 0.030 m. Warren Coll. Acc. no. 1915.28.

NC, 283, no. 361; pl. 21, no. 4. This is the only one of the seven Corinthian vases or fragments at Bowdoin listed in the catalogue of *NC*.

137. *Fragment of a black-figure vase.* The fragment preserves the upper part of the monster Typhon. His head, part of his wings, and part of his snake body are shown. In the field are incised rosettes. The flesh and wings are purple. Decorations of dots and zigzags are in white.

Corinthian ware. From Cerveteri. About 625–600 B.C. H, 0.125 m. W, 0.105 m. Warren Coll. Acc. no. 1913.16.

On Typhon, see *NC*, 76–77, pl. 15, nos. 4, 5; pl. 24, no. 1. The style resembles Protocorinthian, but the clay is unusually red. The use of white for rows of dots which follow the incised lines is a feature of Protocorinthian.

138. *Black-figure ring alabastron.* The top of the lip is decorated with

concentric circles and a circle of dots, the edge with dots, and the shoulder with a ray pattern. The sides of the body are decorated with concentric circles about the central hole; the handle has a row of dots enclosed by a line. The edge is decorated with a scene of snakes and horsemen, with vague blobs in the field.

Corinthian ware. About 600–575 B.C. H, 0.063 m. Diam. of lip, 0.020 m. Warren Coll. Acc. no. 1930.6.

Cf. *NC*, 313, nos. 1057–66.

139. *Black-figure round aryballos.* There are ray patterns on the top of the lip, on the shoulder, and on the bottom, and there are dots around the edge of the lip. The scene, which encircles the body, shows five padded male dancers in various postures, with numerous incised rosettes in the field.

Corinthian ware. About 600–575 B.C. H, 0.060 m. Diam. of lip, 0.036 m. Warren Coll. Acc. no. 1927.15.

On padded dancers, see *NC*, 118–124. Payne suggests that the dance honors Dionysus. This kind of scene begins to appear on Corinthian vases about 625–600 B.C. and remains very common for the next half century.

140. *Black-figure miniature kotyle.* The vase is decorated with bands of red and a border of zigzags at the lip.

Corinthian ware. Sixth century B.C. H, 0.035 m. Diam. of lip, 0.055 m; of base, 0.031 m. Hammond Coll. Acc. no. 1898.8.

Cf. *NC*, 334, type C; *GPP*, 237, pl. 8b.

141. *Black-figure neck amphora.* On both sides of the neck are large dots surrounded by smaller dots and bracketed by pairs of upright wavy lines. On the shoulder are a crane with wings outspread and a panther; in the field incised dot rosettes, and around the handles palmettes and tendrils. The body, of which only the side below the

crane is preserved, shows a griffin, a panther, and a ram. In the next lower zone, the heads of a swan and a panther appear. On the inside of a restored portion is the graffito: NEOΣ.

Attic ware. About 575–550 B.C. H, 0.110 m. Diam of lip, 0.033 m; of shoulder, 0.110 m. Warren Coll. Acc. no. 1913.10.

On neck amphorae of this shape, cf. J. D. Beazley and F. Magi, *Raccolta Benedetto Guglielmi* (1939) 50–52, where the origin of the peculiar neck decoration is also discussed. On the swans and griffins, see *NC*, 76; 90, n. 11; on dot rosettes, *ibid.*, 157, fig. 68a; on the panthers, *Gr Pottery*, pl. 37a; *GPP*, pls. 13, 18, 20b.

142. *Three fragments of a black-figure neck amphora.* Fragment 1, from the shoulder, has a double border of leaves, alternately red and black, around the top. Below on the left a warrior with shield and spear moves upon another fallen before him. On the right another warrior also moves in upon the fallen soldier. All are helmeted and wear short swords slung over the shoulder. To the far right a mounted youth watches the scene. Fragment 2 preserves part of the same zone as Fragment 1, but does not join it. A part of the upper border of leaves and a similar lower one are visible. To the left are the lower parts of a warrior with shield, moving to the left. Part of the shield of another is seen. In the center a warrior with spear poised grasps the crest of a fleeing enemy's helmet. His opponent flees to the right, but at the far right, the thigh of another warrior appears to block his escape. All have short swords slung over the shoulder. Meaningless inscriptions appear in the field. Fragment 3 preserves part of the upper zone, showing the thigh and calf of a kneeling warrior. Below this is the border of leaves, and at the bottom is a lower, narrower zone, on the left of which is the head

of a galloping horse, and on the right the hindquarters of a horse carrying a rider.

Attic ware. Of the Tyrrhenian class of amphorae. From Cerveteri. About 575–550 B.C. Fr. 1: H, 0.120 m. W, 0.210 m. Fr. 2: H, 0.140 m. W, 0.185 m. Fr. 3: H, 0.130 m. W, 0.120 m. Warren Coll. Acc. nos. 1913.25.1–3.

ABV, 100, no. 71.

The scene on fragments 1 and 2 is from the Trojan War, with Greeks slaughtering Trojans. Tyrrhenian amphorae received their name by reason of the fact that most of them were found in Etruria. The long egg-shaped body of this type has a squat neck and rests on a spreading foot. As many as three registers of scenes were painted on the body, but the draftsmanship is rough and careless. Nonsensical inscriptions are one of the signatures of this class, most of which were produced in the second quarter of the sixth century. See *GPP*, 76–77, pl. 20b. D. von Bothmer, *AJA* 48 (1944) 161–170, groups Tyrrhenian amphorae by painters.

143.* *Black-figure panel amphora.* The top of the lip is reserved. Across the top of both panels is a stylized leaf pattern. In scene A, a youth escorted by two satyrs and two maenads is riding an ithyphallic donkey on whose member an amphora is suspended. In scene B, Dionysus cavorts with two maenads and two satyrs. Surrounding the bottom of the vase is a spoke pattern. PL. XX

Attic work. By the Painter of Berlin 1686. From Cerveteri. About 550 B.C. H, 0.324 m. Diam. of lip, 0.130 m; of base, 0.100 m. Warren Coll. Acc. no. 1915.44.

ABV, 297, no. 13.

The Painter of Berlin 1686, rated a capable artist of the second rank, was active between 560 and 530 B.C. See *DABF*, 73; S. Stucchi in *Encic AA*, s.v. "Berlino 1686, Pittore di." The amphora from which he is named shows

a procession honoring Athena, a humble predecessor of the Parthenon frieze. In the light of the resting place of the amphora in scene A of the Bowdoin vase, this artist also shows a nice sense of the ludicrous.

144.* *Black-figure Little Master lip cup.* The upper part of the body is reserved save for a line at the juncture of the offset lip. Outside, on one side, is a cock. The underside is glazed save for a narrow reserved band. The center of the inside is also reserved, but there is a black circle and dot within. PL. XXI

Attic ware. About 550–540 B.C. H, 0.103 m. Diam of lip, 0.140 m; of base, 0.061 m. Warren Coll. Acc. no. 1930.4.

The Little Masters were miniaturists who in the Mature period of Attic black-figure (about 570–525 B.C.) retained the older convention of painting in friezes around the vase at a time when a single large design was becoming popular with many artists. The lip cup and its somewhat later affiliate, the band cup, are distinguished by a tall stemmed foot, spreading bowl, a neat balance of light and dark, and a proportion of height to width of about two to three. On Little Master cups, see *DABF*, 53–56; *ABV*, 159–197; *GPP*, 79–81, pl. 25. The cock on the Bowdoin cup is related to the Tleson Painter, but is less fine. On this painter, see J. D. Beazley, *JHS* 52 (1932) 195–196.

145. *Fragment of a black-figure Little Master lip cup.* The fragment preserves the rim of the cup and a ram moving to the right. Purple is used on the neck and other parts of the animal. The inside is glazed black.

Attic ware. About 550–540 B.C. H, 0.020 m. W, 0.050 m. Warren Coll. Acc. no. 1930.35.

For a similar ram on a contemporary lip cup, cf. *Gr Pottery*, pl. 40b.

146.* *Black-figure Little Master band cup.* In a wide reserved band en-

circling the body on each side are two horsemen. Below is a narrow reserved line, and beside each handle a black palmette. The reserved center of the interior has a dot and black circle in it. PL. XXI

Attic ware. About 550–530 B.C. H, 0.103 m. Diam. of lip, 0.140 m; of base, 0.062 m. Warren Coll. Acc. no. 1915. 45.

J. D. Beazley, *JHS* 52 (1932) 187–191, analyzes the various types of band cup; the Bowdoin cup is not included.

147. *Fragment from the neck of a black-figure bottle.* The vase originally had a narrow neck, two handles, and a wide, egg-shaped body. Around the top of the fragment are horizontal bands of black and there are traces of black around the roots of the handle. On either side a bearded man is embracing a woman; in between is a youth. The flesh of the women is white, the hair and beards of the men purple. The two men wear their himations up over the back of the head.

Attic ware. About 550–525 B.C. H, 0.045 m. Diam. of neck, 0.013 m. Warren Coll. Acc. no. 1927.6.

The general shape seems to have been that of the Corinthian bottle. See *NC*, 313–314.

148.* *Black-figure eye cup.* The center of the interior is reserved with two concentric circles and a dot. There is also a thin reserved line around the lip. On either side on the exterior are figures between large apotropaic eyes. On side A, a warrior strides to the right with spear in hand. He is clad in a short chiton, a wrap, helmet, and greaves; on his shield is painted a tripod. On side B, a warrior strides to the left, equipped like the other, but without the wrap. Beside him an archer in pointed helmet and greaves draws his bow. In the field on both sides are mock inscriptions, and at each handle a vine.

Around the lower part of the body is a ray design. PL. XXII

Attic work. From Cerveteri. About 530–520 B.C. H, 0.115 m. Diam of lip, 0.275 m; of base, 0.125 m. Warren Coll. Acc. no. 1913.7.

About 530 B.C. the eye cup began replacing the Little Master cups. The distinguishing decoration is a pair of great eyes on each side in white, black, and purple, which were originally considered apotropaic. Between them there is either a rough nose or figures, as on the Bowdoin Cup. See *Gr Pottery*, pls. 54, 55; *DABF*, pl. 27, no. 2; *GPP*, 85, fig. 30a.

149. *Fragment of a black-figure stemless cup.* Inside is a gorgoneion. The teeth are in white, the tongue in red, and some details are incised. The head is set off from the rest of the interior by a reserved line. Outside, part of the reserved, raised ring at the join between body and foot is preserved.

Attic ware. About 530–520 B.C. Diam., 0.050 m. Warren Coll. Acc. no. 1927.10.

The gorgoneion, or disembodied head of the Gorgon, is an ornamental and perhaps an apotropaic device which begins to appear on Corinthian pottery early in the seventh century. In the Mature style of Attic black-figure (about 570–525 B.C.) it is often found as the inside decoration of eye cups. See *GPP*, 53, 85.

150. *Fragment of a black-figure vase.* The fragment, which has been burnt gray, is very thick and must have come from a large vase. It preserves the upper part of the head of one horse and apparently the muzzle of another. They would have been a chariot team. Above is a pair of relief lines, and in front of them are unidentifiable vestiges. The inside is glazed black.

Attic ware. About 525–500 B.C. H, 0.035 m. W, 0.065 m. Warren Coll. Acc. no. 1930.26.

This piece represents fine Attic work of the later sixth century B.C. Cf. the horses' heads by the painter Exekias, *DABF*, pls. 29–31.

151. *Black-glazed, unfigured psykter.* The lip and two suspension tubes on each side are reserved. The lid is missing.

Attic ware. About 520–480 B.C. H, 0.224 m. Diam. of lip, 0.077 m; of base, 0.092 m. Warren Coll. Acc. no. 1915.12. *VA*, 28.

The psykter was used to cool wine. The wine was put into it and then by means of the suspension tubes on its sides the psykter was held inside a krater full of cold water. Another means of cooling wine was an amphora with 'double walls. The cold water was poured into the outer compartment. Not many examples of either type have survived. Cf. *Shapes*, 13. For the type, cf. S. Weinberg, *AJA* 43 (1939) 597, fig. 8, no. 2; *CVA Oxford* 1 (J. D. Beazley) 41, pl. xlviii, nos. 25, 26.

152.* *Black-figure one-handled kantharos.* In the scene seven horsemen ride to the right accompanied by two dogs. Four of the horsemen wear the Phrygian cap, six the chlamys. At the far right is a pilaster, perhaps to indicate a homecoming. Six flying birds are in the field. Around the stem is a band of palmettes, alternately erect and inverted. Inside the bowl at the base of the handle is the head of a lion in relief. PL. XXII

Attic work. Class of the one-handled kantharoi. About 510–490 B.C. H, 0.275 c. Diam of lip, 0.210 m; of base, 0.130 m. Warren Coll. Acc. no. 1915. 43. From the Jekyll Coll.

J. D. Beazley and F. Magi, *Raccolta Benedetto Guglielmi* (1939) 53; *ABV*, 346, no. 10.

This is one of twelve vases of the same shape and from the same workshop, but not all by the same hand. For the shape, cf. *Shapes*, 26.

153. *Fragment of a black-figure neck amphora.* Around the top is a horizontal band of tongue pattern, the tongues being alternately red and black. To the left is a palmette and tendril, part of the decoration beneath one of the handles. In the middle stands an old man with white beard and hair, dressed in a cloak. He holds a stick in the left hand and looks to the right at an archer and a hoplite. Of this latter figure only a portion of his round shield remains to indicate his presence. The scene is broken off at the knees of the old man and the archer.

Attic work. By the Painter of London B343. Late sixth century B.C. H, 0.090 m. W, 0.130 m. Warren Coll. Acc. no. 1913.13. *ABV*, 342.

For the complete scene, cf. the contemporary neck amphora, *CVA London* 4 (H. B. Walters) pl. 63, no. 1b. On the artist, see S. Stucchi in *Encic AA*, s.v. "Londra B343, Pittore di."

154. *Fragment of a black-figure vase.* The fragment shows part of a man's face, two hands, an arm, and part of a bull's head. It is obviously the depiction of the struggle between Theseus and the Minotaur.

Attic ware. Late sixth century B.C. H, 0.040 m. W, 0.075 m. Warren Coll. Acc. no. 1930.38.

The slaying of the Minotaur by Theseus was a favorite subject with Attic vase painters from the middle of the sixth century onward. The earliest representation, however, is probably Corinthian, on a gold band of the seventh century. See *DABF*, 45 and *passim*; *ABV*, 727.

155. *Black-figure lekythos.* On the shoulder is a double row of decorations in a tongue pattern. On the body, which is left reserved, is a horizontal cable pattern with four palmettes above and four inverted palmettes below, in black.

Attic ware. About 500–475 B.C. H, 0.140 m. Diam. of lip, 0.034 m; of base, 0.039 m. Warren Coll. Acc. no. 1930.11.

Cf. *NC*, 156, fig. 67b, illustrating double palmette chains. They occur on Middle and Late Corinthian vases and first appear in Attica about 575 B.C.

156. *Black-figure lekythos.* The scene shows one hoplite attacking another. On either side a youth looks on. The inside and outside, but not the top, of the lip are black; so also is the outside of the handle. At the base of the neck is a row of short black vertical lines. Around the shoulder is a broad band of lotus buds in black. An irregular reserved line encircles the lower part of the body, the rest of which was originally black.

Attic work. Of the Class of Athens 581. About 490 B.C. H, 0.195 m. Diam. of base, 0.049 m. Warren Coll. Acc. no. 1913.4.

ABV, 489, no. 11.

Beazley remarks that the drawing on this vase is unusual and meager. It gives the impression both of haste and little talent. Beazley has identified 198 lekythoi of this class in the subdivision having a lotus bud pattern on the shoulder. They are all from the same workshop, or by the same potter or potters. See H. E. Haspels, *Attic Black-figured Lekythoi* (1936) 93–94, 224–225.

157. *Two fragments of a black-figure Panathenaic prize amphora.* Fragment 1 preserves part of the shield of Athena and letters of an inscription: - - -]ΝΑΘΕΝΑ[- - -. Fragment 2 does not make a join with fragment 1. It preserves part of a pillar beside Athena and the letters - - -]ΝΑΘΛ[- - -. Fragment 1 formerly consisted of two pieces, now joined.

Attic work. By the Berlin Painter. About 480 B.C. Fr. 1: H, 0.117 m. W, 0.153 m. Fr. 2: H, 0.115 m. W, 0.075 m. Warren Coll. Acc. no. 1930.13.1–2.

ARV, 952; J. D. Beazley, *AJA* 47 (1943) 449, fig. 3; *ABV*, 408.

The victors in the Panathenaic games received as prizes amphorae of a special type, filled with oil. The body of these vases was fat, the neck and foot small, and the chief decorations were in body panels on front and back. An armed Athena appeared on the front with the legend "from the games at Athens," and a picture of the events was on the back. The Berlin Painter, a great red-figure artist, was also the most important creator of the black-figure prize amphorae of his time. See *ARVS*, 68–70; *DABF*, 93–95; P. Mingazzini, in *Encic AA*, s.v. "Berlino, Pittore di," and *GPP*, 89–90, pl. 21.

158. *Black-figure lekythos.* The handle, lip, and base are missing. On the shoulder is a double band of vertical lines. The scene consists of two satyrs standing between a draped figure, who apparently is asleep. The figures are roughly outlined by incised lines. The lower part of the body is glazed black.

Said to be Etruscan work. Fifth century B.C. H, 0.099 m. Diam. at shoulder, 0.048 m. Gift of Dr. Chauncey W. Goodrich. Acc. no. 1944.12.1.

159. *Fragment of a red-figure cup.* The fragment preserves part of the rim and shows on the outside the upper part of a girl playing the flute. The flute and a fillet in her hair are in red, the outline of the hair incised, and the outline of the face without relief line. The inside is glazed black.

Attic ware. By Oltos. About 525–520 B.C. Bought in Rome. H, 0.029 m. W, 0.056 m. Warren Coll. Acc. no. 1913.14.

Att. V., 16, no. 68; J. D. Beazley, *Campana Fragments in Florence* (1933) pl. x.; *ARV*, 37, no. 44.

The rest of this cup is in Florence, Heidelberg, and Baltimore; the fragments were reassembled by Beazley in *Campana Fragments*, pl. x. The cup is

an early work of Oltos, painted for the potter Kachrylion and signed [XAX]P-[VΛI]ON EΠOIEI. For a discussion of this virile painter's contribution to Early Red-figure style (about 530–500 B.C.), see A. Bruhn, *Oltos and Early Red-figure Vase Painting* (1943); *ARVS*, 48–49, figs. 3 and 35; and *Gr Pottery*, 46, pls. 62 and 64. Cf. an outstanding psykter of his in New York (inv. no. 10. 210.18) in *Vases MMA*, no. 3, pls. 4, 173. The Bowdoin fragment is an excellent example of his work.

160. *Red-figure eye cup.* On the inside appears a running youth, wearing greaves and carrying helmet and shield, on which appears a raven. On the outside in scene A a nude youth carries jumping weights, standing erect. On either side is a large eye; on the side next to each handle is a palmette of the closed type. In scene B a nude youth is bent over, holding weights. In the field above him is the inscription KAΛOΣ. On either side is a large eye, and on the side next to each handle is a palmette of the open type. The innermost circle of each of the four eyes is purple. On the inside of the base are incised two alphas, ΛΛ.

Attic ware. By the Bowdoin Eye Painter. From Cerveteri. About 525 B.C. H, 0.135 m. Diam. of lip, 0.328 m; of base, 0.125 m. Warren Coll. Acc. no. 1913.2.

VA, 13, no. 2; *Att. V.*, 21, no. 2; *ARV*, 95, no. 4; *ARVS*, 23; K. Herbert, *The Walker Art Museum Bulletin* 1, no. 4 (1962) 9.

The Bowdoin Eye Painter, who takes his name from the apotropaic eyes on this vase, possesses only average ability. His palmettes and eyes are carefully executed, but the human figure gives him difficulty. See *ARVS*, 52; E. Paribeni in *Encic AA*, s.v. "Bowdoin, Pittore della Coppa a Occhioni." On *kalos* names, see *ARV*, 912ff.

161. *Fragment of a red-figure cup.*

The fragment is from the rim of the cup and shows the head of a helmeted warrior and part of his shield, the edge of which is incised with a double line. To the left is a single iota in red, probably part of an inscription. The inside is glazed black.

Attic ware. By the Euergides Painter. About 520–510 B.C. H, 0.035 m. W, 0.048 m. Warren Coll. Acc. no. 1913. 15. Formerly in the Bourguignon Coll.

J. D. Beazley, *JHS* 33 (1913) 354–355, no. 50, and fig. 6; *VA*, 19; *Att. V.*, 33, no. 45; *ARV*, 61, no. 36.

The Euergides Painter, to whom over a hundred cups are attributed, favored youths in movement for his subjects and drew them with a rapid, undisciplined line. See *ARVS*, 51, and the cup in New York (inv. no. 09.221.47) in *Vases MMA*, no. 5, pls. 3, 179. The Bowdoin fragment shows him at his best. For a short analysis, but with full bibliography, see A. Stenico in *Encic AA*, s.v. "Euergides, Pittore di."

162. *Two fragments of a red-figure cup.* Fragment 1 preserves the rim of the cup and the head and upper part of a maenad. She wears an Ionic chiton covered with a leopard's skin and a red garland in her hair. Her left arm is extended forward and below it is the top of a thyrsus. On the far right are the beginnings of handle palmettes. Fragment 2, which does not make a join with fragment 1, preserves the rim of the cup and upper part of a maenad garbed in like manner. In the field is the inscription . . . K]AΛO[Σ. Fragment 2 retains a black metallic glaze; fragment 1 is a faded black. The insides of both are glazed black.

Attic ware. In the manner of Skythes. From Cerveteri. About 520–510 B.C. Fr. 1: H, 0.050 m. W, 0.100 m. Fr. 2: H, 0.042 m. W, 0.060 m. Warren Coll. Acc. nos. 1913.17.1–2. Formerly in the Ruspoli Coll.

ARV, 951.

On Skythes, who worked in the

Early Red-figure style, see *ARVS*, 52, fig. 6. One of the best cup painters of the period, he possesses a lively and precise manner. The Bowdoin fragments show a talent for portraying individualized figures.

163. *Fragment of a red-figure cup.* On the inside the fragment preserves the head and hand of a youthful figure, above which is part of a band of meander pattern. The outside is glazed black.

Attic ware. By the Brygos Painter. About 490–480 B.C. Bought in Rome. H, 0.039 m. W, 0.030 m. Warren Coll. Acc. no. 1913.20.

ARV, 252, no. 101.

On the work of the Brygos Painter, one of the masters of the Late Archaic Red-figure style (about 500–480 B.C.), see *Gr Pottery*, 48–53, pls. 74–76, 89; *ARVS*, 78–81, figs. 18, 60, 61; *GPP*, 174, pl. 40; *Gr Painting*, 104, 106–109; and S. Stucchi in *Encic AA*, s.v. "Brygos, Pittore di." An early and late stage in his work have been distinguished, the early marked by vigor and masterful organization, the late by refinement and thinness of line. The present fragment and the one following both appear to belong to his later period. An excellent example of his early period is the kantharos in Boston (inv. no. 95.36), on which Zeus pursues Ganymede. Cf. *Vase MFA*, pt. 1, pl. vi, and *Gr Pottery*, pl. 76a. Boston (inv. no. 13.189) also has an example of late Brygan work, a lekythos on which a woman is working wool. Cf. *Vase MFA*, pt. 1, pl. x, no. 29.

164. *Fragment of a red-figure cup.* The inside of the fragment preserves the upper part of a woman clad in chiton wearing a saccos in her hair. A small garment stands in the field to the left. The outside is glazed black.

Attic ware. By the Brygos Painter. About 480 B.C. H, 0.028 m. W, 0.057 m. Warren Coll. Acc. no. 1913.21.

ARV, 259, no. 10 *bis* and p. 956.

Beazley believes that this fragment belongs to the late period of the painter. See No. 163, above.

165. *Fragment of a red-figure cup.* On the inside a nude woman holds a skyphos in her left hand, which she appears to be filling from a column krater at her feet. Her right hand, which is lost, may have held a ladle. The krater is wreathed with a double band of ivy and on the skyphos is inscribed the name ΔΟΡΙΣ. In the field is [ΠΑΝΑΙΤ]ΙΟΣ ΚΑΛΟ[Σ]. A meander border encircles the scene. The exterior is undecorated. The present fragment has been restored from several pieces, with missing portions replaced by plaster; on the bottom is the graffito of the mender, ΝΕΟΣ.

Attic ware. By the Panaitios Painter. From Cerveteri. About 490 B.C. H, 0.147 m. W, 0.141 m. Warren Coll. Acc. no. 1930.1. Formerly in the Ruspoli Coll.

VA, 87, no. 22, fig. 54; *Att. V.*, 168, no. 37; J. D. Beazley, *JHS* 39 (1919) 82–87; pl. ii, no. 1, and fig. 1; *ARV*, 213, no. 9; *GPP*, 171–172, 174; pl. 40.

Two fragments which portray the lower legs of the woman and the bottom of the krater were discovered in Leipzig by A. Rumpf, who then made them available to Warren. The name on the skyphos is undoubtedly the name of the vase painter Duris, but the cup is not in his style. Duris was a colleague of Panaitios, who both influenced and was influenced by him.

The Panaitios Painter is named after the *kalos* name Panaitios which, as on the Bowdoin fragment, appears often in his work. He is one of the masters of the Late Archaic Red-figure style, his draftsmanship being especially noteworthy. His compositions possess a distinctive harmony and flow, and his lines tend to curve delicately in the treatment of figures. His heads are distinguished by their relative largeness

and by their strong noses with finely curved nostrils. The Bowdoin fragment offers a magnificent illustration of these qualities. A satyr on a cup in Boston (inv. no. 10.179) is an excellent example of his early work, and komasts on a cup, also in Boston (acc. no. 95.27), illustrate his mature period. See *ARVS*, 76–78, fig. 59.

166. *Red-figure askos or flask.* Side A has a winged Eros with a flower in the right hand, a tendril in the left. Side B shows an Eros flying with arms extended. In the field in white is the inscription ΗΟ ΠΑΙΣ ΚΑΛΟΣ.
Attic ware. By Makron. About 490–480 B.C. H, 0.062 m. W, 0.100 m. Warren Coll. Acc. no. 1923.30.
J. D. Beazley, *AJA* 25 (1921) 325–336, figs. 1–4; *Att. V.*, 221, no. 156; *ARV*, 314, no. 242. On the inscription, see *SEG* I, no. 11.
Over 240 works have been attributed to Makron, whose favorite subjects are men, youths, women making love and mythological scenes, especially of the Trojan war. Cf. *Gr Pottery*, pl. 69; *ARVS*, 81–83, fig. 63; E. Paribeni in *Encic AA*, s.v. "Makron." He is especially adept at the portrayal of the flowing garments of women. Some of his best work appears on a number of cups in New York (for example, inv. nos. Gr 1120; 20.246). See *Vases MMA*, no. 56, pls. 57, 180; no. 53, pls. 50, 53, 54, 180.

167.* *Red-figure lekythos.* Around the base of the neck is a narrow horizontal line, below which is a band of short vertical lines bordered by two horizontals. In the scene a seated boy plays the double flutes, his flute case hanging behind him. Below is a band of meander-and-cross design. The edge and bottom of the base and the top of the lip are reserved.　　　PL. XXIII
Attic ware. By the Bowdoin Painter. About 490–480 B.C. H, 0.200 m. Diam.

of lip, 0.043 m; of base, 0.048 m. Warren Coll. Acc. no. 1920.1.
J. D. Beazley, *JHS* 59 (1939) 7–8; *ARV*, 474, no. 12; *ARVS*, 74–75; K. Herbert. *The Walker Art Museum Bulletin* 1, no. 4 (1962) 3–10, and cover illustration.
The present vase is an attractive specimen of this artist, who has been named by virtue of the fact that two of his works are at the college. See also No. 173, below; E. Paribeni in *Encic AA*, s.v. "Bowdoin, Pittore di." More than two hundred works have been attributed to him, chiefly single figures painted on lekythoi, as in the present instance. His attractiveness lies in the simplicity of his subject matter and his treatment. A typical lekythos is in New York (inv. no. 06.1021.90), on which a seated woman working wool is approched by a flying Eros. See *Vases MMA*, no. 34, pls. 33, 175; *ARVS*, pl. 56.

168. *Fragment of a red-figure cup.* On the inside is the upper part of an athlete wearing a tight-fitting cap. His head in profile looks downwards to the right. In the field are the letters ΚΟ, probably part of a *kalos* inscription. A reserved line, part of a circle, is above the head and shoulders of the figure. The outside is glazed black.
Attic ware. Near the style of Onesimos. About 490–480 B.C. H, 0.060 m. W, 0.041 m. Warren Coll. Acc. no. 1923.18.
Onesimos is a follower in the tradition of Panaitios. Fifty-nine cups have been attributed to him, and Lykos is one of four *kalos* names which appear on them. Cf. *ARVS*, 85.

169. *Red-figure squat lekythos.* On the left of the scene a man in a loose cloak leans forward on a stick while addressing a boy to the right. The man puts his weight on his right foot, which is frontal. The boy, clad in a himation,

faces him. Below is a narrow border of key pattern.

Attic ware. By the Syriskos Painter. About 480 B.C. H, 0.140 m. Diam. of lip, 0.048 m; of base, 0.090 m. Warren Coll. Acc. no. 1920.4.

ARV, 197, no. 32.

The Syriskos Painter, closely related to the Copenhagen Painter, is a competent, academic artist of the Late Archaic Red-figure style, as his treatment of the drapery and the attitude of the man on the Bowdoin lekythos indicate. See *ARVS*, 72–73. The present vase is one of two squat lekythoi by him, the other being Naples 3135; see *ARV*, 197, no. 31. This vase is one of the earliest of its type. Cf. *Shapes*, 15.

170. *Fragment of a red-figure cup.* The bottom of the cup, a bit of one handle, and a part of the foot are preserved; some missing parts are restored. The greater part of the picture in the tondo is preserved. To the left an athlete is sitting on the ground arranging his akontion; in the center another akontist moves to the left while looking backward; his akontion stands behind him.

Attic ware. By the Foundry Painter. From Cerveteri. About 480 B.C. H, 0.060 m. W, 0.165 m. Warren Coll. Acc. no. 1913.26. Formerly in the Ruspoli Coll.

VA, 94; *Att. V.*, 188, no. 4; *ARV*, 265, no. 28.

Similar compositions of this painter are to be found on his cups in the Louvre (inv. no. G 290) and in Adria (inv. no. B 489). The upright figure on the Bowdoin cup may be compared with the figure on his cup in Philadelphia (inv. no. 31.19.2). Cf. *Museum Journal* 23 (1932) 34–38 and 42–43, figs. 16 and 19. This lively painter was a member of the Brygan circle. Cf. *ARVS*, 87, fig. 97; M. Cagiano de Azevedo in *Encic AA*, s.v. "Fonderia, Pittore di." The Bowdoin fragment is important, for it shows the artist grappling

with the problems of foreshortening, if not solving them, and boldly placing the figures in various attitudes: frontal, three-quarter, and profile.

171. *Red-figure pyxis with cover.* In the center of the cover a kneeling archer holds a bow in his left hand, and an arrow in the right. His quiver is on his left side. The scene is encircled by a narrow reserved line, with a reserved exergue below. The inside of the cover is reserved, as are the groove in the body, into which it fits, and the bottom of the body. On the bottom is the incised graffito ΔI.

Attic ware. By the Heraion Painter. About 480–470 B.C. H, 0.045 m. Diam. of cover, 0.065 m; of base, 0.063 m. Warren Coll. Acc. no. 1915.14.

Beazley formerly attributed this work to the Bowdoin Painter. Cf. *VA*, 70–72, no. 71; *Att. V.*, 143, no. 112. But he now assigns it to the Heraion Painter. Cf. *ARV* 119, no. 10. He does, however, retain the name of the Bowdoin Painter to describe the two lekythoi at the college and the many pieces elsewhere by him.

See Nos. 167, above, and 173, below. On the Heraion Painter, see E. Paribeni in *Encic AA*, s.v. "Heraion, Pittore della."

172. *Red-figure hydria.* To the left a youth stands with a staff in his right hand; in the center, a seated woman looks to the right and examines a wreath which she holds in her hands; before her feet is a workbasket. Above her head in the field is her name in white letters: NIKAPETE. To the right, a youth stands with right hand on hip, leaning on a staff. Below the scene is a border of meander-and-cross design and around the lip a loop pattern.

Attic ware. In the manner of the Aigisthos Painter. From Naples. About 480–470 B.C. H, 0.310 m. Diam. of

lip, 0.130 m; of base, 0.120 m. Warren Coll. Acc. no. 1913.32.

VA, 193, *add.* to p. 67; *Att. V.*, 291, no. 1; *ARV*, 333, no. 5.

The Aigisthos Painter worked in the Early Classical Red-figure style (about 480–450 B.C.) and was among the first to endow his scenes with psychological realism. See *ARVS*, 110. The Bowdoin hydria illustrates this characteristic very well, for the attitudes and expressions of the youths make plain their concentration on the wreath, which the woman apparently has just finished weaving. For an analysis of all artistic aspects of the period which now follows, see Ernst Langlotz in *EWA*, s.v. "Classical Art."

173. *Red-figure lekythos.* Around the base of the neck is a row of short vertical lines, bordered by a horizontal line below. The shoulder is reserved and is decorated by palmettes and tendrils. Around the top of the body is a narrow reserved line. On the body a lion crouches about to spring and a tree is in the background. In a reserved panel below the scene is a key pattern, bordered above by a single black line, below by two.

Attic ware. By the Bowdoin Painter. From Gela. About 480–470 B.C. H, 0.185 m. Diam. of lip, 0.033 m; of base, 0.046 m. Warren Coll. Acc. no. 1913.5.

VA, 72, no. 58; *Att. V.*, 141, no. 87; *ARV*, 475, no. 133; *ARVS*, 74–75; K. Herbert, *The Walker Art Museum Bulletin* 1, no. 4 (1962) 3–10, fig. 2.

See No. 167, above.

174. *Red-figure squat lekythos.* Above the scene is a rude border in a tongue pattern. In the scene to the left, a youth holds a leopard cub on a leash; to the right, a bearded man leans on a staff. Below, a reserved band encircles the vase and is filled in with a meander pattern in the front.

Attic ware. By the Painter of the Yale Lekythos. About 480–470 B.C. H, 0.150

m. Diam. of lip, 0.047 m; of base, 0.090 m. Warren Coll. Acc. no. 1915.41.

VA, 73, no. 14; *Att. V.*, 144, no. 24; *ARV*, 446, no. 56.

The vase is an early example of this shape, which became popular in the second half of the fifth century and in the fourth. See *Shapes*, 14–15, figs. 99–102. The Painter of the Yale Lekythos shows no great skill or care in the execution of the Bowdoin vase. This lekythos is interesting simply because of the novelty of the scene and because of the earliness of this particular shape. This artist is represented in New York (inv. no. 41.162.134) by a Nolan amphora with a pursuit scene. See *ARVS*, 109.

175. * *Red-figure cup.* Inside is a standing, draped youth holding a stick before him. Behind him is a strigil and sponge. The tondo is encircled by a band of meander-and-cross design. Outside, in scene A two young men, draped and standing, address a boy, also draped and standing, who is between them. On the left, one of the youths leans on his staff and proffers a joint of meat to the boy, who looks to the right at the other youth. This young man extends his right hand toward the boy in addressing him. In the background his staff rests against his arm and a Doric column stands between him and the boy. In the field to the left of the scene are two writing tablets. Scene B is similar to A, but in this case the boy is on the left with a staff in his right hand. He faces two youths on the right, the first of whom leans on his staff, while the other holds his at arm's length. Between the boy and the youths is a Doric column, and a flute case with mouthpiece box hangs in the field.

PL. XXIII

Attic ware. By the Briseis Painter. About 480–470 B.C. Bought at Sirolo. H, 0.110 m. Diam. of lip, 0.235 m; with handles, 0.320 m. Warren Coll. Acc. no. 1920.2.

ARV, 267, no. 17.

The Briseis Painter is a follower of the Brygos Painter. There is a good example of his work on a cup in New York (inv. no. 27.74). See *ARVS*, 87, fig. 62; *Vases MMA*, no. 51, pls. 48, 49, 180. The Bowdoin cup is an ordinary example of his work, which at its best is both lively and refined. For a short analysis of his work, see E. Paribeni in *Encic AA*, s.v. "Briseide, Pittore di."

176. *Fragment of a red-figure cup.* The fragment preserves the rim of the cup and the figure of a victorious athlete down to the knees. His arms and thighs are bound by fillets, and he extends his arms to receive the sprigs which were offered to victors. Behind him are the hands and an arm of one holding a wreath ready for him. This wreath and a fillet in his hair are in red. The inside is glazed black, save for a reserved rim.

Attic ware. About 480–470 B.C. H, 0.070 m. W, 0.040 m. Warren Coll. Acc. no. 1913.19.

This painter shows a deftness of line in everything but his treatment of the face in profile. On the subject, see *Vase MFA*, pt. 1, 13.

177. *Fragment of a red-figure cup.* The fragment preserves the rim of the cup and the head of a bearded man, the upper part of his shield and three of the fingers of his right hand. The hair over the forehead is rendered by tiny raised dots of black paint. To the right is the crook of the shield, and the twirl of a handle palmette. The inside is glazed black.

Attic ware. By Duris. About 470 B.C. H, 0.025 m. W, 0.055 m. Warren Coll. Acc. no. 1913.18.

This fragment joins one in the Villa Giulia in Rome, which with others there and in Florence belong together. Cf. J. D. Beazley, *Campana Fragments in Florence* (1933) 15, pl. 7B25. The

Florence and Villa Giulia fragments are listed in *ARV*, 288, no. 126; the Bowdoin in *VA*, 99, and *ARV*, 288, no. 127, *add.* to p. 957.

On Duris, who spans the Late Archaic and Early Classical Red-figure styles, see *ARVS*, 83–85, figs. 64, 65; *Gr Pottery*, pl. 77; E. Paribeni in *Encic AA*, s.v. "Douris." He was active from about 500 to 470 B.C. and his works have been classified into an early, a middle, and a late period. The Bowdoin fragment, to judge from the careful treatment of hair, eyes, lips, and beard, belongs to the last phase. A superb example of this period is the cup in New York (inv. no. 23.160.54) with its two lovely nudes on the inside. See *Vases MMA*, no. 59, pls. 61, 63, 64, 181; *ARVS*, fig. 65. A cup in Boston (inv. no. 00.343), with a maenad and two satyrs on the inside, is comparable in quality to the vase in New York. Duris, together with Makron, the Panaitios Painter, and the Brygos Painter form a quartet of the greatest cup painters of the Late Archaic period.

178. *Red-figure stemless cup.* The inside is decorated with an incised triple rosette pattern and the lip is offset. Outside, in scene A, a mounted youth wearing a chlamys, with a petasos slung over his shoulder, hurls a spear with his right hand. Scene B is the same, except that there the youth holds his spear at the ready in his left hand. Palmettes and tendrils are under each handle. The foot has a single ridge in it, and the underside is decorated with concentric black circles, one of which is molded.

Attic ware. By the Hippacontist Painter. About 470 B.C. H, 0.060 m. Diam. of lip, 0.208 m; of base, 0.117 m. Warren Coll. Acc. no. 1927.19.

ARV, 455, no. 2; A. D. Ure, *JHS* 56 (1936) 205–206, fig. 1; 209, fig. 10.

This cup is one of four stemless cups with the same subject and by the same hand; the others are Naples 2625,

Basle 1921.376, and Boston 13.203. The use of incised or stamped patterns on the interior of red-figure cups facilitated mass production.

179. *Fragment of a red-figure vase, probably a hydria.* The fragment preserves the upper parts of two figures. Zeus on the left reaches with his right arm to seize Ganymede, who is trundling his hoop by a stick held in the right hand. The god's scepter is also visible. The lower part of the outside is reddened through misfiring, and the inside has two bands of red glaze.

Attic ware. Probably by the Oreithyia Painter. About 470 B.C. H, 0.075 m. W, 0.080 m. Warren Coll. Acc. no. 1927.18.

ARV, 325, no. 1.

For the theme, cf. *Gr Pottery*, pl. 76a, a cup by the Brygos Painter, and *Vase MFA*, pt. 1, pl. vi. Stylistically this fragment reveals an artist of crudity and vigor. The inner corner of the eye is left open; the nostrils and ears are sketched roughly; the scapulae are y-formed; and the retracing of lines gives the impression of haste and uncertainty.

180. *Red-figure lekythos.* The outside of the lip is glazed black, as is the outside of the handle; the neck and inside of the handle are reserved. At the base of the neck is a horizontal row of vertical lines, and on the shoulder a similar row of longer lines. On the body a maenad runs to the right, looking backward to the left, and in her left hand is a wineskin, in her right a thyrsus; she wears a cap, a chiton, and over the chiton has on a leopard's skin. Above the scene is a meander pattern, below it a single reserved line. The glaze has a distinctively metallic quality to it.

Attic ware. In the manner of the Ikaros Painter. About 475–450 B.C. H, 0.155 m. Diam. of lip, 0.033 m; of base, 0.035 m. Warren Coll. Acc. no. 1913.12.

ARV, 961, *add.* to p. 484.

The Ikaros Painter, one of the many minor lights of the Early Classical Red-figure style (475–450 B.C.), worked mainly on lekythoi, some of them on white ground. See *ARVS*, 114. He is named for a vase in New York (inv. no. 24.97.37) with a winged figure, perhaps Ikaros, on it. See J. D. Beazley, *JHS* 47 (1927) 231, fig. 6. The Bowdoin lekythos was executed with haste and no great care. The treatment of the breasts, which are presented frontally, still gives this artist difficulty, for he has them pointing in opposite directions.

181. *Plastic cup in the form of a female head.* The opening in the top of the head has been plastered over mistakenly and painted black; the same treatment has been accorded the place where the handle broke away. The head is crowned by a stephane decorated with meander-and-cross design and by a laurel wreath painted in white. The frontal hair is rendered by raised dots, among which are traces of red. The whites of the eyes are painted white, the pupils are black in the center and edges, with a reserved circle between.

Attic ware. Of the Cook Group, Group N, of female heads. About 475–450 B.C. H, 0.130 m. Warren Coll. Acc. no. 1923.19. Formerly in the Hope Coll.

J. D. Beazley, *JHS* 49 (1929) 61–65; 76, no. 5; *ARV*, 967, *add.* to p. 904, listing the Bowdoin head as no. 113 *bis*.

On the whole problem of using the forms of the human head in making a vase, see Beazley, *loc. cit.*, 38–40. For salutary criticisms and illustrations of this type and the following two classes, see *Gr Pottery*, 55, pl. 92.

182. *Plastic cup in the form of a Negro's head.* The single handle is missing and much of the spout is restored.

The front of the hair is reserved, with raised dots which bear traces of red.

Attic ware. About 475–450 B.C. H, 0.115 m. Diam. of lip, 0.084 m; of base, 0.047 m. Warren Coll. Acc. no. 1913.27.

J. D. Beazley, *JHS* 49 (1929), 76–78, gives a list of Negro-head vases. For the shape, see *Shapes*, fig. 187.

183. *Rhyton in the form of a ram's head.* The flaring lip is glazed black but is decorated with an ivy leaf in white with yellow touches. The fleece is represented by raised, white dots, some of which have broken off.

Possibly Attic ware. Early fifth century B.C. H, 0.105 m. Diam. of lip, 0.067 m. Warren Coll. Acc. no. 1923.23.

On the shape, see *Shapes*, 28–29, figs. 178–180.

184. *Fragment of a red-figure vase.* The fragment preserves the upper part of Eros, flying; the face is frontal. The lines of the potter's wheel on the inside indicate that the figure is in a horizontal position, not upright.

Attic ware. In the manner of the Antiphon Painter. From Athens. About 475–450 B.C. H, 0.067 m. W, 0.032 m. Warren Coll. Acc. no. 1930.34.

ARV, 237, no. 82.

The Antiphon Painter has been associated with the circle of the Panaitios Painter, one of the great draftsmen of the Late Archaic Red-figure period. The Bowdoin fragment is an excellent illustration of this association, for the lines have been drawn with careful and fluid grace. The Antiphon Painter, however, is also said to lack his master's verve and vivacity, and the absence of these qualities is evident in this fragment. See *ARVS*, 85–86. A typical work is a cup in New York (inv. no. GR 575) on which appear youths in a variety of attitudes. See *Vases MMA*, no. 61, pls. 62, 181. For a summary of his work, see M. Cagiano de Azevedo in *Encic AA*, s.v. "Antiphon, Pittore di."

185.* *Red-figure Nolan amphora.* Beneath each three-ribbed handle is an inverted palmette. Scene A shows a seated youth playing the flute and another standing, who looks on while leaning on a cane; he holds a flute in his hand. Scene B shows a running youth. Beneath the scene is a border of meander-and-cross design. PL. XXIV

Attic ware. By the Pan Painter. From Gela. About 460 B.C. H, 0.310 m. Diam. of lip, 0.150 m; of base, 0.085. Warren Coll. Acc. no. 1913.30.

J. D. Beazley, *JHS* 32 (1912) 360, no. 30; *VA*, 115; *Att. V.*, 102, no. 28; J. D. Beazley, *Der Pan-Maler* (1931) 23, no. 31; pl. ii, no. 2; *ARV*, 364, no. 37.

The Nolan type of amphora is distinguished by a small neck and ridged handles. The Pan Painter is named after a bell krater in Boston (inv. no. 10.185) on which Pan appears in pursuit of a shepherd on one side and Artemis slays Actaeon on the other. See *Gr Pottery*, pls. 82, 83; *Gr Painting*, 118–119. Beazley has said that there is no finer vase anywhere and characterizes this incomparable master as follows: "Cunning composition; rapid motion; quick, deft draughtsmanship; strong and peculiar stylization; a deliberate archaism, retaining old forms, but refining, refreshing, and galvanizing them; nothing noble or majestic, but grace, humour, vivacity, originality, and dramatic force" (*JHS* 32 [1912] 354). The qualities of the artist's composition, draughtsmanship, and stylization are readily seen in the Bowdoin amphora.

186.* *Red-figure hydria.* A gadroon pattern runs around the lip, and a pattern of diagonal acanthuses encircles the base of the neck. Beneath this pattern the scene runs around the vase, occupying the shoulder and the major portion of the body. The general subject of the scene is the rape of Oreithyia by Boreas. Boreas flies down and seizes Oreithyia as Athena watches. To the

left of Boreas two women flee toward an old man, probably Erechtheus. To the right of Athena another woman flees toward a woman who holds a small dolphin. The vase has a vertical handle in addition to two horizontal ones, and around the roots of all three are vertical line motives. Around the vertical handle there are also palmettes and tendrils. Beneath the scene is a meander-and-cross design. The left arm of Oreithyia and part of the palmette under the vertical handle are restored.

PL. XXIV

Attic ware. By the Niobid Painter. About 460–450 B.C. H, 0.410 m. Diam. of lip, 0.155 m; of base, 0.155 m. Warren Coll. Acc. no. 1908.3.

VA, 195, no. 150; Att. V., 341, no. 49; T. B. L. Webster, *Der Niobiden-Maler* (1935) 22, no. 49; ARV, 423, no. 54.

The Niobid Painter, named after a calyx krater in the Louvre (inv. no. G341) depicting the death of the Niobids, is important because he is one of the first vase painters to reflect the techniques of the great wall paintings of Polygnotus and his contemporaries. See *Gr Pottery*, 51–52, pl. 87; ARVS, 100–101; *Gr Painting*, 121–124. Yet painting, however fine, must be related to its medium and function, and therefore the present work is an example of failure in these matters, despite great technical skill. The vase is simply a means for the expression of the artist's too ample intentions.

187. *Red-figure mug.* The mug is glazed black inside and out, but the bottom is reserved. The scene shows a satyr dressed in himation and reclining on a cushion. He is propped up on his left elbow with his right arm extended as in a gesture of speech, and he looks around as if to address a companion.

Attic ware. About 460–450 B.C. H, 0.067 m. Diam. of lip, 0.068 m; of base, 0.065 m. Warren Coll. Acc. no. 1930.2.

The painting was hastily done, but the rendering of the position shows that the artist possessed some abilities. On the shape, cf. *CVA Oxford* 2 (J.D. Beazley and others) pl. lxii, nos. 3, 6.

188.* *White-ground lekythos.* The lip, neck, lower body, and base are glazed black. The top of the lip, and the edge and underside of the base are reserved. At the base of the neck is a band of egg pattern, and on the shoulder palmettes and tendrils in red and black. The upper body has a band of black meander pattern and red lines. In the scene, on the left, a woman holds a tray of sashes and garlands. Her hair and the outlines of her body are in lustrous varnish, the sashes in red with a black fringe. In the center stands a stele bound with red sashes, and on the right a man is standing clad in a dull red himation and holding a staff in the right hand. The entire surface is much worn.

PL. XXV

Attic ware. From the school of the Achilles Painter. About 450 B.C. H, 0.312 m. Warren Coll. Acc. no. 1923.26.

Although there were earlier experiments in white-ground painting, this style reached the height of its development and popularity on funerary lekythoi about 450–400 B.C. In this technique the sharpness of red-figure delineation by relief line was replaced first by a softer flat line of shiny dilute paint and later by matt colors, both on a white ground. Because these vases were much used as dedications at graves, funerary subjects quickly became their almost exclusive topic of portrayal. See J. D. Beazley, *Attic White Lekythoi* (1938); GPP, 177–178, 182–183. The scene on the Bowdoin lekythos, that of a woman mourner with offerings of sashes, or taeniae, and a man in a himation before a stele, is a very common one on white-ground lekythoi. See Arthur Fairbanks, *Athenian White Lekythoi* (1914) 228–233, 238–239.

The Achilles Painter has the double distinction of being the last of the great Attic vase painters and the best of those who worked in the white-ground style. The grace and dignity of his figures in scenes of quiet melancholy are unmatched in this art. There are examples in New York of his red-figure and white-ground work; for example, inv. no. 17.230.13, in *Vases MMA*, no. 113, pls. 114, 176; inv. no. 08.258.17., *ibid.*, no. 114, pls. 114, 176. Among those who were associated with him or were his pupils are the Saboureff, Phiale, Persephone, and Dwarf painters. See J. D. Beazley, *JHS* 34 (1914) 179–226; *ARVS*, 118–124; *GPP*, 182–183; *Gr Painting*, 136–147; M. Cagiano de Azevedo in *Encic AA*, s.v. "Achille, Pittore di."

189. *Fragment of a red-figure calyx krater.* The scene is a symposium. To the left, two men recline on a couch; each leans on two striped pillows, and the second figure from the left holds a long napkin. To the right, a flute girl looks to the right at a third man who is also reclining on a couch; hanging above him is a flute case and another napkin. The inside is glazed black.

Attic ware. By the Painter of the Woolly Silens. About 450 B.C. H, 0.095 m. W, 0.180 m. Warren Coll. Acc. no. 1930.8.

Att. V., 477, *add.* to p. 343, no. 2 *bis*; *ARV*, 427, no. 2 *bis*.

The Painter of the Woolly Silens belonged to the circle of the Niobid Painter, a group which was influenced by the murals of Polygnotos and Mikon. They favored elaborate compositions such as Amazonomachies and the like, and they used foreshortening in depicting the various groups. See *ARVS*, 100–104, fig. 74; *GPP*, 180, figs. 32, 33; also T. B. L. Webster, *Der Niobiden-Maler* (1935). A large volute krater in New York (inv. no. 07.286.84) showing a battle of Greeks and Amazons is an excellent example of the organiza-

tional skill of the Painter of the Woolly Silens. See *Vases MMA*, no. 98, pls. 97, 98, 171. The Bowdoin fragment well conveys a sense of the imposing work of this painter.

190. *Two fragments of a red-figure squat oenochoë.* Fragment 1 consists of two mended pieces. Fragments 1 and 2 do not effect a join. Fragment 1 shows a satyr, complete except for head and feet, running to the right in pursuit. Fragment 2 depicts the torso, left arm, and thyrsus of a maenad. The insides of both fragments are poorly glazed in black.

Attic ware. By the Euaion Painter. About 450–440 B.C. Fr. 1: H, 0.050 m. W, 0.075 m. Fr. 2: H, 0.035 m. W, 0.050 m. Warren Coll. nos. 1915.17.1–2.

VA, 158; *Att. V.*, 359, no. 62; *ARV*, 531, no. 99.

The Euaion Painter worked chiefly on cups, his favorite subjects being youths and satyrs delicately drawn. See *ARVS*, 107, fig. 87. The Bowdoin fragments show the fineness of his linework. A satyr on a stemless cup in New York (inv. no. 06.1021.177) is one of his best works. See *Vases MMA*, no. 107, pls. 107, 181. For a summary of his work, see E. Paribeni in *Encic AA*, s.v. "Euaion, Pittore di."

191. *Fragmentary red-figure lekythos.* Several fragments of the body, part of the shoulder, and the base have been restored. The neck, mouth, and handle are missing. On the upper shoulder there is a band of egg pattern, on the lower part palmettes. In the scene a seated woman at the left looks to the right at a standing woman, who extends a lyre to her with the right hand. The seated woman wears a bandeau, the standing one a diadem and earrings. On the seated woman's footstool is an inscription, KA[..]A[.]. Below the scene is a border of meander pattern. At the top of the scene there is a very small reserved piece, presumably part

of a similar pattern of the same height.
Attic ware. By the Trophy Painter. About 440 B.C. H as restored, 0.270 m. Diam. of base, 0.060 m. Warren Coll. Acc. no. 1915.46.

VA, 161, fig. 98; Att. V., 365, no. 7; ARV, 719, no. 7.

The Trophy Painter is a minor artist of the Classical Red-figure style. There is a pelike of his in Boston (inv. no. 20.187), on which Nike is erecting a trophy. See ARVS, 131. The Bowdoin lekythos shows him to be a capable painter of drapery.

192. *Black-painted, unfigured amphoriskos.* At the base of the neck are stamped ovules. On the upper part of the body is a row of stamped palmettes vertically placed, bordered by three grooved lines. Below this is another row of stamped palmettes, inverted.

Attic ware. About 450–425 B.C. H, 0.103 m. Diam. of lip, 0.028 m; of foot, 0.012 m. Warren Coll. Acc. no. 1930.10.

The use of the palmette stamp and ovule stamp on this small perfume bottle shows that it was mass produced for the low-priced market. This technique began in Athens in the second quarter of the fifth century. For the history of impressed decoration, see GPP, 214–215.

193. *Black-painted, unfigured lekanis.* A knob on the lid has a depressed space in the center of its recessed top. The bowl and lid are completely black save for narrow bands on the top and edge of the knob, on the edge of the cover and rim of the bowl, and on the base. Two handles have projections on each side in imitation of metal technique.

Attic ware. About 450–400 B.C. H, with cover, 0.140 m. Diam. of lip, 0.185 m; of base, 0.085 m. Warren Coll. Acc. no. 1930.9.

The lekanis, or covered bowl, was used for cooked food, but could also be a gift container for brides. The form was especially popular in the second half of the fifth century B.C. Cf. Shapes, 23–24, fig. 149; CVA Oxford 2 (J. D. Beazley and others) pl. lxv, nos. 11, 14. On black painted ware, see GPP, 188–189.

194. *Circular flask or canteen.* The flask has two feet and two small shoulders, all of which are pierced by two holes; the rim is ridged in alignment with these holes so that two thongs might completely and securely encircle the flask, which thus could serve as a canteen slung from the shoulder. The rim is reserved; the sides are decorated with concentric bands of black; feet, neck, and shoulders are black.

Attic ware. About 450–400 B.C. H, 0.140 m. Diam., 0.114 m. Warren Coll. Acc. no. 1915.29.

There is a similar flask in Boston (inv. no. 23.545) and replicas are said to be in Cassel and in the collection of Dr. von Schoen in Munich.

195.* *Red-figure lekythos.* Around the base of the neck is a band of egg pattern; around the shoulder, palmettes and tendrils. The upper part of the body has a narrow band of meander-and-cross designs. In the scene a nude dancing girl stands to the left; above her head to the left is a fillet. A dancing mistress stands to the right, fully clothed. Her left hand is on her staff, and she points a direction with her right. Below the scene is a border of key pattern. PL. XXV

Attic ware. By the Painter of the Boston Phiale. From Gela. About 430 B.C. H, 0.375 m. Diam. of lip, 0.065 m; of base 0.070 m. Warren Coll. Acc. no. 1913.11.

VA, 168, fig. 105; 170, no. 33; Att. V., 385, no. 58; J. D. Beazley, AJA 37 (1933) 401, fig. 3; ARV, 657, no. 83.

An Attic red-figure phiale in Boston (inv. no. 97.371) has given its name to the present painter. See VA, 167, fig.

103. The vivacity and expressiveness of the figures on this and the Bowdoin lekythos reveal a graceful and appealing artist. He appears to have been a pupil of the Achilles Painter and he especially liked the lekythos and Nolan amphora as means of expression. For a summary of his work, see E. Paribeni in *Encic AA*, s.v. "Boston-Phiale, Pittore della."

196. *Red-figure column krater.* On the top of the shoulder on both sides is a border in a tongue motive. In scene A, the Sphinx with raised wings crouches on a pedestal and looks to the right at Oedipus, who stands before her leaning on a spear. He is nude save for a himation thrown back over his shoulders; his hat is also in this position. He wears high boots and carries a sheathed sword slung across the right shoulder. Behind him stands a dog. In scene B, a draped old man with a staff stands before a draped woman, who holds out a phiale to him. There is a graffito on the underside of the foot: ΑΙΙΙ ΑΧΕ-ΝΑΤΩΙ ΚΟΡΙΘΙΓΗ. The vase was broken in antiquity and repaired with bronze clamps, a number of which remain; the vase also was restored in modern times from numerous fragments.

Attic ware. Related to the school of Polygnotus. From Gela. About 430 B.C. H, 0.420 m. Diam. of lip, 0.335 m; of base, 0.155 m. Warren Coll. Acc. no. 1913.8.

Polygnotus, who shares his name with two other contemporary pottery painters as well as with the famous muralist, is the leader of a group which flourished in the same period as the Achilles Painter and his group. To prevent confusion, the two lesser artists with this name are known as the Lewis Painter and the Nausikaa Painter. Polygnotus and his school are in the tradition of the Niobid Painter, much of their work being on large vases. The forms of Polygnotus are round and fleshy, and his drawing naturalistic. The painter of

the Bowdoin krater reveals these same characteristics. See *ARVS*, 127–130.

197. *Red-figure pyxis with lid.* On the knobbed lid are two groups: a lion and a boar, and a boar and a hedgehog. Around the lid is a tongue pattern. On the circular body there are also two groups, each of a running Eros and a woman. One Eros carries a perfume vase and what appears to be a fruit, the other a large box. The women in each instance run in front of the deities with arms extended back to them. The action takes place around a house door, on each side of which is a fluted Doric column.

Attic ware. Of the Druot Group. About 430 B.C. H, 0.115 m. Diam., 0.105 m. Warren Coll. Acc. no. 1930.3.

ARV, 760, no. 4.

This pyxis is one of a group of six painted by the same hand near the end of the Classical Red-figure style (about 450–425 B.C.). See *ARV*, 760.

198. *Fragment of a red-figure bell krater.* The present fragment, derived from four mended shards, forms part of the rim and the upper part of the body of the krater. Just below the rim is a band of diagonal acanthuses, and below this are the upper parts of three figures. To the left is the head of Apollo with his laurel staff. In the center a young woman is being pursued by a youth from the right. He wears an Oriental tiara, holds two spears in his right hand, and seizes the woman with his left. The tiara has raised dots as part of its decoration.

Attic ware. By the Painter of Athens 1454. About 430–420 B.C. H, 0.065 m. W, 0.085 m. Warren Coll. Acc. no. 1927.3.

Att. V., 450, no. 6; *ARV*, 796, no. 8.

The Painter of Athens 1454, near the beginning of the Late Classical Red-figure style (425–400 B.C.), reveals the influence of the Eretria Painter in the dainty and overdone qualities of his

work. See *ARVS*, 132–135, figs. 101–103; *GPP*, 182, pl. 47. E. Paribeni in *Encic AA*, s.v. "Atene 1454, Pittore di," describes the Bowdoin fragment as one of his most distinctive works, since it is the only one on which a male figure appears.

199. *White-ground lekythos.* The lip, neck, and handle are black-glazed. At the base of the neck is a band of egg pattern and on the shoulder palmettes and tendrils. On the upper part of the body is a meander-and-cross design. The figures are painted in glaze outlines. In the scene, a woman stands before a stele carrying a basket of sashes. Outlines of her diaphanous garment are almost obliterated, but her cap is vermilion, her hair mat purple. The stele terminates in an acanthus and is bound with vermilion ribbons. On the right a youth in vermilion chlamys stands with his right foot on the step of the stele. His right hand is raised and in his left is a lance. The entire surface is badly worn and cracked.

Attic ware. By the Quadrate Painter. About 425 B.C. H, 0.295 m. Warren Coll. Acc. no. 1923.25.

ARV, 814, no. 2 *bis*.

See No. 188, above.

200. *Red-figure toy oenochoë.* In the scene, a child, standing erect, pushes a two-wheeled cart with shaft. In the cart is an oenochoë and on the shaft a ribbon. An amulet is around the child's neck, and in his right hand is a small animal. Behind the child stands a low table with a jug on it. Around the scene is a border of egg pattern and in the field the inscription ΚΑΛΟΣ.

Attic ware. About 425 B.C. H, 0.072 m. Diam. of lip, 0.042 m; of base, 0.048 m. Warren Coll. Acc. no. 1915.38.

For these toys, given to children on the feast of the Anthesteria, see L. Deubner, *Attische Feste* (1932) 238–247.

201. *Fragment of a red-figure vase.* The fragment is from the body of the vase. To the left is part of the dress of a woman standing on a ladder. To the right a seated woman in a Doric peplos is holding a large object, perhaps a vase.

Attic ware. In the manner of the Painter of Athens 1454. About 425–420 B.C. H, 0.060 m. W, 0.095 m. Warren Coll. Acc. no. 1923.5.

On the Painter of Athens 1454, see No. 198, above. For the woman on the ladder, cf. the fragment of a nuptial *lebes*, or bowl, in the Louvre (inv. no. CA 1079) in G. Nicole, *Meidias et le style fleuri* (1908), pl. 8, no. 2, and pl. 9, and especially the hydria in Athens (inv. no. 1179), *ibid.*, pl. 4 and pl. 8, no. 4. On the subject, *ibid.*, 143–152.

202.* *Red-figure pelike.* On the neck is a border of diagonal acanthuses. In scene A, to the left, appears a mounted youth, wearing a chlamys, a petasos slung back over his shoulder, and a wreath on his head. He holds two spears in his left hand. In the center is a woman wearing a peplos and cap, with an oenochoë in her right hand and a phiale in her left. On the right in front of a Doric column sits a bearded man wearing a garment about the lower part of his body and holding a staff in his left hand; behind him is a youth, clad in a himation and raising his right hand as if in greeting. In scene B, to the left, is seen a bearded man wearing an himation and leaning on a staff. In the center a youth wearing a chlamys and petasos leans on a spear. To the right a girl wearing cap and himation holds out a phiale. Beneath both scenes is a continuous border of meander-and-cross design; beneath both handles are palmettes. Much of the upper surface of the vase is reddened because of inadequate firing. PL. XXVI

Attic ware. By the Dinos Painter. From Thebes. About 425–420 B.C. H,

0.400 m. Diam. of lip, 0.205 m; of base, 0.205 m. Walker Coll. Acc. no. 1895.2.

ARV, 792, no. 32.

The Dinos Painter, of the Late Classical Red-figure style (425–400 B.C.), is the most influential of the later imitators of the Polygnotan school of mural painting. His figures are plump but firmly modeled, there is a sense of the third dimension, and he occasionally uses dilute paint as shadowing. Some thirty paintings have been attributed to him, all on large vases. See *GPP*, 184, pl. 48a; *ARVS*, 143–144, fig. 111; E. Paribeni in *Encic AA*, s.v. "Deinos, Pittore del." The Bowdoin pelike represents him at his best. The figures possess a dignity and grace not to be found in the sentimental work of such contemporaries as the Meidias Painter.

203. *Fragment of a red-figure vase, perhaps a* lebes gamikos, *or marriage bowl.* The fragment consists of three mended pieces. To the left Eros crouches on an outstretched hand. To the right a female figure stands dressed in an overgirt Doric peplos. Her right arm is extended, holding something. The inside is unglazed.

Attic ware. About 410–400 B.C. H, 0.070 m. W, 0.080 m. Warren Coll. Acc. no. 1915.19.

The subject matter and the style imitate the work of the Meidias Painter and his school. For a similar scene, one of Eros leaning on the shoulder of Aphrodite on a pelike in New York (inv. no. 37.11.23), see *ARVS*, 147–149, fig. 114. On the marriage bowl, see *Shapes*, 11, figs. 72–75.

204. *Red-figure squat lekythos.* In the scene a hunter clad in chiton and himation holds a dead hare in the right hand and two spears in the left. To his left is a sitting dog and to his right a standing youth, who wears a figured himation and has a petasos hanging at the back of his neck. He holds a branch in the left hand. The handle is missing and there is a hole where the hunter's head and shoulders would appear.

Attic ware. Perhaps by the Washing Painter. About 400 B.C. H, 0.135 m. Diam. of lip, 0.040 m; of base, 0.074 m. Warren Coll. Acc. no. 1920.3.

ARV, 748, no. 16.

This painter has taken his name from four small hydriae picturing naked women washing. See *ARV*, 745, nos. 62–65. Among a number of his works in New York, one of his best (inv. no. 16.73) is a marriage bowl. See *Vases MMA*, no. 144, pls. 147, 174; *ARVS*, 136–137.

205. *Amphoriskos in the form of an almond.* The neck and mouth are like those of miniature pointed amphorae; together with the single handle they are black-glazed. The body was painted red, for traces of that color remain. It is decorated with impressed patterns: palmettes, circles, and reeding.

Probably Attic ware. About 400 B.C. H, 0.125 m. Diam. of lip, 0.045 m. Warren Coll. Acc. no. 1923.21.

On almond amphoriskoi, see E. von Mercklin, *Archäologischer Anzeiger* 40 (1928) 330–334. They usually have two handles, but for one handle cf. *CVA Oxford* 1 (J. D. Beazley) pl. xl, no. 16.

206. *Three fragments of a red-figure loutrophoros.* Fragment 1 preserves part of a youth seated on a rock in white, wearing a short chiton ornamented with a garland and other devices; before him are a pair of spears, apparently held by his raised left arm. Before him is another youth, also with a pair of spears; in front of the second figure is a horse's foreleg in white. Fragment 2 shows part of a horse's neck in white, and the middle of a chiton. Fragment 3 has a horse's hindquarters in white and a standing draped figure.

Attic ware. Late fifth century B.C. Fr. 1: H, 0.153 m. W, 0.130 m. Fr. 2:

H, 0.055 m. W, 0.080 m. Fr. 3: H, 0.080 m. W, 0.145 m. Warren Coll. Acc. nos. 1915.18.1–3.

The loutrophoros was used to bring water from the fountain Kallirrhoe for the nuptial bath, and it was also placed on the tombs of the unmarried. See *Shapes*, 5–6, and fig. 41, for a late fifth century type.

207. *Fragment of a red-figure marriage bowl.* The fragment preserves a wide band of acanthus pattern, below which is a narrow egg pattern. To the right is a part of a leaf-shaped design such as sometimes appears in the stands of these vases.

Attic ware. Late fifth century B.C. H, 0.105 m. W, 0.090 m. Warren Coll. Acc. no. 1915.20.

Cf. the vase in Athens (inv. no. Acr. 675) in J. D. Beazley, *Der Pan-maler* (1931) pl. 28, 3.

208. *Fragment of a red-figure vase, perhaps a hydria.* Parts of two female figures remain, one seated and dressed in a chiton, on the left; the other standing and clad in a peplos, on the right. At the left edge there appears a black border, which may be that of a himation.

Attic ware. Late fifth century B.C. H, 0.045 m. W, 0.065 m. Warren Coll. Acc. no. 1930.80.

The fineness and closeness of lines in the drapery is reminiscent of the Meidias Painter. See *ARVS*, fig. 114; E. Paribeni in *Encic AA*, s.v. "Meidias, Pittore di."

209. *White-ground lekythos.* The lip, handle, neck, lower part of the body, and upper part of the base are black-glazed. The scene is outlined in matt vermilion. On the left a woman kneels in grief before a grave stele. She wears a thin chiton and holds her right arm aloft while placing her left hand to the top of her head. The stele is bound by a number of sashes and has

another draped around the base; it is topped by an acanthus finial. To the right a youth stands clad in a vermilion cloak, his right shoulder bare and his right hand extended toward the stele.

Attic ware. Near the Painter of Munich 2335. From Athens. Late fifth century B.C. H, 0.280 m. Diam. of lip, 0.049 m; of base, 0.056 m. Warren Coll. Acc. no. 1913.31.

ARV, 964, *add.* to p. 783.

Beazley notes that this artist's best work is on white-ground lekythoi. His red-figure paintings are found on a great variety of vase types, and much of this output, especially in his later period, is described as miserable hackwork.

210. *Red-figure pyxis with cover.* A hole is in the center of the lid for insertion of a bronze attachment and ring, which are missing. Around this is a border of tongue pattern and dots. A figured scene is placed in a circular band around this: a lion, bull, panther, and boar; on the outer edge is a border of egg pattern. The underside is glazed. On the body is a laurel pattern on the projecting edge; there is a black glaze inside and on the bottom. There is an accidental hole in the bottom of the body.

Attic ware. Late fifth century B.C. H, 0.050 m. Diam., 0.130 m. Warren Coll. Acc. no. 1923.31.

Shapes, 20–21, fig. 136, classifies this form as type II, one which was popular in the late fifth and fourth centuries. Four types are recognized, though there is much variety within any given class.

211. *White-ground lekythos.* Only part of the scene is visible because of weathering and incrustations. In the middle is a broad stele outlined in black, crowned by an acanthus anthemion, and bound with sashes in vermilion. The top of the stele extends above the body proper onto the shoulder. To the left is a standing figure,

the folds of whose garment show below. To the right is an irregular vertical band of red. Traces of red appear on the shoulder.

Attic ware. Late fifth century B.C. H, 0.225 m. Diam. of lip, 0.044 m; of base, 0.044 m. Warren Coll. Acc. no. 1930.82.

This lekythos is in such poor condition as to be nearly useless either for exhibition or study.

212. *Red-figure bell krater with cover.* On the cover is a female face in profile to the left, with kerchief, earring and necklace. The knob, broken on top, is situated where the ear would be. The underside is reserved. Scene A on the body shows the head of a youth in profile to the left. He holds a spear over the right shoulder and behind is the head of a horse. Scene B has a large palmette. Under each handle is a plane leaf. The bases of the handles are reserved, and on one there are borders of dots in these spaces. Beneath the scenes are two reserved lines. The base is encircled by a reserved line and the underside of the lip has a pattern of vertical lines around it.

Boeotian ware. Of the Group of the Wurzburg Scylla. Late fifth century B.C. H, 0.205 m. Diam. of lip, 0.190 m; of base, 0.091 m. Warren Coll. Acc. no. 1923.32.

A. D. Ure, *AJA* 57 (1953) 245–249, figs. 9, 10, 25.

Boeotian red-figure ware begins in the second quarter of the fifth century. The drawing tends to be flat and incompetent. The Bowdoin krater belongs to a class produced in the years around 400 B.C. The typical product was a bell krater with a large female head on the front, a large palmette on the back, and another female head on the cover. On the period, see R. Lullies, *Athenische Mitteilungen* 65 (1940) 1–27.

213.* *Red-figure bell krater.* Around the flaring lip is a leaf pattern. Scene A shows Apollo holding a laurel bough

and a partridge on the left, Artemis a phiale and a bow on the right. The goddess wears a peplos and a pantherskin. Between the two stands a thurible. In scene B two youths face each other. Between them hangs the leg of a kid. Beneath each scene is a meander pattern. PL. XXVII

Early South Italian ware. By the Tarporley Painter. About 420–400 B.C. H, 0.031 m. Diam. of lip, 0.340 m; of base, 0.155 m. Warren Coll. Acc. no. 1915.47.

A. D. Trendall, *Frühitaliotischen Vasen* (1938) 25–26, 40–41, lists the works of the Tarporley Painter with some illustrations, but the Bowdoin krater is not included. This painter is distinguished by the litheness of his youths, the rather heavy solemnity of his women, and his preference for Bacchic scenes. Cf. N. Moon, *BSR* 11 (1929) 41, pl. xiii. In fact, the stock subjects of South Italian red-figure vases are either Dionysian frolics or Eros in the company of women, but the average product of this school is far from the best Attic work. The handsome shape of the bell krater was the favorite medium for the early South Italian artists and for none more than the Tarporley Painter.

214. *Red-figure cup.* Inside, in the tondo, are two bald satyrs, the one on the right filling a hydria at a lion's-head fountain, the other on the left crouching and resting his left arm on a neck amphora while awaiting his turn. The stone platform of the fountain appears below and in the field hangs a sash. The tondo is bordered by a band of meander-and-checker design. Outside, on the upper part there is a lozenge design and under each handle a palmette.

Etruscan ware. About 420–400 B.C. H, 0.105 m. Diam. of lip, 0.250 m; of base, 0.126 m. Warren Coll. Acc. no. 1923.4.

N. Plaoutine, *JHS* 57 (1937) 26, fig. 1; *EVP,* 28.

Plaoutine sees the Bowdoin cup as a link between an earlier Etruscan imitation of Attic red-figure from Vulci, about 450 b.c., now in the Rodin Museum in Paris, and the fourth century Etruscan imitations of Attic red-figure. Beazley catalogues it as Earlier Red-figure, and of its date says the late fifth century is possible, but the early fourth should not be excluded. Etruscan red-figure is always provincial art, but at its best it has a homely integrity which avoids the excesses of much South Italian work. See *GPP*, 190–193. The Bowdoin cup is a good representative example. For surveys of Etruscan and Italic art of all types, see G. Colonna in *Encic AA*, s.v. "Italica, Arte," and M. Pallottino in *EWA*, s.v. "Etrusco-Italic Art."

215. *Red-figure stemless cup.* On the inside, in the tondo, is a draped youth holding a jug. Before him is a pillar on which a discus-shaped object is set and behind him in the field is a vertical band of wave pattern. Around the inside edge is a spray of ivy leaves. Outside there are two nearly identical scenes: to the left in one a draped man holding an object similar to a boomerang looks to the right at a draped man leaning on a staff; to the left in the other a man appears to be holding a discus. There are palmettes under the handles and concentric rings on the base. One handle is missing. Attic ware. By the Group of Vienna 116. About 400–380 b.c. H, 0.035 m. Diam. of lip, 0.150 m; of base, 0.075 m. Warren Coll. Acc. no. 1901.1. *ARV*, 887, no. 3. The painting on this cup represents the nadir of red-figure art. The Group of Vienna 116 consists of five stemless cups of the same type: Vienna 116, 165, 166, and 223, and the Bowdoin cup. See *ARV*, 887.

216. *Red-figure squat lekythos.* The upper part of the neck, lip, and handle are missing, and there is a hole in the body. The vase is badly worn, most of the glaze being gone. There are traces of a palmette design on the front of the body. Attic ware. From Egypt. About 400–375 b.c. H, 0.115 m. Diam. of base, 0.050 m. Gift of Mrs. Lucien Howe. Acc. no. 1929.1.

217. *Red-figure squat lekythos.* In the scene is a swan, in front of which is a small plant. The vase is entirely black glazed except the underside of the foot. Attic ware. From Corinth. About 400–375 b.c. H, 0.090 m. Diam. of base, 0.050 m; of lip, 0.030 m. Gift of Mr. and Mrs. J. Henry McLellan. Acc. no. 1935.480.

218. *Black-painted, unfigured cup.* Inside the cup has impressed decorations: two concentric circles, with eight small palmettes on the outer circle. The outer parts of the handles are squared off to the parts which are attached to the cup. Attic ware. 400–350 b.c. H, 0.055 m. Diam. of lip, 0.135 m; of base, 0.062 m. Warren Coll. Acc. no. 1930.12.

219. *Fragment of a large red-figure vase, perhaps a hydria.* At the top are bands of wave and egg pattern, and below these a garland in applied yellow and white. To the left is part of a large handle palmette and an Amazon, complete to the knees, facing another Amazon on the right, whose head only is preserved. The first Amazon wears full Oriental costume: tiara, sleeved undergarment, short chiton, studded belt, and light wrap over the arms. She holds a pair of spears and offers a sheathed sword to her companion. Apulian ware. Of the Group of London, British Museum F331. Early fourth century b.c. H, 0.160 m. W, 0.190 m. Warren Coll. Acc. no. 1927.4. This work is contemporary with the Lycurgus Painter and the Ornate Painter. These artists preferred large pots

such as volute kraters, amphorae, and hydriae, chose their subjects from mythology, frequently tragedy, and often exhibited the cast at as many as three separate registers. See *GPP*, 193–198, pl. 53.

For a short illustrated essay on all South Italian vase painting of the late fifth and fourth centuries, see A. D. Trendall in *Handbook*, 347–353, figs. 465–471, and p. 397, for bibliography. References to more detailed studies of the individual schools are listed in *Encic AA*, s.v. "Italiota, Ceramica." For the present school, see A. Stenico in *Encic AA*, s.v. "Apuli, Vasi."

220. *Red-figure lekanis with cover.* The top of the knob has a wheel pattern with white dots and a red edge. On the lid in scene A, a hermaphroditic Eros in a semikneeling position holds a rattle and a xylophone in the left and right hands respectively. He wears jewelry around one thigh, both ankles, and slung over one shoulder. In scene B, a female head in profile to the left wears a figured cap and jewelry on the ears and neck. Parts of both scenes are painted in white, yellow, and red, and between them on both sides are large palmettes. The rim of the lid has a wave pattern and its underside is unglazed. The body has a band of short vertical lines around the edge, and the foot has two bands in red.

Apulian ware. Contemporary of the Darius Painter. Early fourth century B.C. H, 0.150 m. Diam. of lip, 0.150 m; of base, 0.065 m. Warren Coll. Acc. no. 1928.4.

On the Darius Painter, see A. Stenico in *Encic AA*, s.v. "Dario, Pittore di."

221. *Plastic lekythos, with relief of Nike descending.* The winged Nike is nude save for loose drapery held high by her left hand. It swirls behind her and around the right thigh, and is caught at the ankle. In her right hand she holds a thurible. Seven rosettes are set around the figure, which stands on a flaring base. There are traces of blue on the wings, and white on the body, drapery, and rosettes. The handle is missing and the base has been restored from many fragments. The lip and the back of the body and base are glazed black.

Attic ware. About 375–350 B.C. H, 0.168 m. Diam. of lip, 0.032 m; of base, 0.050 m. Warren Coll. Acc. no. 1915. 39.

Because of the reliefs, this type of vase can also be considered as a class of terracotta figurine. Cf. A. Köster, *Die griechischen Terrakotten* (1926) no. 72, a Nike from Tanagra, and nos. 70 and 71.

222. *Figured bowl with cover.* The body is rounded and squat, with an offset, flaring lip. The foot is narrow and slightly spreading. Designs are in black glaze and applied white on a reserved ground. Short vertical lines, closely set, encircle the lip. On the shoulder is a band of rudimentary palmettes with centers in applied white. Below is another band of black on which is a rude cable pattern in white, with interspersed dots. The cover has a wave pattern around the base of the knob and around its edge is a cable pattern in white.

Campanian ware. Of the Kemai Group. About 350 B.C. H, 0.145 m. Diam. of base, 0.053 m. Warren Coll. Acc. no. 1928.7.

J. D. Beazley, *JHS* 63 (1943) 110, no. 17.

The Kemai Group are non-red-figured vases linked to the last stages of Campanian red-figure ware and take their name from a curious Greek inscription painted on one of them. Beazley lists 38 of the class, the commonest shape being a small stamnoid vessel with lid. On the school, see A. Stenico in *Encic AA*, s.v. "Campani, Vasi."

223. *Lekythos with applied relief.* The vase is unglazed but has a pinkish cast to it. The relief consists of two

dancing maenads clad in thin Doric chitons. The woman on the right holds a torch in her right hand, the one on the left holds a thyrsus in her right and touches her companion with the left.

Attic ware. About 350–325 B.C. H, 0.179 m. Diam. of lip, 0.042 m; of base, 0.050 m. Warren Coll. Acc. no. 1915.40.

The addition of clay reliefs to vases was a technique used in the Archaic period, especially in Crete, Boeotia, and Laconia. It also occurred in Attic ware in the fifth and early fourth century, but it did not become popular until the late fourth century. Cf. *Handbook*, 345, fig. 463.

224. *Red-figure vase.* In the scene to the left is a rearing seahorse; in the center a squid; to right Scylla, a monster with the upper parts of a woman and girt with the heads of three dogs. She raises her right hand and holds a rudder in the left. Beneath her is a fish.

Apulian ware. About 350–325 B.C. H, 0.088 m. Diam. of lip, 0.100 m. Warren Coll. Acc. no. 1927.5.

In the second half of the fourth century there was an immense production of Apulian red-figure ware in smaller vases. The painters avoided the ornate style on the larger pottery and kept for the most part to palmettes and female heads. See *GPP*, 198. The Bowdoin vase is an interesting exception to this rule.

225. *Red-figure bell krater.* Above and below the scenes are borders of wave pattern and under the handles, palmettes. In scene A, Eros flies with a wreath in his left hand to scene B, where a seated woman holds a box and a wreath.

Apulian ware. About 350–300 B.C. H, 0.270 m. Diam. of lip, 0.285 m; of base, 0.130 m. Gift of John Duveen. Acc. no. 1895.3.

226. *Red-figure cup and lid.* On the lid are a pair of anthemia and heads in profile. On the body are white vertical hatchings. The cup is in perfect condition apart from a small amount of chipping on the neck of the cover.

Apulian ware. Fourth century B.C. H, 0.100 m. Diam. of lip, 0.100 m. Gift of Dr. Chauncey W. Goodrich. Acc. no. 1944.12.2.

227. *Black-painted lekanis with cover.* The top of the knob of the cover bears a rosette with yellow center and white petals. The cover is impressed with lines in the form of spokes, bordered by a white circle at the base of the knob and a yellow circle at the edge of the cover. The base of the bowl and the underside of the cover are unglazed.

South Italian ware. About 350–300 B.C. H, 0.080 m. Diam. of lip, 0.080 m; of base, 0.040 m. Warren Coll. Acc. no. 1928.8.

228. *Painted squat lekythos.* The decoration is in applied white, yellow, and purple on a black ground. At the base of the neck are a ray pattern, an egg pattern, and a row of dots in white. In the scene a woman holds double flutes in her left hand and leans against a rock. Her hair is bound with a yellow ribbon. Her chiton is purple, her himation yellow. On either side is a stylized flowering plant. Below the scene is a band of egg pattern.

Gnathian ware. About 325–300 B.C. H, 0.205 m. Diam. of lip, 0.050 m; of base, 0.070 m. Warren Coll. Acc. no. 1915.48.

The essential feature of Gnathian ware, most frequent in Apulia but found throughout South Italy and Sicily, is the use of white, yellow, and purple in portraying figures and decorations. It was the logical extension of the florid trend in Apulian red-figure, in which these colors were used as embellishments on the red figures. See *GPP*, 206–207, pl. 56b. For a summary of

Gnathian art, see C. Drago in *Encic AA*, s.v. "Gnathia."

229. *Red-figure nestoris.* On the neck, scene A shows two nude youths running, one with a torch, the other a thyrsus. In scene B a hound pursues a fawn; between them is a palm branch. On the body, in the upper part of scene A, Nike sits with a palm branch. A nude youth, with one foot on a rock, bends towards her as if to speak. Below, a cloaked youth stands on the left, while on the right is a lyre player in the native Italian costume: short chiton, belt, boots, and high cap. In the upper part of scene B, a youth with stick and pail is on the left, a youth reclines on a couch in the center and looks at a flute girl on the right. Below, a satyr with torches pursues a goat. Two high, vertical handles rise from the shoulders of this large vase. On both of these are four plastic disks, as well as two short horizontal handles just below the shoulders.

Lucanian ware. By the Primato Painter. About 330–300 B.C. H, 0.820 m. Diam. of lip, 0.360 m; of base, 0.160 m. Walker Coll. Acc. no. 1893.1.

J. D. Beazley, *AJA* 43 (1939) 633–635, gives a list of vases by the Primato Painter, but the Bowdoin vase is not listed. Lucanian is the most debased of the four South Italian schools of vase painting and the nestoris is a repulsive shape of Apulian origin, though almost all its examples in red-figure come from Lucania. See *GPP*, 198–199. The style of the painting on the Bowdoin nestoris is thoroughly barbarized and tasteless, and for this very reason, as well as its great size and excellent condition, it is a superb example of its class. For a short study of this school, see A. D. Trendall in *Encic AA*, s.v. "Lucani, Vasi."

230. *Red-figure stamnos.* Around the shoulder is a leaf motive with three dots beneath each. Scene A shows a sea god, with two fishtails for legs, holding large sea shells in each hand. He wears a fillet and necklace. On each side of him are a nude maenad with thyrsus. In the field are four circles ornamented with dots and lines, and below are close white lines to indicate surf. The fishtails, sea shells, thyrsi, and skin of the maenads are painted white. Scene B shows a nude maenad holding a sash while resting her right foot upon a rock. On each side a satyr rests against a high rock, beating a tympanon. The skin of the maenad, rock beneath her foot, and edges of the tympana are white, as are a plant and circular decoration in the field. The satyrs wear white necklaces. Under and around both handles are elaborate palmettes and tendrils.

Etruscan ware. Of the Fluid Group (Late Faliscan). Later fourth century B.C. H, 0.330 m. Diam., 0.190 m; of base, 0.125 m. Warren Coll. Acc. no. 1913.9.

EVP, 153, pl. 35, 1–3.

The Bowdoin stamnos is one of the best examples of what Beazley designates Later Red-figure II in Etruscan vase painting. The Fluid Group takes its name from the flow of the line both in the figures and in the palmette motives. For a similar sea god, cf. *EVP*, 56, pl. 12. For a summary of the school, see P. Mingazzini in *Encic AA*, s.v. "Falisci, Vasi."

231. *Black-painted bowl.* On the inside bottom is a stamped head of rudimentary form, around which are four stamped palmettes, groups of small, concentric circles, and horseshoes; around this seven concentric circles of rouletted lines; around this a row of small concentric circles bordered by a circle, then a row of horseshoes and another row of small concentric circles bordered by a circle; last, a band of five concentric circles of rouletted lines. The bottom is reserved save for concentric circles in black.

Campanian ware. Fourth century B.C. H, 0.075 m. Diam. of lip, 0.225 m; of base, 0.097 m. Gift of Mrs. Lincoln MacVeagh. Acc. no. 1928.14.

The use of rouletting and chains of stamped palmettes were stock decorations in pottery of this type from Attica, Corinth, Boeotia, Campania, and elsewhere in the fourth century. For the history of black-painted ware and its decorations, see *GPP*, 212–215.

232. *Black-painted plate with stamped designs.* In the center are decorations consisting of a face encircled by four palmettes. Between the palmettes are clusters of four circles. Around this are six rows of hatched lines, which were applied by a wheel. Around the edge is a band of ivy leaves. The tendrils are incised, but the leaves painted in white.

Campanian ware. Fourth century B.C. H, 0.040 m. Diam., 0.270 m. Gift of Mrs. Lincoln MacVeagh. Acc. no. 1928.5.

233. *Black-painted bowl.* The rim is wide, the foot high, and the black-glazed surface has an impressed decoration. In the center of the interior is a rude petal design surrounded by three rows of hatched lines. Around the inner edge of the rim is a row of palmettes alternating with circles, and around the outer edge a border of hatched lines.

Campanian ware. Fourth century B.C. H, 0.070 m. Diam. of lip, 0.125 m; of base, 0.057 m. Gift of Mrs. Lincoln MacVeagh. Acc. no. 1928.17.

234. *Black-painted bowl.* The bowl stands on a high, molded foot and has a wide, flat rim. On the rim is a band of wave pattern in white, bordered by white dots on each side, with each band separated from the other by an incised line. In the bottom of the bowl are four small incised petals. The underside of the foot is reserved.

Campanian ware. Fourth century B.C.

H, 0.060 m. Diam. of lip, 0.120 m; of base, 0.048 m. Gift of Mrs. Lincoln MacVeagh. Acc. no. 1928.18.

235. *Black-painted bowl.* The bowl is concave in profile and stands on a short foot. On the bottom of the inside are four stamped palmettes arranged in petal-fashion around the center. The underside is unglazed.

Campanian ware. Fourth century B.C. H, 0.043 m. Diam. of lip, 0.092 m; of base, 0.055 m. Gift of Mrs. Lincoln MacVeagh. Acc. no. 1928.13.

236. *Black-painted trefoil oenochoë.* The curved handle rises from the shoulder to the lip and ends in a lion's head, which projects over the mouth. Incised tendrils surround the neck and there is vertical ribbing on the body, broken by a single horizontal band at the waist.

Campanian ware. Fourth century B.C. H, 0.265 m. Diam. of lip, 0.105 m; of base, 0.088 m. Gift of Mrs. Lincoln MacVeagh. Acc. no. 1928.15.

237. *Black-painted hydria.* The completely utilitarian nature of this pot is revealed in the fact that the join at the shoulder has not been worked over so as to hide it.

Campanian ware. Fourth century B.C. H, 0.320 m. Diam. of lip, 0.135 m; of base, 0.110 m. Gift of Mrs. Lincoln MacVeagh. Acc. no. 1928.16.

238. *Black-painted squat lekythos.* The lip is concave in profile and flaring. The body is wider than it is tall, and is ribbed. The whole is black except the underside of the base.

Campanian ware. Fourth century B.C. H, 0.125 m. Diam. of lip, 0.050 m; of base, 0.093 m. Gift of Mrs. Lincoln MacVeagh. Acc. no. 1928.11.

239. *Black-painted cup.* It has two handles and the base is unpainted.

Provenance unknown. Fourth century B.C. or later. H, 0.045 m. Diam. of

lip, 0.084 m; of base, 0.040 m. Warren Coll. Acc. no. 1928.6.

240. *Unglazed amphora with appliqué reliefs.* On the left is a woman, on the right a man.

Provenance unknown. Fourth century B.C. or later. H, 0.177 m. Warren Coll. Acc. no. 1915.40.

241. *Unglazed lekythos with appliqué figures.* The body is tall and wide, the neck slender, the lip heavy. Five crudely modeled satyrs in relief have been affixed to the vase. Two carry provisions, a third holds a small animal, and a fourth plays the flute. The fifth and central figure appears to be bound to a cross-shaped object, his arms being semiextended on it. Only the roots of the handles remain.

Said to be South Italian ware. Late fourth or third century B.C. H, 0.330 m. Diam. of lip, 0.050 m; of base, 0.090 m. Donor unknown. Acc. no. 1930.79.

242. *Gray glazed bowl with decorative reliefs.* Outside on the upper portion is an egg pattern, and below this are acanthus leaves. On the bottom is an imprint from a coin mold showing Tyche with mural crown and the inscription KIPBEI.

South Russian ware. Third century B.C. H, 0.076 m. Diam. of lip, 0.130 m; of base, 0.043 m. Warren Coll. Acc. no. 1915.16.

R. Zahn, *JDAI* 23 (1908) 55–67, lists four vases of the same shape and with the same inscription as the Bowdoin bowl. They are now in Berlin, Bonn, Heidelberg, and Göttingen. There is also an amphora with this name in Berlin. KIPBEI is found inscribed on a number of Hellenistic vases from South Russia and is the genitive form of the name of a Grecized barbarian, Kirbeis. A Tyche appears on the coins of Olbia.

243. *Small bowl with reliefs.* The bowl has an offset lip, is of gray clay, and is covered with a greenish-brown glaze. The body is decorated with leaves in relief and rests on three knobs, each shaped as the combination of a comic mask and a cockleshell.

Megarian ware. Second century B.C. H, 0.060 m. Diam. of lip, 0.075 m. Warren Coll. Acc. no. 1930.81.

In the commercial sense, Megarian bowls were the most successful relief ware of the Greeks, and as a result they are found at numerous Hellenistic sites. The usual manufacturing technique was to impress patterns in a mold by means of stamps. These patterns could include abstract designs, animal or human figures, or, as in the present instance, floral ornamentation. After firing, the bowl of the pot was thrown inside the mold on the potter's wheel and the lip was added freehand. Then the pot was left to dry and shrink before being removed from the mold. Last, it was painted and refired. This technique of mold decoration was taken over into terra sigillata. See M. A. Del Chiaro in *Encic AA*, s.v. "Megaresi, Vasi," for a detailed article with bibliography; *GPP*, 215–216. For illustrations of the type, see *Gr Pottery*, pl. 95b; *Handbook*, 355–356, fig. 474.

244. *Fragment of a bowl with reliefs.* The fragment includes part of the lip of the bowl, on which is impressed a cable pattern. Beneath it is a concave band, and below that is the scene in relief, with a young dancer wearing a kalathos. Garlands and tambourines are in the field about her. The fabric is a deep brownish-red.

Arretine ware. Late first century B.C. H, 0.085 m. W, 0.065 m. Warren Coll. Acc. no. 1915.34.

Arretine ware designates mold-produced pottery, also called terra sigillata, which began to be manufactured at Arretium in Etruria shortly after 30 B.C. This pottery consists of a fine red-

glazed fabric which imitates metalware in its use of decorations and forms in relief. The origins of this ware are to be found in the eastern Mediterranean, where molded reliefware was popular from the late fourth century B.C. and where red-glaze techniques began in the third. For a full treatment of the subject, see G. H. Chase, *Catalogue of Arretine Pottery. Museum of Fine Arts, Boston* (1916); the present type is treated there on pp. 53–56 and pl. xi. See also A. Stenico in *Encic AA*, s.v. "Aretini o Arretini, Vasi."

245. *Fragment of an Arretine mold.* Above is a band of egg-and-dart pattern. Below, a winged genius plays a harp.

Late first century B.C. H, 0.060 m. W, 0.060 m. Warren Coll. Acc. no. 1915.33.

See G. H. Chase, *Catalogue of Arretine Pottery. Museum of Fine Arts, Boston* (1916) 49–53 and pl. x.

246. *Fragment of an Arretine mold.* Above is a band of egg-and-dart pattern. Below, a silen seated on a rock playing double flutes.

Late first century B.C. H, 0.067 m. W, 0.048 m. Warren Coll. Acc. no. 1915.32.

See G. H. Chase, *Catalogue of Arretine Pottery. Museum of Fine Arts, Boston* (1916) 41–49.

247. *Fragment of an Arretine mold.* At the top is a border of grapes and leaves. Below is a sleeping figure with his arm covering his head. In the field is the stamped signature of the pottery maker: TIGRANI.

Late first century B.C. H, 0.065 m. W, 0.110 m. Warren Coll. Acc. no. 1923.20.

Some of the early Arretine potters bear Oriental names. The inscription TIGRANI is also found on Arretine molds in Boston; see G. H. Chase, *Catalogue of Arretine Pottery. Museum of Fine Arts, Boston* (1916) 18–19.

248. *Spindle-shaped vase.* It is flint gray in color and without decoration.

Greco-Roman ware. About A.D. 100–300. H, 0.140 m. Diam. of lip, 0.033 m; of base, 0.025 m. Hammond Coll. Acc. no. 1906.5.

VI

Terracottas

TERRACOTTA means fire-hardened clay, and in antiquity this material had a number of architectural and artistic uses for both public and private purposes. In architecture baked brick largely supplanted the universally used sun-dried type during the Hellenistic period. In Rome brick was the chief building material throughout the Republic and the Empire, and molded terracotta revetments were also employed during the Empire to decorate domestic interiors. Stone, on the other hand, was the common construction material in Greece, but even there terracotta was widely used in the Archaic period for roof tiles, finial ornaments, and gutterspouts. In the plastic arts terracotta was used in vases, sarcophagi, reliefs, sculpture, and figurines. The art of vase making, including vase painting, is a discipline in its own right and one of the most important means available to us for the study of classical art and culture. Clay sarcophagi with reclining figures on the covers and smaller versions designed as ash urns were made in Etruria in late Archaic and Hellenistic times. Reliefs are perhaps best represented by the tablets from Melos of the early fifth century B.C., which depicted scenes from the myths and were created for votive or decorative purposes. Life-sized or larger terracotta sculpture was limited chiefly to Etruria and Cyprus, where clay appears to have been used for want of other materials, but with impressive results. Finally, and most commonly, terracotta figurines are found from earliest times to the end of the Hellenistic period in a great variety of types and uses.

Figurines are common in the Mycenaean age, but in the three cen-

turies following the decline of that culture they are relatively scarce. Then from the eighth to the first century B.C. there is a steady and large production of these statuettes throughout the Greek world. They have been found in temple precincts, graves, and private houses, and they were used as votive offerings to the gods and the dead and as decorative objects and toys among the living. The early figures were made by hand, but in the second half of the sixth century B.C. the technique of manufacture by molding became common. In this process, a clay mold was made of the original model, usually only of the front, and was then fired. Copies of the original were next attached to a usually unfinished back provided with a vent for evaporation and to a rectangular base. After drying, the whole surface of the resultant hollow statuette was immersed in a thin slip of white clay and fired to a medium heat. Colors were next added in tempera — brown for the skin of men, pink for women, auburn for hair, brown or blue for eyes, and red for lips. Garments could be red, blue, pink, yellow, brown, violet, black, or, rarely, green. Few figures, however, now retain their original colors, and for the most part only the drab mat terracotta or traces of the white slip remain. Smaller figurines were also produced from molds, but in one solid piece.

Figurines and reliefs in clay follow the same lines of stylistic development as the larger sculptures: primitive, archaic, classical, and naturalistic. Some of the centers of production for statuettes were Cyprus, Boeotia, especially the town of Tanagra, South Italy, and the town of Myrina in Asia Minor. In the manufacture of small reliefs Melos was an important Greek center in the early fifth century B.C., and Rome produced a volume of mural reliefs for interior decoration during the late Republic and early Empire. It is indicative of the nature of the Bowdoin collection that it contains good to excellent pieces from all of these places. In fact, judged on the basis of comprehensiveness and quality the terracottas stand together with the coins as second only to the vases among all the categories of classical art at Bowdoin.

In the Archaic period one of the commonest classes of statuette from Cyprus is a female goddess or one of her votaries (Nos. 255–268). The earlier versions have been related to the Phoenician and other love goddesses of the Middle East, for in many of them there can be no mistaking their sexual and fertility functions. A somewhat different type of female with a birdlike head was commonly produced in Boeotia during the sixth century B.C. and has been connected with the worship of Demeter and Persephone (Nos. 269–271). The output of figurines declined in

the fifth century, though centers in South Italy were among those issuing fairly large pieces of good workmanship (Nos. 295–297), and Melos and Locri specialized in small reliefs with mythological themes (Nos. 393–396). In the late fourth century coroplasts of Tanagra in Boeotia under the influence of Praxitelean concepts began making figures of unsurpassed grace and beauty. They usually represent lovely women standing or sitting, fully clothed in tunic and mantle, and quietly pensive in attitude (Nos. 353–355). When a prolonged economic depression beset Boeotia, many of these artists emigrated to Asia Minor in the late third century and re-established the terracotta industry in coastal towns like Myrina. There in the last two centuries before Christ occurred the final flowering of this peculiarly Greek art form. The types of figurines made at Myrina are typically Hellenistic: Erotes, Aphrodites, Nikes, and draped females, among others (Nos. 367–370). Though figures continued to be produced into the Roman period, the use of terracotta in mural reliefs was a distinctively Roman adaptation of this material to domestic interiors (Nos. 407–413).

Among the noteworthy figurines in the collection of terracottas are the following: a woman with birdlike head (No. 271) and a mounted warrior (No. 277), both of the sixth century B.C.; a comic figure astride a donkey (No. 288), the head of a bearded warrior (No. 295), the head of a man (No. 303), and a jointed doll (No. 315), all of the fifth century; and the following pieces of the late fourth century, or Hellenistic period: a comic actor (No. 347), Tanagra figurines (Nos. 353–354), a grotesque Negro (No. 363), a flying Eros (No. 367), a Bacchic flute player (No. 369), a flying Eros in Phrygian garb (No. 370), a standing slave (No. 373), and a dwarf carrying a kid (No. 374). Among the small or mural reliefs there are also a crouching sphinx (No. 393), a satyr's head (No. 398), a head of Ammon (No. 408), satyrs treading grapes (No. 412), and a rainspout in the form of a lion's head (No. 414).

Because the greater part of the Dana Estes Collection consists of terracotta figurines formerly in the Lawrence-Cesnola Collection, it seems desirable to add a note here to prevent confusion between the Lawrence-Cesnola Collection and the Cesnola Collection. Both consist of Cypriot antiquities, but the former was gathered by Alexander Palma di Cesnola and the latter by his older and more famous brother Luigi.

Luigi Palma di Cesnola was a remarkable figure, who by turns was a successful soldier, diplomat, field archaeologist, museum director, and

scholar. He began his career as a professional soldier in his native Italy, but soon came to the United States, where he fought with distinction and gained the rank of brigadier general in the Union Army during the Civil War. Near the end of the war he was appointed consul general of the United States in Cyprus, and once there he took up the then fashionable pastime of his colleagues in the diplomatic corps, searching and digging for ancient remains. But with his characteristic vigor and talent for organization he soon outstripped all others, and by 1876 he had amassed the astounding total of some 35,000 objects of every kind and size. After many difficulties, including loss by shipwreck, he finally managed to bring the greater part of this material to New York. There it was accepted by the newly founded Metropolitan Museum of Art, whose trustees also promptly installed Cesnola himself as its first director, a position he held from 1877 until his death in 1904. During this final busy period of his life he directed the publication of the monumental *Descriptive Atlas of the Cesnola Collection of Cypriote Antiquities in the Metropolitan Museum of Art*, 3 volumes in 6 parts (1885–1903). Anyone visiting the Metropolitan Museum can now see some of the best sculpture from this collection in the main north-south gallery of the newly reorganized Greek and Roman section. Two objects from Cyprus in the Bowdoin collections, the gifts of Mrs. John Mead Howells (Nos. 98 and 126), were reportedly purchased at auction from the Metropolitan Museum about 1929. It has not been possible, however, to identify these pieces with the Cesnola Collection.

Alexander Palma di Cesnola was also attracted to field archaeology, and under the patronage of Edwin Henry Lawrence of London, he excavated in the Salamis region of Cyprus from 1876 to 1878. The resulting accumulation of materials, smaller in number and less significant than the Cesnola Collection, came to be known as the Lawrence-Cesnola Collection. It was brought to London in 1879 and put on display in Lawrence's residence. However, it soon began to be dispersed by sale, and in the year after Lawrence's death in 1891 the last of it was sold at auction. It was apparently at this time or shortly thereafter that a part of the collection came into the possession of Dana Estes.

BIBLIOGRAPHY

E. Pottier, *Les Statuettes de terre cuite dans l'antiquité* (1890).
M. B. Huish, *Greek Terracotta Statuettes* (1900).
Franz Winter, *Die Typen der figürlichen Terrakotten*, 2 vols. (1903).

A. Köster, *Die griechischen Terrakotten* (1926).
D. Burr, *Terracottas from Myrina. Museum of Fine Arts, Boston* (1934).
J. Charbonneaux, *Les Terres-cuites grecques* (1936).
T. B. L. Webster, *Greek Terracottas* (1950).
J. H. Young and S. H. Young, *Terracotta Figurines from Kourion in Cyprus* (1955).
H. von Rohden and H. Winnefeld, *Architektonische römische Tonreliefs der Kaiserzeit*, 2 vols. (1911).

TERRACOTTAS (249–415)

TERRACOTTA FIGURINES

249. *Head of an idol* (broken from figure). A semicircular projection crowns the head in the manner of a large halo. Hair and jewelry are represented by applied bands of clay, the eyes and mouth by small holes. The face is narrow and birdlike. Black vertical bands decorate the projection and the area above the head. The head is attached to a flat backpiece. The clay is yellow ocher. All below the chin is missing.

From Cyprus. About 1200–1100 B.C. H, 0.070 m. Handmade. Estes Coll. Acc. no. 1902.16.

Cf. *Cesnola Collection*, 334, no. 2005. For the type and a study of the subject, see E. Homann-Wedeking in *Encic AA*, s.v. "Idolo."

250. *Head and arms of an idol* (broken from figure). A round crown with a flat front adorns the head. The face has a vertical projection down the center from the crown to the neck. The arms are mere stubs extended outward, and the neck is broad and long. A wide plastic band forms a pectoral decoration across the flat, boardlike chest. The clay is reddish-brown. All below the chest is missing.

From Tiryns. About 700–550 B.C. H, 0.070 m. Handmade. Gift of Mr. and Mrs. J. Henry McLellan. Acc. no. 1935.481.

Cf. *DNM*, 21, nos. 183, 184, pl. 20, similar figures from Tegea; *Figurines Louvre* I, 25, no. B153, pl. 19, from Mycenae.

251. *Head of a man* (broken from figure). The eyes were painted on but now are blank. The ears, the left one now missing, are small pieces separately applied. The nose is large and the chin pointed. He wears a peaked cap or helmet. The clay ranges from yellow to pink ocher.

From Cyprus. Seventh century B.C. H, 0.047 m. Handmade. Estes Coll. Acc. no. 1902.91.

This head was made by the so-called snowman technique, by which the individual parts were separately made and then fitted together. Cf. *BM Terracottas*, pl. 4; *Cesnola Collection*, 344, fig. 2102; *SCE* III, pl. lxxvii, no. 460; *DNM*, pl. 2; *Kourion*, 36, pl. 61, no. 753.

252. *Head of a votary* (broken from figure). The wide face is red, the hair black, and there are traces of white in the eyes. The ears are set abnormally forward. The back is unworked. The expression on the face of this and the next two similar heads is exceptionally crude and stiff. The clay is pink ocher.

From Cyprus. Seventh century B.C. H, 0.055 m. Molded. Hollow. Estes Coll. Acc. no. 1902.83.

This and the following two heads were made in a shallow mold, and a large stub was left at the base of the neck for attaching the head to the body. The bodies of this type are columnar in form with a flaring bottom. They are also hollow and wheel-shaped. These crudely formed votaries were

made in a number of poses: playing a tambourine or lyre, offering a cup or a flower, and the like. They represent a transition from the Geometric to the Oriental period in Cypriot art. Cf. *Cesnola Collection*, 337–340, no. 2030; *SCE* III, pl. cxlv, 1, 2.

253. *Head of a votary* (broken from figure). The wide face is red, the hair black and rendered by incised wavy lines. The back is unworked, but there are two holes. There is a stub at the base of the neck for insertion into the body of the figure. The clay is pink ocher.

From Cyprus. Seventh century B.C. H, 0.070 m. Molded. Hollow. Estes Coll. Acc. no. 1902.84.

See No. 252, above.

254. *Head of a votary* (broken from figure). The wide, fleshy face is red, except for the area around the eyes, which are black; the hair also is black. The back of the head is unworked. The clay is pinkish ocher.

From Cyprus. Seventh century B.C. H, 0.080 m. Molded. Hollow. Estes Coll. Acc. no. 1902.85.

See No. 252, above.

255.* *Standing fertility goddess* (fragmentary). The hair consists of straight, incised lines ending in scallops over the forehead. She wears the typical jewelry of the deity: loop earrings, choker, and two necklaces with pendants. The breasts are bare and the right one is supported by the right hand. The back is unworked. The clay is pink ocher. The left arm and all below the waist are missing. PL. XXVIII

From Cyprus. About 650–550 B.C. H, 0.095 m. Molded. Solid. Estes Coll. Acc. no. 1902.95.

K. Herbert, *CJ* 55 (1959–60) 100, fig. 2.

Cf. *Die Typen* I, 14; *SCE* III, pl. cciii, no. 10; IV, pt. 2, 105–107, pl. vii.

The basic cult activity in early Cyprus appears to have been connected with a fertility deity. In its primitive stage the cult image is an aniconic stone of conical or oval shape. In the theriomorphic phase the god is depicted as a bull, and in the anthropomorphic phase the divinity takes on the form of both male and female. In the former instance the god becomes Zeus and in the latter the primary mother-goddess later becomes specialized as Aphrodite in shrines such as those at Paphos and Amathus. Aphrodite was known to Homer as "the Cyprian," and it is probable that the goddess came to Greece from Cyprus. But though the Hellenic goddess of love was similar in many ways to the Babylonian Ishtar and the Phoenician Astarte, she also owed much to earlier Aegean divinities such as Ariadne.

See Sir George Hill, *History of Cyprus* I (1949) 55–81; F. R. Walton in *OCD*, s.v. "Aphrodite."

256. *Standing fertility goddess* (fragmentary). The hair is rendered by straight vertical lines and it hangs down over the shoulders. She wears the typical jewelry: long, heavy earrings, a choker, and necklaces with pendants. The back is unworked. The clay is pink ocher. All below the breasts is missing.

From Cyprus. 650–550 B.C. H, 0.103 m. Molded. Hollow. Estes Coll. Acc. no. 1902.103.

Cf. *Cesnola Collection*, 351, no. 2168; *SCE* III, pl. cciii, nos. 1, 2, 12; the grim set of the mouth and the style of coiffure makes these figures from Arsos almost identical with the Bowdoin statuette.

257. *Standing fertility goddess* (fragmentary). She wears a peaked headpiece and her hair falls in braids on her shoulders. She wears the typical jewelry: heavy earrings, a choker, and two necklaces with pendants. The back

is unworked. The clay is yellow ocher. All below the breasts is missing.

From Cyprus. 650–550 B.C. H, 0.075 m. Molded. Solid. Estes Coll. Acc. no. 1902.98.

See No. 255, above.

258. *Standing fertility goddess* (fragmentary). The hair, which is indicated by wide bands, is bound with a fillet. The surface is much worn, but traces of a choker and earrings are visible. The back is unworked. The clay is pink ocher. All below the shoulders is missing.

From Cyprus. 650–550 B.C. H, 0.099 m. Molded. Hollow. Estes Coll. Acc. no. 1902.113.

See No. 255, above.

259. *Standing fertility goddess with a small dolphin in her arms* (fragmentary). Her hair is figured in vertical lines ending in scallops over the forehead and she wears a choker necklace. Her arms are handmade and give the impression of being flippers; the dolphin is also handmade. The back is unworked and flat. The clay is pink ocher. All below the abdomen is missing.

From Cyprus. 650–550 B.C. H, 0.090 m. Molded in the face. Solid. Estes Coll. Acc. no. 1902.133.

Cf. *DNM*, 3–4, pl. 3, no. 25, for similar hands; R. Carpenter, *Greek Sculpture: A Critical Review* (1960) pl. 1, a kriophoros of Thasos, holding the animal in the same position.

260. *Head of fertility goddess* (broken from figure). She wears a high, rounded coiffure made of incised vertical lines. The face is stern. The back is flat and unworked. The clay is pink ocher.

From Cyprus. 650–550 B.C. H, 0.043 m. Molded. Hollow. Estes Coll. Acc. no. 1902.105.

See No. 255, above.

261. *Head of fertility goddess* (broken from figure). The coiffure is a heavy pompadour. The right loop earring remains, but the head is broken on the left side of the neck; there is also a hole in the top of the head. The back is unworked. The clay is pink ocher.

From Cyprus. 650–550 B.C. H, 0.065 m. Molded. Solid. Estes Coll. Acc. no. 1902.104.

Cf. *Cesnola Collection* 351, no. 2168; *SCE* III, pl. cciii, nos. 1, 2, for a similar coiffure.

262. *Head of fertility goddess* (broken from figure). The hair is rendered in vertical lines. The head is much worn but the loop earring on the left ear is visible. The nose is very long and prominent. The clay is pink ocher.

From Cyprus. 650–550 B.C. H, 0.045 m. Molded. Solid. Estes Coll. Acc. no. 1902.140.

See No. 255, above.

263. *Head of fertility goddess* (broken from figure). The hair is rendered by incised vertical lines. The eyes are exceptionally large, also being indicated by incised lines. She wears the typical jewelry: loop earrings, choker, and necklaces with pendants. The left ear is bent forward, probably as the result of an accident before firing. The back is concave. The clay is pink ocher. All below the neck is missing.

From Cyprus. 650–550 B.C. H, 0.075 m. Molded. Solid. Estes Coll. Acc. no. 1902.136.

Cf. *SCE* III, pl. cciii, nos. 8, 9.

264. *Standing female votary* (fragmentary). Her hairdress is indicated by straight incised lines over the forehead. She wears the typical jewelry: a choker and two necklaces with pendants. Her breasts are bare and her arms, which are broken off just below the shoulders, are extended out from

the body. The back is flat. The clay is salmon. All below the ribs is missing.

From Cyprus. 650–550 B.C. H, 0.062 m. Molded. Solid. Estes Coll. Acc. no. 1902.93.

Votaries of this type hold a variety of objects in their hands: birds, flowers, lyres, or tambourines. Figurines of this type are usually found in sanctuaries, but they also have been discovered in tombs. Cf. *Cesnola Collection*, 351–352, fig. 2166.

265. *Standing female votary* (fragmentary). Her peaked coiffure is indicated by straight lines. She wears the typical jewelry: a choker and two necklaces with pendants. Her breasts are bare, and her arms, broken off just below the shoulders, apparently extended out from the body. The torso is summarily modeled and is broken on the right side. The back is unworked. The clay is pink ocher. All below the abdomen is missing.

From Cyprus. 650–550 B.C. H, 0.095 m. Molded. Solid. Estes Coll. Acc. no. 1902.94.

See No. 264, above.

266. *Standing female votary* (fragmentary). The figure wears the customary jewelry: drop earrings, choker, and a single necklace with pendant. Her coiffure is in scallops over the forehead. The arms are missing but apparently were extended from the body. The clay is grayish. All below the abdomen is missing.

From Cyprus. 650–550 B.C. H, 0.083 m. Molded. Solid. Estes Coll. Acc. no. 1902.96.

See No. 264, above.

267. *Standing female votary* (fragmentary). The hair is indicated by straight vertical lines ending in scallops over the forehead. She wears the typical jewelry of the fertility goddess: long loop earrings, choker, and two necklaces with pendants. In front of her bare breasts she holds a cup in the left hand. The back is unworked. The clay is pink ocher. All below the waist is missing.

From Cyprus. 650–550 B.C. H, 0.080 m. Molded. Solid. Estes Coll. Acc. no. 1902.92.

Cf. *SCE* III, pl. clxxxvii, no. 1, a fragmentary limestone votary from Arsos holding a cup in this fashion.

268. *Standing female votary* (fragmentary). She wears a bandeau which streams over her shoulder and between her breasts. Her right hand is raised to support the right breast and her left hand holds a jar. The back is unworked. The clay is gray. The left side is broken, and all below the waist is missing.

From Cyprus. 650–550 B.C. H, 0.080 m. Molded. Solid. Estes Coll. Acc. no. 1902.99.

See No. 264, above.

269. *Standing idol with birdlike head.* The figure wears a polos crown with a plastic spiral over the forehead. The face has a beaklike projection with an eye painted on either side. The neck is elongated, with a plastic braid on either side painted with horizontal stripes. A similar braid at the back of the neck is painted with vertical zigzags. She wears a painted necklace with pendants in front. The arms are only rudimentary stubs and the flat, boardlike body is now much faded or reddened from faulty firing. The body is covered with vertical and horizontal lines and zigzags. The clay is buff.

From Boeotia. About 650–600 B.C. H, 0.155 m. W. of bottom, 0.050 m. Handmade. Solid. Warren Coll. Acc. no. 1923.27.

This figurine, one of the *pappades* or doll types, is probably connected with the worship of Demeter and Persephone. It is a survival of a much earlier Mycenaean type. Cf. Köster, *Die griechischen Terrakotten*, 30–32, pls. 4–7; P. Knoblauch, *Studien zur*

archäisch-griechischen Tonbildnerei in Kreta, Rhodos, Athen and Bootien (1937) 194–196; Gr Terracottas 13–14, pls. 12, 13; Figurines Louvre I, 10, nos. B56–59, pl. 7.

270. *Standing idol with birdlike head.* The figure is similar to No. 269, but somewhat larger. The rudimentary arms curve forward. It differs from No. 269 in that it lacks vertical lines on the body.
From Boeotia. About 650–600 B.C. H, 0.168 m. W. of bottom, 0.057 m. Handmade. Solid. Warren Coll. Acc. no. 1923.28.

271.* *Standing idol with birdlike head.* The figure is similar to No. 269, but smaller. It has zigzags on the front braids and over the bosom, but it lacks vertical lines on the body such as are seen in No. 269. PL. XXVIII
From Boeotia. About 650–600 B.C. H, 0.143 m. W. of bottom, 0.047 m. Handmade. Solid. Warren Coll. Acc. no. 1923.29.
K. Herbert, CJ 55 (1959–60) 99–100, fig. 1.

272. *Head of a warrior* (broken from figure). The sidepieces of the helmet, the nose, and the beard were separately applied. The nose is very large and the beard is spade-shaped. The back is unworked. The clay is gray to pink ocher.
From Cyprus. Early sixth century B.C. H, 0.038 m. Handmade. Solid. Estes Coll. Acc. no. 1902.77.

273. *Head of a man* (broken from figure). The nose is very large; it and the ears, consisting of small balls of clay, were separately applied. The hairline over the forehead is represented by a series of scallops. There are traces of red on the lips, cheek, and nose. The clay is gray.
From Cyprus. Early sixth century

B.C. H, 0.052 m. Handmade. Solid. Estes Coll. Acc. no. 1902.79.

274. *Head of a man* (broken from figure). The hair over the forehead consists of narrow vertical incisions and the eyebrows are very heavy. At the back, long hair falls to the shoulders. The exceptionally large nose was separately applied. A lump of clay on the left ear may be an earring. The clay is pink ocher.
From Cyprus. Early sixth century B.C. H, 0.075 m. Handmade. Solid. Estes Coll. Acc. no. 1902.132.

275. *Head of a Negro* (broken from figure). The hair is arranged in a double tier of bangs across the forehead. The nose is flat and wide and the countenance generally indicates a Negroid cast. There is a hole in the right ear, perhaps for the insertion of an earring. At the base of the neck is a large stub for affixing the head to the body of the statuette. The clay is buff.
From Cyprus. Early sixth century B.C. H, 0.080 m. Molded. Solid. Estes Coll. Acc. no. 1902.134.

276. *Face of a woman* (from a relief). The face is broken away at the point of juncture with the background. She wears a low polos, vertically grooved, and beneath it the hair is arranged in scallops over the forehead and is drawn back at the temples. The eyes are slightly angled and almond-shaped, and the lids are indicated by raised lines. The nose is large, and the mouth is set in the archaic smile. The clay is coarse and gray to buff.
West Greek work. Mid-sixth century B.C. H, 0.115 m. Warren Coll. Acc. no. 1913.41.
Cf. G. M. A. Richter, Archaic Greek Art (1949) 84–85, figs. 146, 147, for a similar head dated about 530 B.C.

277.* *Mounted warrior with shield.* The horse and various parts of the man

are glazed reddish-brown. The circular shield, which is held by the left arm, is decorated with a circle of wave patterns, which are in turn encircled by two rows of dots within two lines. The horse's mouth is a knife cut. The warrior wears a crested helmet. The clay is buff. A lance, once held in the right hand, is missing. PL. XXX

From Boeotia. About 550 B.C. H, 0.190 m. L, 0.140 m. Handmade. Solid. Warren Coll. Acc. no. 1913.3.

K. Herbert, *CJ* 55 (1959–60) 100, fig. 3.

Cf. *Gr Terracottas* 12, pl. 8; *Figurines Louvre* I, 19, no. B107, pl. 14.

278. *Head of a man wearing a cap* (broken from figure). The cap has ear flaps, which are turned up, and a soft peak which trails down the back. In the back the hair flows from underneath the cap. The ears were separately applied, and the right one is now missing. The nose is prominent and the clean-shaven chin small and pointed. There are traces of pink on the face. The clay is gray.

From Cyprus. Sixth century B.C. H, 0.150 m. W, 0.077 m. Handmade. Hollow. Estes Coll. Acc. no. 1902.123.

Cf. *Cesnola Collection*, 256, no. 1452.

279.* *Head of a warrior* (broken from figure). He wears a tall, pointed cap and has a thin, pointed beard. On each side of the cap is a stud. The eyes are almond-shaped and the nose prominent. The hair over the forehead flows out beneath the cap, on which there is a trace of blue. The clay is gray to buff. PL. XXIX

From Cyprus. Sixth century B.C. H, 0.080 m. Handmade. Solid. Estes Coll. Acc. no. 1902.64.

K. Herbert, *CJ* 55 (1959–60) 100–102, fig. 4.

Cf. *SCE* III, pl. cxlvii, no. 888; *Kourion*, pl. 23, no. 1252. The Bowdoin figure was probably part of a

chariot group of figures, perhaps a driver, an archer, or a horseman.

280. *Head of a warrior* (broken from figure). He wears a tall, peaked cap showing traces of light blue. The eyes are outlined in black and the beard is rendered by a black band around the receding chin. The nose was separately applied. The clay is pink ocher.

From Cyprus. Sixth century B.C. H, 0.068 m. Handmade. Solid. Estes Coll. Acc. no. 1902.87.

Cf. *BM Terracottas*, pl. 4, no. A235; *SCE* III, pl. lxxvii, no. 331.

281. *Head of a warrior* (broken from figure). The helmet is peaked and has cheekplates indented at the lips. His beard is rendered as a series of vertical grooves. The eyes, which are unmodeled, were painted on, and the nose was separately applied. The back is unworked. There are traces of red on the helmet. The clay is yellow ocher.

From Cyprus. Sixth century B.C. H, 0.070 m. Handmade. Solid. Estes Coll. Acc. no. 1902.89.

282. *Head of a warrior* (broken from figure). The peak of the helmet is broken away. It has cheekpieces and a nose guard, but the large nose of the figure dwarfs the latter. His beard is rendered by straight, vertical lines. The clay is gray to pink ocher.

From Cyprus. Sixth century B.C. H, 0.055 m. Handmade. Solid. Estes Coll. Acc. no. 1902.90.

Cf. *Kourion*, 55–56, pl. 60.

283. *Head of a warrior* (broken from figure). He wears a leather helmet with ear flaps. The eyes and pupils are black, as are the mustache, beard, and the edges and back of the helmet. The beard is spade-shaped and the nose prominent. The clay is buff.

From Cyprus. Sixth century B.C. H,

0.055 m. Handmade. Solid. Estes Coll.
Acc. no. 1902.78.

Cf. *Die Typen* I, 13, no. 3.

284. *Head of a man* (broken from
figure). He wears a wide-brimmed
fillet. The face is broad, the eyes pro-
truding, and the chin prominent. The
back is unworked. The clay is pink
ocher.

From Cyprus. Sixth century B.C. H,
0.055 m. Molded. Solid. Estes Coll.
Acc. no. 1902.88.

Cf. *SCE* III, clxxxii, no. 22, a some-
what similar head from Soli.

285. *Female mask.* Four horizontal
bands of red run across the top. The
ears are large and square-shaped. The
hair at the side of the head is repre-
sented by horizontal incised lines. There
are three holes, one on top and one on
each side, for suspension. The clay is
buff.

From Cyprus. Sixth century B.C. H,
0.085 m. W, 0.060 m. Molded. Estes
Coll. Acc. no. 1902.12.

Small clay masks were commonly
dedicated at sanctuaries to place the
dedicant under the protection of the
particular deity. They were usually sus-
pended so as to catch the wind and
face in every direction. This type of
mask was also found in tombs in the
seventh and sixth centuries B.C. See
Cesnola Collection, 349.

286. *Head of a man* (broken from
figure). His short, peaked cap is painted
red. A row of plastic curls over the
forehead are black, and the eyes and
brows are also outlined in black. The
back is unworked. The clay is very
gritty and is buff to brown.

From Cyprus. Sixth century B.C. H,
0.055 m. Handmade. Solid. Estes Coll.
Acc. no. 1902.86.

See No. 280, above.

287.* *Standing woman, perhaps a
votary.* The figure wears a high, plain

polos. Her face is modeled in the Late
Archaic manner, and the body is flat
and boardlike. The hair falls in two
plastic braids over the shoulders.
Across her bosom are two other plastic
decorations, one plain and one twisted,
ending in pompons on each shoulder.
The left hand is extended forward and
holds a large fruit. Her dress trails to
the ground without folds or decorations.
The figure stands on a thin, square
base, and the back is unworked. The
clay is buff. The right arm is missing.

PL. XXIX

Boeotian work. About 550–500 B.C.
Molded in the face, handmade in the
body. Solid. H, 0.185 m. W of base,
0.058 m. Warren Coll. Acc. no. 1923.3.

K. Herbert, *CJ* 55 (1959–60) 102–
103, fig. 6.

Cf. *Terracottas BM* I, 273–274; pl.
139, nos. 991–994; *Figurines Louvre I,*
11–13, nos. B63–74, pls. 8, 9. This type
is a development of the earlier bird-
faced figurines from Boeotia. See Nos.
269–271, above.

288.* *Comic figure on a donkey.* The
rider, who is wearing a comic mask,
leans backward and flings his arms up
in joy. In response, the donkey also has
his head upraised and is braying. There
are traces of pink on the rider's body.
The clay is reddish-brown. The don-
key's left ear is missing. PL. XXXI

From Tanagra, Boeotia. About 525–
500 B.C. H, 0.090 m. L, 0.105 m. Hand-
made, save for mask which is molded.
Solid. Warren Coll. Acc. no. 1923.10.

K. Herbert, *CJ* 55 (1959–60) 102,
fig. 5.

Cf. *Die Typen* I, p. 223, no. 4, a
similar type in which the rider is a
monkey; *Gr Terracottas,* 12–13, pls.
10, 11. Equestrian groups are a com-
mon class of figurine in the Archaic
period. The present figure was prob-
ably a child's toy.

289. *Hand* (broken from statue).
It is a left hand and about life-sized.
On three of the fingers are rings, and

part of a bracelet or cuff remains at the wrist. The hand was holding a javelin or other round object, for there is a space at both ends of the curved fingers and palm through which it was fitted. The clay is pink ocher.

From Cyprus. About 500 B.C. L, 0.130 m. Handmade. Hollow. Estes Coll. Acc. no. 1902.125.

Cyprus is devoid of marble and therefore clay was used in life-sized colossal statues as an alternative to stone in some localities, Salamis among them. Cf. *Cesnola Collection*, 255–261, no. 1485. For a full treatment of terracotta sculptures in Cyprus, see *SCE* IV, pt. 2, 92ff.

290. *Hand* (broken from statue). It is a right hand, about three-quarters of life-size. It was clenched to hold some object, perhaps a spear and it is broken on the inner side. The clay is gray.

From Cyprus. About 500 B.C. L, 0.085 m. Handmade. Solid. Estes Coll. Acc. no. 1902.131.

See No. 289, above.

291. *Leg and base* (broken from statue). On the foot is a shoe with up-turned tip, bound with thongs which are covered with a flap. The clay is reddish-brown. Only a part of the base remains, and all above the calf is missing.

From Cyprus. About 500 B.C. H, 0.150 m. Handmade. Hollow. Estes Coll. Acc. no. 1902.128.

Cf. *Cesnola Collection*, 261, nos. 1478–84, for other shoes of Oriental style.

292. *Pair of feet with base* (broken from statue). The base is broken between the feet and around the edges. The clay is yellow ocher. All above the ankles is missing.

From Cyprus. About 500 B.C. H, 0.080 m. W, 0.145 m. T, 0.170 m.

Handmade. Hollow. Estes Coll. Acc. no. 1902.135.

See No. 291, above.

293. *Parts of two feet and base* (broken from statue). Only the front parts of the feet remain. They have sandals, and between them is the hem of a garment. The clay is pink ocher.

From Cyprus. About 500 B.C. H, 0.140 m. W, 0.110 m. T, 0.075 m. Handmade. Hollow. Estes Coll. Acc. no. 1902.130.

See No. 291, above.

294. *Standing woman.* She wears a mantle and chiton with himation. The right hand is raised to the shoulder, and the left hand is under the folds of the garment. The figure is very roughly finished. The clay is pink ocher.

From Cyprus. Early fifth century B.C. H, 0.120 m. Molded. Solid. Estes Coll. Acc. no. 1902.137.

Cf. *Terracottas BM* I, pl. 21, no. 110.

295.* *Head of a bearded warrior* (broken from figure). The helmet rises to a ridge and has cheekpieces and a nose guard. The man wears a long, straight beard and mustache. The clay is rusty orange. The ends of the beard and back of the head are chipped.

PL. XXXII

From Medma, South Italy. Early fifth century B.C. H, 0.130 m. W, 0.055 m. Molded. Warren Coll. Acc. no. 1913.37.

K. Herbert, *CJ* 55 (1959–60) 103–104, fig. 8.

The style is reminiscent of the head of the dying warrior from the east pediment of the Temple of Aphaia on Aegina, a sculpture dating from about 490 B.C. Cf. *Gr Sculpture* 47–48, pls. 80, 81. For a similar figure from Medma, cf. A. Levi, *Le terrecotte figurate del Museo Nazionale di Napoli* (1925) 3, fig. 1.

296. *Head of a bearded man* (broken from figure). He wears a tight-fitting

cap, from which curly hair escapes on both sides. He has a mustache and a full, flowing beard. Part of the left shoulder remains and the back of the figure is flat and unworked. The clay is rusty orange.

From Medma. Early fifth century B.C. H, 0.120 m. Molded. Hollow. Warren Coll. Acc. no. 1913.37a.

See No. 295, above.

297. *Head of a bearded man* (broken from figure). He wears a short, flat cap and his front hair is arranged in small, tightly woven curls. He has a mustache and a full spade-shaped beard. The back is unworked. The clay is rusty orange.

From Medma. Early fifth cenutry B.C. H, 0.115 m. Molded. Hollow. Warren Coll. Acc. no. 1913.38.

See No. 295, above.

298. *Head of a man* (broken from figure). The hair is close-cut, being indicated by incised lines. The ears are large and the nose long and prominent. Traces of red remain. The lower left side of the face and the chin are missing. The clay is gray.

From Cyprus. Early fifth century B.C. H, 0.110 m. Handmade. Hollow. Estes Coll. Acc. no. 1902.127.

K. Herbert, *CJ* 55 (1959–60) 103, fig. 7.

Cf. *Kourion*, 36, pl. 10, no. 744.

299. *Horse and rider* (fragmentary). The rider, facing right, wears a tight-fitting cap and a short garment with many folds at the chest and shoulders. Both hands rest on the reins. The back is concave. Only that part of the horse directly in front of the rider's knee is preserved and all below the rider's knee is missing. The clay is buff.

From Cyprus. Early fifth century B.C. H, 0.090 m. Molded. Hollow. Estes Coll. Acc. no. 1902.138.

Cf. *Terracottas BM* I, 309, pl. 155, no. 1134.

300. *Owl.* The bird perches on a high oval base, facing left. His tail is represented as a spiral. Markings on the body are in black glaze, and a zig-zag encircles the base, which is hollow underneath. The clay is buff. A fragment of the base is missing.

Greek work. Early fifth century B.C. H, 0.030 m. W, 0.040 m. Molded. Solid. Warren Coll. Acc. no. 1915.21.

The owl is similar to that on the Athenian silver tetradrachm of the fifth century. Cf. *HN*, 371, fig. 209.

301. *Head of a dog* (broken from figure). The hair on the neck is roughly indicated. A broad collar remains on the right side, but the left side of the neck is missing. The clay is light brown.

From Cyprus. Early fifth century B.C. H, 0.050 m. Molded. Hollow. Estes Coll. Acc. no. 1902.115.

Cf. *Terracottas BM* I, 75, pl. 32, no. 171.

302.* *Standing goddess holding a fawn.* She wears a high polos with three horizontal rows of decoration. At the top is a row of birds with outspread wings, in the middle a row of flowers, and at the bottom rosettes. She wears earrings with pendants and two neck-laces, the lower necklace also having pendants. On each wrist is a cordlike bracelet. Her dress is the Doric peplos, the folds of which are held by the right hand. The left arm cradles the fawn. She stands, with the right leg slightly bent, in a stiff, frontal pose. The back is unworked and has a circular vent-hole. The clay is pink ocher. PL. XXXII

From Cyprus. Mid-fifth century B.C. H, 0.660 m. W, 0.177 m. T, 0.140 m. Molded. Hollow. Estes Coll. Acc. no. 1902.23.

Salaminia 223, fig. 213; *Lawrence-Cesnola Collection*, unnumbered pl.; P. L. de Feis, *Le antichita di Cipro ed i fratelli L. ed A. P. di Cesnola* (1900) 19, fig. 24a.

Cf. *Die Typen* I, 58–59.

303. *Head of a young man* (broken from figure). Some of the locks, which were separately applied over the forehead, are missing. The head is slightly turned to the right. The nose is straight and the eyes deep-set. The clay is yellow ocher.

From Tarentum. Mid-fifth century B.C. H, 0.115 m. W, 0.050 m. Molded. Hollow. Warren Coll. Acc. no. 1913.39.

Cf. G. Schneider, *Bulletin van der Vereeniging* 12 (1937) 3–8, and 13 (1938) 5–10, for similar Tarentine heads.

304. *Face of a woman* (broken from figure). Much of the left side of the face is missing and all of the hair except a small section on the right side. Despite its fragmentary nature, the face retains the severe beauty of the early Classical period. The back is concave. The clay is pink ocher.

From Cyprus. Mid-fifth century B.C. H, 0.060 m. W, 0.050 m. Molded. Hollow. Estes Coll. Acc. no. 1902.65.

Cf. *Terracottas BM* I, 89, pl. 40, no. 239; 143, pl. 70, no. 526; *Handbook*, 92, fig. 122.

305. *Head of a woman* (broken from figure). She wears a pointed cap, beneath which escapes a finely detailed fringe of curly hair to frame the face. The clay is pinkish-gray. The tip of the nose is missing. A concave section at the neck indicates that the body was hollow.

From Cyprus. Mid-fifth century B.C. H, 0.043 m. Molded. Solid. Estes Coll. Acc. no. 1902.55.

Lawrence-Cesnola Collection, unnumbered pl.

Cf. *Terracottas BM* I, 181–182, pl. 89, no. 680.

306. *Flute-playing Silenus* (fragmentary). He is fully bearded and is in a squatting position. His double flutes, held by both hands, rest upon his paunch as he plays. The left leg

and all below the paunch are missing. The back is flat but hollow beneath the head. The clay is brownish.

Greek work. Mid-fifth century B.C. H, 0.100 m. W, 0.060 m. Molded. Hollow. Warren Coll. Acc. no. 1930.84.

Cf. C. A. Hutton, *Greek Terracotta Statuettes* (1899) fig. 34; *DNM*, 35, nos. 312–313, pl. 37; *Terracottas BM* I, 73–74, pl. 31, nos. 159–165; 223, pl. 115, no. 840. This type is probably of Boeotian origin, for about 40 specimens have been found at the Theban Kabirion. See *DNM*, 35.

307. *Standing woman* (fragmentary). She wears a polos of medium height. Her braided hair lies on both shoulders. Both arms are under her outer garment, but the right is drawn up beneath the breast, while the left hangs at the side. The back is unworked. The clay is pink ocher. All below the hips is missing.

From Cyprus. Mid-fifth century B.C. H, 0.085 m. Molded. Solid. Estes Coll. Acc. no. 1902.97.

Cf. *Gr Terracottas*, pl. 21; *Terracottas BM* I, 83, pl. 36, no. 208.

308. *Head of a woman* (broken from figure). She wears a low polos over her tightly curled hair and also has circular earrings. The back of the head is flat and roughly finished. Traces of white slip are visible. The clay is yellow ocher.

From Cyprus. Mid-fifth century B.C. H, 0.040 m. Molded. Solid. Estes Coll. Acc. no. 1902.75.

Cf. *Terracottas BM* I, 217–218, pl. 112, no. 814; 255–256, pl. 134, no. 938b.

309. *Head of a woman* (broken from figure). She wears a diadem decorated with short, straight lines and heavy earrings. There are traces of white slip and the back is unworked. The clay is pink ocher.

From Cyprus. Mid-fifth century B.C.

H, 0.050 m. Molded. Solid. Estes Coll.
Acc. no. 1902.102.
Cf. *Terracottas BM* I, 290–291, pls.
146, 147.

310. *Face of a woman* (broken from
figure). Traces of white slip remain.
The clay is gray to yellow ocher.
From Cyprus. Mid-fifth century B.C.
H, 0.035 m. Molded. Solid. Estes Coll.
Acc. no. 1902.119.

311. *Head* (broken from figure).
The figure wears a peaked cap, be-
neath which flows the hair on the fore-
head and sides. The clay is yellow
ocher.
From Cyprus. Mid-fifth century B.C.
H, 0.030 m. Molded. Solid. Estes Coll.
Acc. no. 1902.122.
Cf. *Gr Terracottas*, pl. 25, a similar
head on a woman kneading dough,
from Rhodes; *Kourion*, 47, pl. 15, nos.
964–970.

312. *Head* (broken from figure). A
peaked cap covers the ears. The sur-
face is much worn and the back is un-
worked. The clay is orange-brown.
From Cyprus. Mid-fifth century B.C.
H, 0.030 m. Molded. Solid. Estes Coll.
Acc. no. 1902.120.
See No. 311, above.

313. *Head of a warrior* (broken from
figure). His helmet has sidepieces
which cover the ears. The eyes have
sculptured pupils. His mustache is full
and the beard round and curly. The
clay is a dark brown. The top of the
helmet is missing.
From Medma. Mid-fifth century B.C.
H, 0.085 m. Molded. Hollow. Warren
Coll. Acc. no. 1913.36.
Cf. *Terracottas BM* I, 367, pl. 188,
nos. 1351–54.

314. *Woman with child riding a
mule sidesaddle.* The woman, in chiton
and himation, holds the child with her
right arm and the reins with her left

as the mule moves to the right. The
mule looks around to the right. The
group stands on a high pedestal which
was decorated in low relief that is
now almost obscured. The surface of
the whole is much worn, but there
are traces of light blue on the pedestal.
The back is unworked but has a cir-
cular vent. The clay is yellow ocher.
From Cyprus. Late fifth century B.C.
H, 0.170 m. W of pedestal, 0.100 m.
Molded. Hollow. Estes Coll. Acc. no.
1902.49.
Cf. *SCE* III, pl. lxxx, no. 100, a simi-
lar figure of a woman riding a mule
sidesaddle from Vouni and of the late
fifth century B.C. This figure is a well-
known Greek type imported into Cy-
prus.

315. *Jointed female doll.* The arms
and the legs from the knees down are
attached separately. The hair is en-
circled by a band and tied in a bow
in front. Castanets are held in the
hands. There are traces of white slip
on the body and of red on the feet.
The clay is cream.
Greek work. Late fifth century B.C.
H, 0.150 m. Molded head and torso;
handmade limbs. Solid. Warren Coll.
Acc. no. 1923.22.
Cf. *Terracottas BM* I, 257, pl. 134,
no. 942, a near replica from Corinth.
See also No. 339, below. On the whole
subject of Greek dolls, see José Dörig,
Antike Kunst 1 (1958) 41–52, pls. 22–
26.

316. *Head of satyr.* The features are
very crudely rendered. His eyes bulge,
his tongue protrudes, and his beard is
full. Horns protrude from his forehead.
The back is flat and there is a hole on
the top for suspension. The clay is
cream. One ear is missing.
From Cyprus. About 425–350 B.C.
H, 0.085 m. Handmade. Solid. Estes
Coll. Acc. no. 1902.114.
Cf. *DNM*, 35–36, pl. 37, no. 316, for
a somewhat similar head.

317. *Head of a goddess* (broken from figure). She wears a high polos decorated with incised palmettes. Her hair is parted in the middle and drawn to the sides. The face is rectangular and severe. The back is unworked. The clay is yellow ocher.

From Cyprus. About 425–300 B.C. H, 0.080 m. Molded. Solid. Estes Coll. Acc. no. 1902.58.

Lawrence-Cesnola Collection, unnumbered pl.; K. Herbert, *CJ* 55 (1959–60) 105, fig. 14.

This and the following eleven heads are all broken from figurines of goddesses and votaries, and variously represent Demeter, Persephone, Aphrodite, Cybele, and their priestesses and votaries. They belong to the Late Classical or Early Hellenistic periods. Cf. C. A. Hutton, *Greek Terracotta Statuettes* (1899) fig. 13; *Die Typen* I, 90–91; *Cesnola Collection*, 356–357, fig. 2198; *DNM*, 8, pl. 7, nos. 54–57.

318. *Head of a goddess* (broken from figure). She wears a high polos, decorated with two horizontal rows of vertical lines, and heavy earrings. The face is fleshy and there are creases in the neck. The back is unworked. The clay is pink ocher.

From Cyprus. About 425–300 B.C. H, 0.070 m. Molded. Hollow. Estes Coll. Acc. no. 1902.52.

Lawrence-Cesnola Collection, unnumbered pl. See No. 317, above.

319. *Head of a goddess* (broken from figure). She wears a high polos, decorated with rows of semicircular impressions, and medallion earrings. Her hair tightly encircles her head. The face is heavy but the eyes are lightly rendered. The back is concave. The clay is pink ocher.

From Cyprus. About 425–300 B.C. H, 0.065 m. Molded. Solid. Estes Coll. Acc. no. 1902.101.

See No. 317, above.

320. *Head of a goddess* (broken from figure). She wears a high polos decorated with a band of rosettes and a horizontal band of vertical lines. She also has heavy drop earrings. Her hair is parted in the middle and drawn to the sides. The face is fleshy and the neck lined. The back is unworked. The clay is cream.

From Cyprus. About 425–300 B.C. H, 0.050 m. Molded. Solid. Estes Coll. Acc. no. 1902.116.

See No. 317, above.

321. *Head of a goddess* (broken from figure). She wears a plain polos crown and heavy circular earrings. The hair is parted in the middle. The face is heavy. The back is unmodeled. The clay is light gray.

From Cyprus. About 425–300 B.C. H, 0.045 m. Molded. Solid. Estes Coll. Acc. no. 1902.108.

See No. 317, above.

322. *Head of a goddess* (broken from figure). She wears a high polos decorated with incised vertical lines. The face is almost worn away. The back is unworked and flat. The clay is pink ocher.

From Cyprus. About 425–300 B.C. H, 0.040 m. Molded. Solid. Estes Coll. Acc. no. 1902.110.

See No. 317, above.

323. *Head of a goddess* (broken from figure). She wears a low polos with vertically incised lines and heavy drop earrings. Her coiffure is drawn over her forehead in a semicircle. The back is unworked. The clay is yellow ocher.

From Cyprus. About 425–300 B.C. H, 0.040 m. Molded. Solid. Estes Coll. Acc. no. 1902.118.

See No. 317, above.

324. *Head of a goddess* (broken from figure). She wears a high polos with vertical ribbing and heavy ear-

rings. The face is full and oval. The back of the head is unworked. The clay is pink ocher.

From Cyprus. About 425–300 B.C. H, 0.036 m. Molded. Solid. Estes Coll. Acc. no. 1902.8.

See No. 317, above.

325. *Head of a goddess* (broken from figure). She wears a low, plain polos, below which her hair is in a semicircle over her forehead. The back is unworked. The clay is orange-brown.

From Cyprus. About 425–300 B.C. H, 0.036 m. Molded. Solid. Estes Coll. Acc. no. 1902.80.

See No. 317, above.

326. *Head of a votary* (broken from figure). She wears heavy earrings and a headdress which rises to a point and is covered on the sides by a veil. The face is heavy and the jaw protrudes. The back is unworked. The clay is pink ocher.

From Cyprus. About 425–300 B.C. H, 0.048 m. Molded. Solid. Estes Coll. Acc. no. 1902.109.

Cf. *Cesnola Collection*, 355, fig. 2198, showing similar votaries.

327. *Head of a votary* (broken from figure). She wears two heavy fillets over the forehead. These are covered by a veil which rises to a peak. The eyes and lips are well delineated. The back is unworked. The clay is pink ocher.

From Cyprus. About 425–300 B.C. H, 0.043 m. Molded. Solid. Estes Coll. Acc. no. 1902.54.

Cf. *Cesnola Collection*, 355, fig. 2191.

328. *Head of a votary* (broken from figure). Her headdress has a herringbone pattern and she wears large circular earrings. The back of the head is unworked. The clay is pink ocher.

From Cyprus. About 425–300 B.C

H, 0.027 m. Molded. Solid. Estes Coll. Acc. no. 1902.74.

See No. 326, above.

329. *Cock.* He stands on a low pedestal looking to the right. The tail feathers arch in a semicircle. The back, which has a circular vent, is smooth. The figure is unglazed. The clay is pink ocher.

From Cyprus. Fifth century B.C. H, 0.140 m. Molded. Hollow. Estes Coll. Acc. no. 1902.61.

Lawrence-Cesnola Collection, unnumbered pl.

Cf. *Terracottas BM*, pl. 47, no. 278.

330. *Bird.* It stands on a low pedestal, with wings furled. Traces of white slip remain. The back is unmodeled.

From Cyprus. Fifth century B.C. H, 0.115 m. W, 0.050 m. Hollow. Molded. Estes Coll. Acc. no. 1902.63.

331. *Owl* (fragmentary). The bird is represented standing in frontal position. The head and body are covered with raised dots. The eyes are large and have spokelike decorations at the edges. The back is concave. The clay is rusty orange. All below the breast is missing.

South Italian work. Fifth century B.C. H, 0.040 m. Molded. Hollow. Warren Coll. Acc. no. 1923.9.

See No. 300, above. The owl is regularly associated with Athena in the Classical period.

332. *Pig* (fragmentary). The animal is very fat and short-legged. Only the front half of the figure remains. The back is concave. The clay is pink ocher.

From Cyprus. Fifth century B.C. H, 0.045 m. L, 0.085 m. Molded. Hollow. Estes Coll. Acc. no. 1902.111.

Cf. P. N. Ure, *Aryballoi and Figurines from Rhitsona in Boeotia* (1934) 71, pl. 17; *Terracottas BM* I, 77–78, pl. 33, nos. 180–182, showing similar types of the same period. For other

animals from Cyprus of the Classical period, cf. *DNM*, pl. 8.

333. *Donkey with two baskets* (fragmentary). The mane is hogged. Both front legs are missing and only stumps of the hind one remain. An orange-red glaze covers the whole. The clay is pink ocher.

From Cyprus. Fifth century B.C. H, 0.100 m. L, 0.135 m. Handmade. Solid. Estes Coll. Acc. no. 1902.62.

Cf. *Cesnola Collection*, 360, no. 2271, a similar figure.

334. *Whistle in the form of a boy's head.* The mouthpiece is at the back of the base; there is a hole in the center of the bottom and a smaller hole in the top of the head. The clay is medium gray. The nose and mouth of the face are much worn.

Greek work. Fifth century B.C. H, 0.050 m. Molded. Hollow. Warren Coll. Acc. no. 1930.91.

This whistle was probably a child's toy. Ancient toys did not differ essentially from modern ones, especially those for the younger child. For the infant there were clappers and rattles in a variety of forms. *Crepundia*, miniature objects and charms hung around the infant's neck, were often used in stories to identify kidnapped children, and bells served both to amuse and to avert the evil eye. At an older age dolls with movable limbs were common, and balls, tops, hoops, swings, and seesaws were all used in play. See F. N. Pryce, in *OCD*, s.v. "Toys."

335. *Standing girl holding a dove.* Clad in chiton and himation, she stands with her weight on the right leg. Her hair is parted in the middle and drawn to the sides. Her right arm is at her side, her left raised to the waist to support the dove. The drapery subtly reveals her figure beneath. There is white slip over all, with additional traces of red on the lips, hair and base, and blue on the bird. The back is unworked, and lacks a vent, since the heavy base on which the figure stands is open at the bottom. The clay is medium brown.

Greek work. About 400 B.C. H, 0.156 m. W, 0.048 m. Molded. Hollow. Warren Coll. Acc. no. 1915.13.

336. *Head of a woman* (broken from figure). She wears a plain, heavy polos over a coiffure which flares out on the sides. There are holes irregularly placed along the lower edges of the polos for the insertion of an additional ornament. There is also a hole in each ear for the insertion of earrings. The back of the head is unworked. There are traces of pink on the polos and face. The clay is gray to pink ocher.

From Cyprus. About 400 B.C. H, 0.080 m. Molded. Solid. Estes Coll. Acc. no. 1902.51.

Lawrence-Cesnola Collection, unnumbered pl.

337. *Head of a woman* (broken from figure). The hair is parted in the middle and drawn to the sides in large waves. The lips and eyes are heavily accentuated. The back is concave. The clay is gray.

From Cyprus. Early fourth century B.C. H, 0.060 m. Molded. Hollow. Estes Coll. Acc. no. 1902.57.

Cf. *Terracottas BM* I, 320–321, pl. 162, nos. 1181–89.

338. *Head of a satyr.* The upper forehead is bald and wrinkled, and the beard is full. The back is unworked. The clay is yellow ocher. All on a line from the left ear to the right armpit is missing.

From Cyprus. Early fourth century B.C. H, 0.060 m. Molded. Hollow. Estes Coll. Acc. no. 1902.152.

Cf. *Terracottas BM* I, 96, pl. 46, nos. 270–272.

339.* *Jointed female doll holding rattles.* The arms and the legs from the knees down are attached separately. The legs may not be original with the figure. The back is fully modeled and the breasts are slightly developed. The figure is nude. There is a hole in the top of the head for suspension. The clay is gray to yellow ocher. The rattle in the right hand is missing. PL. XXXIII

Greek work. Mid-fourth century B.C. H, 0.190 m. Molded. Solid. Warren Coll. Acc. no. 1913.28.

K. Herbert, *CJ* 55 (1959–60) 105–106, fig. 11.

Dolls have been found in the graves of children, but also in temple precincts, since Greek girls dedicated them to such goddesses as Athena, Aphrodite, Artemis, and Demeter before marriage. Boys dedicated their toys at the end of childhood to Apollo and Hermes. Dolls were feminine for the most part, as both the names for them, *nymphai* and *korai*, and the extant remains indicate. See K. Elderkin, *AJA* 34 (1930) 455–467.

340. *Head of a bearded man* (broken from figure). The figure, which is very roughly finished, wears a full beard and mustache. The nose and studs over the ears are represented by small pieces of clay separately applied. The back is flat and unworked. The clay is yellow ocher.

From Cyprus. Mid-fourth century B.C. H, 0.055 m. Handmade. Solid. Estes Coll. Acc. no. 1902.106.

Cf. *Terracottas BM* I, 139, pls. 68, 69, nos. 506 and 508.

341. *Head of a woman* (broken from figure). The hair is bound with a fillet, the ends of which trail down the back of the neck. The hair is parted in the middle, drawn to the temples, where it is curled in ringlets; there are also braids down each side. The face is heavy and the eyes and lips emphasized. The clay is pink ocher. The nose is chipped.

From Cyprus. Mid-fourth century B.C. H, 0.058 m. Molded. Hollow. Estes Coll. Acc. no. 1902.59.

The Lawrence-Cesnola Collection, unnumbered pl.

Cf. *Terracottas BM* I, 400–401, pl. 205, nos. 1523 and 1528.

342. *Head of a woman* (broken from figure). The hair is combed upward and formed into ringlets at the top; a mantle covers the head. The back of the head is unworked. The clay is pink ocher.

From Cyprus. Mid-fourth century B.C. H, 0.052 m. Molded. Solid. Estes Coll. Acc. no. 1902.100.

Cf. *Terracottas BM* I, 364, pl. 186, nos. 1340–41, for similar coiffures.

343. *Head of a woman* (broken from figure). A veil covers the forehead and all the face except the eyes and nose. Traces of white slip are evident. The back is unworked. The clay is pink ocher.

From Cyprus. Late fourth century B.C. H, 0.030 m. Molded. Solid. Estes Coll. Acc. no. 1902.141.

The use of the veil in this manner imitates a well-known head, also from Cyprus and now in the British Museum. The subtle and delicate treatment of these heads is in the Praxitelean manner. Cf. *Gr Terracottas*, 10–11, pls. 4, 5. There is also a near replica in Copenhagen. Cf. *DNM*, 78, no. 751, pl. 89.

344. *Standing woman.* She wears a chiton and a himation and stands with her weight on the right leg. Her right arm is bent across the body and in the hand is a fan, the top of which is missing. Her left hand holds the himation. Her hair, a rusty red color, is parted in the middle and knotted behind. The skin is flesh-colored, the

himation pink, the chiton blue. In general the color is well preserved. The figure stands on a stepped base and there is a square vent in the back.

Greek work of the Tanagra type. Late fourth century B.C. or later. Molded. Hollow. H, 0.193 m. W, 0.050 m. Warren Coll. Acc. no. 1915.12.1.

Most of the Tanagra figurines represent women, fully garbed in mantle and tunic, in various poses or domestic situations. Cf. *Gr Terracottas*, pls. 37–42, 44; *Handbook*, figs. 336–338. For all types of standing female figures of this period, cf. *Die Typen* II, 3–103.

345. *Standing woman.* She is wrapped in a himation and her arms are covered by this garment. The left hand holds up folds and the right hand alone is exposed. The back is fully worked. There are traces of white slip, and the hair, worn in a melon coiffure, has red on it. She stands on a low rectangular base. The clay is yellow ocher.

Greek work of the Tanagra type. Late fourth century B.C. or later. H, 0.120 m. W of base, 0.038 m. Molded. Solid. Warren Coll. Acc. no. 1915.57.

For a replica in London, see *BM Terracottas*, pl. 30, no. 3.

346. *Head of a woman* (broken from figure). The handsome face looks down to the right. Most of the coiffure is missing. She wears heavy oval earrings, which were separately applied. The eyes are deep-set and softly delineated. The clay is cream to gray. The back of the head is missing.

Greek work. Late fourth century B.C. or later. H, 0.080 m. Molded. Hollow. Warren Coll. Acc. no. 1913.40.

The serenity and loveliness of this work indicates that it was fashioned in imitation of the Praxitelean style. Cf. *Sculpture and Sculptors*, 259–267; *Gr Sculpture*, 73, pls. 228, 229.

347. *Comic actor with long beard* (fragmentary). His nose and ears are large, and his beard flows down his chest. He stands in frontal pose, clad in a short jacket, which reaches only to the hips. His hands are underneath the cloak, and part of the phallus remains visible. The back is hollow. The clay is reddish-brown. The crown of the head and all below the thighs is missing.

Eastern Greek work. Late fourth century B.C. or later. H, 0.106 m. W, 0.047 m. Molded. Hollow. Warren Coll. Acc. no. 1915.24.

K. Herbert, *CJ* 55 (1959–60) 106, fig. 12.

A complete set of seven statuettes from a fourth century Athenian grave may illustrate a comedy involving Herakles in a seduction: the figurines include a hero with phallus, an obviously pregnant young woman, a nurse with a baby, a weeping old man, and three slaves, two of them preparing a feast and the other seated. See *Gr Terracottas*, 22–23, pls. 27–33.

348. *Standing man with cloak over shoulder* (fragmentary). He is nude except for the cloak, which covers the back of his head and falls over his left shoulder. His body is very muscular. His head is inclined to the left. The back is unworked and part of the vent remains. The clay is yellow ocher. All below the waist is missing.

From Cyprus. Late fourth century B.C. or later. H, 0.090 m. Molded. Hollow. Estes Coll. Acc. no. 1902.151.

349. *Head of woman* (broken from figure). The face looks up and slightly leftward. The hair is bound with a garland of leaves and fruit. The eyes are very softly delineated. The clay is medium gray.

From Cyprus. Late fourth century B.C. or later. H, 0.055 m. Molded. Solid. Estes Coll. Acc. no. 1902.53.

Lawrence-Cesnola Collection, unnumbered pl.

Cf. *Sculpture and Sculptors*, figs. 174, 175, 207, 688.

350. *Head of a grotesque monkey* (broken from figure). The lower part of the face protrudes and the whole of it is heavily lined. The back is unworked. The clay is light brown.

From Cyprus. Late fourth century B.C. or later. H, 0.025 m. Handmade. Solid. Estes Coll. Acc. no. 1902.121.

Cf. *Terracottas BM*, 262, pl. 136, no. 966.

351. *Face of a woman* (broken from figure). The face is full and fleshy; only it and the neck remain. The back is concave. The clay is gray to pink ocher.

From Cyprus. Fourth century B.C. H, 0.035 m. Molded. Hollow. Estes Coll. Acc. no. 1902.139.

352. *Head of a woman* (broken from figure). The face is almost completely worn away. Her braided hair falls on the shoulders. The back is unworked. Much white slip remains. The clay is pink ocher.

From Cyprus. Fourth century B.C. H, 0.040 m. Molded. Solid. Estes Coll. Acc. no. 1902.142.

353.* *Standing woman leaning on a pillar.* Clad in chiton and himation, she rests her left elbow on the top of the pillar and holds a circular mirror in her left hand. Her weight is on the right leg and her left leg is crossed over in front of it. Her right arm is brought across the front of her body. She wears a melon coiffure, tied in a bun at the back, and her head is turned to the left and slightly downward. The surface of the figure is much worn and there is a large rectangular vent in the back. The pillar, which is draped, has a high base of its own, and the figure stands on a low rectangular base. The clay is orange-brown. The figure has

been mended, and a piece at the base of the pillar is missing. PL. XXXIII

From Tanagra. Late fourth or early third century B.C. Molded. Hollow. H, 0.197 m. W of base, 0.085 m. Warren Coll. Acc. no. 1908.12.

K. Herbert, *CJ* 55 (1959–60) 105, fig. 10.

Cf. *BM Terracottas*, pl. 32, no. 1, for a nearly identical figure. For a useful, short survey of Tanagra figurines from the Archaic to the Hellenistic periods, see S. Besques-Mollard, *Tanagra* (1950). For older works with many illustrations, see Pottier, *Les Statuettes de terre cuite dans l'antiquité*, 79–114, and Huish, *Greek Terracotta Statuettes*, 100–130.

354.* *Standing woman holding a chaplet.* The hair is covered by a scarf open at the back. Clad in chiton and himation, she stands with her weight on the left leg. Both hands are covered by the garment, with the right brought over to rest on the left, which holds the chaplet. The head looks down to the right. There is a square vent in the back and there are traces of white slip, of brownish-red on the hair, pink on the face, and red on the lips. The clay is reddish-brown. PL. XXXIV

From Tanagra. Late fourth or early third century B.C. Molded. Hollow. H, 0.210 m. W of base, 0.073 m. Warren Coll. Acc. no. 1908.10.

K. Herbert, *CJ* 55 (1959–60) 104–105, fig. 9.

Cf. *Die Typen* II, 33, no. 5, a replica; Köster, *Die griechischen Terrakotten*, pl. 49, a similar figure without the chaplet.

355. *Standing woman.* She wears a chiton and a himation, which is wrapped around her neck and caught up under her left arm. She wears a melon coiffure tied in a bun at the back. Her gaze is downward to the right. The right arm is akimbo, the left at her side holding a fan. Her weight is on the

right leg, with her left slightly behind. There are traces of brown on the hair, blue on the chiton, and rose on the himation; remains of white slip are all over the figure. The back is unworked and has a square vent in it. The figure stands on a thin rectangular base. The clay is orange-brown.

Greek work. Third century B.C. Molded. Hollow. H, 0.185 m. W of base, 0.068 m. Warren Coll. Acc. no. 1923.2.

Cf. *Die Typen* II, 25, nos. 1 and 4, for the type, and II, 25, no. 2, a near replica in Boston.

356. *Standing woman.* A veil is drawn over and around her head. The right arm is drawn up to the bosom and the left hand holds a fan upright at her side, but both hands are under the garment. There are a few traces of white slip. The back is unworked and she stands on a low, irregularly shaped base: the front and two sides are straight, the back rounded. The clay is yellow-brown.

From Athens. Third century B.C. Molded. Solid. H, 0.111 m. W of base, 0.040 m. Warren Coll. Acc. no. 1908. 11.

357. *Head of a young man* (broken from figure). The head is somewhat triangular and the hair is short and curly. The strong face has a pained expression on it and the head is bent slightly to the right. The clay is orange-brown.

From Cyprus. Third century B.C. Molded. Hollow. H, 0.045 m. Estes Coll. Acc. no. 1902.56.

Lawrence-Cesnola Collection, unnumbered pl.

Cf. *SCE* III, pl. cxxxviii, no. 616, a similar head in limestone which is clearly influenced by the tradition of Scopas or Lysippus, both of whom flourished in the fourth century B.C. Scopas was the first sculptor to portray violent emotion in his faces, and Lysip-

pus influenced Hellenistic sculpture by his modifications of the earlier canon in making the head smaller, the body more slender, and the muscles closer to the surface. Cf. *Hellenistic Age,* figs. 54–56, 63, 72–76.

358. *Head of a woman* (broken from figure). The hair is in a melon coiffure. The face is much worn, but the soft quality of the treatment remains visible. The back is unworked and white slip remains. The clay is pink ocher.

From Cyprus. 3rd century B.C. Molded. Solid. H, 0.045 m. Estes Coll. Acc. no. 1902.117.

Cf. *SCE* III, pl. cl, no. 425, a marble head from Soli treated in the same manner.

359. *Head of a woman* (broken from figure). The head is slightly tilted to the right. Her hair is in a melon coiffure. Traces of white and brown remain on the hair. The back is unworked. The clay is yellow ocher.

From Cyprus. Third century B.C. Molded. Solid. H, 0.050 m. Estes Coll. Acc. no. 1902.107.

360. *Boy wearing a coat.* The head is declined so that the chin is covered by the top of the garment. The outline of his right arm drawn up over his chest is visible under the cloak. The back of the head is broken. The back of the body is hollow. The clay is pink ocher.

Greek work. Third or second century B.C. Molded. Hollow. H, 0.075 m. W, 0.045 m. Warren Coll. Acc. no. 1923.11.

Cf. A. W. Lawrence, *Later Greek Sculpture* (1927) pls. 74, 75, a boxer clad in a coat, now in Constantinople; *Griechische Plastik* IV, fig. 10.

361. *Child crouching on a pedestal.* The child, who may be playing knucklebones, wears a mantle drawn over the

left shoulder but leaving the back bare. It is wrapped around the right hip and covers the legs. The head looks downward and the right arm is drawn up. On the left of the pedestal is the figure of a bird in relief and the right a stamped delta. Some object was also applied to the front of the stand, but it has fallen off. Traces of white slip are abundant. The figure rests on a rectangular base. The clay is medium brown.

Greek work. Third or second century B.C. Molded. Hollow. H, 0.110 m. W of base, 0.030 m. Warren Coll. Acc. no. 1923.37.

The graceful, light, and playful side of Hellenistic art took children, adolescents, and old people as its main subjects. Children are portrayed at their games, with animals, running, and in a great variety of other attitudes. This rococo trend was centered at Alexandria in the third century B.C., but it was also widespread in Asia Minor at the same time. See *Hellenistic Age*, 136–138, esp. fig. 53, and figs. 534–558.

362. *Mask of young faun.* There is a vine wreath in the hair, which is brushed upward at the forehead. The ears are pointed, the mouth smiling. There are traces of red paint on the face. On top is a semicircular hole, and the lower part of the chin is missing.

Greek work. Third or second century B.C. H, 0.205 m. W, 0.175 m. Warren Coll. Acc. no. 1913.42.

Cf. A. W. Lawrence, *Later Greek Sculpture* (1927) pls. 30b–31a.

363.* *Head of a grotesque Negro* (broken from a figure). The hair is formed into nodules. The ears are monstrously large. The forehead is heavily lined, and the areas over the eyes and the lips are exaggerated. Part of the right ear is missing. PL. XXXVI

From Medma. Third or second century B.C. Molded. Hollow. H, 0.065 m. Warren Coll. Acc. no. 1913.53.

K. Herbert, *CJ* 55 (1959–60) 109–110, fig. 19.

Many such types of statuettes were produced in the third century and later — Negroes, musicians, acrobats, and others of the lower classes — both in humor and in mockery. See *Hellenistic Age*, 96–97, figs. 376, 377, 385, 548; cf. *Die Typen* II, 432–469, for all kinds of caricatures. For a study of the type, see G. Becatti in *Encic AA*, s.v. "Caricatura."

364. *Winged Eros with cymbals.* He wears a heavy Phrygian cap and holds the cymbals out from the body, the one in the left hand raised high, the one in the right held low. He is nude save for drapery, which hangs over the right shoulder, falls down the back, and curls around the left leg. The wings are short and stubby. There are traces of white on the body. The clay is tan to pink ocher. The right leg and left foot are missing.

Greek work. Third or second century B.C. Molded. Solid. H, 0.085 m. Armspread, 0.070 m. Warren Coll. Acc. no. 1908.17.

In general it may be said of Eros that in Greek art he grows younger with each passing period. He begins in the Archaic period as nearly a grown boy, then becomes a young boy in the Classical age, and ends in the Hellenistic and Greco-Roman periods as a sportive *putto.* But there are exceptions, such as instances in which he appears with Psyche and in the androgynous type from Myrina. See G. M. A. Hanfmann in *OCD*, s.v. "Eros"; *Myrina*, 47, pl. 14, nos. 34, 35. For many types of winged Erotes from Myrina, see Huish, *Greek Terracotta Statuettes*, pls. xlvi, xlvii.

365. *Flying Eros.* The figure, in chiton and himation, is represented as flying down with wings outspread. He wears a wreath, which has a number of small indentations on top. He is lifting his garment with his right hand, and

his left hand is at his side; it may once have held an object such as a ball. Traces of white slip remain. The clay is pink ocher. The left foot is missing.

From Tanagra. Second century B.C. Molded. Solid. H, 0.067 m. Wingspread, 0.065 m. Warren Coll. Acc. no. 1908.16.

It is thought that flying types originated in painting, for they do not appear in terracottas until the third century B.C. The artisans began by depicting Erotes and then gradually turned to flying adult types as well. See Köster, *Die griechischen Terrakotten*, pl. 77a; *Myrina*, 47, pl. 14, nos. 34, 35.

366. *Flying Eros.* He has a fillet on his head and his wings are outstretched. He wears a brief shirt. The right hand rests on the hip and the left is raised. There are traces of blue and white on the body and dark reddish-brown on the hair. The clay is pink ocher.

From Tanagra. Second century B.C. Molded. Solid. H, 0.060 m. Wingspread, 0.045 m. Warren Coll. Acc. no. 1908.2.

Cf. *Myrina*, 47, pl. 14, nos. 34, 35.

367.* *Flying Eros.* He wears a melon coiffure that is formed in a crown of ringlets at the back. The wings are outspread and the right arm is upraised. He is nude and is somewhat androgynous in physique. The left leg is advanced. The back is fully modeled and there is a round vent and a smaller hole above it for suspension. Traces of white slip remain. The clay has a pink cast. The left arm and toes, and the right hand are missing. PL. XXXIV

From Myrina, Lydia. Second or first century B.C. Molded. Hollow. H, 0.270 m. Warren Coll. Acc. no. 1908.13A.

K. Herbert, *CJ* 55 (1959–60) 107–108, fig. 15.

This figure represents a type that was popular at Myrina in the second and first centuries. Most noteworthy is the treatment of the body: the abdominal muscles are those of an adolescent boy, but the thighs, breasts, and buttocks are softened and rounded. See *Myrina*, 50–55, pls. 18–24.

368. *Flying Eros.* The head is crowned by a large, heavy fillet and the arms are held out before him. He is nude and is somewhat androgynous in physique. The right leg is advanced before him. The back is fully modeled and there is a round vent and a smaller hole above it for suspension. Slight traces of white slip remain. The clay has a pink cast. The wings are missing, as are the fingers. The figure is much mended.

From Myrina. Second or first century B.C. Molded. Hollow. H, 0.260 m. Armspread, 0.125 m. Warren Coll. Acc. no. 1908.13.

Cf. *Myrina*, 51–52, pl. 19, nos. 47, 48.

369.* *Male Bacchic flute player.* He is represented as bounding forward on his right foot. He is nude save for an animal skin which covers his chest and a garland in crossbands from shoulders to waist. He also wears a heavy fillet on the head and buskins on the feet. There are traces of red and white on the buskins. The back is fully worked and has a square vent and a smaller hole for suspension. The clay has a pink cast. The flute, the fingers of the right hand, and parts of the buskins are missing. The figure is much mended. PL. XXXV

From Myrina. Second or first century B.C. Molded. Hollow. H, 0.335 m. Warren Coll. Acc. no. 1908.18.

K. Herbert, *CJ* 55 (1959–1960) 108–109, fig. 17.

Cf. *Die Typen* II, 338, no. 6 and 339, no. 5, near replicas; *Myrina*, pl. 19, no. 47; pl. 22, no. 56.

370.* *Flying Eros in Phrygian garb.* The figure is represented with both arms outstretched. He wears the short, high-belted tunic with sleeves, full length trousers, and the Phrygian cap. His

right leg is advanced. The back as a triangular vent and two small holes for suspension. The clay has a pink cast. Part of the left wing is missing. The figure is mended. PL. XXXV

From Myrina. Second or first century B.C. Molded. Hollow. H, 0.287 m. Wingspread, 0.170 m. Warren Coll. Acc. no. 1908.9.

K. Herbert, *CJ* 55 (1959–60) 108, fig. 16.

This type of flying figure in Phrygian garb has often been called Attis, the companion and lover of Cybele, the Great Mother of Anatolian orgiastic cults. Though Attis did tend to identify himself with a number of Hellenic gods, with Apollo, for example, in his role as giver of oracles and with Asklepios as healer of the sick, it is difficult to see him assuming the role of Eros. See *Myrina*, 56–57, nos. 63, 64, pl. 25.

371. *Winged Eros standing on a pedestal.* The figure wears a peaked cap with flaps which cover the sides of his head and chin. Two long locks of hair escape from underneath and fall on his shoulders. His wings are relatively small in spread. He wears a high-girt chiton and leggings, and stands on a slightly inclined pedestal with right leg crossed over the left. His arms are also held akimbo. The back is unworked and has a circular vent. The clay is pink ocher.

From Cyprus. Second or first century B.C. Molded. Hollow. H, 0.185 m. Estes Coll. Acc. no. 1902.41.

Salaminia, 214; pl. opposite 208, fourth figure from the right; *Lawrence-Cesnola Collection*, unnumbered pl.

372. *Mask of Eros.* The god has curly hair gathered in bunches, two on top of the head and one behind each ear. The cheeks are prominent and the face smiling. The back is hollow and there are two holes in the upper part of the hair for suspension. The clay is yellow ocher.

Eastern Greek work. Second or first century B.C. Molded. H, 0.127 m. W, 0.113 m. Warren Coll. Acc. no. 1915.54.

Cf. *Myrina*, 52; pl. 20, no. 50.

373. *Standing slave* (fragmentary). He is bald and wears only a cloak, drawn around his right thigh and up over his left arm. This arm is bent upward. There are traces of white slip. The clay has a pink cast. The right arm and both feet are missing.

From Smyrna. Second or first century B.C. Molded. Solid. H, 0.140 m. W, 0.040 m. Warren Coll. Acc. no. 1915.22. From the van Branteghem Coll.

W. Froehner, *Collection van Branteghem* (1892) pl. 75, no. 435, where the figure appears with the right arm and left foot still attached.

Cf. *Die Typen* II, 442, no. 5.

374.* *Dwarf carrying a kid on his shoulders* (fragmentary). The head is oversize for the body and it is turned upward and to the left. The dwarf holds the kid secure on his shoulders by holding the legs with both hands. The head of the kid appears to be a caricature of a human face. The dwarf is ithyphallic. The clay is reddish-brown. The part of the figure below the hips is missing. PL. XXXVII

Eastern Greek work. Second or first century B.C. Molded. Hollow. H, 0.062 m. Warren Coll. Acc. no. 1915.51.

K. Herbert, *CJ* 55 (1959–60) 110, fig. 20.

The technical term for this type is *kriophoros*, or ram bearer, a twin to the *moskophoros*, or calf bearer. The class is perhaps best known from the archaic marble figure at Athens, which represents a dedicant bearing a calf as a sacrificial offering to Athena. Cf. *Griechische Plastik* I, figs. 53a-c; *Gr Sculpture*, 39, pls. 22, 23. The Bowdoin statuette is a typical Hellenistic caricature of the class, an irreverent and ludicrous treatment of a handsome and

famous examplar. Cf. A. Köster, *Die griechischen Terrakotten*, 88–90, and figs. 3, 4, comparing the marble statue of the Spinario or the Boy with a thorn in his foot and the terracotta caricature of it from Priene.

375. *Standing woman holding a winged Eros in her arms* (fragmentary). The woman wears a cap and himation, in which her right arm is wrapped. She supports the Eros against her bosom with her left arm and right hand, which rests on his left shoulder. He is nude. The drapery of the lower part of the figure is drawn up under the left arm. There is a circular vent in the back. The head of the Eros and the lower part of the figure are missing.

Eastern Greek work. From Thyateira. Late second century B.C. Molded. Hollow. H, 0.225 m. W, 0.068 m. Warren Coll. Acc no. 1908.15.

Cf. *Die Typen* II, 35, nos. 6–8, near replicas; *Myrina*, 71–72, pl. 38, nos. 101, 102.

376. *Head of a chubby Eros.* The curly hair is drawn behind the ears. Over the head at a 45 degree angle is a heavy woolen fillet. The back is only roughly worked and there is a hole in the crown of the head. The clay is buff.

Greek work of the Myrina type. First century B.C. Molded. Hollow. H, 0.085 m. Warren Coll. Acc. no. 1923.13.

Cf. *Myrina*, 40, pl. 9, no. 19.

377. *Standing Macedonian youth.* The youth wears a chiton, a long chlamys, and a headpiece. His right arm is at his side, and his left under the cloak is raised to his chest. He stands on an oval pedestal. The back is unworked. Remains of white slip are evident. The clay is medium brown.

From the Troad. Hellenistic period. Molded. Hollow. H, 0.147 m. W of base, 0.052 m. Warren Coll. Acc. no. 1908.14.

Cf. *Die Typen* II, 239, nos. 1–5, for other terracotta figures of Macedonians.

378. *Satyr holding the infant Dionysos in his arms.* The satyr is standing with a cloak about his shoulders and back. The child is cradled in the left arm. Along his left leg up to the hip is a tree stump. The eyes of both figures are pierced through. The back is summarily treated and has a ring handle at the small of the back. The bottom was left open in firing, then sealed with a cover. The clay is medium brown.

Greek work. Hellenistic period. Molded. Hollow. H, 0.165 m. W, 0.060 m. Warren Coll. Acc. no. 1923.12.

K. Herbert, *CJ* 55 (1959–60) 109, fig. 18.

The satyr in Hellenistic art is not only good-natured and playful, he is also helpful and kindly, as in this instance. See *Hellenistic Age*, 139–140, figs. 569–572.

379. *Standing youth with cock.* The youth wears a cloak about the upper part of his body but is otherwise nude. With both hands he holds a bunch of grapes against his breast. He wears jewelry on the right side of his forehead. The cock stands to his left looking up at him. In relief on the front of the pedestal, on which the figures stand, is an indistinct scene of a youth with a club followed by a figure in a cart drawn by two animals. The back is unworked, but there is a square vent in the back of the youth.

From Cyprus. Hellenistic period or later. Molded. Hollow. H, 0.335 m; of base, 0.060 m. W, 0.110 m. Estes Coll. Acc. no. 1902.47.

Lawrence-Cesnola Collection, unnumbered pl.

380. *Head of a woman* (broken from figure). Her head and ears are covered by a hood, in front of which appears part of her coiffure, parted in the middle. Her brow, cheeks, and neck

are lined with age. Traces of white slip are abundant. The clay is light brown. The tip of the nose is missing and there is a crack in the crown of the head.

Greek work. Hellenistic period. Molded. Hollow. H, 0.095 m. Warren Coll. Acc. No. 1913.35.

The naturalistic approach of Hellenistic art enabled it to go beyond the idealism of the Classical period, which with few exceptions was limited to Greek types, and then only to the beautiful and the young. But the art of the Hellenistic period took as its subjects other races and all ages and stations in life: Gauls and Negroes, old women and young children, slaves and peasants. See *Hellenistic Age*, 3–6.

381. *Standing slave* (fragmentary). The figure wears a peaked cap but is otherwise nude. The head is bent down to the right in a grimace. The back is fully modeled. The clay is pink ocher. All below the chest is missing.

From Cyprus. Hellenistic period. Molded. Hollow. H, 0.082 m. Estes Coll. Acc. no. 1902.50.

Lawrence-Cesnola Collection, unnumbered pl.

382.* *Miniature mask of a satyr.* Ivy leaves are entwined in the hair over the heavily wrinkled brow. The mouth is open and it is framed by the full beard and moustache. There are two holes in the crown of the head for suspension. The clay is dark brown. PL. XXXVI

From Cyprus. Hellenistic period. Molded. H, 0.072 m. W, 0.045 m. Estes Coll. Acc. no. 1902.42.

Salaminia, 236, figs. 219, 220; *Lawrence-Cesnola Collection*, unnumbered pl.

383. *Mask of a youth.* The mouth is slightly open and smiling. Entwined in a fillet around his head are large leaves and berries. There are two holes

in the top of the head for suspension. The clay is reddish-brown.

From Cyprus. Hellenistic period. Molded. H, 0.045 m. Estes Coll. Acc. no. 1902.43.

Salaminia, 235, fig. 218; *Lawrence-Cesnola Collection*, unnumbered pl.

Cf. *Gr. Terracottas*, 23 and pl. 34, a larger mask of the same type from Myrina, of the second century B.C., now in Boston. These masks were suspended at the Dionysiac festival of the Anthesteria in Athens, among other places.

384. *Female Bacchic mask.* The hair is parted in the middle and brushed to the sides of this unglazed mask. Above the forehead two pearls appear in the coiffure and large earrings are also worn. There are small holes in the forehead and below the right ear for suspension, and the eyes are pierced. A small part of the left side is missing.

From Cyprus. Hellenistic period. Molded. H, 0.170 m. W, 0.160 m. Estes Coll. Acc. no. 1902.44.

Salaminia, 238, fig. 223; *Lawrence-Cesnola Collection*, unnumbered pl.

On the general subject, see G. Krien-Kummrow in *Encic AA*, s.v. "Maschera."

385. *Female mask* (fragmentary). The original lower edge is preserved. The sides of the face and the upper forehead are broken away, as well as pieces around the lips and eye holes. Parts of the suspension holes on both sides are preserved on this mask of unglazed reddish clay.

From Cyprus. Hellenistic period. Molded. H, 0.110 m. W. 0.120 m. Estes Coll. Acc. no. 1902.48.

Lawrence-Cesnola Collection, unnumbered pl. The photograph was made when the upper left side of the mask remained.

386. *Head of a boy.* The surface is badly worn and friable. There is also a hole on the right side.

From Cyprus. Hellenistic period. Molded. Hollow. H, 0.090 m. Estes Coll. Acc. no. 1902.126.

387. *Head of Eros.* The back is flat. From Cyprus. Hellenistic period. Molded. Solid. H, 0.025 m. Estes Coll. Acc. no. 1902.76.

388. *Standing dog.* The head and body are turned to the right. The dog wears a collar with pendants on it and a thick harness over his back. The back of the figure is unworked and has a circular vent. The figure stands on a high base. The dog is of the so-called Maltese type.
From Cyprus. About 100 B.C.–A.D. 100. Molded. Hollow. H, 0.150 m. Estes Coll. Acc. no. 1902.124.
Cf. *Kourion*, 53, pl. 17, nos. 1035–40.

389. *Miniature herm of Silenus.* The bearded head is bent down and rests upon the chest. The lower part of the figure is missing.
Greek work. Hellenistic period. Molded. Hollow. H, 0.032 m. W, 0.020 m. Warren Coll. Acc. no. 1913.22.

390. *Hand from a statuette.* The fingers are clenched loosely into a fist. The piece is broken off at the wrist. The hand is unglazed.
From Cyprus. Hellenistic period. Handmade. Solid. H, 0.055 m. W, 0.030 m. Estes Coll. Acc. no. 1908.82.

TERRACOTTA RELIEFS

391. *Head of a woman* (in relief). She is in frontal pose and wears a low polos with vertically grooved edges. Underneath it her hair over the forehead is arranged in scallops and drawn back at the temples. The eyes are almond-shaped and slightly canted. The tip of the nose is prominent and the mouth has the archaic smile. The clay

is coarse and ranges from buff to cream in color. The object is broken on all sides.
From Sicily or South Italy. Late sixth century B.C. H, 0.115 m. Warren Coll. Acc. no. 1913.41.
Cf. *Terracottas BM*, 149, pl. 72, no. 544.

392. *Head of the Gorgon Medusa* (in relief). She is in frontal pose and wears a crown of tongue pattern; beneath, the hair is parted in the middle and drawn to the sides in stylized waves. The pupils are rendered by incised lines and the tongue protrudes through closed lips. The back is flat. The clay is gray to yellow ocher. The object is broken on all sides.
From South Italy. Early fifth century B.C. H, 0.125 m. W, 0.110 m. Warren Coll. Acc. no. 1913.49.
Cf. *Tonreliefs*, 180–183, pls. 26, 36.

393.* *Crouching sphinx* (in relief). The body is in profile to the right, but the head is frontal. She wears a polos, and the coiffure emerges beneath it to encircle the forehead; stylized braids with horizonal lines fall on the shoulders. The wings are unfurled and the tail is curled into a figure eight. The back is slightly depressed but unworked. There are traces of red on the body. The clay is gray to yellow ocher. The front legs, hind paws, and base are missing. PL. XXXVIII
Melian work. About 470 B.C. H, 0.075 m. L, 0.080 m. Molded. Warren Coll. Acc. no. 1923.7.
Cf. *MR*, 89, pl. 66b, a replica in Athens. The so-called Melian reliefs, to which class this and the following three figures belong, chiefly consist of mythological scenes and are dated to the early and mid-fifth century. They were probably used as domestic wall decorations, because they have holes for fastening.

394. * *Winged woman* (in relief). The figure is in profile facing left and is preserved to the waist. Her hair is worn short and the wings are outspread. She holds a hare in the right palm and a dish of fruit with the left arm. There are traces of pink all over. The back is flat and unworked. The clay is gray to pink ocher. PL. XXXVIII

Melian work. About 470–460 B.C. Molded. H, 0.068 m. W, 0.084 m. Warren Coll. Acc. no. 1923.6.

J. D. Beazley, *AJA* 45 (1941) 342, fig. 1.

Beazley joins the Bowdoin fragment to its lower portion, now in Hamburg, to form an almost complete pendant. He says that the head is unusually charming and is important for its resemblance to the head of Atalanta in the Melian relief in Amsterdam. See *MR*, 25–27, nos. 16–18, pl. 9; no. 12, pl. 27.

395. * *Cock* (in relief). The bird is in profile facing left. There are traces of red on the low base and the wings, and black on the neck. There are two holes in the upper part of the body for suspension. The feathers on the body and tail are rendered plastically. The back is flat and unworked. The clay is buff. PL. XXXVIII

Melian work. About 450 B.C. Molded. H, 0.085 m. W, 0.085 m. Warren Coll. Acc. no. 1923.8.

Cf. *MR*, 90, pl. 67c, a near replica of a type which survives in numerous copies.

396. *Eros* (in relief). He faces right and holds his hands outstretched before him, the left raised above the right. His wings, of which only the right is visible, stretch out behind him. He is completely nude. The back of the plaque is flat. The clay is orange. All below the knees is missing.

Melian work. Mid-fifth century B.C. Molded. H, 0.068 m. W, 0.097 m. Warren Coll. Acc. no. 1915.25.

Cf. *MR*, pl. 5, nos. 7, 8, for similar treatment of the wing.

397. *Head of the Gorgon Medusa* (in relief). The face is frontal. The tongue is pendant, and the teeth and two tusks on each side are seen in the open mouth. The hair is treated as a horizontal series of knots across the head. The back is flat. The clay is light brown.

From Suessula, Campania. Mid-fifth century B.C. Molded. H, 0.060 m. Warren Coll. Acc. no. 1915.23.

Cf. *Terracottas BM* I, 341, pl. 171, nos. 1251, 1251 *bis*.

398. *Antefix in the form of a satyr's head.* The ears are pointed, the moustache and beard full and flowing. The semicircular back cover for attachment to the roof is hollow. The clay is reddish-brown and very sandy. Part of the back attachment is missing.

From Medma. Late fifth century B.C. H, 0.240 m. W, 0.170 m. Warren Coll. Acc. no. 1913.43.

Cf. A. Andrén in *Encic AA*, s.v. "Antefissa," fig. 558.

399. *Young satyr* (in relief). There is a vine wreath in the hair. The ears are pointed, the mouth smiling, and there are traces of red paint on the face. The back is hollow, and a semicircular section at the top of the head indicates that this mask may have been attached to a pole or column of some type. The back is hollow. The clay is yellow ocher. The chin and lower jaw are missing.

Greek work. Third century B.C. H, 0.165 m. W. 0.190 m. Warren Coll. Acc. no. 1913.42.

Cf. A. W. Lawrence, *Later Greek Sculpture* (1927) pls. 30b and 31a, a satyr of the third century B.C.

400. *Clay medallion with gorgon's head* (in relief). Traces of blue paint remain. The head is humanized, with

small wings rising from the crown. The clay is cream.

From Cyprus. Hellenistic period. Diam, 0.040 m. Molded. Estes Coll. Acc. no. 1902.66.

In art of the Classical period the earlier horrible visage of the gorgon is humanized, and in the Hellenistic period it even becomes handsome. The head, as in this and the following medallions, always remained a popular apotropaic device in antiquity for warding off evil. See G. Glotz in *Dar.-Sag.*, s.v. "Gorgones," cols. 1627–29; *Kourion*, 214, pl. 33, no. 2214.

401. *Clay medallion with gorgon's head* (in relief). There are traces of blue on the head.

From Cyprus. Hellenistic period. Diam. 0.035 m. Molded. Estes Coll. Acc. no. 1902.68.

See No. 400, above. Medallions of this type were even worn as jewelry. Cf. *DNM*, 61–62, nos. 569 and 583, pl. 71.

402. *Clay medallion with gorgon's head* (in relief). There are traces of blue on the head.

From Cyprus. Hellenistic period. Diam, 0.035 m. Molded. Estes Coll. Acc. no. 1902.69.

This medallion and No. 404, below, appear to have come from the same mold; see No. 400, above.

403. *Clay medallion with gorgon's head* (in relief). There are traces of blue on the head. The piece is much worn.

From Cyprus. Hellenistic period. Diam, 0.040 m. Molded. Estes Coll. Acc. no. 1902.70.

See No. 400, above.

404. *Clay medallion with gorgon's head* (in relief). There are traces of blue on the head. The piece is much worn.

From Cyprus. Hellenistic period.

Diam, 0.038 m. Molded. Estes Coll. Acc. no. 1902.71.

See No. 400, above.

405. *Clay medallion with gorgon's head* (in relief). Only the head itself remains.

From Cyprus. Hellenistic period. W, 0.030 m. Molded. Estes Coll. Acc. no. 1902.72.

See No. 400, above.

406. *Plaque with gorgon's head* (in relief). The left edge is missing.

From Cyprus. Hellenistic period. H, 0.035 m. W, 0.040 m. Molded. Estes Coll. Acc. no. 1902.67.

See No. 400, above.

407. *Fragment of sima with the head of Silenus* facing left. This fragment is the right-hand portion of a gutter slab. The original edge is preserved on the bottom and right. In front of Silenus is part of a thyrsus. There are traces of white on the face, blue in the background, and red on the full, flowing beard. The back has a thick, curved ribbing running horizontally across the center. The clay is very gritty and is a pink-buff.

Roman work. First century B.C. H, 0.170 m. W, 0.170 m. T, 0.070 m. Warren Coll. Acc. no. 1913.46.

The full design, preserved in similar but not identical replicas, consists of three faces: a maenad in frontal position between a young satyr and Silenus. Cf. *Tonreliefs*, 258, pl. 39.

408.* *Fragment of revetment plaque with the head of Ammon.* From the head rise heavy ram's horns. Between them is a volute decoration and below them a bandanna across the forehead. The figure also has a heavy mustache and an elaborately curled beard. Below are additional volutes. The back is flat. The clay is gray to pink ocher. The object is broken on top and both sides.

PL. XXXVIII

Roman work. First century A.D. H, 0.220 m. W, 0.100 m. T, 0.015–.030 m. Warren Coll. Acc. no. 1913.48.

Originally the god of Thebes in Egypt, Ammon became a national deity in the period of the Egyptian Empire. To the Greeks of the Classical age the fame of his oracle at Siwa rivaled that of the oracles of Apollo at Delphi and Zeus at Dodona. At Athens in the fourth century B.C. he received public sacrifice and in Greek art he is usually portrayed with a head of Zeus, to which his own ram's horns are added. A complete replica of this type is in the Museo delle Terme in Rome. Cf. *Tonreliefs*, 75, pl. 103. The head appears between two winged satyrs who end below in leafage. Another copy is in London. Cf. *BM Terracottas*, 380, no. D504.

409. *Fragment of revetment plaque with the head of Dionysus* in frontal position. The hair is heavy and the beard full. A fillet around the forehead terminates in leaves and buds. The pupils of the eyes are incised, and the mouth is open so that the teeth show. The back is flat. The clay is reddish-orange. The relief is broken on all sides.

Roman work. First century A.D. H, 0.170 m. W, 0.180 m. T, 0.025 m. Warren Coll. Acc. no. 1913.47.

Cf. *Tonreliefs*, 34, no. 69.

410. *Fragment of revetment plaque with a mask of the Gorgon Medusa.* Above the head are snakes and what appears to be a diadem. Wings rise from the crown of the head and the hair is so arranged that three vertical tufts, one in the center and one over each ear, are connected by horizonal waves. The teeth are shown and the tongue is out at full length. The chin is bordered by a ropelike object, which is perhaps a snake. Traces of yellow can be seen on the cheeks. The back is flat. The clay is reddish-brown. The relief is broken on all sides and the right cheek is chipped.

Roman work. Augustan period. H, 0.210 m. W, 0.190 m. T, 0.030 m. Warren Coll. Acc. no. 1913.45.

This fragment is a replica of a plaque in Naples, which in archaistic style represents Perseus and Athena holding the head of Medusa between them. It is attributed to the Augustan period. Cf. *Tonreliefs*, 14–17, pls. 115, 140; cf. a similar relief in London, *BM Terracottas*, 400, no. D602. The mask of Medusa is a commonplace on Roman terracotta reliefs. Cf. *DNM*, pls. 107–129 *passim*.

411. *Fragment of sima with Eros carrying a cluster of fruit.* Eros stands looking to his right with wings outspread. He is nude and has raised his left arm above his shoulder to support the weight of the fruit. There are traces of blue, green, and yellow on the relief. Above the relief is a fillet and on the top a sunken channel. The back is smooth and flat. The clay is light brown.

Roman work. Augustan period. H, 0.150 m. W, 0.140 m. T, 0.060 m. Warren Coll. Acc. no. 1913.44.

There is a similar plaque in Berlin showing two Erotes. Cf. *Tonreliefs*, 187–189, pl. 59, no. 2. For other Erotes on simas, cf. *DNM*, 97, no. 924, pl. 123; 93, no. 884, pl. 118.

412.* *Fragment of cresting with satyrs treading grapes.* Above is part of a rolled fillet. Two satyrs stand facing each other over a large pile of grapes, holding a ring between them. The figure on the left is bearded, the one on the right is clean-shaven and more youthful. They are both nude except for pantherskins slung over the shoulders and both have short tails. The back is flat. The clay is gray to pink ocher. The relief is broken on all sides and forms a rough triangle. PL. XXXVIII

Roman work. First century A.D. H, 0.230 m. W, 0.260 m. T, 0.017–.030 m. Warren Coll. Acc. no. 1913.29.

The design recurs in many other revetment crestings, but there are differences of detail in each. The complete piece consists of four figures: to the left of the two treaders is a young satyr playing the flute, to the right an older one bringing a basket of grapes. Cf. *Tonreliefs*, 65–69. For the head of the young satyr in the Bowdoin relief, cf. the fragment in Berlin, *ibid.*, 288; for a complete replica in London, *BM Terracottas*, 389, no. D543; in Copenhagen, *DNM*, 90, no. 856, pl. 110.

413.* *Fragments of cresting with a statue in the colonnade of a palaestra.* The statue of an athlete stands on a small pedestal; he holds a hoop in the right hand and a palm branch in the left. On both sides are Corinthian columns, and above is an architrave surmounted by a row of palmettes; fillets hang between the capitals. To the right can be seen part of a palm branch held by another figure. Traces of white, yellow, and blue paint remain visible. The back is flat. The clay is pink ocher. This relief is in two fragments, which join above the head of the youth. The left side and bottom are preserved.

PL. XXXIX

Roman work. Second century A.D. H, 0.345 m. W, 0.210 m. T, 0.035 m. Warren Coll. Acc. nos. 1927.24.1–2.

Complete replicas in the Palazzo dei Conservatori, Rome, and in Boston and Copenhagen show three statues between the columns of a palaestra: to the left is a figure similar to the Bow-doin one; in the middle, a victorious boxer; and to the right, an athlete crowning himself with a wreath. See *Tonreliefs*, 144–152; *DNM*, 92–93, no. 877, pl. 116; cf. *BM Terracottas*, 408, no. D632, for a similar scene.

414.* *Rainspout in the form of a lion's head.* The mouth is open and cut through. The back is hollow and roughly finished. The clay is orange to gray. The left ear, part of the mane, and one tooth are missing. PL. XXXIX

Provenance unknown. H, 0.200 m. W, 0.150 m. T. 0.125 m. Warren Coll. Acc. no. 1913.57.

Other types of spouts included dogs' and satyrs' heads; cf. *DNM*, 97, nos. 925–929, pl. 126.

415. *Finial in the form of a lion's head.* The mouth is open, but is not cut through. Above and behind the head is a projection smoothly finished on two sides which are at right angles to each other. The clay is gritty and brown. The nose and ears are chipped.

Provenance unknown. H, 0.200 m. W, 0.150 m. T, 0.125 m. Warren Coll. Acc. no. 1913.57.

For the probable use of this head, cf. D. S. Robertson, *A Handbook of Greek and Roman Architecture* ² (1959) fig. 96, showing the entablature of the Temple of Jupiter at Baalbek, as restored. This and the preceding piece could belong to the Hellenistic or to the Roman period. Cf. *DNM*, 64, no. 604, pl. 73.

VII

Small Bronzes

ARTIFACTS of bronze in the collections belong to two distinct categories. Statuettes and small reliefs comprise the first, implements and utensils the second. There are no bronze statues in the collections, but these are relatively rare because most such works were melted down in the Dark Ages to put the metal to practical uses. In general only those statues which were hidden either by earth or sea survived to be rediscovered in the modern period. Outstanding examples are the bronze Charioteer found in the sanctuary of Apollo at Delphi, the larger than life-size Poseidon brought up from the sea off Artemision, and the recently discovered *kouros* from a street excavation in Piraeus. The smaller bronzes were also preserved by being buried in the ruins of houses, tombs, and temples, and happily they have been found in fairly large numbers in both categories described above.

Bronze statuettes and small reliefs were used in antiquity as ornamental figurines, votive or funerary dedications, and decorative features on a variety of domestic and public objects. The Warren Collection has excellent examples illustrative of each of these groups. A dancing satyr (No. 428) is a good instance of the type of figurine which graced the atrium or peristyle of Roman villas, and a Silenus mask (No. 426) may also have served the same purpose. A Geometric horse (No. 416) and a resting Poseidon (No. 425) represent the class of votive decorations, and in the third and last category, decorative projections and reliefs, are a griffin protome (No. 417), a reclining Samian youth (No. 418), and the back handle from a hydria, or water jar (No. 420). The quality

of workmanship in these pieces places them among the most important objects in the collections and gives proof of the attractiveness and beauty of ancient metalworking in reduced scales.

Of the second class of small bronzes, implements and utensils, it must at once be noted that in antiquity bronze was used for a broad range of objects which are now made from steel, iron, aluminum, brass, glass, or plastic. Some of these were available to the ancient artisan, but bronze was felt to be more serviceable and often better suited to the artistic as well as the utilitarian ends of many objects. Among the varied pieces of interest in this class are a large Italian fibula (No. 439), a well-preserved Corinthinian helmet (No. 445), an Athenian strigil (No. 449), a large ladle (No. 447), and two thimbles (Nos. 465, 466).

BIBLIOGRAPHY

H. B. Walters, *Select Bronzes, Greek, Etruscan, and Roman. British Museum* (1915).
G. M. A. Richter, *Greek, Etruscan and Roman Bronzes. Metropolitan Museum of Art* (1915); *A Handbook of Greek Art*, rev. ed. (1960).
K. A. Neugebauer, *Bronzestatuetten* (1921); *Die griechischen Bronzen der klassischen Zeit und des Hellenismus* (1951).
Winifred Lamb, *Greek and Roman Bronzes* (1929).
J. Charbonneaux, *Les Bronzes grecs* (1958).
R. Lullies and M. Hirmer, *Greek Sculpture* (1957) *passim*, for life-size and colossal bronze statutes.

SMALL BRONZES (416–481)

BRONZE STATUETTES AND SMALL RELIEFS

416. * *Horse.* He stands on a perforated base, which has a snakelike decoration on its underside. The lower left foreleg is missing, and the right foreleg and tail are broken. PL. XL

Greek work. About 725 B.C. Cast and hammered. H, 0.100 m. Base: L, 0.057 m; W, 0.031 m. Warren Coll. Acc. no. 1927.14.

Casson, *Catalogue*, 13, no. 98; D. K. Hill, *AJA* 59 (1955) 39.

This Geometric statuette was probably a votive figure. See *Bronzes*, 39–40; *Gr Sculpture*, pl. 1; *Griechische Plastik* I, 14–21, figs. 10–15.

417. * *Griffin protome, or small bust* (from the shoulder of a caldron). The head and the neck are covered with semicircular scales. The eyes are of one piece with the rest. Three rivets remain in the base of the neck. Parts of the ears, a knob on the forehead, and the tip of the tongue are missing. PL. XL

Greek work. About 620–600 B.C. Hollow in the neck. L, 0.160 m. Diam. at base, 0.060 m. Warren Coll. Acc. no. 1923.16.

Casson, *Catalogue*, no. 122.

The head is one of several that were fastened to the shoulder of a bronze caldron. Such caldrons decorated with animal busts were among the favorite dedications in the sanctuaries of Archaic Greece. The griffin is an Oriental motive, found in Mesopotamian and Egyptian art, but the present type is a

Greek invention of the eighth century B.C. The knob on the forehead of the Hellenic versions is probably a stylized rendition of the top curl of an oriental prototype. Cf. A. Furtwängler, *Olympia* IV (1890) 115, 121–123; *Bronzes*, 70–72, fig. 8; *Gr. Sculpture*, 36, pls. 4, 5; *Griechische Plastik* I, 57–59, figs. 50a-b; On the whole subject, see O. Jantzen, *Griechische Greifenkessel* (1955).

418. *Reclining youth.* The figure is nude save for a mantle covering the lower part of the body and legs. The hair is worn long down the back and behind the ears, and the locks are arranged in a schematized checker pattern bound with a fillet. The youth supports himself on his left elbow, and his right hand rests on his right knee. The figure comes from the rim of a caldron. The left hand is missing.

Samian work. About 570–50 B.C. Solid. H, 0.050 m. L, 0.070 m. Warren Coll. Acc. no. 1923.17.

Casson, *Catalogue*, no. 103; V. Muller, *Art in America* 32 (1944) 19–25, fig. 1.

In the sixth century B.C. Samos was a commercial and cultural center where metalworkers, sculptors, architects, and gem engravers flourished. Among the writers and philosophers who lived there were Aesop, Anacreon, and Pythagoras. Unfortunately few bronzes of this school have survived, but the male figurines all display certain identifying features: a short, thick neck, heavy face, and broad chest. Cf. *Bronzes*, 101–103, pls. 21c, 36a. For the whole subject of Samian sculpture, see E. Buschor, *Altsamische Standbilder*, 5 vols. (1934 —).

419. *Youth carrying a burden.* The object, held over the left shoulder, is club-shaped in its present condition, but it may be the broken remains of a pole, on which a burden was carried. The youth wears a garment which is bound under his armpits and reaches to his feet. His shoulders are bare. The figure is worn, especially about the head.

Greek work. About 480–450 B.C. Solid. H, 0.090 m. Warren Coll. Acc. no. 1923.49.

Casson, *Catalogue*, 14, no. 105; V. Muller, *Art in America* 32 (1944) 19–25, figs. 2–3.

Cf. *Bronzes*, pl. 53b, a male nude from Athens of the same period. On the basis of the type of garment, Muller identifies this figure as a priest of Isis from Egypt and dates it about the last third of the third century B.C.

420.* *Back handle of a hydria* (kalpis shape). The upper attachment, oval in shape, is decorated with half-palmettes on each side. The outside of the stem of the handle is fluted. The lower attachment is elaborate and may be treated in three parts: the upper is a half-oval and is also decorated with half-palmettes on each side; the middle section shows a siren, frontal and in relief, with wings turned down; the lower part, an inverted palmette, has the feet of the monster resting on it. PL. XLI

Peloponnesian work. About 470–460 B.C. Solid. L, 0.160 m. Warren Coll. Acc. no. 1915.26.

Casson, *Catalogue*, 15, no. 123.

The back handles of fifth century kalpides often end below in a siren standing on a palmette. A list by G. Weicker, *Der Seelenvogel in der alten Literatur und Kunst* (1902) 131–133. For types of back handles cf. *Handbook*, nos. 298, 299, 305, 307.

421. *Bull.* The tail lies on the right flank. On the back is inscribed HIEPOI KABEIPOI. The figure stands on all fours without a support.

Greek work. About 500–460 B.C. Solid. H, 0.035 m. L. 0.041 m. Warren Coll. Acc. no. 1923.109.

Casson, *Catalogue*, 14, no. 106; K. Herbert, *AJA* 66 (1962) 381–382, pl. 104, fig. 1.

This votive figure may have come from the famous Kabeirion near Thebes in Boeotia. There is a similar figure in the Louvre. See J. G. Frazer, *Pausanias' Description of Greece* V (1898) 136–138; Neugebauer, *Die griechischen Bronzen*, nos. 30, 39; pl. 18.

422.* *Standing woman.* She wears a peplos with napkin and holds her skirt with the left hand. Her right arm was extended. The minor folds of the garment are done in incised lines. The face is battered and the right arm below the elbow is missing. PL. XLI
Peloponnesian work. About 470–450 B.C. Solid. H, 0.091 m. Warren Coll. Acc. no. 1913.33.
Casson, *Catalogue*, no. 104.
The standing woman in heavy woollen dress is a stock female type of Peloponnesian art in the sixth and fifth centuries B.C. One of the best examples of the type and near contemporary of the Bowdoin statuette is a bronze figurine of a girl at Berlin. Its attractiveness is heightened by the note of archaic restraint, a quality to be seen also in the Bowdoin figurine despite its mutilations. Cf. *Bronzes*, 149–150, pl. 55b; V. Poulsen, *Der strenge Stil* (1937) 16–34; Neugebauer, *Die griechischen Bronzen*, no. 8, pls. 8–10.

423. *Mina weight.* The object is rectangular. The upper surface bears a bull's head, frontal, in relief, and the inscription ΔΑΜΟΣΙΑ ΑΓΟΡΑΝΟΜΕΟΝΤΟΣ ΜΕΝΕΞΕΝΟΥ. All the omicrons are formed by dots in a circle.
Greek work. About 350–250 B.C. Solid. H, 0.067 m. 0.071 m. T, 0.009 m. Warren Coll. Acc. no. 1923.14.
Casson, *Catalogue*, no. 100; Casson, *AJA* 39 (1935) 516–517, fig. 6; K. Herbert, *AJA* 66 (1962) 382–383, pl. 104, fig. 4.
The inscription, which mixes the Doric and Ionic dialects, signifies that the piece, a market weight of one mina, was issued during the magistracy of

Menexenos as town clerk. Most weights of this type were square in shape and had a great variety of reliefs: the tortoise, dolphin, bull, the Sphinx, and Nike, among others. The weight of the Bowdoin slab, 413.3 gm, shows that it was made according to the Attic-Euboic standard, in which the norm for the mina is 431.0 gm. The difference in the present instance is not excessive and is partly the result of slight nicks in the slab. The Euboic standard was introduced into Attica by Solon, and in later times it tended to displace the other major system of weights, the Aeginetic, in which the mina norm was 630.0 gm. See E. Michon in *Dar.-Sag.*, s.v. "Pondus," and F. N. Pryce in *OCD*, s.v. "Weights."

424. *Cerberus squatting.* The large, central head is that of a lion, with smaller canine heads projecting from either shoulder. These lesser heads are supposed to represent a dog and a wolf, but they are not particularly differentiated in this small scale. Snakes twine about the forelegs of the figure and curl up behind and on top of the two lesser heads.
Greek work. About 400–200 B.C. Solid. H, 0.054 m. L, 0.045 m. Warren Coll. Acc. no. 1923.45.
Casson, *Catalogue*, 14, no. 101.
This piece is associated with a type of Cerberus represented in the Serapeum of Alexandria and coupled with the famous statue of Serapis by Bryaxis. Macrobius, *Saturnalia* I, 20, 13, describes the type, which Wilcken found in the entrance to the Serapeum at Memphis. Cf. *JDAI* 32 (1917) 190. For specimens in the British Museum, see A. Michaelis, *JHS* 6 (1886) 293; there are still others in Copenhagen, Turin, and Alexandria.

425.* *Poseidon.* The god is nude, with long hair and short, thick beard. His right leg is bent at the knee as he rests it on a rock. His right arm rests on

the right knee and his left arm is raised, for it once held a trident, now lost.

PL. XLII

Greek work. About 250 B.C. Solid. H, 0.060 m. Warren Coll. Acc. no. 1915.60.

Casson, *Catalogue*, no. 107.

The statuette is the same type as the Lateran statue, which is thought to be a copy of the Isthmian Poseidon by Lysippos. Casson notes that it also resembles in style the larger figures of the same period from near Dodona, which are now in the British Museum. For a statuette of Poseidon of the same size and posture, from India, see Sir Mortimer Wheeler, *Rome beyond the Imperial Frontiers* (1954) 180–181, pl. 20. For the artist and his work, see F. P. Johnson, *Lysippos* (1927); A. Giuliano and S. Ferri in *Encic AA*, s.v. "Lisippo."

426.* *Miniature Silenus mask.* He is bald, bearded, and wears an ivy wreath. Behind his horse's ears are circular cuttings. The tip of the nose is flat, an ancient mutilation; three rings, one on the top and each side, were cut off in modern times. PL. XLII

Greek work. From Ancona. Hellenistic period. Hollow. H, 0.120 m. W, 0.075 m. T. 0.040 m. Warren Coll. Acc. no. 1915.50. Formerly in the Tyskiewicz Coll.

W. Froehner, *Tyskiewicz Collection* (1893) pl. xi, no. 146; Casson, *Catalogue*, 16, no. 130.

Onto the original casting elements such as the leaves and berries of the wreaths were later soldered in the appliqué process.

427.* *Priapus.* He is nude, elongated, and angular. The chest is sunken, and the hips are forward. The arms are held akimbo, and the genitals are pronounced. He stands on a thin arc, which has small bosses on top. PL. XLII

Italian work. First century B.C. Solid. H, 0.105 m. W of arc at base, 0.046 m. Warren Coll. Acc. no. 1915.37.

Casson, *Catalogue*, 15, no. 128.

For four examples of this elongated type of figurine, cf. O. W. von Vacano, *Die Etrusker. Werden und Geistige Welt* (1955) pl. 86.

428. *Dancing satyr.* He is nude save for a pelt over the chest. The right arm is extended from the body horizontally; the left arm is missing. The right foot is forward. The figure is mounted on a modern pedestal.

Greco-Roman work. First century A.D. Hollow. H, 0.215 m. W, including arm, 0.115 m. Warren Coll. Acc. no. unknown.

Casson, *Catalogue*, 15, no. 126.

The left arm was probably bent so that the hand rested on the shoulder. The modeling is excellent. Cf. *MMA Bronzes*, 84–85, fig. 129.

429. *Plant or human hand.* The statuette vaguely resembles a human hand. Four of the five branches which rise from a single stock are broken; the fifth curves back upon itself. Ivy entwines itself around one of the branches and the head of a ram hangs from the same branch.

Roman work. Said to be from Pompeii. Solid. H, 0.053 m. W, 0.033 m. Johnson-Chase Estate. Acc. no. 1958.33.

The fragment may be from a stock such as appears in a statuette dedicated to the goddess Artio. Cf. *Bronzes*, pl. 52. This object also has a certain resemblance to symbolic hands. Cf. *BM Bronzes*, 160–161, nos. 875, 876.

430. *Silenus herm* (furniture support). He wears a cap with a crest on top. He is bearded and nude, and his arms are not represented below the shoulders, nor his body below the hips. The male organs are represented, but the penis is missing. The figure is set on a tall, thin pilaster, which has incised striations on the front. The bottom has moldings and the back a small projection for insertion.

Greco-Roman work. First or second

century A.D. Solid. H, 0.135 m. Warren
Coll. Acc. no. 1923.38.
 Casson, *Catalogue*, 14, no. 115.

431. *Lion's head.* The relief is cir-
cular, and features are indicated by
carelessly incised lines. The mouth is
open, with the tongue protruding be-
tween the two large incisors. The right
one of these, however, is broken away.
The mask was affixed to its background
by four rivets, three of which remain.
The head was made by the *repoussé*
process.
 Roman work. From Syria. First or
second century A.D. Hollow. Diam.,
0.170 m. Hammond Coll. Acc. no.
1898.18.
 In the *repoussé* process the design of
the relief was initially traced on the re-
verse of a bronze sheet. The sheet was
then heated and hammered out over
lead or pitch. Finally the plate was re-
versed, heated again, and the necessary
finishing touches were applied to the
front. In antiquity *repoussé* reliefs were
used in the decoration of furniture and
other objects. See *MMA Bronzes*, xxi–
xxii. Similar reliefs appear on the side
of a bronze bathtub from Boscoreale.
Cf. Mary Johnston, *Roman Life* (1957)
245.

432. *Lion's head.* The relief is simi-
lar to No. 431, above, but it is in better
condition.
 Roman work. From Syria. First or
second century A.D. Hollow. Diam.,
0.170 m. Hammond Coll. Acc. no. 1898.
19.

433. *Rider and pony.* The lower
parts of the rider's legs and his right
arm are missing, as are all the legs of
the pony. The piece is generally bat-
tered. The rider has a cloak thrown
back over his shoulders. There is also
a broken stub under the front legs of
the animal, which was probably a sup-
port.
 Roman work. First or second century

A.D. Solid. H, 0.087 m. W, 0.080 m. T,
0.027 m. Johnson-Chase Estate. Acc.
no. 1958.36.

434. *Right arm and hand holding a
lotus blossom* (from a statuette). The
bud is held between the thumb and the
first two fingers. Four holes for fasten-
ing the arm to the body are in the
drapery.
 Roman work. First or second century
A.D. Hollow in the arm. L, 0.130 m.
Diam. at elbow, 0.050 m. Warren Coll.
Acc. no. 1913.24.
 Casson, *Catalogue*, 15, no. 121.

435. *Phallus amulet.* The object has
a ring for suspension.
 Roman work. First or second century
A.D. Solid. L, 0.037 m. W, 0.019 m.
Warren Coll. Acc. no. 1930.27.
 Amulets were worn in antiquity to
protect the wearer from all kinds of
untoward events. Their forms were in-
numerable. See S. Eitrem in *OCD*, s.v.
"Amulets," with references; L. Roc-
chetti in *Encic AA*, s.v. "Amuleti," fig.
473.

436. *Winged monster with a dog
on its back.* The monster has horns and
a long tail which curves in corkscrew
fashion at the tip. Its legs are heavy-
set and its long neck is raised, with the
head looking upward. The dog's tail
is curled over his back, and his head
is turned to the right. A pin 0.040 m
in length extends downward from the
small base for attachment to a vessel
or piece of furniture. In general, the
piece is very crudely executed.
 Possibly Coptic work. Solid. H, 0.100
m. L, 0.075 m. Donor unknown. Acc.
no. 1930.32.
 Cf. J. Strzygowski, *Koptische Kunst.
Catalogue general MC* (1904) 329, no.
7016.

437. *Hephaistos* (modern replica).
He is nude and stands with his hands
raised above his head, perhaps in the

act of swinging the axe to cleave open the head of Zeus in order to release Athena.

H, 0.225 m. Hollow. Warren Coll. Acc. no. 1915.56.

Casson, *Catalogue*, 15, no. 124.

The present cast was made from the fifth century B.C. original, now in Dumbarton Oaks. See *Handbook*, 183, fig. 276.

BRONZE IMPLEMENTS AND UTENSILS

438. *Fibula.* The body is boat-shaped and is decorated with incised bands of herringbone design and concentric circles. There is a hole in the underside and the pin is missing.

Italian work. About 700–500 B.C. L, 0.105 m. H, 0.070 m. W of bow, 0.040 m. Warren Coll. Acc. no. 1913.34.

The primitive fibula or brooch, similar to the modern safety pin and shaped like a violin bow, is found during the late Bronze Age in Greece, northern Italy, and central Europe. It is generally thought to have developed in the Aegean area from a Minoan type of pin with a bent end to prevent slipping. The fibula evolved when the end was flattened into a catch to engage the point. It passed through a number of types, falling into comparative disuse in Greece after 600 B.C. but continuing in Italy into Roman times. Cf. *BM Bronzes*, 292, fig. 31; *MMA Bronzes*, 307–330; F. N. Pryce in *OCD*, s.v. "Fibula"; M. Pallottino in *Encic AA*, s.v. "Fibula," esp. fig. 782.

439.* *Fibula.* The turns of the bow are spiral-shaped and the whole of it has a herringbone design. The long pin has three disks at its top. Part of the catchplate is missing. PL. XLIII

Italian work. About 700–500 B.C. L, 0.255 m. W of bow, 0.055 m. Warren Coll. Acc. no. 1930.83.

Casson, *Catalogue*, no. 132.

Cf. O. Montelius, *La Civilisation primitive en Italie* I (1895) pl. 14.

440. *Fibula.* The sheathlike foot ends in a semicircular head, the tip of which is a spiral of two turns. The head is decorated with five small knobs. Part of the pin remains, being stuck in the catchplate.

Italian work. About 700–500 B.C. L, 0.045 m. Warren Coll. Acc. no. 1930. 26.

Cf. O. Montelius, *La Civilisation primitive en Italie* I (1895) pl. 10.

441. *Fibula.* A part of the catchplate and the bow up to the middle is preserved. The lower part of the bow is incised with horizontal bands, the upper with wide zones.

Italian work. About 700–500 B.C. L, 0.075 m. Hammond Coll. Acc. no. 1898.10.

442. *Bracelet.* The band is of thin sheet bronze ending in coiled, overlapping snakes' heads. The sides are chased with rows of scales.

Greek work. About 700 B.C. W, 0.008 m. Diam., 0.064 m. Warren Coll. Acc. no. 1930.7.

Casson, *Catalogue*, 16, no. 133.

In the Bronze Age bracelets were worn apparently by both men and women, but in Greek and Roman times they were commonly worn only by women. Bracelets of bronze were probably worn by those who could not afford the costlier ones of silver and gold. See *MMA Bronzes*, 336–342; R. Pulinas in *Encic AA*, s.v. "Braccialetto."

443. *Amuletic horse trapping.* The object consists of two rings separated by three vertical prongs. At the base of the prongs is a bull's head in relief, and on the side of each ring is a phallus.

Italian work. Seventh century B.C. H, 0.045 m. L, 0.073 m. T, 0.029 m. Warren Coll. Acc. no. 1915.27.

Casson, *Catalogue*, 15, no. 127.

On these objects, see W. B. Mc-

SMALL BRONZES

Daniel, *AJA* 22 (1918) 25–43. There are a number of them in Boston (inv. no. 02.330, for example).

444. *Amuletic horse trapping.* Two small rings are joined by a center piece with three upright prongs. On the front of each ring is a phallus.
Italian work. Seventh century B.C. L, 0.062 m. W, 0.027 m. T, 0.027 m. Johnson-Chase Estate. Acc. no. 1958. 28.
See No. 443, above.

445. * *Helmet* (Corinthian type). Cheekpieces and nose guard are extensions of the helmet itself. The nose guard is now bent upward. The object is otherwise in perfect condition.
PL. XLIII
Greek work. About 600–500 B.C. H, 0.225 m. L, 0.300 m. W, 0.170 m. Warren Coll. Acc. no. 1908.1.
Casson, *Catalogue*, 15, no. 129.
This type of helmet is so named because of its frequent occurrence on the coins of Corinth. It also appears on Corinthian and Attic black-figure and early red-figure vases. Cf. *MMA Bronzes* 411, fig. 1530. There is a Corinthian helmet in Boston (inv. no. 98.664). For the helmet in antiquity, see L. Guerrini and G. A. Mansuelli in *Encic AA*, s.v. "Elmo."

446. *Fibula.* The long catchplate, decorated with a knob at its end, leads into a semicircular bow. Two knobs project from the sides of the bow. The pin is missing.
Italian work. About 600–400 B.C. L, 0.047 m. Warren Coll. Acc. no. 1930. 25.

447. *Ladle.* The bowl is shallow. The top of the long handle divides into two swans' heads. The bowl is partly eroded.
Greek work. About 600–400 B.C. H, 0.380 m. Diam. of bowl, 0.092 m. Warren Coll. Acc. no. 1927.8.
Casson, *Catalogue*, 15, no. 135.

Ladles of this shape have been found in great numbers with Athenian black- and red-figure vases in Etruria. Cf. *MMA Bronzes*, no. 648.

448. *Jar.* The object is decorated with concentric circles and incised lines in two zones. Small areas of the base are eroded.
Greek work. About 500–300 B.C. H, 0.125 m. Diam. of lip, 0.060 m; of base, 0.053 m. Warren Coll. Acc. no. 1923.15.
Casson, *Catalogue*, 15, no. 125.

449. *Strigil.* The handle is curved back in the form of a swan's head in relief. The front of the handle is decorated with two spearhead designs. The back has an inscription incised in dotted letters in white: ΔΙΟΤΙΜΟΣ ΑΘΕΝΑΙΟΣ. The lower tip of the blade is missing.
Greek work. Fifth century B.C. L, 0.300 m. Warren Coll. Acc. no. 1913. 23.
Casson, *Catalogue*, 15, no. 120; K. Herbert, *AJA* 66 (1962) 382, fig. 3.
The strigil is a bath implement used in antiquity for scraping oil from the body after anointing. The blade is curved and hollow inside to catch the oil. This instrument was probably first produced in the sixth century B.C. and continued in use to the end of antiquity. In the earlier types the blade tends to be curved only slightly and the handle to be turned in a loop into which the hand was inserted. The Roman version, however, usually had a rectangular handle. See *MMA Bronzes*, 293–298.

450. *Strigil.* The blade bends at an angle of about 75 degrees. The looped handle, originally attached at the back of the blade, is now broken loose. On the front of the handle is stamped the name ΕΡΜΩΝ.
Greek work. Fifth or fourth century

B.C. L, 0.185 m. W, 0.020 m. Warren Coll. Acc. no. 1930.15.

On the personal name, see T. Lenschau in *RE VIII* (1913) s.v. "Hermon," cols. 893–894. The name is known from the fifth century on.

451. *Strigil.* The looped handle is now detached from the back of the blade. The tip of the blade is broken away but is preserved.

Greek work. Fifth or fourth century B.C. L, 0.140 m. W, 0.020 m. Warren Coll. Acc. no. 1930.16.

452. *Strigil.* The top of the handle is missing.

Greek work. Fourth century B.C. or later. L, 0.150 m. W, 0.022 m. Warren Coll. Acc. no. 1930.209.

453. *Strigil-handle.* Fourth century B.C. or later. The name ΣΩΓΕΝΗΣ is stamped on the fragment.

Greek work. L, 0.080 m. W, 0.015 m. Warren Coll. Acc. no. 1930.17.

On the name, see W. Kroll and others in *RE* III A (1927) s.v. "Sogenes," cols. 793–794.

454. *Disk mirror.* The flat side is decorated with concentric circles. The polished side is recessed to receive a cover.

Greek work. Hellenistic period. Diam., 0.110 m. Hammond Coll. Acc. no. 1898.6.

This type was made in pairs, one of which, like the present mirror, had a beveled edge. Into it the other fitted like a cover. The polished sides were set face to face and thus were protected from tarnishing. Cf. *MMA Bronzes*, no. 787.

The mirror is found in use in Egypt as early as the third millennium B.C. It was known to the Mycenaeans and was a commonplace toilet article of the Greeks and Romans, but it was not until the Roman period that mirrors were made of glass. Prior to that time polished metal, usually bronze, was employed, and this was sometimes covered with gold or silver foil. See *MMA Bronzes*, 251.

455. *Utensil ring.* The clasp consists of two dog's heads, which closes by the insertion of the tongue of one into the mouth of the other.

Roman work. First or second century A.D. Diam., 0.120 m. Warren Coll. Acc. no. 1927.7.

Casson, *Catalogue*, 16, no. 134.

Rings of this type were used in the bath for hanging up such objects as strigils, ointment bottles, and the like. Cf. *MMA Bronzes*, 298–299, no. 869.

456. *Ring.* The ends of this heavy utensil overlap. It was probably used for attaching bath implements.

Roman work. Said to be from Pompeii. First century A.D. Diam., 0.117 m. Johnson-Chase Estate. Acc. no. 1958.46.

457. *Two utensil rings.* They both are without adornment.

Roman work. Said to be from Pompeii. First century A.D. Diam., 0.045 m. Johnson-Chase Estate. Acc. nos. 1958.26.1–2.

458. *Strigil.* The blade is bent halfway at a right angle to the handle. Both handle and blade have linear stamping on the backs.

Roman work. Said to be from Pompeii. First century A.D. L, 0.180 m. W, 0.012 m. Johnson-Chase Estate. Acc. no. 1958.24.

459. *Strigil.* Part of the handle and part of the blade are missing.

Roman work. First century A.D. or later. L, 0.205 m. W, 0.040 m. Hammond Coll. Acc. no. 1898.21.

460. *Two large needles.* The thread hole of no. 1 is quite large (diam., 0.004 m), and the body is correspond-

ingly thick at the top. The thread hole of no. 2 is even larger, being rectangular (L, 0.015 m).

Roman work. Said to be from Pompeii. First century A.D. L of no. 1, 0.149 m; of no. 2, 0.180 m. Johnson-Chase Estate. Acc. nos. 1958.25.1–2.

These needles were used for heavy work, such as stitching leather or mending nets. See *MMA Bronzes*, 441–444, with figs.

461. *Bell.* The handle is circular. The upper surface of the bell, which is conical in shape, is raised above the lower and is ornamented with incised vertical lines ending in punched dots. The clapper was originally attached through the top, which is pierced by two holes, but the clapper is now missing.

Roman work. First century A.D. or later. H, 0.070 m. Diam., 0.037 m. Warren Coll. Acc. no. 1930.18.

Small bells are very commonly found on many ancient sites. The round bell is found in both Greek and Roman times, but those of rectangular shape are Roman. Bells were used on doors, in temples, on harnesses, and are frequently found suspended on armlets, since they were thought to possess magical qualities. See *MMA Bronzes*, 463–465.

462. *Bell.* The body is ovoid, the ring handle angular. The upper part around the handle is slightly raised. There are holes on both sides of the handle for the attachment of the clapper, which is missing.

Roman work. First century A.D. or later. H, 0.038 m. Diam., 0.027 m. Warren Coll. Acc. no. 1930.19.

463. *Bell.* The body is ovoid, the ring handle angular. The body is encircled by three bands of closely spaced, incised lines. The clapper is missing.

Roman work. First century A.D. or later. H, 0.022 m. Diam., 0.018 m. Warren Coll. Acc. no. 1930.21.

464. *Two inkstands.* The containers are identical. Each is round and has a series of horizontal bands encircling the sides and concentric circles on the slightly concave undersides.

Roman work. Said to be from Pompeii. First century A.D. H, 0.045 m. Diam., 0.034 m. Johnson-Chase Estate. Acc. nos. 1958.45.1–2.

A number of cups similar to the Bowdoin type have been found at Pompeii. Cf. *MMA Bronzes*, 448, fig. 1737.

465. *Thimble.* The object is covered with regularly spaced triangular impressions.

Roman work. First century A.D. or later. H, 0.030 m. Diam. of opening, 0.023 m. Warren Coll. Acc. no. 1930. 22.

Cf. Mary Johnston, *Roman Life* (1957) 209.

466. *Thimble.* The top is open. The sides are covered with closely punched dots.

Roman work. First century A.D. or later. H, 0.025 m. Diam. of top, 0.013 m; of bottom, 0.025 m. Warren Coll. Acc. no. 1930.20.

467. *Spatula.* There is a round protuberance between the handle and the blade. Its shape and size indicate that it was used in medical practice.

Roman work. First century A.D. or later. L, 0.098 m. W of blade, 0.006 m. Warren Coll. Acc. no. 1930.29.

Cf. *MMA Bronzes*, 450–451, and see the excellent articles with full bibliographies by Charles Singer in *OCD*, s.vv. "Medicine" and "Surgery."

468. *Spatula.* The object has a long handle.

Roman work. First century A.D. or

later. L, 0.132 m. W of blade, 0.080 m. Warren Coll. Acc. no. 1930.30.

469. *Fibula.* The bow is narrow and four-sided at the join with the catch-plate. It then becomes broad and flat. At the end it curves in a loop. The pin is missing.

Italian work. Said to be from Pompeii. First century A.D. L, 0.052 m. Johnson-Chase Estate. Acc. no. 1958. 31.

470. *Spoon.* The handle is thin and four-sided; at its end are two horizontal bars. The scoop is oval in shape and moderately deep.

Roman work. Said to be from Pompeii. First century A.D. *L*, 0.153 m. W of scoop, 0.038 m. Johnson-Chase Estate. Acc. no. 1958.19.

471. *Spoon probe.* It has a short, knobbed handle. Its size indicates that it was used by an apothecary or a physician.

Roman work. First century A.D. or later. L, 0.041 m. W, 0.009 m. Warren Coll. Acc. no. 1930.28.

Cf. *MMA Bronzes,* 452, fig. 1767. See No. 467, above.

472. *Tweezers.* The tips are flat, not pointed.

Roman work. Said to be from Pompeii. First century A.D. L, 0.077 m. Johnson-Chase Estate. Acc. no. 1958. 30.

Cf. *BM Bronzes,* 318; *MMA Bronzes,* 300–302.

473. *Hinge.* The leaf has numerous perforations, and its small size indicates that it was used on a chest.

Roman work. Said to be from Pompeii. First century A.D. L, 0.035 m. W, 0.027 m. Johnson-Chase Estate. Acc. no. 1958.35.

Cf. *MMA Bronzes,* 359.

474. *Key.* The body has a ring at its end and is stamped with a variety of lines. At the front of the body, at right angles, is a bar with three teeth on its left side.

Roman work. Said to be from Pompeii. First century A.D. L, 0.063 m. Johnson-Chase Estate. Acc. no. 1958. 20.

Cf. *MMA Bronzes,* 362, fig. 1247. The modern type of lock, in which the bolt is rotated on a pivot by a key, was common in Roman times. See F. N. Pryce in *OCD,* s.v. "Keys and Locks."

475. *Belt buckle.* The face has three moldings on all sides and volutes on the top and bottom. The back plate is attached to the facing at right.

Roman work. Said to be from Pompeii. First century A.D. H, 0.047 m. W, 0.020 m. T, 0.010 m. Johnson-Chase Estate. Acc. no. 1958.23.

Cf. *MMA Bronzes,* 330–335, with figs., showing a great variety of ancient belts.

476. *Fragmentary plate with handle.* The plate has a number of irregular perforations in it. From its present condition it is impossible to state its original purpose.

Roman work. Said to be from Pompeii. First century A.D. W, 0.070 m. Johnson-Chase Estate. Acc. no. 1958. 34.

477. *Handle of a spoon.* The upper end is slightly concave.

Roman work. Said to be from Pompeii. First century A.D. L, 0.088 m. Johnson-Chase Estate. Acc. no. 1958. 29.

478. *Small chain.* It is broken into two pieces.

Roman work. Said to be from Pompeii. First century A.D. Johnson-Chase Estate. Acc. no. 1958.27.

479. *Fragmentary hinge with two knuckles.* The leaf of the hinge is

pierced by one large and two small holes.

Roman work. First century A.D. or later. H, 0.038 m. W, 0.028 m. Warren Coll. Acc. no. 1930.24.

Cf. *BM Bronzes*, 371, no. 3197.

480. *Lamp.* The bowl is open, and the nozzle is long and uncovered. The base is slightly offset and circular and is divided through the center by an incised line. The rim is ridged, with small protuberances at regular intervals. There is a short, three-pointed handle.

Roman work. Third or fourth century A.D. L, 0.103 m. H, 0.023 m. Diam.

of bowl, 0.053 m. Warren Coll. Acc. no. 1930.23.

Casson, *Catalogue*, 16, no. 131.

481. *Perfume container with stopper.* The handle of the stopper consists of a crescent within which are spokes attached to a small hub. The stopper is threaded. From a narrow neck the body becomes fully rounded on the sides and rests on a small, rising base with four sides. The front and back of the body are flat and are decorated with floral designs. Some red enamel remains on the metal.

Arabic work. H, 0.095 m. W, 0.030 m. T, 0.024 m. Johnson-Chase Estate. Acc. no. 1958.44.

VIII

Engraved Gems and Jewelry

THE use of precious stones with engraved or intaglio designs for seals
is known from the early Sumerian period. Though Minoan and Myce-
naean artisans produced a wide range of designs on gems of lenticular
or glandular shape, production of such objects ceased for the most part
in sub-Mycenaean and Geometric times. A renaissance in Greece of the
sixth century B.C. is marked by the imitation of an Egyptian form, the
scarab or beetle shape; this was later modified to the scaraboid type,
without delineation of the beetle's back. The finished gems were regu-
larly set in swivel rings or attached as pendants to rings. Choice of sub-
jects followed contemporary tastes in the larger art forms, reflecting in
miniature the sequence of archaic, classical, and naturalistic tendencies
in representation. In the sixth and early fifth centuries B.C. favorites
included Heracles, Silenus, the Sphinx, warriors, and animals cut on
carnelian, chalcedony, or agate. Women in various poses and goddesses
such as Aphrodite and Nike were popular in the late fifth and fourth
centuries B.C., especially on chalcedony. Many new kinds of precious
stones, garnet, sardonyx, and topaz among them, were introduced from
the East in the Hellenistic period, and the simple ring stone, usually
flat on one side and convex on the other, then supplanted the scarab
and the scaraboid type as the standard. Portraits and scenes from daily
life or mythology were the chief subjects. An important technical de-
velopment of the period was the cameo, or relief, technique, which pri-
marily employed separate layers of colored quartzes to represent differ-
ing aspects of the relief.

In Italy, Etruscan gems employed the scarab form, mainly in carnelian, until the third century B.C., when it was superseded by the ring stone. By the late Republican period Greek stylistic elements predominated over Etruscan qualities and prepared the way for the classicist style of the Augustan age. In this time the ardor with which the great and wealthy, Julius Caesar among them, collected gems is especially noteworthy. Many such collections were exhibited in temples for all to see and enjoy. Subjects included mythological topics, everyday scenes, and portraits, for which the cameo was a most effective medium. Gem engraving declined in the middle Empire despite the general prosperity, and then saw another revival in the age of Constantine.

It is likely that the ancient gem cutter employed the rotating wheel to spin drills in the working of harder stones. At first the drill points were coated with emery powder mixed in oil, but later the Romans employed diamond dust in oil as an abrasive. It is also probable that a magnifying device was used, for the ancients were aware of the principle of magnification.

The working of gold and silver into pieces of jewelry was another art early practiced in Egypt and Mesopotamia, and so the Greeks probably learned much about it from their contacts with these countries. Through the centuries the Greeks and Romans used the following techniques in working these metals: modeling, casting, *repoussé*, cutting, granulation, filigree, plaiting, inlay, and chasing. Types produced include diadems, necklaces, earrings, bracelets, pins, and settings for ring gems. But because silver is subject to corrosion, relatively little silver jewelry has survived, whereas gold, being impervious to humidity, is preserved almost in its original condition.

The first large production of jewelry after the Minoan-Mycenaean age occurs in the seventh century B.C., chiefly in the prospering cities of Asia Minor and the Aegean islands. The style shows Oriental influence and the types include coiled bracelets and earrings ending in animal heads and pendants in the form of flowers. From the next century examples of the goldsmith's and silversmith's art are relatively scarce, perhaps because of the depredations of the Persian wars. But in the Classical and Hellenistic periods jewelry is abundant and fully developed in form. Human and animal motives are not uncommon, and painstaking use of filigree work is characteristic. Earrings have survived in the greatest number, ranging from superb and intricately wrought sculptural groups in miniature, such as the golden Nike driving a two-horse chariot, now in

Boston, to the common ring type in which one end forms an animal head, the other a hook, with the hoop between either plain or spirally wound. The availability of precious stones from the East in the late Republican and Imperial ages at Rome brought a change in design of jewelry, for gems then were set in the center of pieces and the gold or silver work became subsidiary. Garnets were favored at first, but later sapphires, emeralds, pearls, and many other stones were used in this work.

The following gems and jewelry in the collections are worthy of note: an Etruscan onyx scarab with an intaglio of Poseidon, of the early fifth century B.C. (No. 487); an agate cylinder with an intaglio of a standing heron, of the late fifth century B.C. and possibly the work of the famous engraver Dexamenos (No. 491); a nicolo cameo of three layers with Nike in a biga, of the late Hellenistic period (No. 506); a chalcedony cameo of two layers with busts of a man and wife, of the late Republican period (No. 507); a fragment of a blue-shell cameo with the head of the Emperor Commodus (No. 511), and an electrum diadem, of about the eighth century B.C. (No. 515); a gold earring (No. 524), a gold necklace with pearl-shaped sards (No. 525), a gold pin with carnelian head (No. 527), and a gold cable bracelet (No. 528), all of the Hellenistic period.

The following objects listed in Casson, *Catalogue*, 8–13, could not be found: no. 82, an oval garnet with an intaglio of Apollo with a lyre, of the Hellenistic period; no. 83, a green gem with the figures of a seated man detaining a slave boy from behind by the wrists, perhaps Hittite work; nos. 93 and 94, clay moldings made from Greek coins for use in burials; nos. 92a and b, identical glass moldings from a Roman cup, showing what may be the head of an emperor; and no. 116, a gold ring with carnelian scarab inset showing a goat intaglio on the underside, of about 450 B.C.

BIBLIOGRAPHY

A. Furtwängler, *Die antiken Gemmen*, 3 vols. (1900).
F. H. Marshall, *Catalogue of the Jewellery, Greek, Etruscan and Roman. British Museum, London* (1911).
J. D. Beazley, *The Lewes House Collection of Ancient Gems* (1920).
H. B. Walters, *Catalogue of Engraved Gems and Cameos, Greek, Etruscan and Roman in the British Museum* (1926).
E. Coche de la Ferté, *Les Bijoux antiques* (1956).
G. M. A. Richter, *Catalogue of Engraved Gems, Greek, Etruscan and Roman.*

Metropolitan Museum of Art (1956); *Handbook of Greek Art*, rev. ed. (1960) 232–242; 251–260.

Encyclopaedia Britannica (1961) s.vv. "Gems in Art," by G. M. A. Richter, and "Silversmiths' and Goldsmiths' Work: Egyptian to Roman," by E. J. Forsdyke.

Enciclopedia dell' arte antica classica e orientale, 4 vols. (1958 —) s.vv. "Cammeo," by L. Rocchetti, and "Glittica," by L. Breglia.

Encyclopedia of World Art, 6 vols. (1959 —) s.vv. "Gems and Glyptics: Archaic Greek Glyptics, etc.," by M.-L. Vollenweider, and "Gold- and Silverwork," by Pierre Amandry.

R. A. Higgins, *Greek and Roman Jewellery* (1961).

ENGRAVED GEMS AND JEWELRY (482–531)

ENGRAVED GEMS

482. *Carnelian bead* of three sides with intaglio of a stag on one side, scallops and linear decorations on the other two. The head of the stag is lowered as if to charge.

Middle Minoan III. About 1600–1550 B.C. H, 0.008 m. L, 0.018 m. Warren Coll. Acc. no. 1930.209.

AG, pl. lxi, no. 16, wherein it is identified as archaic; Casson, *Catalogue*, no. 64.

This bead was identified and dated by Mr. John Boardman of the Ashmolean Museum in a personal letter of April 1, 1961. The writer is most grateful for his assistance. Cf. V. E. G. Kenna, *Cretan Seals, with a Catalogue of the Minoan Gems in the Ashmolean Museum* (1960) 108, no. 146, pl. 7.

483. *Steatite bead* of lentoid shape with intaglio of a winged demon. On each side is a triangular pattern.

Greek work. Of the Island class. About 700 B.C. Diam., 0.015 m. Warren Coll. Acc. no. 1915.66.

Casson, *Catalogue*, no. 65.

Cf. *AG*, pl. v, no. 27, a similar figure from Melos.

484. *Sapphirine chalcedony seal* in the shape of a hexagonal cone with intaglio of a winged Artemis holding two lions by the tail. The lions are on both sides of the goddess, with heads turned

back toward her. The seal is of Assyrian shape.

Greek work. From Ionia. About 550 B.C. H of cone, 0.028 m. W of seal, 0.021 m. Warren Coll. Acc. no. 1915. 67.

Casson, *Catalogue*, no. 72.

Similar gems imported from Miletus and other cities of Asia Minor have been found in the Russian part of the Black Sea area, where this gem is said to have been found about 1850. Cf. *AG*, pl. vii, no. 51.

485. *Sard scarab* with intaglio of a centaur fighting a lion. The centaur has a rock raised in his right hand as he grapples with the lion at close quarters. The border is of cable pattern and there are hatched lines in the exergue. The work on the beetle is roughly done and there is a hole drilled lengthwise through the gem.

East Greek work. About 550 B.C. L, 0.009 m. Warren Coll. Acc. no. 1915. 68. From the Bruschi Coll.

AG, pl. vi, no. 45; Casson, *Catalogue*, no. 66.

Furtwängler sees Phoenician influence in this scarab.

486. *Discolored chalcedony scaraboid* with intaglio of the Gorgon's head. The front hair of the head is heavily cut; above and around the head snakes writhe in the air. In the lower left is

the retrograde inscription IΣ. The mount is modern.

Greek work. About 450–375 B.C. W, 0.018 m. Warren Coll. Acc. no. 1915. 71.

Casson, *Catalogue*, no. 90; K. Herbert, *AJA* 66 (1962) 382, pl. 104, fig. 2.

The treatment of the face of this gorgoneion identifies it with the type intermediate between the earlier archaic class and the later, handsome class of the Hellenistic period. This transitional type, beginning about the middle of the fifth century, modified the more hideous aspects of the archaic face. See A. Furtwängler in *Lex. Myth.* I, pt. 2, cols. 1718–21; cf. *AG*, pl. xl, no. 25.

487. *Brown onyx scarab* with intaglio of a beardless Poseidon pulling a rock formation apart in order to allow water to escape. The figure of the beetle is carefully worked; there is a hatched border around its base. The gem is drilled lengthwise. Poseidon, in right profile, has his right leg fixed horizontally against the rock wall and is using both hands to pry the rock loose. A stream of water is issuing forth, and his trident rests unused against the rock.

Greek work. About 450 B.C. H, 0.017 m. Warren Coll. Acc. no. 1915. 70.

Casson, *Catalogue*, no. 74.

This scarab ranks with the best examples of the Greek gem cutter's art in the opinion of Casson. Cf. *AG*, pl. xvii, no. 12. The water represents the spring of Amymone, created by Poseidon in honor of the Danaïd of that name whom he rescued from a satyr and then made his own.

488. *Emerald ring gem* of oval shape with intaglio of a lion pulling down a bull.

North Greek work. Early fifth century B.C. L, 0.019 m. Warren Coll. Acc. no. 1915.80.

Casson, *Catalogue*, no. 68.

Cf. *AG*, pl. vi, nos. 44, 51, 52. The subject apparently was a common theme in Archaic gems.

489. *White-paste glass* of oval shape with a drilled figure of a seated woman holding a trigonon, or triangular lyre, in her lap. The figure, in right profile, holds the instrument with her right hand and a plectrum in her left. The gem has a drilled hole running from top to bottom, and has a border of rope pattern. The glass is iridescent.

Greek work. About 450 B.C. H, 0.026 m. Warren Coll. Acc. no. 1915. 73.

Casson, *Catalogue*, no. 95e.

This gem is a contemporary imitation of a scaraboid type. Cf. *AG*, pls. xiii, no. 13; xiv, no. 19.

490. *Carnelian scarab* with intaglio of a kneeling bull. The left back of the beetle is chipped away. The bull kneels on his front right leg and is in right profile. There is a cable border.

Greek, or possibly Etruscan, work. About 450 B.C. W, 0.018 m. Warren Coll. Acc. no. 1915.84.

Casson, *Catalogue*, no. 67. Cf. *Lewes House Collection*, pl. a, nos. 14, 15.

491. *Buff and brown striated agate bead* of cylindrical shape and with intaglio of a standing heron. The bird stands on one leg, with the other pulled up and extended horizontally. The bead is drilled lengthwise.

Greek work. About 450–425 B.C. L, 0.026 m. Warren Coll. Acc. no. 1915. 14.

Lewes House Collection, 48–49, 59–61, pl. b, no. 4; cf. pl. 10, no. 66; Casson, *Catalogue*, no. 71.

The crane or heron was a great favorite of Greek gem cutters from the time of the fifth century B.C. artist Dexamenos. Beazley in his notes thinks that the present gem may be his work. See

L. Vlad Borrelli in *Encic AA*, s.v. "Dexamenos."

492. *Amethystine chalcedony seal* in the shape of an octagonal cone with intaglio of a leonine griffin. The griffin is in right profile with his left forepaw raised. He has two tails.

Greco-Persian work. Fifth century B.C. H of cone, 0.018 m. W of seal, 0.013 m. Warren Coll. Acc. no. 1923.112.

Casson, *Catalogue*, no. 73.

This class of gem was probably engraved for Persian clients by Greek artists. Among the subjects portrayed are hunts, battles, Persian men and women, animals, and monsters. See *Handbook*, 238–239, fig. 350.

493. *Greenish paste glass molding* of the head of Medusa.

Greek work. Fifth to third century B.C. Diam., 0.030 m. Warren Coll. Acc. no. 1915.81.

Casson, *Catalogue*, no. 91.

Paste glass is found as early as the fifth century but does not become common until the third. See Walters, *Catalogue of Engraved Gems and Cameos*, xvii.

494. *Greenish paste glass molding* of the head of Medusa, from the same mold as No. 493, above. The surface, however, is more worn and the glass is iridescent.

Warren Coll. Acc. no. 1915.107.

Casson, *Catalogue*, no. 91.

495. *Striped sardonyx* of oval shape with intaglio of a man, perhaps Ajax, killing a sheep. The man holds the animal's head with his right hand, and presses his knee into its back. His sword is in his left hand, and his cloak flutters behind him. The cable-pattern border is partially obscured by the fob type of mount, which is modern.

Greek work. Late fifth century B.C. Warren Coll. Acc. no. 1915.79.

Casson, *Catalogue*, no. 87.

For a contemporary gem showing Ajax committing suicide, see *AG*, pl. xvii, no. 32.

496. *White chalcedony scaraboid* with intaglio of a calf. A halter is suspended from the animal's neck.

Greek work. Late fifth or fourth century B.C. W, 0.023 m. Warren Coll. Acc. no. 1915.76.

Lewes House Collection, 66, pl. b, no. 5; Casson, *Catalogue*, no. 70.

This was a popular subject among Greek gem cutters.

497. *White paste glass molding* of oval shape with the figure of a rider and horse. The figures are in left profile, and the rider's cloak flows behind him.

Greek work. Late fourth century B.C. L, 0.023 m. Warren Coll. Acc. no. 1915.77.

Casson, *Catalogue*, no. 95c.

498. *Brown chalcedony scarab* with intaglio of Heracles bent over with broom in hand. The hero wears the lion's skin on his back and holds the broom in the right hand, perhaps cleaning out the Augean stables. A cable pattern surrounds the scene. Small metal tubes project from both ends of the lengthwise drilling.

Greek work. Hellenistic period. L, 0.021 m. Warren Coll. Acc. no. 1915.109.

499. *Carnelian ring gem* with intaglio of two heads. The figure on the left is a gorgon, that on the right a satyr.

Greek work. Hellenistic period. W, 0.014 m. Warren Coll. Acc. no. 1915.103.

Casson, *Catalogue*, no. 78.

500. *White paste glass molding* of oval shape with the figure of Aphrodite Anadyomene.

Greek work. Hellenistic period. H, 0.023 m. Warren Coll. Acc. no. 1915. 82.

Casson, *Catalogue*, no. 95d.

Cf. *AG*, pl. xliii, nos. 46–48.

501. *Greenish paste glass molding of the head of Medusa.* The reverse is convex and broken around an inner rim, indicating that this piece comes from a bowl or cup.

Greek work. Hellenistic period. Diam., 0.038 m. Warren Coll. Acc. no. 1915.106.

Casson, *Catalogue*, no. 91.

502. *Gray agate scarab* with intaglio of an Egyptian uraeus, or sacred asp. Above is the small figure of a bird.

Greco-Egyptian work. Ptolemaic period. H, 0.010 m. Warren Coll. Acc. no. 1915.110.

503. *Sard ring-gem* of oval shape with intaglio of a bull, head down and pawing the ground.

Greek work. Late Hellenistic period. W, 0.015 m. Warren Coll. Acc. no. 1915.84.

Casson, *Catalogue*, no. 69.

504. *Golden sard* of circular form with intaglio of the head of Medusa. Snakes surround the head.

Greek work. Late Hellenistic period. Diam., 0.013 m. Warren Coll. Acc. no. 1915.81.

Casson, *Catalogue*, no. 80.

Casson thinks that the head is of Hypnos.

505. *White on dark blue onyx* of circular form with intaglio of the head of a Negro. The head is in left profile.

Greek work. Late Hellenistic period. Diam., 0.010 m. Warren Coll. Acc. no. 1915.45.

Casson, *Catalogue*, no. 77.

506. *Cameo in three-layered nicolo,* dark brown, bluish white, and dark

brown again, of Nike in a biga, or chariot drawn by two horses. The figures move to the left, both horses rising up on their hind legs. The outer horse is dark brown; the inner one, the figure of Nike, and the wheel of the chariot are bluish-white. The mount is modern.

Greek work. First century B.C. W, 0.022 m. Warren Coll. Acc. no. 1915. 86.

Casson, *Catalogue*, no. 86.

The subject is a common one and much resembles a gem by Sostratus. Cf. *AG*, pl. lvii, no. 5.

507.* *Cameo in two-layered chalcedony,* white on pinkish-gray, with the busts of a man and wife. The mount is modern, and the noses of both figures are slightly chipped. Both heads are turned slightly toward each other.

PL. XLIV

Roman work. First century B.C. W, 0.041 m. Warren Coll. Acc. no. 1915.1.

Casson, *Catalogue*, no. 96.

For cameo portraits of the Roman period, see Walters, *Catalogue of Engraved Gems and Cameos,* pls. xxxviii–xlii.

508. *Chalcedony* of oval form with intaglio of a man in left profile. The head is possibly of Julius Caesar.

Roman work. Late Republican or early Imperial period. H, 0.021 m. Warren Coll. Acc. no. 1915.88.

Casson, *Catalogue*, no. 97.

Casson thinks the gem modern, but Warren and Beazley attest to its genuineness; see *President's Report: Bowdoin College Bulletin* (1924–25) 48ff. For gem portraits of Julius Caesar, see *AG*, pl. xlvii, nos. 34–37.

509. *Paste glass molding* of round shape with the head of a woman in right profile, probably from a cup. The letter K is in the field in the lower right.

Roman work. First or second cen-

ENGRAVED GEMS AND JEWELRY 135

tury A.D. Diam., 0.021 m. Warren Coll. Acc. no. 1915.108.

510. *Discolored sard* of oval shape with intaglio of the face of a satyr. On the left of the face in late letters is the name Τείμων, perhaps the owner of the gem. The setting is modern.

Greek work. Second century A.D. or later. H, 0.008 m. Warren Coll. Acc. no. 1915.87.

On the name, see J. Regner and others in *RE* VI A (1937) s.v. "Timon," cols. 1297–1303. It was especially common in the Hellenistic period.

511.* *Large fragment of a blue-shell cameo*, white on gray, with the upper part of an Antonine bearded head in left profile. The head is broken away below the nose on a horizontal line which curves down to the back of the neck. The head is crowned by a laurel wreath, with streamers flowing down the back of the neck. A piece of the neck is chipped away, and the setting is modern. PL. XLIV

Roman work. Late second century A.D. H, 0.028 m. Warren Coll. Acc. no. 1915.89.

Casson, *Catalogue*, no. 85.

Casson thinks that the portrait is of the emperor Antoninus Pius, A.D. 138–161, but the figure is probably the Emperor Commodus, A.D. 180–192. Cf. M. Hirmer, *Römische Kaizermunzen* (1942) pl. 43, a bronze coin with a quite similar head of Commodus in right profile, struck after A.D. 185. Cf. *AG*, pl. xlviii, nos. 18, 19, for the head of this emperor crowned in the same manner.

512. *Translucent sard ring gem* of oval shape with an inscription in raised letters. The mount is modern. The inscription reads

λέγουσιν
ἃ θέλουσιν·
λεγέτωσαν
οὐ μέλι μοί.

Byzantine work. About the tenth century A.D. W, 0.018 m. Warren Coll. Acc. no. 1928.1.

Casson, *Catalogue*, no. 109; K. Herbert, *AJA* 66 (1962) 387, pl. 104, fig. 11.

To judge from the sentiment of the inscription, this gem was intended for the current inamorata of some man-about-town.

513. *White chalcedony* of rectangular shape with intaglio of a centaur and Lapith in combat. The centaur, on the left, is about to strike with the butt end of a trident. On the right, the fallen Lapith prepares to ward off the blow with a shield raised on his right arm. In the exergue is the name ΚΡΩΜΟΥ retrograde. The setting is bronze with tiny ribbing.

English or German work. Late eighteenth or early nineteenth century. H, 0.030 m. W, 0.045 m. Warren Coll. Acc. no. 1915.90.

Casson, *Catalogue*, no. 81.

Casson describes the work as in the neoclassical style of Thorwaldsen and Flaxman, the famous sculptors of the late eighteenth and early nineteenth centuries. On Thorwaldsen and gems in imitation of his style, see George Lippold, *Gemmen und Kameen des Altertums und der Neuzeit* (1922) p. xii and pl. cxxx, nos. 1, 2.

514. *Reddish-brown onyx seal ring* with intaglio of a frog. The setting is modern.

Of unknown origin. H, 0.013 m. Bequest of Reginald E. Goodell. Acc. no. 1944.13.1.

JEWELRY

515. *Electrum diadem* decorated with stars and asterisks in relief and applied studs. The band is in a number of fragments, and several small pieces are missing.

Greek work. About the eighth cen-

tury B.C. H, 0.033 m. L, 0.210 m. Warren Coll. Acc. no. 1923.1.

Casson, *Catalogue*, no. 119.

Cf. Marshall, *Catalogue of Jewellery in the British Museum*, pl. xiii, no. 1157, a diadem of the eighth century B.C. with similar decoration. For the materials and techniques employed in ancient gold and silver metallurgy, see *GRJ*, 3–45.

516. *Gold ring* inset with burnt sard scarab, on a swivel, having an intaglio of Heracles. He is carrying two of the servants of Busiris slung from a pole with heads down. The band is decorated by incised rings near the swivel points and by offsets on its sides.

Greek work. Sixth century B.C. W of scarab, 0.015 m. Warren Coll. Acc. no. 1928.10.

For the swivel type of ring in a fifth century example, cf. Karl Schefold, *Meisterwerke griechischer Kunst* (1960) no. 563.

517. *Gold ring* insert with a carnelian having an intaglio of Athena holding a small Nike in her left palm. The goddess is helmeted and holds a staff in her left hand.

From Cyprus. Fifth century B.C. L, 0.012 m. Estes Coll. Acc. no. 1902.19.

For types of finger rings used in the Archaic and Classical periods, see *GRJ*, 129–131, pl. 24c, d, e.

518. *Gold ring* inset with carnelian having an intaglio of Hermes holding the caduceus. The band of the ring is thick on the sides and slender in the back.

From Cyprus. Fifth or fourth century B.C. H of stone, 0.011 m. Estes Coll. Acc. no. 1902.20.

519. *Bronze ring* with intaglio of Nike about to cut the throat of a sacrificial ram.

Greek work. About 400 B.C. H, 0.020 m. Warren Coll. Acc. no. 1915.75.

Casson, *Catalogue*, no. 84.

520. *Silver ring* with intaglio of a running horse. Above him is a crescent.

Greek work. Late fourth or third century B.C. W, 0.014 m. From Grotto Santo Stephano, Lake Bolsena, Italy. Warren Coll. Acc. no. 1923.114.

Casson, *Catalogue*, no. 88.

For contemporary rings of this type, cf. Karl Schefold, *Meisterwerke griechischer Kunst* (1960) nos. 568–569.

521. *Silver ring* with intaglio of a Maltese dog holding a wreath in his jaws. Above him is a crescent.

Greek work. Late fourth or third century B.C. W, 0.011 m. From Grotto Santo Stephano, Lake Bolsena, Italy. Warren Coll. Acc. no. 1923.13.

Casson, *Catalogue*, no. 89.

See No. 520, above.

522. *Gold earring* of coiled strands ending in the head of a hunting dog. Between the head and the ring there is filigree work in patterns of loops and volutes.

Greek work. Third century B.C. H, 0.015 m. Warren Coll. Acc. no. 1930.14.

Casson, *Catalogue*, no. 117.

Cf. H. Maryon and H. J. Plenderleith, "Fine Metal-Work," in *A History of Technology*, ed. Charles Singer and others, I (1954) 654–659, for a discussion of the techniques employed to create such work.

523.* *Gold earring* of interwoven strands which curve and thicken to terminate in a lion's head. There are filigree spirals on a band between the head and the ring. The lion's mouth is open. PL. XLV

Greek work. Third century B.C. H, 0.020 m. Warren Coll. Acc. no. 1923.34.

Casson, *Catalogue*, no. 112.

Cf. *GRJ*, pl. 47. Earrings decorated with the heads of animals, especially of lions, are a common feature of Greek jewelry in the Hellenistic period.

524. *Gold earring* of interwoven strands which terminate in the head of a leonine griffin. Two curved ringlets rise above the head, and between them is a small rectangular decoration. The eyes are of blue paste and the closed mouth holds a loop by which the pin may be fastened.

Greek work. Third century B.C. H, 0.025 m. Warren Coll. Acc. no. 1923. 33.

Casson, *Catalogue*, no. 112.

GRJ, 160–168, classifies Hellenistic earrings in six categories, the tapering hoop, chiefly with an animal head for a finial, and the pendant types being the most popular.

525.* *Gold necklace* of bent double-looped links and pear-shaped sards, with a lion's head for a finial. The matching lion's head is missing. PL. XLV

Greek work. About the third century B.C. L, 0.180 m. Warren Coll. Acc. no. 1923.36.

Casson, *Catalogue*, no. 111.

See *Handbook*, pl. facing p. 254; *GRJ*, 168–170, pl. 51b.

526. *Gold ring* inset with steatite scarab having an intaglio of a woman standing between two warriors. They wear helmets, greaves, and shields.

Etruscan work. Third century B.C. H of scarab, 0.012 m. Warren Coll. Acc. no. 1915.78.

Casson, *Catalogue*, no. 76.

Cf. *AG*, pl. xxii, no. 40.

527. *Gold pin* with round carnelian head. At the join of pin and stone there is some fine, circular filigree work.

Greek work. Hellenistic period. L, 0.102 m. Diam. of stone, 0.011 m. Warren Coll. Acc. no. 1928.9.

Casson, *Catalogue*, no. 114.

Pins are not normally part of Hellenistic jewelry. See *GRJ*, 175–176.

528.* *Gold cable bracelet* decorated with pellets. The join is covered by a rope type of winding. PL. XLV

Greek work. Hellenistic period. Diam., 0.065 m. Warren Coll. Acc. no. 1923.35.

Casson, *Catalogue*, no. 118.

Cf. Marshall, *Catalogue of Jewellery in the British Museum*, no. 1959, pl. xxxiv, a contemporary gold necklace with the same type of finely plaited gold wire.

529.* *Pair of gold earrings* ending in houndlike heads. The band of each ring is made of fine, tightly coiled threads followed by three beads, the inner one green, the outer two grayish. The ending is an animal's head with a pointed crest. The mouth is closed upon a round object, and beneath the chin is a loop into which the pin fits. PL. XLV

Greco-Egyptian work. Late Ptolemaic period. H, 0.033 m. Gift of Mr. John Hubbard. Acc. no. 1927.23.

Cf. Marshall, *Catalogue of Jewellery in the British Museum*, pls. xxxi–xxxii, for many examples of the type.

530. *Gold ring* inset with white on black onyx having an inscription in raised letters. The inscription consists of a large lunate E, below which in very small letters is χρυσοῦν. The setting is modern. The inscription appears to refer to the golden E dedicated by the Empress Livia at the shrine of Apollo at Delphi; cf. Plutarch, *Moralia*, 385 F.

Greek work. Late first century A.D. H, 0.010 m. Warren Coll. Acc. no. 1915.102.

Casson, *Catalogue*, no. 110.

531. *Gold ring* inset with sardonyx, on which in cameo is the head of a

satyr in white on dark brown. On each side of the band is a youthful bust in relief.

Roman work. About the second century A.D. H, 0.015 m. Warren Coll. Acc. no. 1923.115.

Casson, *Catalogue*, no. 75.

The Romans wore rings as marks of dignity, for ornamentation, or as seal-rings, and, unlike the Greeks, as tokens of betrothal. See *GRJ*, 189–192, pl. 62e.

IX

Coins

A COIN is a flan, or disk, of metal stamped with a mark by some author-
ity as a guarantee of value and used as money. Coinage, which began
in Lydia about 700 B.C. and soon thereafter in the Ionian Greek cities,
was a major advance in the history of man's attempts to facilitate the
exchange of goods. Beginning with simple barter, or the direct exchange
of goods or services without money, early agricultural and pastoral com-
munities advanced to the use of cattle or implements as standards of
value. The etymology of the Latin *pecunia*, money, from *pecus*, cattle,
gives evidence of this stage of the process. Next came the step in which
metal by weight was accepted as a more convenient medium, a stage
which developed in varied ways. In the trade of precious metals, for
example, bullion in various shapes and sizes began to be stamped with
marks as a warrant of quality. In Greece a *drachma*, or handful of iron,
or *obeliskoi*, or bronze spits, also came to be accepted as standards of
value. From these customs evolved the practice of coinage, in which
a piece of metal of suitable size could be exchanged with confidence and
without weighing because of the certifying stamp upon it.

Aegina was the first mainland city to strike silver coins, and soon after-
ward the Aeginetan standard for coinage was established, in which a
drachma was fixed as an ingot of about 90 grains of silver instead of
iron. Corinth, Chalcis, and Athens followed with their issues, and under
Solon Athens began using the lighter Attic-Euboean standard, in which
the drachma weighed about 65 grains. Early types or emblems on the
coins come chiefly from the animal and vegetable world, such as the

Pegasus on those of Corinth and the ear of wheat on those of Metapontum. But the most famous types are the head of Athena on the obverse and her owl on the reverse of the Athenian tetradrachm, a coin which dominated the Greek market in the fifth century B.C. (see Nos. 668–675). The earliest issues of the various cities had no inscriptions, but with increasingly wider circulation it became necessary to add legends to the locally known types. The first of these were often only the initial or beginning letters of the town's name. Silver was used almost exclusively, copper not finding employment until the latter part of the fifth century and gold no extensive use until the time of Philip II of Macedon.

In the period from the Peloponnesian War to the accession of Alexander the Great (431–336 B.C.) the art of engraving coins reached an excellence in the Greek cities which has never been equaled since. There are beautiful examples from Elis, Argos, Akragas, and Amphipolis, but none surpass the work of the Syracusan artists. The superb decadrachm of Evaenetus, issued to commemorate the great victory over the Athenians in 413 B.C., shows the head of Persephone surrounded by dolphins on the obverse and a victorious quadriga, with armor in the exergue, on the reverse (see No. 583). In the Hellenistic period Egypt, which had not previously issued coins, produced the richest series under the Ptolemies and also added a most significant innovation when the portrait of a living king, Ptolemy I, appeared in 306 B.C. on his coins. This device was to find its fullest exploitation among the Roman emperors. The advance of Roman influence first ended the issues of the Greek cities in South Italy and Sicily at the end of the third century B.C. and later had the same effect in Greece proper after the conquest of 146 B.C. Athens, one of the few cities privileged to continue its own coinage until the Empire, put forth one of the last important series of Greek coins, tetradrachms with a copy of the head of Athena Parthenos by Phidias on the obverse and her owl set upon a Panathenaic amphora on the reverse (see Nos. 682–684).

The comparatively late emergence of Rome as a great power is proven by such facts of her commercial life as the use of cattle as a standard of value down to about 450 B.C. and of uncoined bronze lumps (*aes rude*) until after 300 B.C. A forward step was taken in 289 B.C. with the issuance of heavy bronze bars stamped on both sides (*aes signatum*), but it was not until the middle of the third century that a true coinage appeared. In imitation of the Greek style a silver didrachm was struck for the cities and in continuance of the old system the heavy as (*aes*

grave), a pound of bronze and its subdivisions, was cast for the more conservative farming regions (see Nos. 757, 758). About 187 B.C. the silver denarius was introduced and quickly became the chief coin. Its original types were the head of Roma on the obverse and the Dioscuri on the reverse, but in the last century of the Republic a great variety of types appeared, many of them referring to the family history of the moneyers and others to events of Roman history which had significance as propaganda. This tendency reached its logical conclusion when the Senate authorized Julius Caesar to issue coins with his own portrait upon them (see No. 786).

From the time of Augustus onward the emperor controlled the gold and silver issues and the Senate, using the mark SC for Senatus Consulto, was chiefly responsible for the brass and copper (*aes*) coinage. The most important pieces were the aureus in gold, denarius in silver, sestertius and dupondius in brass, and the as in copper. All of the emperors made full use of the coinage to advertise themselves both by means of portraits and by the beneficial aspects of their rule as depicted in a great variety of legends and commemorative scenes. The gods of the state were also freely enlisted in this policy, appearing as protectors of the ruler or as the very personification of his virtues and those of his regime. It is this aspect of indoctrination in the imperial coinage which makes it a most important source for the history of the period, and its bias in favor of the ruling power in the cases of Tiberius, Nero, and Domitian, for example, forms an instructive contrast to the bleak and harrowing portrayals of these emperors in the works of Tacitus. Nero was the first to debase the silver coinage, an act which began a series of monetary devaluations and difficulties not ended until the time of Diocletian. Finally, the increasing use of Christian symbols and ultimately the appearance of Christ himself and the Virgin Mary on the coins of the Byzantine Empire reveal the theocratic qualities of the successor to Rome in the East (see Nos. 894, 899, 903–907).

The collection of Greek, Hellenistic, Roman, Byzantine, and early European coins forms a superb corpus for the study of ancient numismatics. The durability and size of coins make them especially desirable for a study collection such as the one at Bowdoin, and the quality of this particular section of the collections puts it on the same level as that of the terracotta figurines, being surpassed only by those of the vases and the sculptures. The Warren Collection, moreover, includes over 330 uncatalogued electrotypes of Greek coins in excellent condition. Be-

cause many of these copies include types not found among the origi-
nals, they form a most useful supplementary corpus.

On the Greek side the collection has 28 coins from Syracuse, of which
only four are duplicates; on the Roman side the portrait of every im-
portant Roman emperor with the exception of Diocletian is represented
on the coins from Augustus until Constantius II, in the middle of the
fourth century of the Christian era. These two examples are offered
simply to give some sense of the depth and range of the coins in the
collection. It is difficult to present a short, selective list of outstanding
individual pieces, but the following will serve that purpose: (1) silver
coin of Metapontum of about 550–470 B.C., with an ear of wheat on the
obverse and reverse (No. 545); (2) silver stater of Thasos of about
550–463 B.C., with an ithyphallic satyr struggling with a nymph on the
obverse (No. 626); (3) gold daric of Persia of about 521–425 B.C. (No.
725); (4) silver tetradrachm of Athens of about 514–407 B.C., with the
head of Athena on the obverse and the owl on the reverse, the most
famous coin of the period (Nos. 668–675); (5) silver decadrachm of
Syracuse of about 412–405 B.C., with the head of Persephone on the ob-
verse and a victorious quadriga on the reverse, perhaps the most beauti-
ful coin ever struck (No. 583); (6) silver tetradrachm of Carthage of
about 410–310 B.C. (No. 754); (7) gold stater of Alexander the Great
of about 336–323 B.C., with the head of Athena on the obverse and a
winged Nike on the reverse (No. 617); (8) gold octadrachm of Egypt
of about 270 B.C., with the head of Queen Arsinoë II on the obverse (No.
751); (9) aureus of Augustus Caesar of about 14–12 B.C. (No. 793);
(10) aureus of Hadrian of about A.D. 134–138 (No. 822); (11) gold
solidus of the Byzantine Emperor Constans II of about A.D. 651–659
(No. 891); and (12) gold solidus of the Holy Roman Emperor Fred-
erick II of about A.D. 1211–1250, one of the most handsome of medieval
coins (No. 908).

A special biographical note is in order here concerning John Max
Wulfing (1859–1929), the donor of fifty selected coins of the Roman
imperial age. He was born and educated in St. Louis, Missouri, and also
studied for a time in Germany. Though his career was devoted to the
family business interests, his lifelong avocation was the study of the
classics and especially Greek and Roman numismatics. His gift to Bow-
doin was occasioned by the fact that he maintained a summer home on
the Maine coast, but the greater part of his large and excellent coin
collection, one of the best of its kind in the nation, was bequeathed to

Washington University, St. Louis. With its related archaeological and numismatic library it is now suitably housed there in the Wulfing Room of Steinberg Hall. There are also a number of coins from the Wulfing Collection in the holdings of the American Numismatic Society in New York City.

The following donors have given ancient coins which cannot presently be identified or found: Charles Mustard, two bronze coins (Acc. no. 1898.59); Miss Veturia Manson, 15 coins (Acc. no. 1906.31); Miss S. M. Wells, two denarii (Acc. no. 1906.32); Miss Alice Sewall, three Republican coins (Acc. no. 1910.5); George D. Chase, a Roman as (Acc. no. 1912.12); and Frederick and Edward S. Dodge, an uncertain number of coins (Acc. no. 1925.11). There are also some 70 coins whose donors are unknown and which are in such condition as to be of little or no use for purposes of study or display. Some few of these may be identified by further study.

BIBLIOGRAPHY

Warwick Wroth, *British Museum Catalogue of the Imperial Byzantine Coins*, 2 vols. (1908).
B. V. Head, *Historia Numorum* [2] (1911).
H. Mattingly, E. A. Sydenham, C. H. V. Sutherland, and R. A. G. Carson, *The Roman Imperial Coinage*, 5 vols. in 7 parts (1923 —).
Sylloge Nummorum Graecorum (1931 —).
Oxford Classical Dictionary (1949) s.vv. "Coinage, Greek," by J. G. Milne, and "Coinage, Roman," by H. Mattingly.
E. A. Sydenham, *The Coinage of the Roman Republic*,[2] rev. by G. C. Haines (1952).
C. T. Seltman, *Greek Coins* [2] (1955).
F. P. Rosati in *Encyclopedia of World Art*, 6 vols. (1959 —) s.v. "Coins and Medals."
John Allan in *Encyclopaedia Britannica* (1961) s.v. "Numismatics: Greek Coins, Roman Coins."
H. Mattingly, *Roman Coins from the Earliest Times to the Fall of the Western Empire* [2] (1960).
Karl Schefold, *Meisterwerke griechischer Kunst* (1960) 284–307.

COINS (532–941)

GREEK COINS

532. *Silver coin of Etruria.* About 300–265 B.C. *Ob:* Bearded male head. The letter Λ. *Rv:* Plain.

Johnson Coll. Acc. no. 1919.58.10. Cf. *HN*, 13.

533. *Silver didrachm of Capua, Campania.* About 286–268 B.C. *Ob:* Head of youthful Janus. *Rv:* Jupiter in his quadriga. ROMA.

Johnson Coll. Acc. no. 1919.58.96. Cf. *HN*, 33–34, fig. 10.

534. *Silver didrachm of Hyria, Campania.* About 400–335 B.C. *Ob*: Head of Athena in crested Athenian helmet decorated with olive branch and owl. *Rv*: Man-headed bull. ΥΡΙΝΑΙ.
Johnson Coll. Acc. no. 1919.58.7. Cf. *HN*, 37–38.

535. *Silver didrachm of Neapolis, Campania.* About 340–241 B.C. *Ob*: Head of a nymph. *Rv*: Man-headed bull crowned by Nike. Signature ΙΣ beneath bull; in exergue, ΝΕΟΠΟΛΙΤΩΝ.
Johnson Coll. Acc. no. 1919.58.73. Cf. *HN*, 38–39, fig. 17.

536. *Silver didrachm of Arpi, Apulia.* Third century B.C. *Ob*: Head of Persephone. *Rv*: Prancing horse. Star in field and object beneath horse, perhaps a helmet. ΔΑΙΟΥ.
Johnson Coll. Acc. no. 1919.58.14. Cf. *HN*, 44, fig. 22.

537. *Silver diobol of Tarentum, Calabria.* About 400–300 B.C. *Ob*: Head of Athena in Attic helmet. *Rv*: Heracles strangling the lion.
Warren Coll. Acc. no. 1920.8.37. *Sammlung Warren*, no. 57. Cf. *HN*, 66–67.

538. *Silver didrachm of Tarentum.* About 380–345 B.C. *Ob*: A jockey up and crowning his horse with a victory wreath. A Λ in the field beneath the horse. *Rv*: Taras astride a dolphin. ΤΑΡΑΣ.
Warren Coll. Acc. no. 1920.8.38. Casson, *Catalogue*, no. 51. Cf. *HN*, 59–60.
This coin belongs to the period in which Archytas, the philosopher-statesman, was practically the ruler of Tarentum.

539. *Silver didrachm of Tarentum.* About 334–302 B.C. *Ob*: A naked horseman lancing downward. Beneath the horse's legs the letters ΣΑ. *Rv*: A naked boy astride a dolphin; below, a smaller, distant dolphin. ΤΑΡΑΣ.

Warren Coll. Acc. no. 1920.8.2. Casson, *Catalogue*, no. 52. Cf. *HN*, 61.

540. *Silver didrachm of Tarentum.* About 334–302 B.C. *Ob*: Naked horseman lancing downward. Letters ΣΑ under horse. *Rv*: Naked boy astride a dolphin, carrying a distaff. ΤΑΡΑΣ.
Johnson Coll. Acc. no. 1919.58.23. Cf. *HN*, 61.

541. *Silver drachm of Tarentum.* About 302–281 B.C. *Ob*: Head of Athena with figure of Scylla on helmet. *Rv*: Owl with closed wings on olive spray. ΤΑΡ.
Johnson Coll. Acc. no. 1919.58.98. Cf. *HN*, 68.

542. *Silver didrachm of Tarentum.* About 281–272 B.C. *Ob*: Boy rider crowning his horse. Signature of magistrate and moneyer: ΙΩ ΝΕΥΜΗ. *Rv*: Taras on his dolphin, holding a distaff. In the field, two stars. ΤΑΡΑΣ and signature ΠΟΛΥ.
Johnson Coll. Acc. no. 1919.58.27. Cf. *HN*, 62–63.

543. *Silver didrachm of Tarentum.* About 272–235 B.C. *Ob*: Boy rider crowning his horse. ΕΥΙΣΤΙΑΡ. *Rv*: Taras on his dolphin, holding an unidentifiable object in his right hand and a trident in his left. In the field, a bunch of grapes. ΤΑΡΑΣ.
Johnson Coll. Acc. no. 1919.58.25. Cf. *HN*, 64.

544. *Silver didrachm of Heraclea, Lucania.* About 281–268 B.C. *Ob*: Head of Athena in Corinthian helmet. ΗΡΑΚΛΕΙΩΝ. *Rv*: Heracles standing, holding club and lionskin, and being crowned by Nike. ΦΙΛΟ.
Warren Coll. Acc. no. 1915.98. Casson, *Catalogue*, no. 56. Cf. *HN*, 73.

545. *Silver third of a stater of Metapontum, Lucania.* About 550–470 B.C.

Ob: Ear of wheat in high relief. META.
Rv: Ear of wheat incuse.
Johnson Coll. Acc. no. 1919.58.29.
Cf. *HN*, 75, fig. 35.

546. *Silver stater of Metapontum.*
About 330–300 B.C. *Ob*: Head of De-
meter with wreath of wheat and flow-
ing hair. *Rv*: Ear of wheat; in the
field, a plow. META and magistrate's
name, MAN.
Johnson Coll. Acc. no. 1919.58.19.
Cf. *HN*, 79, fig. 40.

547. *Silver stater of Poseidonia, Lu-
cania.* About 470–400 B.C. *Ob*: Poseidon
wielding trident. *Rv*: Bull. ΠΟΣΕΙΔ
(retrograde).
Johnson Coll. Acc. no. 1919.58.30.
Cf. *HN*, 81, fig. 42.

548. *Silver stater of Poseidonia.*
About 470–400 B.C. *Ob*: Poseidon
wielding trident. ΠΟΣΕΙΔ and mark L.
Rv: Bull. ΠΟΣΕΙΔΑ (retrograde).
Johnson Coll. Acc. no. 1919.58.8.
Cf. *HN*, 81.

549. *Silver stater of Thurium, Lu-
cania.* About 425–400 B.C. *Ob*: Head of
Athena in helmet bound with olive
branch. *Rv*: Bull with head lowered.
In exergue, a fish. ΘΟΥΡΙΩΝ.
Johnson Coll. Acc. no. 1919.58.28.
Cf. *HN*, 86.
Coins of this period from Thurium
are among the finest specimens of nu-
mismatic art.

550. *Silver stater of Thurium.* About
425–400 B.C. *Ob*: Head of Athena in
helmet bound with olive branch. *Rv*:
Bull walking with head lowered.
ΘΟΥΡΙΩΝ.
Johnson Coll. Acc. no. 1919.58.26.
Cf. *HN*, 86, fig. 45.

551. *Silver stater of Thurium.* About
400–350 B.C. *Ob*: Head of Athena in
helmet adorned with the figure of
Scylla. On the neckplate the letters

ΣΩ. *Rv*: Rushing bull. In exergue, a
fish. ΘΟΥΡΙΩΝ and the letter Ω.
Johnson Coll. Acc. no. 1919.58.31.
Cf. *HN*, 86, fig. 46.

552. *Silver stater of Thurium.* About
400–350 B.C. *Ob*: Head of Athena in
helmet adorned with the figure of
Scylla. *Rv*: Rushing bull. ΘΟΥΡΙΩΝ.
Warren Coll. Acc. no. 1920.8.39. Cf.
HN, 86.

553. *Silver stater of Velia, Lucania.*
About 400 B.C. or later. *Ob*: Head of
Athena in helmet adorned with griffin.
Rv: Lion prowling. ΥΕΛΗΤΩΝ and
five-pointed star in field.
Johnson Coll. Acc. no. 1919.58.17.
Cf. *HN*, 89.

554. Similar type to above, but with
these differences: *Ob*: The letter A be-
hind the neckplate of the helmet. *Rv*:
In the field, a dolphin and the letters
IΦ.
Johnson Coll. Acc. no. 1919.58.68.

555. *Silver didrachm of Velia.*
About 400 B.C. and later. *Ob*: Head of
Athena in helmet adorned with a grif-
fin. Behind it are the letters IE. *Rv*:
Lion seizing upon a stag.
Johnson Coll. Acc. no. 1919.58.104.
Cf. *HN*, 89.

556. *Bronze coin of the Bruttii.*
About 282–203 B.C. *Ob*: Head of
bearded Ares, helmeted. *Rv*: Athena
fighting. ΒΡΕΤΤΙΩΝ.
Johnson Coll. Acc. no. 1919.58.70.
Cf. *HN*, 92.

557. *Silver third of a stater of Cau-
lonia, Bruttium.* About 480–388 B.C.
Ob: Naked male figure advancing; in
his uplifted right hand a stalk and in
his outstretched left arm a small, run-
ning naked figure. In the field, a stag.
ΚΑΥΛΟ (retrograde). *Rv*: Stag.
Johnson Coll. Acc. no. 1919.58.99.
Cf. *HN*, 92–94.

558. *Silver stater of Croton, Bruttium.* About 550–480 B.C. *Ob*: Tripod with crane. Koppa and PO (retrograde). *Rv*: Tripod incuse.
Johnson Coll. Acc. no. 1919.58.67. Cf. *HN*, 95, fig. 52.

559. Same type as above.
Johnson Coll. Acc. no. 1919.58.58.

560. *Silver stater of Croton.* About 390 B.C. *Ob*: Head of Apollo, laureate and with flowing hair. ΚΡΟΤΩΝΙΑΤΑΣ. *Rv*: Infant Heracles strangling two serpents.
Warren Coll. Acc. no. 1920.8.40. *Sammlung Warren*, no. 156. Cf. *HN*, 97.

561. *Bronze coin of Rhegium, Bruttium.* About 350–270 B.C. *Ob*: Lion's head, facing. *Rv*: Head of Apollo with flowing hair. ΡΗΓΙΝΩΝ.
Johnson Coll. Acc. no. 1919.58.93. Cf. *HN*, 111.

562. *Bronze coin of Rhegium.* About 270–203 B.C. *Ob*: Head of Artemis. *Rv*: Lion walking. ΡΗΓΙΝΩΝ.
Johnson Coll. Acc. no. 1919.58.5. Cf. *HN*, 111.

563. *Bronze coin of Rhegium.* About 203–89 B.C. *Ob*: Heads of Dioscuri. *Rv*: Hermes standing. ΡΗΓΙΝΩΝ and marks of value | | | |.
Johnson Coll. Acc. no. 1919.58.107. Cf. *HN*, 111–112.

564. *Silver third of a stater of Terina.* After 400 B.C. *Ob*: Head of Terina with curly hair. ΤΕΡΙΝΑΙΩΝ. *Rv*: Winged Nike-Terina seated on cippus, with bird perched in right hand.
Johnson Coll. Acc. no. 1919.58.3. Cf. *HN*, 113, fig. 64.

565. *Silver didrachm of Agrigentum, Sicily.* About 550–472 B.C. *Ob*: Eagle with closed wings. ΑΚΡΑΓΑΣ. *Rv*: Crab.

Johnson Coll. Acc. no. 1919.58.80. Cf. *HN*, 120.

566. *Bronze coin of Agrigentum.* About 430–413 B.C. *Ob*: Eagle. *Rv*: Crab.
Johnson Coll. Acc. no. 1919.58.79. Cf. *HN*, 120.

567. *Silver didrachm of Agrigentum.* About 450–406 B.C. *Ob*: Standing eagle. Illegible inscription. *Rv*: Crab.
Warren Coll. Acc. no. 1920.8.41. Cf. *HN*, 120–121.

568. *Silver tetradrachm of Agrigentum.* About 472–413 B.C. *Ob*: Eagle devouring a hare. ΑΚΡΑΓΑΝΤΙΝΟΝ. *Rv*: Crab; below, a river fish.
Warren Coll. Acc. no. 1915.101. Cf. *HN*, 121.
This coin is stated by Beazley and Warren to be false. It was put in the collection for purposes of study so that such forgeries might be more readily recognized.

569. *Silver coin of Agrigentum.* About 413–406 B.C. *Ob*: Eagle tearing a tunny. Inscription illegible. *Rv*: Crab. ΑΚΡΑΓΑΝΤΙΝΟΝ.
Warren Coll. Acc. no. 1920.8.83. Cf. *HN*, 121.

570. *Bronze coin of Agrigentum.* Of the rule of the tyrant Phintias (287–279 B.C.). *Ob*: Head. *Rv*: Wild boar. ΒΑΣΙΛΕΟΣ ΦΙΝΤΙΑ.
Johnson Coll. Acc. no. 1919.58.11. Cf. *HN*, 123.

571. *Bronze coin of Centuripae, Sicily.* After 241 B.C. *Ob*: Head of Demeter. *Rv*: Bird sitting on a plow. ΚΕΝΤΟΡΙΠΙΝΩΝ.
Johnson Coll. Acc. no. 1919.58.81. Cf. *HN*, 135.

572. *Bronze coin of Centuripae.* About 241 B.C. or after. *Ob*: Head of

Zeus. *Rv*: Winged fulmen. KENTO-
PIΠINΩN.
Johnson Coll. Acc. no. 1919.58.74.
Cf. *HN*, 135.

573. *Silver litra of Entella, Sicily.*
About 400 B.C. *Ob*: Female figure sac-
rificing. *Rv*: Man-headed bull. In ex-
ergue, a snake. ENTEΛΛINΩN.
Warren Coll. Acc. no. 1920.8.42. Cf.
HN, 137.

574. *Silver tetradrachm of Leontini,
Sicily.* About 466–422 B.C. *Ob*: Head
of Apollo, laureate. *Rv*: Lion's head
with open jaws, surrounded by four
grains of wheat. ΛEONTINON.
Warren Coll. Acc. no. 1923.118.2.
Sammlung Warren, no. 250; Casson,
Catalogue, no. 47. Cf. *HN*, 149, fig. 78.

575. *Bronze coin of Messana, Sicily.*
About 288–210 B.C. *Ob*: Head of Ares,
laureate, copied from the Syracusan
Zeus Hellanios. In the field, a spear-
head. APEOΣ. *Rv*: Eagle, wing open,
on a fulmen. MAME.
Johnson Coll. Acc. no. 1919.58.106.
Cf. *HN*, 156.

About 288 B.C. Messana was cap-
tured by a band of Campanian mer-
cenaries who called themselves Mam-
ertini, after an Oscan form of the name
for Mars. They proceeded to plunder
northeast Sicily, until defeated by
Hieron of Syracuse about 265 B.C. They
also precipitated the First Punic War
when they appealed to Rome for pro-
tection from Carthage.

576. *Bronze coin of Messana.* After
210 B.C. *Ob*: Head of Ares. *Rv*: Dios-
curos beside horse. In the field, the
letter Π. MAMEPTINΩN.
Johnson Coll. Acc. no. 1919.58.108.
Cf. *HN*, 156.

577. *Silver didrachm of Selinus,
Sicily.* About 466–415 B.C. *Ob*: Heracles
struggling with a bull, whose horn he
holds with his left hand; in his right

he raises a club to strike. Inscription
illegible. *Rv*: Figure of river Hypsas
facing except for head, which is right;
to the left is an altar, around which a
serpent coils. Hypsas holds a branch
and phiale. To the right is a marsh bird
and in the field a selinon leaf. HYΨAΣ.
Johnson Coll. Acc. no. 1919.58.21.
Cf. *HN*, 168.

578. *Silver tetradrachm of Syracuse,
Sicily.* About 474–466 B.C. *Ob*: Female
head surrounded by four dolphins.
ΣYPAKOΣION. *Rv*: Slow biga, the
horses being crowned by a flying Nike.
In the exergue, a pistrix, or sea monster.
Johnson Coll. Acc. no. 1919.58.24.
Cf. *HN*, 173, fig. 93.

This coin is from the reign of Hieron
I (478–467 B.C.), famous for his patron-
age of poets and philosophers — Aes-
chylus, Pindar, Bacchylides, Simonides,
and Xenophanes. The chariot on the
obverse commemorates his victories in
the Games, and the sea monster may re-
fer to his great victory over the Etrus-
cans off Cumae in 474 B.C.

579. Same type as above.
Johnson Coll. Acc. no. 1919.58.22.

580. *Silver tetradrachm of Syracuse.*
About 474–466 B.C. *Ob*: Female head
to right with hair bound by a plain
fillet, surrounded by four dolphins.
ΣYPAKOΣION. *Rv*: Slow biga, the
horses crowned by a flying Nike.
Johnson Coll. Acc. no. 1919.58.8b.
Cf. *HN*, 174, fig. 94.

581. *Silver tetradrachm of Syracuse.*
About 466–430 B.C. *Ob*: Female head
with hair bound up in a spiral, sur-
rounded by four dolphins. ΣYPAKO-
ΣIO. *Rv*: Slow quadriga, the horses
crowned by a flying Nike.
Johnson Coll. Acc. no. 1919.58.78.
Cf. *HN*, 174, fig. 95.

This is a coin of the democracy
which followed upon the expulsion of
the Gelonian dynasty in 466 B.C.

582. *Gold diobol of Syracuse.*
About 413–357 B.C. *Ob*: Head of young
Heracles in lionskin. *Rv*: Quadripartite
incuse square with female head in center.
Johnson-Chase Estate. Acc. no. 1958.
18.15. Cf. *HN*, 175.

583. *Silver decadrachm of Syracuse.*
About 412–405 B.C. *Ob*: Head of Persephone crowned with cereal leaves and
wearing triple earrings. Four dolphins
encircle the head. *Rv*: Quadriga and
charioteer. Overhead, a Nike bears a
crown. In the exergue, a breastplate
between two greaves in the center, a
shield to the left, and a helmet to the
right.
Warren Coll. Acc. no. 1914.6.1.
Sammlung Warren, no. 360; Casson,
Catalogue, no. 45. Cf. *HN*, 176, fig. 99.
This magnificent coin was issued
after the great victory over the Athenians in 413 B.C.

584. *Silver drachm of Syracuse.*
About 413–357 B.C. *Ob*: Head of
Athena, facing, in richly adorned helmet, surrounded by dolphins. ΩNE-
ΥΡΟΣ. *Rv*: Hero Leukaspis with shield
and spear, fighting. Behind him, an
altar; before, a dead ram. ΣΥΡΑΚΟ-
ΣΙΟΝ; in the exergue, an illegible name.
Warren Coll. Acc. no. 1920.8.43. Cf.
HN, 177–178.

585. *Electrum coin of Syracuse.*
About 357–353 B.C. *Ob*: Head of
Apollo. *Rv*: Tripod. ΣΥΡΑΚΟΣΙΩΝ.
Johnson Coll. Acc. no. 1919.58.20.
Cf. *HN*, 178.
This piece belongs to the time of
Dion, the disciple of Plato who expelled the tyrant Dionysius II in 357
and was himself assassinated in 353.

586. *Bronze coin of Syracuse.* About
350–216 B.C. *Ob*: Head of Apollo,
laureate. *Rv*: Pegasus. In the field, a
star. Inscriptions illegible.

Johnson Coll. Acc. no. 1919.58.72.
Cf. *HN*, 180, 185.

587. *Bronze coin of Syracuse.* About
345–317 B.C. *Ob*: Head of Zeus. ΖΕΥΣ
ΕΛΕΥΘΕΡΙΟΣ. *Rv*: Thunderbolt; small
eagle in the field. ΣΥΡΑΚΟΣΙΩΝ.
Johnson Coll. Acc. no. 1919.58.77.
Cf. *HN*, 180.

588. *Bronze coin of Syracuse.* About
345–317 B.C. *Ob*: Head of Apollo. *Rv*:
Pegasus; the letter A beneath him.
Johnson Coll. Acc. no. 1919.58.90.
Cf. *HN*, 180.

589. Similar type to above, but
smaller.
Johnson Coll. Acc. no. 1919.58.29b.

590. *Bronze coin of Syracuse.* About
317–310 B.C. *Ob*: Head of Persephone.
Inscription illegible. *Rv*: Bull rushing.
In the field, dolphins and the letters
ΛΚ.
Johnson Coll. Acc. no. 1919.58.13.
Cf. *HN*, 181.

591. *Bronze coin of Syracuse.* About
317–310 B.C. *Ob*: Head of Persephone.
ΣΥΡΑΚΟΣΙΩΝ. *Rv*: Bull rushing. The
coin is badly worn, especially the reverse.
Warren Coll. Acc. no. 1920.8.5. Cf.
HN, 181.

592. Same type, but in better condition. On the reverse, two dolphins
and the letters AI in the field.
Johnson Coll. Acc. no. 1919.58.71b.

593. Same type, but in poor condition.
Johnson Coll. Acc. no. 1919.58.87.

594. *Silver tetradrachm of Syracuse.*
About 317–310 B.C. *Ob*: Head of Persephone surrounded by three dolphins.
Below, the letters ΝΙ. *Rv*: Quadriga
with driver. Above, the symbol of triskeles, or three legs. In the exergue,

ΣΥΡΑΚΟΣΙΩΝ. Below, monogram of the letters Λ and Υ.
Warren Coll. Acc. no. 1895.1. Casson, *Catalogue*, no. 33. Cf. *HN*, 181, fig. 104.
This coin belongs to the early part of the rule of Agathocles (317–289 B.C.), a demagogue famous for his wars against Carthage and the other towns of Greek Sicily.

595. Same type as above.
Johnson Coll. Acc. no. 1919.58.1.

596. *Bronze coin of Syracuse.* About 304–289 B.C. *Ob*: Head of Artemis. ΣΩΤΕΙΡΑ. *Rv*: Fulmen. ΑΓΑΘΟ-ΚΛΕΟΣ ΒΑΣΙΛΕΟΣ.
Johnson-Chase Estate. Acc. no. 1958. 18.3. Cf. *HN*, 182.

597. *Bronze coin of Syracuse.* About 288–279 B.C. *Ob*: Head of Persephone with long hair. ΣΥΡΑΚΟΣΙΩΝ. *Rv*: Biga. In the field, a star.
Johnson Coll. Acc. no. 1919.58.72a. Cf. *HN*, 183.

598. *Bronze coin of Syracuse.* About 288–279 B.C. *Ob*: Head of Zeus Hellanios. ΔΙΟΣ ΕΛΛΑΝΙΟΥ. *Rv*: Eagle on fulmen. ΣΥΡΑΚΟΣΙΩΝ.
Johnson Coll. Acc. no. 1919.58.105. Cf. *HN*, 183.

599. Similar type to above, but in much better condition.
Johnson Coll. Acc. no. 1919.58.75.

600. Similar type to above, but with head to right on the obverse.
Johnson Coll. Acc. no. 1919.58.85.

601. *Bronze coin of Syracuse.* About 278–275 B.C. *Ob*: Head of Persephone with long hair. ΣΥΡΑΚΟΣΙΩΝ. *Rv*: Nike in a biga.
Johnson Coll. Acc. no. 1919.58.86. Cf. *HN*, 183.

602. *Bronze coin of Syracuse.* About

278–275 B.C. *Ob*: Head of Heracles with lionskin covering. *Rv*: Athena in fighting stance, her right arm with javelin upraised, her left arm holding shield forward. ΣΥΡΑΚΟΣΙΩΝ.
Johnson Coll. Acc. no. 1919.58.76. Cf. *HN*, 183.
This coin probably belongs to the time of Pyrrhus' expedition into Sicily.

603. *Silver litra of Syracuse.* About 274–216 B.C. *Ob*: Head of Queen Philistis, veiled. *Rv*: Quadriga driven by Nike. ΒΑΣΙΛΙΣΣΑΣ ΦΙΛΙΣΤΙΔΟΣ.
Johnson Coll. Acc. no. 1919.58.2. Cf. *HN*, 184–185, fig. 108.
Philistis was the queen of Hieron II, a young officer of Pyrrhus, who after his departure from Sicily rose to great power at Syracuse and after a victory over the Mamertines became king in 269 B.C.

604. *Bronze coin of Syracuse.* About 274–216 B.C. *Ob*: Head of Hieron, diademed. The letter Υ in field. *Rv*: Armed horseman. ΙΕΡΩΝΟΣ. The letter Λ in field.
Johnson Coll. Acc. no. 1919.58.15. Cf. *HN*, 185.

605. *Silver coin of Syracuse.* About 215–212 B.C. *Ob*: Head of Athena, helmeted. *Rv*: Artemis hunting with hound. ΣΥΡΑΚΟΣΙΩΝ and the letters ΣΩ.
Warren Coll. Acc. no. 1920.8.44. Cf. *HN*, 186.

606. *Bronze coin of Tauromenium, Sicily.* About 275–210 B.C. *Ob*: Head of Apollo. *Rv*: Tripod. ΤΑΥΡΟΜΕΝΙ-ΤΑΝ.
Johnson Coll. Acc. no. 1919.58.7b. Cf. *HN*, 189.

607. *Bronze coin, perhaps of Tauromenium.* About 275–213 B.C. *Ob*: Head of a deity, laureate and with flowing hair. *Rv*: Tripod.
Johnson Coll. Acc. no. 1919.58.88. Cf. *HN*, 189.

608. *Silver drachm of Neapolis, Macedonia.* About 411–350 B.C. *Ob*: Gorgon with protruding tongue. *Rv*: Head of Aphrodite bound with laurel wreath. Letter Π on left, O on right.
Warren Coll. Acc. no. 1914.6.8. *Sammlung Warren*, no. 583; Casson, *Catalogue*, no. 57. Cf. *HN*, 196.

609. *Silver one and a half obol of Lete in the Emathian district, Macedon.* Before 500 B.C. *Ob*: Satyr squatting. *Rv*: Incuse square divided into four triangular parts.
Johnson Coll. Acc. no. 1919.58.4. Cf. *HN*, 198.

610. *Silver tetradrachm of Acanthus, Macedonia.* About 500–424 B.C. *Ob*: Lion athwart a bull, sinking his claws and teeth into his victim's hindquarters. Above, the letter Θ; in exergue, an uncertain symbol. *Rv*: Quadripartite incuse square.
Warren Coll. Acc. no. 1915.94. Casson, *Catalogue*, no. 48; cf. *HN*, 204.

611. *Silver tetradrachm of Macedon.* Of the reign of Philip II (359–336 B.C.). *Ob*: Head of Zeus, laureate. *Rv*: Naked boy astride a horse, bearing a palm. In the field, an amphora. ΦΙΛΛΙΠΠΟΥ.
Johnson Coll. Acc. no. 1919.58.5a. Cf. *HN*, 223, fig. 136.

612. Same type as above.
Warren Coll. Acc. no. 1915.97. Casson, *Catalogue*, no. 32.

613. Same type as above, but in the field, a helmet and the letter M.
Warren Coll. Acc. no. 1915.97a.

614. *Silver tetrobol of Macedon.* Of the reign of Philip II. *Ob*: Head of Apollo, bound with plain band. *Rv*: Naked horseman prancing. Inscription illegible.
Johnson Coll. Acc. no. 1919.58.97. Cf. *HN*, 223–224.

615. *Silver hemiobol of Macedon.* Of the reign of Philip II. *Ob*: Female head. *Rv*: Fulmen and crescent. ΦΙΛΛΙΠΠΟΥ.
Donor unknown. Acc. no. 1931.11.29. Cf. *HN*, 223–224.

616. *Bronze coin of Macedon.* Of the reign of Philip II. *Ob*: Head of Apollo with plain band. *Rv*: Naked horseman. ΦΙΛΛΙΠΠΟΥ.
Johnson Coll. Acc. no. 1919.58.94. Cf. *HN*, 224.

617. *Gold stater of Macedon.* Of the reign of Alexander the Great (336–323 B.C.). *Ob*: Head of Athena in crested Corinthian helmet adorned with a serpent. *Rv*: Winged Victory holding a mast with a spar and a wreath. ΑΛΕΞΑΝΔΡΟΥ.
Gift of M. P. Mason. Acc. no. 1947. 26. Cf. *HN*, 226, fig. 137.
Athena and her attendant Nike were first introduced into the Macedonian coinage by Alexander.

618. *Silver tetradrachm of Macedon.* Of the reign of Alexander the Great. *Ob*: Head of young Heracles in lionskin. *Rv*: Zeus seated on throne, holding eagle and resting on scepter. ΑΛΕΞΑΝΔΡΟΥ ΒΑΣΙΛΕΩΣ and the letters ΗΡ and ΝΙ.
Johnson-Chase Estate. Acc. no. 1958. 18.5. Cf. *HN*, 226.

619. Same type as above, except for the lack of inscriptions on the reverse.
Hammond Coll. Acc. no. 1898.66.1.

620. *Silver tetradrachm of Macedon.* Of the reign of Alexander the Great or later. *Ob*: Head of young Heracles in lionskin. *Rv*: Zeus seated on throne holding eagle and resting on scepter. ΑΛΕΞΑΝΔΡΟΥ and the letter Α beneath throne.
Johnson Coll. Acc. no. 1919.58.3. Cf. *HN*, 226–227, fig. 138.

621. Similar type to above, except for monogram for ΣΟΦ and the letter M beneath the throne on the reverse.
Johnson Coll. Acc. no. 1919.58.4a.

622. *Bronze coin of Macedon.* Of the reign of Demetrius II (239–229 B.C.). *Ob*: Macedonian shield bearing monogram for ΔΗΜΗΤΡΙ. *Rv*: Macedonian helmet. ΒΑΣΙ.
Johnson Coll. Acc. no. 1919.58.6. Cf. *HN*, 232.

623. *Silver hemidrachm of Macedon.* Of reign of Philip V (220–179 B.C.). *Ob*: Head of king, diademed and lightly bearded. *Rv*: Club in oak wreath. ΒΑΣΙΛΕΩΣ ΦΙΛΛΙΠΠΟΥ and the letters Η, Λ, and Ε in the field.
Warren Coll. Acc. no. 1923.119.5. Cf. *HN*, 233.

624. *Silver tetradrachm of Macedon.* Of the reign of Perseus (179–168 B.C.). *Ob*: Head of king, bearded and with a diadem. *Rv*: Eagle on a fulmen and within an oak wreath. ΒΑΣΙΛΕΩΣ ΠΕΡΣΕΩΣ.
Warren Coll. Acc. no. 1923.119.9. Casson, *Catalogue*, no. 44. Cf. *HN*, 235, fig. 147.

625. *Silver hemidrachm of Maroneia, Thrace.* About 450–400 B.C. *Ob*: Forepart of a horse. In the field, the letters ΜΟΛ, Ο, and Π. *Rv*: Cluster of grapes in incuse square with border of dots. Below, the letters ΜΑ and ΕΠΙ.
Warren Coll. Acc. no. 1915.95. Cf. *HN*, 249.

626. *Silver stater of the island of Thasos, Thrace.* About 550–463 B.C. *Ob*: Naked ithyphallic satyr on one knee, holding a struggling nymph in his arms. *Rv*: Quadripartite incuse square.
Johnson Coll. Acc. no. 1919.58.40. Cf. *HN*, 264, fig. 161.

627. Similar type to above, but in better condition.
Warren Coll. Acc. no. 1914.6.16. *Sammlung Warren*, no. 602.

628. *Silver drachm of Thasos.* About 550–463 B.C. *Ob*: Naked ithyphallic satyr on one knee, holding a struggling nymph in his arms. *Rv*: Quadripartite incuse square.
Warren Coll. Acc. no. 1914.6.2. Cf. *HN*, 264.

629. Same type as above.
Warren Coll. Acc. no. 1914.6.3.

630. *Silver tetradrachm of Thasos.* After 146 B.C. *Ob*: Head of young Dionysus with band across forehead and ivy wreath. *Rv*: Naked Heracles standing with club and lionskin. In the field, monogram for ΗΡΑΚΛΕ and the name ΗΡΑΚΛΕΟΥΣ ΣΩΤΗΡΟΣ ΘΑΣΙΩΝ.
Johnson Coll. Acc. no. 1919.58.39a. Cf. *HN*, 266, fig. 164.

631. *Silver drachm of Byzantium, Thrace.* About 416–357 B.C. *Ob*: Cow standing on a dolphin. The letters ΥΠΥ. *Rv*: Quadripartite incuse pattern.
Johnson Coll. Acc. no. 1919.58.16. Cf. *HN*, 267.

632. *Silver drachm of Istrus, the Danubian district.* Fourth century B.C. *Ob*: Two heads united in opposite directions, upward and downward. *Rv*: Sea eagle on dolphin. ΙΣΤΡΙΗ.
Warren Coll. Acc. no. 1920.8.45. Cf. *HN*, 274.

633. Same type as above, but in poor condition and with a hole drilled through it.
Warren Coll. Acc. no. 1920.8.46.

634. *Bronze coin, perhaps of Mesembria in the Danubian district.* About 450–350 B.C. *Ob*: Head of a goddess. *Rv*: Wheel of four spokes, with ob-

scured symbols between the spokes.
Johnson Coll. Acc. no. 1919.58.2b.
Cf. *HN*, 278.

635. *Silver tetradrachm of Thrace.*
Of the reign of Lysimachus (306–281
B.C.). *Ob*: Head of the deified Alex-
ander with the horn of Ammon. *Rv*:
Athena Nikephoros, seated. ΒΑΣΙΛΕΩΣ
ΛΥΣΙΜΑΧΟΥ and monograms for
ΑΥ and ΚΡ in the field.
Johnson Coll. Acc. no. 1919.58.37.
Cf. *HN*, 284–285, fig. 170.

636. Same type as above, except for
monograms for ΑΡ and ΛΥΣΙΜΑΧΕ
on the reverse.
Warren Coll. Acc. no. 1914.6.7.
Sammlung Warren, no. 518; Casson,
Catalogue, no. 31.

637. Same type as above, but there
are no monograms on the reverse.
Donor unknown. Acc. no. 1931.11.
14.

638. *Silver didrachm* of Larissa,
Thessaly. About 400–344 B.C. *Ob*:
Head of fountain nymph Larissa, fac-
ing, with full flowing locks. *Rv*: Horse
held by man. Inscription illegible.
Johnson Coll. Acc. no. 1919.58.91.
Cf. *HN*, 299, fig. 174.

639. *Bronze coin of Magnetes,*
Thessaly. About 197–146 B.C. *Ob*:
Head of Zeus. *Rv*: Centaur holding
branch. ΜΑΓΝΗΤΩΝ.
Hammond Coll. Acc. no. 1898.66.2.
Cf. *HN*, 300.

640. *Bronze coin of the Thessali.*
About 196–146 B.C. *Ob*: Head of
Apollo. *Rv*: The Thessalian Athena
Itonia in fighting attitude. ΘΕΣΣΑΛΩΝ.
Hammond Coll. Acc. no. 1898.66.3.
Cf. *HN*, 311.

641. Same type as above, but in
poor condition.
Hammond Coll. Acc. no. 1898.66.4.

642. *Bronze coin of Epirus.* Of the
reign of Pyrrhus, 295–272 B.C. *Ob*:
Head of Dodonaean Zeus. *Rv*: Fulmen
in oak wreath with the letter Σ and an-
other unidentifiable one in the field.
Johnson Coll. Acc. no. 1919.58.101.
Cf. *HN*, 324.

643. *Silver drachm of the Epirote*
Republic. About 238–168 B.C. *Ob*:
Head of Dodonaean Zeus. In the field
the monogram for ΕΚ. *Rv*: Eagle in
oak wreath. ΑΠΕΙΡΩΤΑΝ.
Johnson Coll. Acc. no. 1919.58.65.
Cf. *HN*, 324.

644. *Bronze coin of the Epirote*
Republic. Probably after 238 B.C. *Ob*:
Head of Dodonaean Zeus. *Rv*: Fulmen
in oak wreath. ΑΠΕΙΡΩΤΑΝ.
Hammond Coll. Acc. no. 1898.66.5.
Cf. *HN*, 324–325.

645. *Silver didrachm of Corcyra.*
About 450–300 B.C. *Ob*: Amphora. *Rv*:
Stellate pattern with eight spokes. ΚΟΡ.
Johnson Coll. Acc. no. 1919.58.62.
Cf. *HN*, 326.

646. *Silver stater of Leukas, Acar-*
nania. Of the fifth century B.C. *Ob*:
Pegasus. ΛΕΥ beneath his legs. *Rv*:
Head of Athena with helmet, in incuse
square.
Warren Coll. Acc. no. 1920.8.47.
Casson, *Catalogue*, no. 38. Cf. *HN*,
329–330; Seltman, *Greek Coins*, 117,
pl. 18, nos. 12–16.

647. Same type as above.
Warren Coll. Acc. no. 1920.8.48.
Casson, *Catalogue*, no. 39.

648. *Silver stater of Leukas.* About
300–250 B.C. *Ob*: Pegasus. Letter Λ
beneath him. *Rv*: Head of Athena in
Corinthian helmet. Behind her, an an-
chor. ΑΡΙ.
Johnson Coll. Acc. no. 1919.58.18.
Cf. *HN*, 329–330.

649. *Bronze coin of Aetolia.* About 279–168 B.C. *Ob*: Young male head, laureate. *Rv*: Spearhead and jawbone of the Calydonian boar. ΑΙΤΩΛΩΝ.
Johnson Coll. Acc. no. 1919.58.87a. Cf. *HN*, 335.

650. *Silver didrachm of Locris Opuntii.* About 400–338 B.C. *Ob*: Head of a goddess. *Rv*: The Locrian Ajax, naked, but armed with helmet, sword, and shield, advancing to fight. ΟΠΟΝΤΙΟΝ.
Johnson-Chase Estate. Acc. no. 1958. 18.14. Cf. *HN*, 336.

651. *Silver obol of Locris Opuntii.* About 390–340 B.C. *Ob*: Amphora. ΟΠΟΝ. *Rv*: Star, the badge of the Eastern Locrians.
Johnson Coll. Acc. no. 1919.58.63. Cf. *HN*, 336.

652. *Silver obol of Phocis.* About 550–421 B.C. *Ob*: Bull's head. *Rv*: Forepart of boar, in incuse square.
Johnson Coll. Acc. no. 1919.58.64. Cf. *HN*, 338.

653. *Silver didrachm of Haliartus, Boeotia.* Before 480 B.C. *Ob*: Boeotian shield. *Rv*: Quadripartite incuse square with the archaic aspirate in the center.
Warren Coll. Acc. no. 1923.118.3. *Sammlung Warren*, no. 769. Cf. *HN*, 345.

654. *Silver triobol of Orchomenus, Boeotia.* About 387–374 B.C. *Ob*: Boeotian shield. *Rv*: ΕΡΧ in a wreath of grain.
Warren Coll. Acc. no. 1923.118.4. *Sammlung Warren*, no. 773. Cf. *HN*, 347.

655. *Silver drachm of Tanagra, Boeotia.* About 600–480 B.C. *Ob*: Boeotian shield with the letter Τ in side opening. *Rv*: Incuse square with four triangles and the letters Τ and Τ within two of them.

Warren Coll. Acc. no. 1923.118.5. *Sammlung Warren*, no. 776. Cf. *HN*, 348.

656. *Silver obol of Tanagra.* About 456–374 B.C. *Ob*: Boeotian shield. *Rv*: Concave circle around the forepart of a springing horse. ΤΑ.
Johnson Coll. Acc. no. 1919.58.12. Cf. *HN*, 348.

657. Same type as above.
Johnson Coll. Acc. no. 1919.58.66.

658. Same type as above.
Warren Coll. Acc. no. 1920.8.49.

659. Same type as above.
Warren Coll. Acc. no. 1920.8.50.

660. *Silver stater of Thebes, Boeotia.* About 480–446 B.C. *Ob*: Boeotian shield. *Rv*: Amphora in incuse square. ΘΕ.
Warren Coll. Acc. no. 1920.8.51. Casson, *Catalogue*, no. 42. Cf. *HN*, 349.

661. *Silver hemidrachm of Thebes.* About 338–315 B.C. *Ob*: Boeotian shield. *Rv*: Kantharos in incuse square. ΒΟ and ΔΩ.
Warren Coll. Acc. no. 1920.8.52. Cf. *HN*, 352.

662. Same type as above.
Warren Coll. Acc. no. 1920.8.53.

663. Same as above, except for the letters ΡΑ on the reverse.
Warren Coll. Acc. no. 1920.8.54.

664. *Silver obol of Thespiae, Boeotia.* About 387–374 B.C. *Ob*: Boeotian shield. *Rv*: Half moon, open upward. ΘΕΣ above.
Warren Coll. Acc. no. 1923.118.6. *Sammlung Warren*, no. 789. Cf. *HN*, 354.

665. *Silver didrachm of Chalcis, Euboea.* About 550–507 B.C. *Ob*: Ar-

chaic wheel with transverse spokes. *Rv:* Incuse square, diagonally divided.
Johnson Coll. Acc. no. 1919.58.57. Cf. *HN*, 358.

666. *Bronze coin of Chalcis.* About 369–336 B.C. *Ob:* Female head covered with headdress of pearls. *Rv:* Eagle devouring serpent. XAΛ.
Johnson Coll. Acc. no. 1919.58.82. Cf. *HN*, 359.

667. *Bronze coin of Eretria, Euboea.* About 197–146 B.C. *Ob:* Veiled female head. *Rv:* Recumbent ox. EPETPI-EΩN.
Johnson Coll. Acc. no. 1919.58.82b. Cf. *HN*, 363.

668. *Silver tetradrachm of Athens.* About 514–407 B.C. *Ob:* Head of Athena with helmet adorned with three olive leaves and at the back with a floral scroll. *Rv:* Owl with head facing in incuse square; behind, an olive spray and a crescent moon. AΘE.
Warren Coll. Acc. no. 1920.8.1. Cf. *HN*, 371, fig. 209.
This coin enjoyed universal circulation for almost two centuries until it was superseded by the tetradrachm of Alexander the Great.

669. Same type as above.
Johnson Coll. Acc. no. 1919.58.89.

670. Same type as above.
Warren Coll. Acc. no. 1920.8.55.

671. Same type as above.
Warren Coll. Acc. no. 1914.6.15. *Sammlung Warren,* no. 830; Casson, *Catalogue,* no. 35, part 2.

672. Same type as above.
Johnson Coll. Acc. no. 1919.58.35.

673. Same type as above.
Warren Coll. Acc. no. 1914.6.10. *Sammlung Warren,* no. 849.

674. Same type as above.
Warren Coll. Acc. no. 1914.6.14. *Sammlung Warren,* no. 833; Casson, *Catalogue,* no. 35, part 3.

675. Same type as above.
Warren Coll. Acc. no. 1914.6.13. *Sammlung Warren,* no. 817; Casson, *Catalogue,* no. 35, part 4.

676. *Silver drachm of Athens.* About 514–407 B.C. *Ob:* Head of Athena, her helmet adorned in front with three olive leaves erect, and at the back with a floral scroll. *Rv:* Owl, head facing and wings closed, in incuse square. Behind, an olive spray. AΘE.
Warren Coll. Acc. no. 1914.6.4. *Sammlung Warren,* no. 837. Cf. *HN*, 372, fig. 211.

677. *Silver hemiobol of Athens.* About 514–407 B.C. *Ob:* Head of Athena. *Rv:* Owl in incuse square. AΘE.
Johnson-Chase Estate. Acc. no. 1958.18.2. Cf. *HN*, 372.

678. *Silver triobol of Athens.* Of the fifth century B.C. *Ob:* Head of Athena, her helmet adorned in front with three olive leaves erect. *Rv:* Incuse circle with owl facing and wings closed, between olive branches. AΘE.
Johnson Coll. Acc. no. 1919.58.95. Cf. *HN*, 372, fig. 212.

679. *Silver obol of Athens.* About 514–407 B.C. *Ob:* Head of Athena, her helmet adorned in front with three olive leaves erect, and at the back with a floral scroll. *Rv:* Owl, to right, in incuse square. Behind, an olive spray. AΘE.
Warren Coll. Acc. no. 1914.6.6. *Sammlung Warren,* no. 845. Cf. *HN*, 372.

680. *Silver tetradrachm of Athens.* About 393–339 B.C. *Ob:* Head of Athena with helmet. *Rv:* Owl, head

facing, in incuse square. Behind, an olive spray and crescent moon. AΘE.
Johnson Coll. Acc. no. 1919.58.36. Cf. *HN*, 374.

681. Same type as above.
Warren Coll. Acc. no. 1920.8.56.

682. *Silver tetradrachm of Athens.* About 167–162 B.C. *Ob*: Head of Athena Parthenos in Attic helmet with triple crest, adorned on the side with Pegasus and on the back with a scroll. *Rv*: Owl standing on Panathenaic amphora. To the right, a statue of Apollo Delios. AΘE and the names of magistrates ΣΩΚΡΑΤΗΣ and ΔΙΟΝΥΣΟΔΩ. Below, the letters ΣΕ.
Johnson Coll. Acc. no. 1919.58.38. Cf. *HN*, 383.

683. Similar type to above, except that on the reverse, below the names of the magistrates, is ΑΡΤΕΝΙ.
Warren Coll. Acc. no. 1920.8.57.

684. *Silver tetradrachm of Athens.* About the year 125 B.C. *Ob*: Head of Athena Parthenos in Attic helmet with triple crest, adorned with a scroll on the side. *Rv*: Owl standing on Panathenaic amphora. AΘE and the names of the magistrates ΝΙΚΗΤΗΣ and ΔΙΟΝΥΣΙΟΣ. In the field a Gorgon's head; the whole in an olive wreath.
Warren Coll. Acc. no. 1914.6.12. *Sammlung Warren*, no. 856; Casson, *Catalogue*, no. 36. Cf. *HN*, 378, 385, fig. 216.

685. *Silver stater of Aegina.* About 600–550 B.C. *Ob*: Sea turtle. *Rv*: Incuse square with five compartments.
Johnson-Chase Estate. Acc. no. 1958.18.1. Cf. *HN*, 394–396.
Aegina was the first city in European Greece to use coined money. The oldest staters of the turtle type (about 650 B.C. and later) held undisputed priority over all other coins of the Greek mainland.

686. *Silver triobol of Aegina.* About 600–550 B.C. *Ob*: Sea turtle with plain shell. *Rv*: Incuse square divided into five sections.
Johnson Coll. Acc. no. 1919.58.56. Cf. *HN*, 396.

687. *Silver drachm of Aegina.* About 404–350 B.C. *Ob*: Land tortoise with the structure of the shell plates clearly designed. *Rv*: Shallow incuse pattern in five sections.
Warren Coll. Acc. no. 1915.93. Casson, *Catalogue*, no. 49. Cf. *HN*, 397.

688. *Silver stater of Corinth.* About 430–400 B.C. *Ob*: Pegasus with curled wing, galloping. *Rv*: Head of Athena in Corinthian helmet in incuse square. The eye is in profile.
Warren Coll. Acc. no. 1914.6.9. *Sammlung Warren*, no. 869. Cf. *HN*, 401.

689. *Silver stater of Corinth.* About 400–338 B.C. *Ob*: Pegasus flying, with upcurled wing. In the field the letter koppa. *Rv*: Head of Athena in Corinthian helmet over large neck flap. In the field, a small figure with one arm raised.
Warren Coll. Acc. no. 1920.8.58. Cf. *HN*, 401, fig. 221.

690. *Silver hemidrachm of Corinth.* About 338–300 B.C. *Ob*: Pegasus. In the field the letter koppa. *Rv*: Female head with hair in snood. In the field, the magistrates' letters ΔΙ.
Johnson Coll. Acc. no. 1919.58.69. Cf. *HN*, 402–403.

691. *Silver triobol of Sicyon.* About 400–323 B.C. *Ob*: Chimaera. ΣΙ. *Rv*: Dove flying. In the field, the letters ΤΥ.
Warren Coll. Acc. no. 1920.8.59. Cf. *HN*, 410.

692. *Silver obol, probably of Sicyon.* About 400–323 B.C. *Ob*: Head of

Apollo, helmeted. *Rv*: Dove with wings outspread. AT.
Donor unknown. Acc. no. 1931.11.13. Cf. *HN*, 409–410.

693. *Silver hemidrachm of the Achaean League.* About 370–360 B.C. *Ob*: Laureate head of a god. *Rv*: Laurel wreath with monogram for AY within.
Johnson Coll. Acc. no. 1919.58.13a. Cf. *HN*, 416.

694. *Silver stater of Elis, Peloponnese.* About 421–400 B.C. *Ob*: Head of Hera wearing a stephanos adorned with conventional floral design. *Rv*: Fulmen flaming at both ends and enveloped by an olive wreath. FA in the field.
Warren Coll. Acc. no. 1923.119.7. Casson, *Catalogue*, no. 46. Cf. *HN*, 422, fig. 231.

695. *Silver tetrobol of Argos.* About 322–229 B.C. and later. *Ob*: Forepart of a wolf. *Rv*: Large A in incuse square. Below is a crescent and above, the letters AP.
Warren Coll. Acc. no. 1920.8.60. Cf. *HN*, 439.

696. *Silver triobol of Argos.* About 322–229 B.C. and later. *Ob*: Head of a wolf, to right. Above, the letters XX. *Rv*: Large A in incuse square. Above, the letters ΠΡ and below, a club.
Warren Coll. Acc. no. 1914.6.11. *Sammlung Warren*, no. 940. Cf. *HN*, 439.

697. *Bronze of Cnossus, Crete.* About 400–350 B.C. *Ob*: Head of Demeter. *Rv*: Square labyrinth of meander pattern. ΚΝΩ.
Johnson Coll. Acc. no. 1919.58.83. Cf. *HN*, 461.

698. *Silver stater of Gortyna, Crete.* About 430–300 B.C. *Ob*: Europa seated in tree. *Rv*: Bull standing, with head turned back.

Warren Coll. Acc. no. 1920.8.61. Cf. *HN*, 466; fig. 248, is of same series.

699. *Bronze coin of Naxos, the Cyclades.* About 400–300 B.C. *Ob*: Head of bearded Dionysos. *Rv*: Kantharos. NA.
Donor unknown. Acc. no. 1931.11.19. Cf. *HN*, 488.

700. *Bronze coin from Iulis, the Cyclades.* After 300 B.C. *Ob*: Head of Artemis. *Rv*: Bee within wreath. ΙΟΥ.
Johnson Coll. Acc. no. 1919.58.102. Cf. *HN*, 484.

701. *Bronze coin of Amisus, Pontus.* Of the reign of Mithradates VI the Great (120–63 B.C.). *Ob*: Head of Dionysos. *Rv*: Cista and thyrsos. ΑΜΙΣΟΥ.
Johnson Coll. Acc. no. 1919.58.15a. Cf. *HN*, 497.

702. *Silver tetradrachm of Pontus.* From the reign of Mithradates VI. Probably struck after 88 B.C. *Ob*: Head of the king with flowing hair. *Rv*: Stag feeding; in the field, a crescent, star, and monogram of Pergamum, where the coin was struck, and the date ΓΚΣ. ΒΑΣΙΛΕΩΣ ΜΙΘΡΑΔΑΤΟΥ ΕΥΠΑΤΟΡΟΣ and the letter Δ; the whole in an ivy wreath.
Warren Coll. Acc. no. 1923.119.1. Formerly in Heseltine Coll. Casson, *Catalogue*, no. 29. Cf. *HN*, 501–502, fig. 263.

703. *Bronze coin of Bithynia.* Of the reign of Prusias II (183–149 B.C.). *Ob*: Head of Dionysos. *Rv*: Centaur Cheiron with lyre. ΒΑΣΙΛΕΩΣ ΠΡΟΥΣΙΟΥ.
Johnson Coll. Acc. no. 1919.58.16a. Cf. *HN*, 519.

704. *Electrum hecte of Cyzicus, Mysia.* About 500–450 B.C. *Ob*: Sphinx above a tunny. *Rv*: Rude square incuse with four triangles.

Warren Coll. Acc. no. 1915.92. Casson, *Catalogue*, no. 59. Cf. *HN*, 524, fig. 269.

The electrum staters of this prosperous town were called cyzicenes and became famous everywhere.

705. *Silver coin of Parium on the Propontis.* About 400 B.C. *Ob*: Gorgoneion. *Rv*: Bull looking back. Below, a crescent. ΠΑ ΡΙ.
Donor unknown. Acc. no. 1931.11.16. Cf. *HN*, 531.

706. *Silver diobol of Pergamum.* About 300–284 B.C. *Ob*: Head of young Heracles. *Rv*: Palladium. ΠΕΡΓΑΜΗ.
Johnson Coll. Acc. no. 1919.58.59. Cf. *HN*, 532.

707. *Silver tetradrachm of Pergamum.* Of the reign of Eumenes I (263–241 B.C.). *Ob*: Head of Philetaerus, diademed. *Rv*: Athena seated, her outstretched arm resting on her shield; to the right is a bow. ΦΙΛΕΤΑΙΡΟΥ. On her throne, the letter Α.
Warren Coll. Acc. no. 1914.6.5. *Sammlung Warren*, no. 1025; Casson, *Catalogue*, no. 30. Cf. *HN*, 533, fig. 283.
Philetaerus (283–263 B.C.), founded the Attalid dynasty of Pergamum by deserting Lysimachus and seizing his treasure of 9000 talents deposited in the city. He had previously served Lysimachus as his treasurer and guardian of this hoard.

708. *Bronze coin of Pergamum.* Probably of the reign of Attalus II (159–138 B.C.). *Ob*: Head of Athena. *Rv*: Thyrsos. ΦΙΛΕΤΑΙΡΟΥ.
Johnson Coll. Acc. no. 1919.58.14a. Cf. *HN*, 533–534.

709. *Bronze coin of Pergamum.* About 200–133 B.C. *Ob*: Head of Athena, helmeted. ΠΕΡΓΑΜΗΝΩΝ. *Rv*: Nike standing. ΠΕΡΓΑΜΗΝΩΝ.

Johnson Coll. Acc. no. 1919.58.9. Cf. *HN*, 535–536.

710. *Bronze coin of Cebren, Troas.* About 400–310 B.C. *Ob*: Two rams' heads; between them, a floral device. *Rv*: ΚΕ in monogram.
Johnson Coll. Acc. no. 1919.58.60. Cf. *HN*, 543.

711. *Silver coin of Scepsis in the Troad.* About 460–400 B.C. *Ob*: Forepart of winged Pegasus. ΣΚΗΨΙΟΝ. *Rv*: Fir tree in linear and dotted square within incuse square. The letter Ν.
Warren Coll. Acc. no. 1920.8.62a. Cf. *HN*, 548–549.

712. *Silver drachm of Clazomenae, Ionia.* About 387–301 B.C. *Ob*: Head of Apollo, nearly facing. *Rv*: Swan with open wings. ΚΛΑ and the magistrate's name, ΜΑΝΔΡΩΝΑΞ.
Warren Coll. Acc. no. 1914.6.18. *Sammlung Warren*, no. 1092; Casson, *Catalogue*, no. 55. Cf. *HN*, 568, fig. 293.

713. *Silver didrachm of Erythrae, Ionia.* About 500 B.C. *Ob*: Naked horseman astride a prancing steed. *Rv*: Quadripartite incuse square.
Warren Coll. Acc. no. 1914.6.19. *Sammlung Warren*, no. 1113. Cf. *HN*, 578.

714. *Silver didrachm of Chios.* About 500 B.C. *Ob*: Sphinx seated; in front, an amphora. *Rv*: Quadripartite incuse square.
Warren Coll. Acc. no. 1915.66. Cf. *HN*, 599.

715. Same type as above.
Johnson Coll. Acc. no. 1919.58.10a.

716. *Silver didrachm of Caria.* Of the satrapy of Pixodarus (340–334 B.C.). *Ob*: Head of Apollo, laureate, facing. *Rv*: Zeus Labraundos, armed with spear and double axe. ΠΙΞΩΔΑΡΟ.

Johnson Coll. Acc. no. 1919.58.100. Cf. *HN*, 630.

717. *Silver didrachm of Rhodes.* About 333–304 B.C. *Ob*: Radiate head of Helios. *Rv*: A rose.
Johnson Coll. Acc. no. 1919.58.61. Cf. *HN*, 639.

718. *Silver half stater of Lydia.* Of the reign of Croesus (561–546 B.C.). *Ob*: Foreparts of lion and bull, facing one another. *Rv*: Two incuse squares of different sizes, side by side.
Johnson Coll. Acc. no. 1919.58.11a. Cf. *HN*, 646, fig. 312.

719. *Bronze coin of Apameia, Phrygia.* About 133–48 B.C. *Ob*: Bust of Athena. *Rv*: Eagle flying over meander symbol, between caps of the Dioscuri. In the field, three stars. ΑΠΑ-ΜΕΩΝ.
Johnson Coll. Acc. no. 1919.58.92. Cf. *HN*, 666.

720. *Silver tetradrachm.* Of the second reign of the Seleucid ruler Demetrius II Nicator (129–125 B.C.). *Ob*: Head of the king, bearded and with diadem. *Rv*: Eagle and palm branch. ΔΗΜΗΤΡΙΟΥ ΒΑΣΙΛΕΩΣ and the letters ΙΕ and ΑΣΣΠΡ.
Warren Coll. Acc. no. 1920.8.63. Casson, *Catalogue*, no. 50. Cf. *HN*, 768.

721. *Bronze coin of Antiocheia ad Orontem, Syria.* About the first century B.C. *Ob*: Head Zeus. *Rv*: Zeus Nikephoros enthroned. ΑΝΤΙΟΧΕΩΝ ΤΗΣ ΜΗΤΡΟΠΟΛΕΩΣ; remainder of inscription illegible.
Johnson Coll. Acc. no. 1919.58.1a. Cf. *HN*, 778.

722. *Silver tetradrachm of Sidon, Phoenicia.* Of the period of Alexander the Great and later, 333–202 B.C. *Ob*: Head of Heracles. *Rv*: Zeus Olympios enthroned, with an eagle in his out-stretched right hand and a scepter in his left. ΑΛΕΞΑΝΔΡΟΥ and mint mark Σ in the field.
Johnson Coll. Acc. no. 1919.58.9a. Cf. *HN*, 796–797.

723. *Silver tetradrachm of Parthia.* Of the reign of Arsaces Euergetes (249–247 B.C.). *Ob*: Head of king, crowned and wearing a square, spade-shaped beard. *Rv*: Standing Tyche presenting a palm branch to the seated king. ΒΑΣΙΛΕΩΣ ΒΑΣΙΛΕΩΝ ΑΡΣΑΚΟΥ ΕΥΕΡΓΕΤΟΥ ΔΙΚΑΙΟΥ ΕΠΙΦΑΝΟΥ ΦΙΛΕΛΛΗΝΩΝ.
Warren Coll. Acc. no. 1920.8.64. Casson, *Catalogue*, no. 54. Cf. *HN*, 817–821.

724. *Silver tetradrachm of Parthia.* Of reign of Orodes I (57–37 B.C.). *Ob*: Head of king. *Rv*: Zeus seated and holding a Victory. ΒΑΣΙΛΕΩΣ ΒΑΣΙΛΕΩΝ ΑΡΣΑΚΟΥ ΕΥΕΡΓΕΤΟΥ ΔΙΚΑΙΟΥ ΕΠΙΦΑΝΟΥΣ ΦΙΛΕΛΛΗΝΟΣ.
Donor unknown. Acc. no. 1931.11.1. Cf. *HN*, 820, fig. 359.

725. *Gold daric of Persia.* About 521–425 B.C. *Ob*: King bearded and in half-kneeling posture, crowned and clad in long robe; at his back a quiver, in his right hand a spear, in his left a bow. *Rv*: Irregular oblong incuse.
Warren Coll. Acc. no. 1923.119.8. Casson, *Catalogue*, no. 58. Cf. *HN*, 827–828, fig. 362.

726. *Silver coin of Persia.* Of the reign of Chosroes I (A.D. 531–579), of the Sassanid dynasty. *Ob*: Head of king within a circle, with stars and crescent moons at the bottom and both sides and a fist-shaped symbol at the top. *Rv*: Two figures standing on either side of an altar.
Johnson Coll. Acc. no. 1919.58.18a. See A. U. Pope, ed., *Survey of Persian Art* (1938) I, 817–818; IV, pl. 252g, a similar coin.

727. *Silver tetradrachm.* Of Euthydemus II, king of Bactria and northwestern India. About 180–170 B.C. *Ob*: Boyish head of the king. *Rv*: Heracles facing. ΒΑΣΙΛΕΩΣ ΕΥΘΥΔΗΜΟΥ and the mark of the moneyer.
Warren Coll. Acc. no. 1920.8.65. Cf. *HN*, 837, fig. 366.

728. Similar type to above, but with head on obverse treated in a flat and barbarized manner.
Warren Coll. Acc. no. 1920.8.66.

729. *Silver drachm.* Of Agathocles, king of Bactria and northwestern India. About 200 B.C. *Ob*: Head of Dionysus. *Rv*: Panther. ΒΑΣΙΛΕΩΣ ΑΓΑΘΟΚΛΕΟΥΣ.
Donor unknown. Acc. no. 1931.11.4. Cf. *HN*, 838.

730. *Silver drachm.* Of Eucratides, king of Bactria and northwestern India. About 200–150 B.C. *Ob*: Head of king, helmeted. *Rv*: The Dioscuri on horseback. ΒΑΣΙΛΕΩΣ ΜΕΓΑΛΥ ΕΥΚΡΑΤΙΔΥ.
Warren Coll. Acc. no. 1920.8.67. Cf. *HN*, 838–839.

731. Similar type to above.
Warren Coll. Acc. no. 1920.8.68.

732. Similar type to above.
Warren Coll. Acc. no. 1920.8.69.

733. *Silver tetradrachm.* Of Eucratides. *Ob*: Head of king, helmeted. *Rv*: The Dioscuri on horseback. ΒΑΣΙΛΕΩΣ ΜΕΓΑΛΟΥ ΕΥΚΡΑΤΙΔΟΥ and the letter Σ.
Warren Coll. Acc. no. 1920.8.70. Cf. *HN*, 839, fig. 369.

734. Similar type to above, but in poor condition. On the reverse is monogram for ΠΟ.
Warren Coll. Acc. no. 1920.8.71.

735. *Silver tetradrachm.* Of Eucra-
tides. *Ob*: Helmeted bust of king. ΒΑΣΙΛΕΥΣ ΜΕΓΑΣ ΕΥΚΡΑΤΙΔΗΣ. *Rv*: Busts of his father, Heliocles, and mother. Laodice. ΗΛΙΟΚΛΕΟΥΣ ΚΑΙ ΛΑΟΔΙΚΗΣ.
Warren Coll. Acc. no. 1920.8.72. Cf. *HN*, 839.

736. *Silver tetradrachm.* Of Heliocles, king of Bactria and northwestern India. About 150–125 B.C. *Ob*: Bust of king, diademed. *Rv*: Zeus standing, holding fulmen and spear. ΒΑΣΙΛΕΩΣ ΗΛΙΟΚΛΕΟΥΣ ΔΙΚΑΙΟΥ and monogram for ΗΛΙΟΚΛΕ.
Warren Coll. Acc. no. 1920.8.73. Cf. *HN*, 839.

737. Same type as above, except that a symbol with a circle and three lines depending beneath it is on the reverse.
Warren Coll. Acc. no. 1920.8.74.

738. *Square bronze coin.* Of Antalcidas, king of Bactria and northwestern India. About 150 B.C. *Ob*: Bust of the king. Inscription illegible. *Rv*: Caps of the Dioscuri. Inscription illegible.
Johnson Coll. Acc. no. 1919.58.17a. Cf. *HN*, 840.

739. *Square silver quarter stater.* Of Apollodotus, king of Bactria and northwestern India. About 140 B.C. *Ob*: Elephant. ΒΑΣΙΛΕΩΣ ΑΠΟΛΛΟΔΟΤΟΥ ΣΩΤΗΡΟΣ and monogram for ΚΡ. *Rv*: Humped bull. Indian inscription in Kharosthi signifying the same as the Greek on the obverse.
Donor unknown. Acc. no. 1931.11. 9a. Cf. *HN*, 841.

740. Same type as above, but in poor condition.
Donor unknown. Acc. no. 1931.11.9b.

741. *Silver quarter stater.* Of Menander, king of Bactria and northwestern India. About 160–140 B.C. *Ob*: Bust of the king, helmeted. ΒΑΣΙΛΕΩΣ

ΣΩΤΗΡΟΣ ΜΕΝΑΝΔΡΟΥ. *Rv*: Athena fighting. Indian inscription in Kharosthi signifying the same as the Greek on the obverse.
Warren Coll. Acc. no. 1920.8.75. Cf. *HN*, 842 and 844.

742. Similar type to above.
Warren Coll. Acc. no. 1920.8.76.

743. *Square silver stater.* Of Menander. About 160–140 B.C. *Ob*: Head of the king, helmeted. ΒΑΣΙΛΕΩΣ ΣΩΤΗΡΟΣ ΜΕΝΑΝΔΡΟΥ. *Rv*: Shield. Indian inscription in Kharosthi signifying the same as the Greek on the obverse.
Warren Coll. Acc. no. 1920.8.77. Cf. *HN*, 842.

744. Similar type to above, except that an owl is on the reverse.
Warren Coll. Acc. no. 1920.8.78.

745. Similar type to above.
Donor unknown. Acc. no. 1931.11.8.

746. *Silver quarter stater of Bactria and northwestern India.* Perhaps of the reign of Antimachus II. About 100 B.C. *Ob*: King on horseback. Greek inscription illegible. *Rv*: Nike holding unidentified object. Kharosthi inscription.
Donor unknown. Acc. no. 1931.11.32. Cf. *HN*, 842.

747. *Silver stater.* Of Hippostratus, king of Bactria and N.W. India. About 80 B.C. *Ob*: Head of the king. ΙΠΠΟΣ-ΤΡΑΤΟΥ ΒΑΣΙΛΕΩΣ ΜΕΓΑΛΟΥ ΣΩ-ΤΗΡΟΣ. *Rv*: Rider and horse. Indian inscription in Kharosthi signifying the same as the Greek on the obverse; symbol of a circle with three lines depending beneath it, and the whole within a larger circle.
Donor unknown. Acc. no. 1931.11.5. Cf. *HN*, 843.

748. *Silver stater.* Of Hippostratus. About 100 B.C. *Ob*: Head of the king,

diademed. ΒΑΣΙΛΕΩΣ ΣΩΤΗΡΟΣ ΙΠ-ΠΟΣΤΡΑΤΟΥ. *Rv*: Tyche standing. Indian inscription in Kharosthi signifying the same as the Greek on the obverse.
Warren Coll. Acc. no. 1920.8.79. Cf. *HN*, 843–844.

749. *Silver tetradrachm of Egypt.* Of the reign of Ptolemy I (323–285 B.C.). *Ob*: Head of Alexander the Great in elephant skin. *Rv*: Archaistic figure of Athena Promachos hurling a javelin; in the field, an eagle and another bird. ΑΛΕΞΑΝΔΡΟΥ and monogram for ΥΟ.
Johnson Coll. Acc. no. 1919.58.6a. Cf. *HN*, 849, fig. 374.

750. Similar type to above, except for three monograms on the reverse for the letters ΠΑ, ΔΟΦ, and ΑΤ.
Johnson Coll. Acc. no. 1919.58.12a.

751. *Gold octadrachm of Egypt.* Of the reign of Ptolemy II Philadelphus (285–246 B.C.). Struck after 270 B.C. *Ob*: Head of Queen Arsinoë II, veiled and wearing a stephane. To the left, the letter Κ. *Rv*: Double cornucopiae, filleted. ΑΡΣΙΝΟΗΣ ΦΙΛΑΔΕΛΦΟΥ.
Gift of Mr. John Hubbard. Acc. no. 1927.38. Cf. *HN*, 850; Seltman, *Greek Coins*, 242, pl. 58, no. 6.
When Arsinoë died in 270 B.C., she was promptly deified and given a role in temple cults, a shrewd policy which transferred to the royal treasury great sums from the temples forced to accept her as a deity. In her honor quantities of golden octadrachms and silver decadrachms were coined from these proceeds.

752. Same type as above.
Warren Coll. Acc. no. 1920.8.80.

753. *Bronze coin of Egypt.* Of the reign of Ptolemy III Euergetes (246–221 B.C.). *Ob*: Head of Zeus. *Rv*: Eagle on a fulmen; in front, a cornucopia. ΒΑΣΙΛΕΩΣ ΠΤΟΛΕΜΑΙΟΥ. This coin

is large and heavy (70.6 grams).

Johnson-Chase Estate. Acc. no. 1958. 18.10. Cf. *HN*, 852.

754. *Silver tetradrachm of Carthage, Zeugitana.* About 410–310 B.C. *Ob*: Forepart of horse, crowned by Nike. סרח חרשת. *Rv*: Date-palm tree.

Warren Coll. Acc. no. 1915.96. Cf. *HN*, 877.

755. *Silver tetradrachm of Carthage.* About 300 B.C. *Ob*: Head of Heracles in lionskin. *Rv*: Head of horse and palm tree.

Warren Coll. Acc. no. 1920.8.81. Cf. *HN*, 877–878.

756. *Silver coin, perhaps of Carthage or one of her colonies.* About 250–150 B.C. *Ob*: Head of Persephone. *Rv*: Horse prancing, looking back. The letter U.

Warren Coll. Acc. no. 1920.8.82. Cf. *HN*, 879–882.

ROMAN COINS

In the Roman coinage the aureus and solidus were struck in gold, the denarius and quinarius in silver, the sestertius and dupondius in orichalcum (brass), and the as in copper.

757. *Silver didrachm.* About 241–222 B.C. *Ob*: Head of Mars, beardless. *Rv*: Bust of horse; behind a sickle. ROMA.

Warren Coll. Acc. no. 1923.119.2. From Heseltine Coll. Casson, *Catalogue*, no. 43. Cf. *HN*, 33, fig. 9; *CRR*, 3.

758. *Libral as.* About 222–205 B.C. *Ob*: Head of Janus. *Rv*: Prow. This coin weighs 297.67 grams (10.5 ounces).

Hammond Coll. Acc. no. 1898.66.11. Cf. *CRR*, 7.

759. *Silver didrachm.* About 222–205 B.C. *Ob*: Head of Janus, laureate.

Rv: Jupiter in fast quadriga, hurling thunderbolt and holding scepter. Behind him, Victory. ROMA in incuse letters on raised tablet.

Donor unknown. Acc. no. 1931.11. 23. Cf. *CRR*, 5–6.

760. *Silver victoriate.* About 222–187 B.C. *Ob*: Head of Jupiter, laureate. *Rv*: Victory crowning a trophy. ROMA.

Johnson-Chase Estate. Acc. no. 1958. 18.16. Cf. *CRR*, 13.

761. *As.* About 155–150 B.C. *Ob*: Head of Mercury. *Rv*: Prow. ROMA.

Warren Coll. Acc. no. 1920.8.35. Casson, *Catalogue*, no. 41. Cf. *CRR*, 35.

762. *As.* About 145–138 B.C. *Ob*: Head of Janus. *Rv*: Prow. SAR.

Hammond Coll. Acc. no. 1898.66.6. Cf. *CRR*, 43.

763. *Denarius.* About 137–134 B.C. *Ob*: Head of Roma. *Rv*: Dioscuri on horses. Q. MINV. RVF.

Johnson Coll. Acc. no. 1919.58.67a. Cf. *CRR*, 49.

764. *Denarius.* About 133–126 B.C. *Ob*: Head of Roma. X. *Rv*: Victory in biga. C. VAL. C. F. ROMA. Above, FLAC.

Hammond Coll. Acc. no. 1898.66.5. Cf. *CRR*, 51, 53.

765. *Denarius.* About 133–126 B.C. *Ob*: Head of Roma. In the field, a jug and the letter X. *Rv*: Faustulus, fig tree, wolf and Romulus and Remus. SEX. PO. FOSTLVS. ROMA.

Johnson-Chase Estate. Acc. no. 1958. 18.4. Cf. *CRR*, 54.

766. Same type as above.

Hammond Coll. Acc. No. 1898.66.7.

767. *Denarius.* About 120 B.C. *Ob*: Head of Roma. TAMPIL and X. *Rv*: Apollo in quadriga, holding a branch

in his right hand and an arrow in his left. In the field, ROMA; in exergue M. BAEBI. Q. F.

Donor unknown. Acc. no. 1931.11.24. Cf. *CRR*, 59.

768. *Denarius.* About 120 B.C. *Ob*: Head of Roma. *Rv*: Sol in quadriga. M. ABVRI. M. F. GEM. ROMA.

Johnson Coll. Acc. no. 1919.58.61a. Cf. *CRR*, 58; *RC*, 55, pl. 11, no. 16; *MRR* II, 430.

769. *Denarius.* About 119–110 B.C. *Ob*: Head of Roma. M. VARG. and six-pointed star. *Rv*: Jupiter in slow quadriga. ROMA.

Hammond Coll. Acc. no. 1898.66.8. Cf. *CRR*, 62.

770. *Denarius.* About 106–105 B.C. *Ob*: Head of Roma. ROMA and X. *Rv*: Victory with wreath in a biga. L. FLAMINI. CILO.

Johnson Coll. Acc. no. 1919.58.41. Cf. *CRR*, 70.

771. *Quinarius.* About 100–97 B.C. *Ob*: Head of Jupiter, laureate. *Rv*: Victory crowning trophy. P. SABIN. and Q.

772. *Quinarius.* About 100–97 B.C. *Ob*: Head of Jupiter, laureate. *Rv*: Victory standing, holding palm and crowning trophy placed on head of a Gaulish captive. T. CLOVLI. Q.

Donor unknown. Acc. no. 1931.11. 50. Cf. *CRR*, 81.

773. *Denarius.* About 92–91 B.C. *Ob*: Head of Apollo. L. METEL. A. ALB. S. F. *Rv*: Victory crowning seated Roma.

Johnson Coll. Acc. no. 1919.58.58a. Cf. *CRR*, 87.

774. *Denarius.* About 89–88 B.C. *Ob*: Head of Apollo. PANSA. *Rv*: Pallas in quadriga. C. VIBIVS. C. F.

Hammond Coll. Acc. no. 1898.66.10. Cf. *CRR*, 105.

775. *Denarius.* About 84 B.C. *Ob*: Head of youth, laureate. M. FONTEI. C. F. *Rv*: Infant genius on goat; caps, thyrsus, and fillet.

Johnson Coll. Acc. no. 1919.58.32a. Cf. *CRR*, 114.

776. *Denarius.* About 74 B.C. *Ob*: Head of Mars with helmet. S. C. *Rv*: Ram. L. RVSTI.

Johnson Coll. Acc. no. 1919.58.41a. Cf. *CRR*, 128.

777. *Denarius.* About 65 B.C. *Ob*: Head of Vesta. S. C. *Rv*: Knife, simpulum, and axe. P. GALB. ÆD. CVR.

Johnson-Chase Estate. Acc. no. 1958. 18.9. Cf. *CRR*, 138.

778. *Denarius.* About 63–62 B.C. *Ob*: Head of Flora. FLORAL. PRIMVS. *Rv*: Two soldiers saluting each other with swords. C. SERVEIL. C. F.

Johnson Coll. Acc. no. 1919.58.47. Cf. *CRR*, 147.

779. *Denarius.* About 60 B.C. *Ob*: Bust of Diana. III VIR. GETA. *Rv*: Calydonian boar pierced by spear and attacked by hound. C. HOSIDI. C. F.

Johnson Coll. Acc. no. 1919.58.68a. Cf. *CRR*, 149.

780. *Denarius.* About 60 B.C. *Ob*: Head of Liberty. LIBERTAS. *Rv*: The consul L. Junius Brutus with two lictors preceded by an accensus. BRVTVS.

Johnson-Chase Estate. Acc. no. 1958.18.7. Cf. *CRR*, 150.

781. *Denarius.* 55 B.C. *Ob*: Head of Bonus Eventus. *Rv*: Wellhead ornamented with laurel and two lyres. PVTEAL. SCRIBON. LIBO.

Johnson Coll. Acc. no. 1919.58.49. Cf. *CRR*, 155.

782. *Denarius.* About 54–51 B.C. *Ob*: Elephant trampling on a dragon. CAESAR. *Rv*: Pontifical equipment:

cap of a flamen, securis, aspergillum, and simpulum.
Johnson-Chase Estate. Acc. no. 1958. 18.11. Cf. *CRR*, 167.

783. *Denarius.* 49–48 B.C. *Ob*: Head of Apollo. Q. SICINIVS. III VIR. *Rv*: Lionskin and club of Hercules. C. COPONIVS. PR. S. C.
Johnson Coll. Acc. no. 1919.58.22a. Cf. *CRR*, 157.

784. *Denarius.* 49–48 B.C. *Ob*: Head of Pietas. PIETAS. *Rv*: Two right hands joined, holding a winged caduceus. ALBINVS. BRVTI. F.
Johnson Coll. Acc. no. 1919.58.80a. Cf. *CRR*, 158.

785. *Denarius.* About 46 B.C. *Ob*: Jugate heads of Dioscuri. RVFVS. III VIR. *Rv*: Venus Verticordia holding scales and scepter; behind her, Cupid. M. CORDI.
Donor unknown. Acc. no. 1931.11.49. Cf. *CRR*, 162.

786. *Denarius.* About 44 B.C. *Ob*: Head of Julius Caesar. CAESAR. DICT. PERPETVO. *Rv*: Venus Victrix holding a Victory in her hand and leaning on scepter. P. SEPVLLIVS. MACER.
Johnson Coll. Acc. no. 1919.58.79a. Cf. *CRR*, 178.

787. *Denarius.* 32–31 B.C. *Ob*: Galley with rowers; standard at prow. ANT. AVG. III VIR. R. P. C. *Rv*: Three legionary standards: an aquila between two signa. LEG. XX.
Hammond Coll. Acc. no. 1898.66.12. Cf. *CRR*, 195–196.

788. *Denarius.* 31 B.C. *Ob*: Head of M. Antonius. M. ANTONIVS. AVG. IMP. IIII COS. TERT. III VIR. R. P. G. *Rv*: Victory holding a wreath and palm branch, the whole encircled by a wreath of laurel.
Johnson Coll. Acc. no. 1919.58.43. Cf. *CRR*, 195.

789. *Silver coin.* Of the reign of Augustus (27 B.C.–A.D. 14). About 27 B.C. *Ob*: Head of young Augustus. IMP. CAESAR. *Rv*: Bundle of wheat. AVGVSTVS.
Donor unknown. Acc. no. 1931.11. 53. Cf. H. A. Grueber, *Coinage of the Roman Republic in the British Museum* II (1910) 545.

790. *As.* Of Augustus. 27 B.C. *Ob*: Head of Agrippa, crowned. M. AGRIPPA. L. F. COS. III. *Rv*: Neptune, standing, and holding trident with mantle over his arms. S. C.
Hammond Coll. Acc. no. 1898.66.14.

791. Same type as above.
Wulfing Coll. Acc. no. 1926.10.51.

792. Same type as above.
Johnson Coll. Acc. no. 1919.58.65a.

793. *Aureus.* Of Augustus. 14–12 B.C. *Ob*: Head of emperor. AVGVSTVS. DIVI. F. *Rv*: Bull charging. IMP. X.
Warren Coll. Acc. no. 1923.119.3. From Heseltine Coll. Casson, *Catalogue*, no. 1. Cf. *RIC* I, 88.

794. *Denarius.* Of Augustus. About 2 B.C.–A.D. 14. *Ob*: Head of emperor, laureate. CAESAR. AVGVSTVS. DIVI. F. PATER. PATRIAE. *Rv*: Gaius and Lucius standing, each holding spear and shield. In the field, simpulum and lituus. C. L. CAESARES. AVGVSTI. F. COS. DESIG. PRINC. IVVENT.
Johnson Coll. Acc. no. 1919.58.46. Cf. *RIC* I, 90.

795. *Denarius.* Of Augustus. About A.D. 13–14. *Ob*: Head of emperor, laureate. Part of inscription illegible. AVG. F. AVGVSTVS. *Rv*: Seated figure, holding staff and laurel. PONTIF. MAXIM.
Donor unknown. Acc. no. 1931.11.54.

796. *As.* Of the reign of Tiberius (A.D. 14–37). About A.D. 14–15. *Ob*:

Head of Augustus. DIVVS. AVGVS-
TVS. PATER. *Rv*: Fulmen.
Johnson Coll. Acc. no. 1919.58.50.
Cf. *RIC* I, 95.

797. *As.* Of Tiberius. After A.D. 22.
Ob: Head of Augustus. DIVVS.
AVGVSTVS. PATER. *Rv*: Altar.
PROVIDENT. S. C.
Johnson Coll. Acc. no. 1919.58.81a.
Cf. *RIC* I, 95.

798. Same type as above.
Hammond Coll. Acc. no. 1898.66.13.

799. *As.* Of Tiberius. About A.D. 34–
36. *Ob*: Head of emperor, laureate. TI.
CAESAR. DIVI. AVGVST. IMP. VIII.
Rv: Winged caduceus. PONTIF. MAX-
IM. TRIBVN. POTEST. XXXVII. S. C.
Wulfing Coll. Acc. no. 1926.10.3. Cf.
RIC I, 109.

800. *Denarius.* Of Tiberius. *Ob*:
Head of emperor, laureate. TI.
CAESAR. DIVI. AVG. F. AVGVSTVS.
Rv: Livia seated, holding an olive
branch. PONTIF. MAXIM.
Johnson-Chase Estate. Acc. no. 1958.
18.13. Cf. *RIC* I, 103.

801. *Dupondius.* Of the reign of
Caligula (A.D. 37–41). *Ob*: Head of
Augustus. DIVVS. AVGVSTVS. S. C.
Rv: Augustus seated, holding olive
branch.
Wulfing Coll. Acc. no. 1926.10.2. Cf.
RIC I, 96.

802. *Sestertius.* Of Caligula. *Ob*:
Pietas seated. C. CAESAR. DIVI.
AVG. PRON. AVG. P. M. TRI. III.
P. P. *Rv*: Hexastyle temple. In front,
Caligula standing by altar. Victimarius
leading bull to sacrifice; attendant hold-
ing patera. DIVO. AVG. S. C.
Warren Coll. Acc. no. 1920.8.36. Cf.
RIC I, 116–117.

803. *As.* Of Caligula. *Ob*: Head of
emperor, laureate. C. CAESAR. AVG.

GERMANICVS. PON. M. TR. POT.
Rv: Vesta seated. VESTA. S. C.
Wulfing Coll. Acc. no. 1926.10.4. Cf.
RIC I, 116–117.

804. *As.* Of the reign of Claudius
(A.D. 41–54). *Ob*: Head of emperor,
laureate. TI. CLAVDIVS. CAESAR.
AVG. P. M. TR. P. IMP. P. P. *Rv*:
Minerva holding shield and javelin.
S. C.
Wulfing Coll. Acc. no. 1926.10.5.
Cf. *RIC* I, 129.

805. *As.* Of the reign of Nero (A.D.
54–68). *Ob*: Head of emperor, laureate.
NERO. CAESAR. AVG. GERM. IMP.
Rv: Temple of Janus with closed door.
PACE. P. R. TERRA. MARIQ. PARTA.
IANVM. CLVSIT.
Wulfing Coll. Acc. no. 1926.10.6. Cf.
RIC I, 156.

806. *As.* Of the reign of Galba (A.D.
68–69). *Ob*: Head of emperor, laure-
ate. IMP. SER. SVLP. GALBA. CAES.
AVG. TR. P. *Rv*: Liberty. LIBERTAS.
PVBLICA. S. C.
Wulfing Coll. Acc. no. 1926.10.48.
Cf. *RIC* I, 205.

807. *As.* Of the reign of Vespasian
(A.D. 69–79). A.D. 71. *Ob*: Head of em-
peror, laureate. IMP. CAES. VES-
PASIAN. AVG. COS. III. *Rv*: Victory
striding to left. VICTORIA. AVGVSTI.
S. C.
Wulfing Coll. Acc. no. 1926.10.7.
Cf. *RIC* II, 75.

808. *As.* Of Vespasian. A.D. 73. *Ob*:
Head of emperor, laureate. IMP. CAES.
VESP. AVG. P. M. TR. P. COS. IIII.
CENS. *Rv*: Hope standing. S. C.
Wulfing Coll. Acc. no. 1926.10.8.
Cf. *RIC* II, 79.

809. *As.* Of the reign of Domitian
(A.D. 81–96). A.D. 85. *Ob*: Head of
emperor, laureate. IMP. CAES. DOMI-
TIAN. AVG. GERM., etc. *Rv*: Figure

holding a Victory. S. C.
Wulfing Coll. Acc. no. 1926.10.10.
Cf. *RIC* II, 186 ff.

810. *Dupondius.* Of Domitian. A.D. 90–91. *Ob*: Head of emperor, radiate. IMP. CAES. DOMIT. AVG. GERM. COS. XV. CENS. PER. P. P. *Rv*: Moneta standing, holding scales. MONETA AVGVSTI.
Wulfing Coll. Acc. no. 1926.10.11. Cf. *RIC* II, 203.

811. *Sestertius.* Of Domitian. A.D. 92–94. *Ob*: Head of emperor, laureate. IMP. CAES. DOMIT. AVG. GERM. COS. XVI. CENS. PER. P. P. *Rv*: Jupiter seated, holding Victory and scepter. IOVI. VICTORI. S. C.
Hammond Coll. Acc. no. 1898.66.15. Cf. *RIC* II, 204.

812. *Sestertius.* Of Domitian. *Ob*: Head of emperor, laureate. IMP. CAES. DIVI. VESP. F. DOMITIANVS. P. P. *Rv*: Standing figure, with lance. Inscription illegible.
Wulfing Coll. Acc. no. 1926.10.9.

813. *As.* Of the reign of Nerva (A.D. 96–98). A.D. 97. *Ob*: Head of emperor, laureate. IMP. NERVA. CAES. AVG. P. M. TR. P. COS. III. P. P. *Rv*: Fortune standing. FORTVNA. AVGVSTI. S. C.
Wulfing Coll. Acc. no. 1926.10.12. Cf. *RIC* II, 228.

814. *Dupondius.* Of Nerva. A.D. 97. *Ob*: Head of emperor, laureate. IMP. NERVA. CAES. AVG. P. M. TR. P. COS. IIII. *Rv*: Liberty. LIBERTAS. PVBLICA. S. C.
Wulfing Coll. Acc. no. 1926.10.44. Cf. *RIC* II, 229.

815. *As.* Of the reign of Trajan (A.D. 98–117). About A.D. 103–111. *Ob*: Head of emperor, laureate. IMP. CAES. NERVAE. TRAIANO. AVG. GER. DAC. P. M. TR. P. COS. V. P. P. *Rv*:

Abundantia standing, holding ears of corn and cornucopiae. In front, a kneeling child. S. P. Q. R. OPTIMO. PRINCIPI. S. C.
Wulfing Coll. Acc. no. 1926.10.1. Cf. *RIC* II, 277.

816. *Denarius.* Of Trajan. About A.D. 103–111. *Ob*: Head of emperor, laureate. IMP. TRAIANO. AVG. GER. DAC. P. M. P. TR. *Rv*: Ceres standing. COS. V. P. P. S. P. Q. R. OPTIMO. PRINC.
Hammond Coll. Acc. no. 1898.66.16. Cf. *RIC* II, 251.

817. *Dupondius.* Of Trajan. About A.D. 112–117. *Ob*: Head of emperor, radiate. IMP. CAES. NERVAE. TRAIANO. AVG. GER. DAC. P. M. TR. P. COS. VI. P. P. *Rv*: Felicitas standing, holding caduceus and cornucopiae. SENATVS. POPVLVSQVE. ROMANVS. S. C.
Wulfing Coll. Acc. no. 1926.10.41. Cf. *RIC* II, 288.

818. *Sestertius.* Of Trajan. About A.D. 114–117. *Ob*: Head of emperor, laureate. IMP. CAES. NER. TRAIANO. OPTIMO. AVG. GER. DAC. PARTHICO. P. M. TR. P. COS. VI. P. P. *Rv*: Providence standing. PROVIDENTIA. AVGVSTI. S. P. Q. R. S. C.
Wulfing Coll. Acc. no. 1926.10.13. Cf. *RIC* II, 291.

819. *Denarius.* Of Trajan. *Ob*: Head of emperor, laureate. Inscription illegible, but TRAIANO visible. *Rv*: Two caps. Inscription illegible.
Johnson Coll. Acc. no. 1919.58.84.

820. *Dupondius.* Of the reign of Hadrian (A.D. 117–138). About A.D. 119–121. *Ob*: Head of emperor, radiate. IMP. CAESAR. TRAIANVS. HADRIANVS. AVG. P. M. TR. P. COS. III. *Rv*: Salus standing, with foot on globe. SALVS. PVBLICA. S. C.

Wulfing Coll. Acc. no. 1926.10.15.
Cf. *RIC* II, 418.

821. *Sestertius*. Of Hadrian. About
A.D. 119–121. *Ob*: Head of emperor,
laureate. IMP. CAESAR. TRAIAN.
HADRIANVS. AVG. *Rv*: Ceres stand-
ing. P. M. TR. P. COS. III. S. C.
Wulfing Coll. Acc. no. 1926.10.14.
Cf. *RIC* II, 419.

822. *Aureus*. Of Hadrian. About
A.D. 134–138. *Ob*: Head of emperor,
laureate. HADRIANVS. AVG. COS.
III. P. P. *Rv*: Victory with wreath and
palm. VICTORIA. AVG.
Warren Coll. Acc. no. 1923.119.4.
Formerly in the Heseltine Coll. Casson,
Catalogue, no. 2. Cf. *RIC* II, 372.

823. *As*. Of Hadrian. A.D. 137. *Ob*:
Head of L. Aelius. L. AELIVS.
CAESAR. *Rv*: Standing woman (For-
tuna-Spes). TR. POT. COS. II. S. C.
Wulfing Coll. Acc. no. 1926.10.43.
Cf. *RIC* II, 482.

824. *As*. Of Hadrian. *Ob*: Head of
emperor, laureate. Inscription illegible,
but HADRIANVS visible. *Rv*: Stand-
ing figure. SALVS. AVGVSTA. S. C.
COS. III.
Wulfing Coll. Acc. no. 1926.10.16.

825. *Sestertius*. Of the reign of An-
toninus Pius (A.D. 138–161). A.D. 139.
Ob: Head of emperor, laureate. AN-
TONINVS. AVG. PIVS. P. P. *Rv*: God-
dess holding object. TR. POT. COS. II.
S. C.
Hammond Coll. Acc. no. 1898.66.17.
Cf. *RIC* III, 100–101.

826. *As*. Of Antoninus Pius. A.D.
139. *Ob*: Head of emperor, laureate.
ANTONINVS. AVG. PIVS. P. P. *Rv*:
Genius sacrificing at altar. TR. POT.
COS. II. S. C.
Wulfing Coll. Acc. no. 1926.10.20.
Cf. *RIC* III, 103.

827. *Denarius*. Of Antoninus Pius.
A.D. 140. *Ob*: Head of emperor, laure-
ate. ANTONINVS. AVG. PIVS. P. P.
TR. P. COS. III. *Rv*: Head of the
young Marcus Aurelius. AVRELIVS.
CAESAR. AVG. PII. F. COS.
Donor unknown. Acc. no. 1931.11.
48. Cf. *RIC* III, 78.

828. *Dupondius*. Of Antoninus Pius.
About A.D. 140–144. *Ob*: Head of em-
peror, radiate. ANTONINVS. AVG.
PIVS. P. P. TR. P. COS. III. *Rv*: Salus
feeding a snake coiled around altar.
SALVS. AVG. S. C.
Wulfing Coll. Acc. no. 1926.10.49.
Cf. *RIC* III, 114.

829. *Sestertius*. Of Antoninus Pius.
About A.D. 140–144. *Ob*: Head of em-
peror, laureate. ANTONINVS. AVG.
PIVS. P. P. TR. P. COS. III. *Rv*: Apollo
standing with patera and lyre. APOL-
LINI. AVGVSTO. S. C.
Johnson Coll. Acc. no. 1919.58.25a.
Cf. *RIC* III, 107.

830. *Sestertius*. Of Antoninus Pius.
About A.D. 140–144. *Ob*: Head of em-
peror, laureate. ANTONINVS. AVG.
PIVS. P. P. TR. P. COS. III. *Rv*: Italy
seated on globe with scepter and cornu-
copia. ITALIA. S. C.
Wulfing Coll. Acc. no. 1926.10.17.
Cf. *RIC* III, 122.

831. *Dupondius*. Of Antoninus Pius.
A.D. 141. *Ob*: Head of Faustina I, wife
of emperor. DIVA. FAVSTINA. *Rv*:
Ceres standing. AVGVSTA. S. C.
Wulfing Coll. Acc. no. 1926.10.19.
Cf. *RIC* III, 167.

832. *Sestertius*. Of Antoninus Pius.
A.D. 141. *Ob*: Head of Faustina I.
DIVA. FAVSTINA. *Rv*: Ceres stand-
ing. AVGVSTA. S. C.
Wulfing Coll. Acc. no. 1926.10.18.
Cf. *RIC* III, 162–163.

833. *As*. Of Antoninus Pius. A.D.
141. *Ob*: Head of Faustina I. DIVA.

AVGVSTA. FAVSTINA. *Rv*: Pietas standing. PIETAS. AVG.
Wulfing Coll. Acc. no. 1926.10.21.
Cf. *RIC* III, 169.

834. *Denarius.* Of Antoninus Pius. A.D. 145. *Ob*: Head of emperor, laureate. ANTONINVS. AVGVSTVS. *Rv*: Standing woman. COS. IIII.
Hammond Coll. Acc. no. 1898.66.18.
Cf. *RIC* III, 42–43.

835. *Denarius.* Of the reign of Marcus Aurelius (A.D. 161–180). *Ob*: Head of Antoninus Pius, laureate. DIVVS. ANTONINVS. *Rv*: Façade of the pyre of Antoninus. CONSECRATIO.
Johnson Coll. Acc. no. 1919.58.45.
Cf. *RIC* III, 247.

836. *As.* Of Marcus Aurelius. A.D. 161–175. *Ob*: Head of Faustina II, wife of emperor. FAVSTINA. AVGVSTA. *Rv*: Salus seated. SALVS. AVGVSTAE.
Wulfing Coll. Acc. no. 1926.10.23.
Cf. *RIC* III, 347.

837. *Sestertius.* Of Marcus Aurelius. About A.D. 161–175. *Ob*: Head of Faustina II. FAVSTINA. AVGVSTA. *Rv*: Fecundity standing. FECVNDITAS. S. C.
Wulfing Coll. Acc. no. 1926.10.25.
Cf. *RIC* III, 345.

838. *Dupondius.* Of Marcus Aurelius. A.D. 162–163. *Ob*: Head of emperor, radiate. IMP. CAES. M. AVREL. ANTONINVS. AVG. P. M. *Rv*: Salus standing. SALVTI. AVGVSTI. TR. P. XVII. COS. III. S. C.
Wulfing Coll. Acc. no. 1926.10.40.
Cf. *RIC* III, 280.

839. *As.* Of Marcus Aurelius. A.D. 163–164. *Ob*: Head of emperor, laureate. M. ANTONINVS. AVG. P. M. *Rv*: Winged Victory. TR. P. XVIII. IMP. II. COS. III. S. C.
Wulfing Coll. Acc. no. 1926.10.45.
Cf. *RIC* III, 281.

840. *Sestertius.* Of Marcus Aurelius. A.D. 173–174. *Ob*: Head of emperor, laureate. M. ANTONINVS. AVG. TR. P. XXVIII. *Rv*: Jupiter seated, holding a Victory and scepter. IMP. VI. COS. III. S. C.
Wulfing Coll. Acc. no. 1926.10.26.
Cf. *RIC* III, 300.

841. *As.* Of Marcus Aurelius. About A.D. 174–175. *Ob*: Head of emperor, laureate. M. ANTONINVS. AVG. TR. P. XXIX. *Rv*: Hands joined before a standard. CONCORD. EXERC. IMP. VII. COS. III. S. C.
Wulfing Coll. Acc. no. 1926.10.22.
Cf. *RIC* III, 302.

842. *Sestertius.* Of Marcus Aurelius. After A.D. 175. *Ob*: Head of Faustina II. DIVA. FAVSTINA. *Rv*: Aeternitas standing. AETERNITAS. S. C.
Wulfing Coll. Acc. no. 1926.10.24.
Cf. *RIC* III, 349.

843. *As.* Of the reign of Commodus (A.D. 180–192). *Ob*: Head of Crispina, wife of Emperor. CRISPINA. AVGVSTA. *Rv*: Victory seated. Illegible inscription. S. C.
Wulfing Coll. Acc. no. 1926.10.29.
Cf. *RIC* III, 398–400.

844. *Sestertius.* Of Commodus. After A.D. 180. *Ob*: Head of Crispina. CRISPINA. AVGVSTA. *Rv*: Goddess seated. S. C.
Wulfing Coll. Acc. no. 1926.10.28.
Cf. *RIC* III, 442.

845. *Sestertius.* Of Commodus. A.D. 183. *Ob*: Head of emperor, laureate. M. COMMODVS. ANTONINVS. AVG. *Rv*: Fortuna with rudder and cornucopia. TR. P. VIII. IMP. V. COS. III. P. P. S. C.
Wulfing Coll. Acc. no. 1926.10.27.
Cf. *RIC* III, 409.

846. *Dupondius.* Of Commodus. A.D. 183. *Ob*: Head of emperor, radiate. M.

COMMODVS. ANTON. AVG. PIVS. *Rv*: Fortuna holding rudder and cornucopia. TR. P. VIII. IMP. VI. COS. IIII. P. P. S. C.
Wulfing Coll. Acc. no. 1926.10.42.
Cf. *RIC* III, 411.

847. *Sestertius.* Of Commodus. A.D. 183. *Ob*: Head of emperor, laureate. M. COMMODVS. ANTONINVS. AVG. PIVS. *Rv*: Quadriga wtih driver. TR. P. VIII. IMP. VI. COS. IIII. P. P. S. C.
Hammond Coll. Acc. no. 1898.66.19.
Cf. *RIC* III, 411.

848. *Denarius.* Of the reign of Septimus Severus (A.D. 193–211). A.D. 210. *Ob*: Head of emperor, laureate. SEVERVS. PIVS. AVG. BRIT. *Rv*: Jupiter between two children. TR. P. XVIII. COS. III. P. P.
Johnson Coll. Acc. no. 1919.58.60a.
Cf. *RIC* IV, 1, 121.

849. *Sestertius.* Of Septimus Severus. *Ob*: Head of emperor, laureate. L. SEPT. SEVERVS. PIVS. AVG. *Rv*: Two Victories holding objects between them. VICTORIAE. PRISCAE, with rest of inscription illegible. S. C.
Hammond Coll. Acc. no. 1898.66.20.

850. *As.* Of the reign of Severus Alexander (A.D. 222–235). *Ob*: Head of Julia Mamaea, mother of emperor. IVLIA. MAMEA. AVGVSTA. *Rv*: Vesta standing. VESTA. S. C.
Wulfing Coll. Acc. no. 1926.10.33.
Cf. *RIC* IV, 2, 127.

851. *Sestertius.* Of Severus Alexander. *Ob*: Head of Julia Mamaea. IVLIA. MAMAEA. AVGVSTA. *Rv*: VENERI. FELICI. S. C.
Wulfing Coll. Acc. no. 1926.10.31.
Cf. *RIC* IV, 2, 126.

852. *Sestertius.* Of Severus Alexander. About A.D. 231–235. *Ob*: Head of emperor, laureate. IMP. ALEXANDER.

PIVS. AVG. *Rv*: Mars with spear and shield. MARS. VLTOR.
Wulfing Coll. Acc. no. 1926.10.30.
Cf. *RIC* IV, 2, 120.

853. *As.* Of Severus Alexander. About A.D. 231–235. *Ob*: Head of emperor, laureate. IMP. ALEXANDER. PIVS. AVG. *Rv*: Hope holding a Victory.
Wulfing Coll. Acc. no. 1926.10.32.
Cf. *RIC* IV, 2, 121.

854. *Sestertius.* Of the reign of Maximinus (A.D. 235–238). A.D. 236–238. *Ob*: Head of emperor, laureate. MAXIMINVS. PIVS. AVG. GERM. *Rv*: Peace with palm. PAX. AVGVSTI. S. C.
Wulfing Coll. Acc. no. 1926.10.34.
Cf. *RIC* IV, 2, 146.

855. *As.* Of Maximinus. A.D. 236–238. *Ob*: Head of emperor, laureate. MAXIMINVS. PIVS. AVG. GERM. *Rv*: Peace standing. PAX. AVGVSTI. S. C.
Wulfing Coll. Acc. no. 1926.10.35.
Cf. *RIC* IV, 2, 146.

856. *Sestertius.* Of the reign of Gordian III (A.D. 238–244). After A.D. 239. *Ob*: Head of emperor, laureate. IMP. GORDIANVS. PIVS. FEL. AVG. *Rv*: Standing Jupiter. IOVI. STATORI. S. C.
Wulfing Coll. Acc. no. 1926.10.36.
Cf. *RIC* IV, 3, 48.

857. *As.* Of Gordian III. After A.D. 239. *Ob*: Head of emperor, laureate. IMP. GORDIANVS. PIVS. FEL. AVG. *Rv*: Gordian standing. P. M. TR. P. III. COS. II. P. P. S. C.
Wulfing Coll. Acc. no. 1926.10.47.
Cf. *RIC* IV, 3, 49.

858. *Dupondius.* Of Gordian III. Between A.D. 241 and 243. *Ob*: Head of emperor, radiate. IMP. GORDIANVS. PIVS. FEL. AVG. *Rv*: Hercules

resting on club. VIRTVTI. AVGVSTI. Donor unknown. Acc. no. 1931.11.47. Cf. *RIC* IV, 3, 25.

859. *Double denarius.* Of Gordian III. About A.D. 243–244. *Ob*: Head of emperor, laureate. IMP. GORDIANVS. PIVS. FEL. AVG. *Rv*: Securitas standing. SECVRITAS. PERPETVA. Johnson Coll. Acc. no. 1919.58.78a. Cf. *RIC* IV, 3, 31.

860. *Sestertius.* Of the reign of Philippus I (A.D. 244–249). *Ob*: Head of emperor, laureate. IMP. M. IVL. PHILIPPVS. AVG. *Rv*: Peace standing. PAX. AETERNA. S. C. Wulfing Coll. Acc. no. 1926.10.46. Cf. *RIC* IV, 3, 91.

861. *Sestertius.* Of Philippus I. *Ob*: Head of emperor, laureate. IMP. M. IVL. PHILIPPVS. AVG. *Rv*: Securitas seated. SECVRIT. ORBIS. S. C. Hammond Coll. Acc. no. 1898.66.21. Cf. *RIC* IV, 3, 92.

862. *Sestertius.* Of Philippus I. A.D. 244. *Ob*: Head of emperor, laureate. IMP. M. IVL. PHILIPPVS. AVG. *Rv*: Felicitas standing. P. M. TR. P. III. COS. II. P. P. S. C. Wulfing Coll. Acc. no. 1926.10.50. Cf. *RIC* IV, 3, 87.

863. *As.* Of the reign of Trajan Decius (A.D. 249–251). *Ob*: Head of emperor. The inscription is illegible. *Rv*: The two Pannoniae standing. PANNONIAE. Wulfing Coll. Acc. no. 1926.10.38. Cf. *RIC* IV, 3, 122.

864. *Double sestertius.* Of Trajan Decius. *Ob*: Head of Herennia Etruscilla, wife of emperor. HER. ETRVSCILLA. AVG. *Rv*: Pudicitia seated. PVDICITIA. AVG. S. C. Donor unknown. Acc. no. 1931.11.39. Cf. *RIC* V, 1, 137.

865. *Dupondius.* Of the reign of Gallienus (A.D. 253–268). A.D. 257–259 and later. *Ob*: Head of emperor, radiate. GALLIENVS. AVG. *Rv*: Mars advancing with shield, spear, and helmet. MARS. VLTOR. Donor unknown. Acc. no. 1931.11.38. Cf. *RIC* V, 1, 188.

866. *Dupondius.* Of Gallienus. About A.D. 258. *Ob*: Head of emperor, radiate. GALLIENVS. P. F. AVG. *Rv*: Victory with wreath on globe, at each side of which sits a captive. Donor unknown. Acc. no. 1931.11.36. Cf. *RIC* V, 1, 72.

867. *Bronze coin.* Of Gallienus. *Ob*: Head of emperor, radiate. GALLIENVS. AVG. *Rv*: Victory holding wreath. VICTORIA; rest of inscription missing. Donor unknown. Acc. no. 1931.11.40. Cf. *RIC* V, 1, 143 ff.

868. *Bronze coin.* Of Victorinus. Between A.D. 260 and 270. *Ob*: Head of ruler, radiate. IMP. C. VICTORINVS. P. F. AVG. *Rv*: Standing figure and illegible inscription. Donor unknown. Acc. no. 1931.11.37. Cf. *RIC* V, 2, 379–398.

869. *As.* Of the reign of Aurelian (A.D. 270–275). *Ob*: Head of emperor, laureate. IMP. AVRELIANVS. AVG. *Rv*: Emperor and empress standing with hands joined. CONCOR. AVG. Wulfing Coll. Acc. no. 1926.10.39. Cf. *RIC* V, 1, 274.

870. *Dupondius.* Of the reign of Probus (A.D. 276–282). *Ob*: Head of emperor, radiate. IMP. C. PROBVS. P. F. AVG. *Rv*: Securitas standing, leaning on a column. SECVRIT. PERP. S. XXI. Donor unknown. Acc. no. 1931.11.34. Cf. *RIC* V, 2, 77.

871. *Dupondius.* Of the reign of Maximian (A.D. 286–305). *Ob*: Head

of emperor, radiate. IMP. MAXIMI-ANVS. AVG. *Rv*: Salus standing. SALVS. AVG. C.

Donor unknown. Acc. no. 1931.11.33. Cf. *RIC* V, 2, 269.

872. *Large bronze coin.* Of Maximian. *Ob*: Head of emperor, laureate. IMP. C. MAXIMIANVS. P. F. AVG. *Rv*: Providentia standing with scales and cornucopia. Inscription illegible.

Donor unknown. Acc. no. 1931.11.41. Cf. *RIC* V, 2, 259–273; 284–287.

873. *As.* Of the reign of Gaius Galerius Valerius Maximinus (A.D. 305–311). About A.D. 305–308. *Ob*: Head of emperor, laureate. IMP. C. GAL. VAL. MAXIMINVS. P. F. AVG. *Rv*: Standing man. GENIO. IMP. PAS-TORIS. KPS. ALE.

Johnson Coll. Acc. no. 1919.58.54.

874. *As.* Of Gaius Galerius Valerius Maximinus. About A.D. 305–308. *Ob*: Head of emperor, laureate. GAL. VAL. MAXIMINVS. NOB. CAES. *Rv*: Standing man. GENIO. CAESARIS.

Johnson Coll. Acc. no. 1919.58.77a.

875. *As.* Of the reign of Constantine I (A.D. 311–337). Between A.D. 313–317. *Ob*: Head of emperor, laureate. IMP. CONSTANTINVS. P. F. AVG. *Rv*: Mars standing with shield and spear stuck in ground. MARTI. CON-SERVATORI. ST.

Donor unknown. Acc. no. 1931.11.42. Cf. *Numismatique constant.* II, 250.

876. *As.* Of Constantine I. Between A.D. 320 and 324. *Ob*: Head of emperor, laureate. CONSTANTINVS. AVG. *Rv*: Altar. VOTIS. XX. BEATA. TRAN-QVILLITAS.

Donor unknown. Acc. no. 1931.11.43. Cf. *Numismatique constant.* II, 111.

877. *As.* Of Constantine I. Between A.D. 320 and 324. *Ob*: Head of emperor,

laureate. CONSTANTINVS. AVG. *Rv*: Wreath with streamers, in which is inscribed VOT. XX. DN. CONSTAN-TINI. MAX. AVG. ARLS.

Donor unknown. Acc. no. 1931.11.44. Cf. *Numismatique constant.* II, 166, no. vi.

878. *As.* Of Constantine I. Between A.D. 320 and 324. *Ob*: Head of emperor, laureate. CONSTANTINVS. AVG. *Rv*: Camp gate with two towers, and a star on top. PROVIDENTIAE. AVGG. STRE.

Donor unknown. Acc. no. 1931.11.45. Cf. *Numismatique constant.* I, 475.

879. *As.* Of Constantine I. Between A.D. 333 and 335. *Ob*: Head of emperor, laureate. CONSTANTINVS. IVN. NOB. C. *Rv*: Two standing legionaries with spears; between them, two standards. GLORIA. EXERCITVS. SMTSB.

Donor unknown. Acc. no. 1931.11.46. Cf. *Numismatique constant.* II, 603–604.

880. Same type as above, except for mint mark on the reverse: SMHA.

Donor unknown. Acc. no. 1931.11.46a.

881. *Bronze coin.* Of the reign of Constantius II (A.D. 337–361). About A.D. 355. *Ob*: Head of emperor, laureate. DN. CONSTANTIVS. P. F. AVG. *Rv*: Warrior spearing fallen foe. FEL. TEMP. REPARATIO.

Donor unknown. Acc. no. 1931.11.35. Cf. *RIC* IX, xxix–xxx, 150n.

882. *Solidus.* Of Constantius II. *Ob*: Head of emperor, diademed. FL. AVG. CONSTANTIVS. PERP. AVG. *Rv*: Roma and Constantinople as seated figures with a shield between them, on which is inscribed VOT. MVLT. GLORIA. REIPVBLICAE. SMNB.

Warren Coll. Acc. no. 1923.119.6. Casson, *Catalogue*, no. 4. Cf. H. Cohen,

Description historique des monnaies frappées sous l'empire romain VII (1888) 456 ff.

883. *Solidus.* Of the reign of Valens (A.D. 364–378). Between A.D. 364 and 367. *Ob*: Head of emperor. DN. VALENS. PER. F. AVG. *Rv*: Emperor holding standard with cross and a Victory on globe. RESTITVTOR. REIPVBLICAE. ANTT.
Warren Coll. Acc. no. 1920.8.7. Casson, *Catalogue*, no. 5. Cf. *RIC* IX, 272.

884. *Silver siliqua.* Of Valens. *Ob*: Head of emperor. DN. VALENS. P. F. AVG. *Rv*: Roma holding a Victory in her hand. VRBS. ROMA. TRPS.
Johnson Coll. Acc. no. 1919.58.74. Cf. *RIC* IX, 19.

885. *Bronze coin.* Of Procopius. About A.D. 365. *Ob*: Head of Procopius. DN. PROCOPIVS. P. F. AVG. *Rv*: Procopius holding standard. REPARATIO. FEL. TEMP. CONST.
Warren Coll. Acc. no. 1920.8.8. Casson, *Catalogue*, no. 6. Cf. *RIC* IX, 214.

886. *Solidus.* Of the reign of Theodosius II (A.D. 408–450). *Ob*: Head of emperor. DN. THEODOSIVS. P. F. AVG. *Rv*: Emperor seated, holding scepter and orb. VOT. XXX. MVLT. XXXXI. CONOB.
Warren Coll. Acc. no. 1920.8.9. Casson, *Catalogue*, no. 7. Cf. *RIC* IX, xxxvii–xxxviii.

BYZANTINE COINS

887. *Gold solidus.* Of the reign of Anastasius I (A.D. 491–518). *Ob*: Head of emperor, beardless, with helmet, spear, and shield. DN ANASTASIVS PP AVC. *Rv*: Winged Victory holding staff with cross. In the field, a star. VICTORIA AVC CCS. CONOB.
Warren Coll. Acc. no. 1920.8.10. Casson, *Catalogue*, no. 8. Cf. *IBC* I, 1.

888. *Bronze coin.* Of the reign of Justinian I (A.D. 527–565). A.D. 538–539. *Ob*: Bust of emperor, beardless, with helmet and holding globus and shield. In the field, a cross. DN IVSTINIANVS PP AVC. *Rv*: Large M in center, ANNO XII on right and left. Above, a cross; beneath, Δ. In the exergue, CON.
Warren Coll. Acc. no. 1920.8.11. Casson, *Catalogue*, no. 9. Cf. *IBC* I, 30–31.

889. *Gold solidus.* Of the reign of Phocas (A.D. 602–610). *Ob*: Bust of emperor, with pointed beard, wearing crown and armor, and holding globus. DN FOCAS PERP AVC. *Rv*: Victory with sacred monogram on cross and globus. VICTORIA AVSVI. CONOB.
Warren Coll. Acc. no. 1920.8.12. Casson, *Catalogue*, no. 10. Cf. *IBC* I, 162–163.

890. *Gold solidus.* Of the reign of Heraclius (A.D. 610–641). About A.D. 613–630 or later. *Ob*: Bust of emperor, bearded, on left, and smaller bust of his son, Heraclius Constantine, on right. Each wears paludamentum, cuirass, and crown with globus; above, a cross. DDNN HERACLIUS ET HERA CONST PP. *Rv*: Cross potent on three steps. VICTORIA AVGU B. CONOB.
Warren Coll. Acc. no. 1920.8.13. Casson, *Catalogue*, no. 11. Cf. *IBC* I, 186.

891. *Gold solidus.* Of the reign of Constans II (A.D. 641–668). A.D. 651–659. *Ob*: Bust of emperor, with long beard, wearing paludamentum, cuirass, and crown with globus, and holding globus. DN CONSTANTIUS PP AV. *Rv*: Cross potent on three steps. VICTORIA AVGU H. CONOB.
Warren Coll. Acc. no. 1920.8.14. Casson, *Catalogue*, no. 12. Cf. *IBC* I, 258.

892. *Gold solidus.* Of the reign of Constans II (A.D. 641–668). A.D. 654–

659. *Ob*: Bust of emperor, with long beard, and smaller bust of his son Constantine IV, beardless. Each wears paludamentum, cuirass, and crown with globus; between them is a small cross. DN CONSTANTINVS C CONSTAN. *Rv*: Cross potent on three steps. VICTORIA AVGU A. CONOB.

Warren Coll. Acc. no. 1920.8.15. Casson, *Catalogue*, no. 13. Cf. *IBC* I, 259.

893. *Gold solidus.* Of the reign of Constantine IV (A.D. 668–685). A.D. 668–669. *Ob*: Bust of emperor, beardless, wearing armor and helmet, and holding spear and shield. DN CONSANUS P. *Rv*: Cross potent on three steps between brothers of Constantine. On left is Heraclius, on right Tiberius, each wearing long robes and crown with cross and holding globus. VICTORIA AVGU B. CONOB.

Warren Coll. Acc. no. 1920.8.16. Casson, *Catalogue*, no. 14. Cf. *IBC* II, 313–314.

894. *Gold solidus.* Of the first reign of Justinian II (A.D. 685–695). *Ob*: Bust of Justinian II, bearded, wearing crown with globus and scarf of lozenge pattern. He holds cross potent and globus with patriarchal cross and PAX inscribed. DN IVSTINIANUS MULTUS AN. *Rv*: Bust of Christ with cross behind head. The right hand blesses, the left holds the book of the Gospels. DN IHS CHS REX REGNANTIUM.

Warren Coll. Acc. no. 1920.8.17. Casson, *Catalogue*, no. 15. Cf. *IBC* II, 332.

895. *Gold solidus.* Of the reign of Leo III (A.D. 717–741). About A.D. 720 and later. *Ob*: Bust of emperor, bearded, wearing paludamentum, cuirass, and crown with globus. In the right hand is a globus, in the left a mappa. DNO LEON PAMUL. *Rv*: Bust of Constantine V, beardless, wearing paludamentum, cuirass, and crown

with globus. In the right hand is a globus, in the left a mappa. DN CONSTANTINUM.

Warren Coll. Acc. no. 1920.8.18. Casson, *Catalogue*, no. 16. Cf. *IBC* II, 366–367.

896. *Silver coin.* Of the reign of Leo V (A.D. 813–820). *Ob*: Cross potent on three steps. Border of dots. IHSUS XPISTUS NIC A. *Rv*: + LEON / SCONSTAN / TINEEC⊕EU / BASILISRO / MAION.

Warren Coll. Acc. no. 1920.8.19. Casson, *Catalogue*, no. 17. Cf. *IBC* II, 409.

897. *Gold solidus.* Of the reign of Michael II (A.D. 820–829). *Ob*: Bust of emperor, bearded, wearing mantle, robe, and crown with globus. In the right hand is a cross potent, in the left a mappa. MIXAHL BASILEUS. *Rv*: Bust of Theophilus, his son, beardless, wearing crown with globus and robe of lozenge pattern. In the right hand is a globus, in the left a cross. + ⊕EOFILO DESP' + E.

Warren Coll. Acc. no. 1920.8.20. Casson, *Catalogue*, no. 18. Cf. *IBC* II, 414.

898. *Silver coin.* Of the reign of Constantine VII (A.D. 913–959). Of the period A.D. 945–959, in which his son Romanus II was associated in the rule. *Ob*: Cross on three steps with smaller cross at each extremity. In the center is an X and beneath steps a globule. The whole is bordered with three circles of dots. IHSUS XPISTUS NIC A. *Rv*: + CONST'T' / ΠORFVROG' / CEROMANO / ENX'ΩEVSEB' / B'RΩMEON. The whole is bordered as on the obverse.

Warren Coll. Acc. no. 1920.8.21. Casson, *Catalogue*, no. 19. Cf. *IBC* II, 466.

899. *Gold nomisma.* Of the reign of Nicephorus II (A.D. 963–969). *Ob*:

Bust of emperor, bearded, in robe of lozenge pattern, and bust of Basil II, beardless, in mantle and robe. Between them they hold the patriarchal cross and each wears a crown with cross. NICHFOR'CEBASIL'AUGGBK'. *Rv*: Bust of Christ, wearing tunic, mantle, and nimbus. The right hand is raised in benediction, the left is holding the book of the Gospels. + IHS XPS REX REGNANTIHM.

Warren Coll. Acc. no. 1920.8.22. Casson, *Catalogue*, no. 20. Cf. *IBC* II, 471.

900. Same type as above.
Warren Coll. Acc. no. 1920.8.23.

901. *Silver coin.* Of Nicephorus II. A.D. 963 (or later)–969. *Ob*: A cross, crosslet, on two steps, has in its center a medallion with four lobes, the letters NICF in the four corners, and a bust of the emperor, bearded. The whole is bordered by three circles of dots. + IHSUS XPISTUS NICA and * dotted. *Rv*: A cross of dots and lines appears above and below the inscription. + NICHF' / ENX'ΩAVTO / CRAT'EVSEB' / BASILEVS / RΩMAIΩ'.

Warren Coll. Acc. no. 1920.8.24. Casson, *Catalogue*, no. 22. Cf. *IBC* II, 472.

902. *Silver coin.* Of the reign of John I Zimisces (A.D. 969–976). *Ob*: A cross, crosslet, on two steps, has in its center a circular medallion with the letters IΩAN and a bust of the emperor, bearded. The whole is bordered by three circles of dots. *Rv*: A cross of dots and lines appears above and below the inscription. + IΩANN' / ENX'ΩAVTO / CRAT'EVSEB' / BASILEVS / RΩMAIΩ'.

Warren Coll. Acc. no. 1920.2.25. Casson, *Catalogue*, no. 23. Cf. *IBC* II, 475.

903. *Gold nomisma.* Of the reign of Romanus III (A.D. 1028–1034). *Ob*:

Emperor, bearded, wearing crown and jeweled robes and holding globus, stands as he is crowned by the Virgin. She wears nimbus, veil, tunic, and mantle. Above are the letters M̄Θ̄. ΘCEBOHΘ'RΩMANΩ. *Rv*: Christ, seated on throne, wears nimbus, tunic, and mantle. The right hand blesses, the left holds the book of the Gospels.

Warren Coll. Acc. no. 1920.8.26. Casson, *Catalogue*, no. 25. Cf. *IBC* II, 494.

904. *Gold nomisma.* Of the reign of Constantine IX (A.D. 1042–1055). *Ob*: Bust of emperor, bearded, wearing crown with cross and jeweled robe. In the right hand he holds a labarum, in the left a globus. + CΩNSTANTINO-J'AS RM. *Rv*: Bust of Christ, wearing nimbus, tunic, and mantle, and holding the book of the Gospels. + IHS XIS REX REGNTIHM.

Warren Coll. Acc. no. 1920.8.27. Casson, *Catalogue*, no. 24. Cf. *IBC* II, 499–500.

905. *Gold concave nomisma.* Of the reign of Constantine X (A.D. 1059–1067). *Ob*: Emperor, bearded, standing. He wears crown, long jeweled robe, and cloak, and holds labarum and globus with cross and shaft. + KΩN-RACΛO ΔOVKAC. *Rv*: Christ seated on throne. He wears nimbus, tunic, and mantle, and holds the book of the Gospels. + IHSI XS REX REGNANTIHM.

Warren Coll. Acc. no. 1920.8.28. Casson, *Catalogue*, no. 26. Cf. *IBC* II, 514–515.

906. Same type as above. A small hole is in the coin at the foot of the emperor.

Warren Coll. Acc. no. 1920.8.29.

907. *Gold nomisma.* Of the reign of John II Comnenus (A.D. 1118–1143). *Ob*: Emperor, bearded, stands as he is crowned by the Virgin. In the field, above is M̄Θ̄. John wears a crown,

jeweled robe, and holds labarum and mappa. The Virgin wears nimbus, veil, tunic, and mantle. The inscription is on the left and right as follows:

ĪΩ	ΦV
ΔCC	PO
ΠOT	ΓC
TΩ	NH
Π	T

Rv: Christ seated on backless throne. In the left hand he holds the book of the Gospels, with the right he blesses. Above, IC and X̄C̄.

Warren Coll. Acc. no. 1920.8.30. Cf. *IBC* II, 557, 560.

EARLY EUROPEAN COINS

908. *Gold augustal.* Of the reign of Emperor Frederick II of the Holy Roman Empire (A.D. 1211–1250). *Ob*: Head of emperor, laureate. CESAR. AVG. IMP. ROM. *Rv*: Eagle with head to right and wings outspread. FRIDERICVS.

Warren Coll. Acc. no. 1920.8.31. Casson, *Catalogue*, no. 3. In workmanship the gold coins of Frederick were the finest produced in the Middle Ages. See John Allan in *Encyclopaedia Britannica* (1961) s.v. "Numismatics: Mediaeval and Later European Coins."

909. *Gold coin of France.* Of the reign of Francis I (A.D. 1515–1547). *Ob*: Arms of France, crowned, with star above. REX. I. FRANCISCVS. DEI. GRATIA. FRANCORVM. *Rv*: Greek cross with fleur-de-lis at each end. Letter F in two quadrants, fleur-de-lis in other two. Inscription partly obscured, but IMPERAT. legible.

Warren Coll. Acc. no. 1920.8.33. Casson, *Catalogue*, no. 61.

910. *Silver testoon of France.* Of the reign of Francis II and Mary Stuart (A.D. 1559–1560). Struck in 1560. *Ob*: Arms with fleur-de-lis in left half and lion rampant in right; above, a crown.

FRAN. ET. MA. D. G. R. R. FRANCO. SCOTORVMQVE. *Rv*: Monogram for F and M flanked by thistle and unidentifiable object, all crowned. VICIT. LEO. DE. TRIBV. IVDA. 1560.

Warren Coll. Acc. no. 1920.8.34. Casson, *Catalogue*, no. 62.

911. *Gold coin of France.* Of the reign of Charles IX (A.D. 1560–1574). *Ob*: Arms of France, crowned, with star above. REX. I. KAROLVS. DEI. GRATIA. FRANCORVM. *Rv*: Greek cross with fleur-de-lis at each end. Inscription partly obscured, but IMPERAT. legible.

Warren Coll. Acc. no. 1920.8.32. Casson, *Catalogue*, no. 60.

912. *Silver Oxford shilling of England.* Of the reign of Charles I (A.D. 1625–1649). A.D. 1643. *Ob*: Bust of Charles, to left, crowned. In the field, the numeral XII. CAROLVS. D. G. MAG. BR. FR. ET. HI. REX. *Rv*: Three crowns above, with this inscription in the center: RELIG. PROT. LEG. ANG. LIB. PAR. and the date 1643 at bottom with OX. EXVRGAT. DEVS. DISSIPENTVR. INIMICA. around the edge.

Warren Coll. Acc. no. 1920.8.6. Casson, *Catalogue*, no. 63. Cf. G. C. Brooke, *English Coins* [3] (1950) 214, pl. 49, no. 2.

913. *Silver coin of England.* Of the reign of Elizabeth I (A.D. 1558–1603). A.D. 1566. *Ob*: Head of queen, crowned. ELIZABETH. D. G. ANG. FR. ET. HI. REGINA. *Rv*: Coat of arms on a quadripartite field; lions in the upper right and lower left quadrants, fleur-de-lis in the upper left and lower right. POSVI. DEV. ADIVTOREM. MEV.

Johnson-Chase Estate. Acc. no. 1958. 18.6.1. Cf. G. C. Brooke, *English Coins* [3] (1950) 198.

914. Same type as above, but of the year A.D. 1567.

Johnson-Chase Estate. Acc. no. 1958.
18.6.2.

915. Same type as above, but of the
year A.D. 1580.
Johnson-Chase Estate. Acc. no. 1958.
18.6.3.

916. Same type as above, but of
the year A.D. 1581.
Johnson-Chase Estate. Acc. no. 1958.
18.6.4.

<center>UNIDENTIFIED COINS</center>

917. *Bronze coin. Ob*: Pegasus. *Rv*:
Unidentified object.
Johnson Coll. Acc. no. 1919.58.82d.

918. *Silver coin. Ob*: Female head
to right with diadem and necklace. *Rv*:
Female figure astride a prow.
Donor unknown. Acc. no. 1931.11.31.

919. *Silver coin. Ob*: Female head
to right. Letter O and illegible inscrip-
tion. *Rv*: Naked man carrying clothed
woman on his shoulder. Illegible in-
scription.
Donor unknown. Acc. no. 1931.11.30.

920. *Silver coin. Ob*: Head of Her-
acles in lion's skin. *Rv*: Club and un-
identified object. EPY and MOΛIΩN.
Donor unknown. Acc. no. 1931.11.28.

921. *Silver coin. Ob*: Female head
to right. *Rv*: Figure with spear, seated
on what may be a prow.
Donor unknown. Acc. no. 1931.11.27.

922. *Silver coin. Ob*: Helmeted head
to left. *Rv*: Owl, frontal. Letter M.
Donor unknown. Acc. no. 1931.11.26.

923. *Silver coin. Ob*: Female head
with two faces, one left, one right. Dol-
phins in field. *Rv*: Running horse.
Donor unknown. Acc. no. 1931.11.2.

924. *Silver coin. Ob*: Helmeted head
to right. *Rv*: Owl to right, with head
facing. Illegible inscription.
Donor unknown. Acc. no. 1931.11.20.

925. *Silver coin. Ob*: Helmeted head
to left. *Rv*: Bull with man's head to left.
ΥΡΙΝΑΙ.
Donor unknown. Acc. no. 1931.11.21.

926. *Silver stater. Ob*: Female head
to right. *Rv*: Horse with head turned
back. Letter U.
Donor unknown. Acc. no. 1931.11.3.

927. *Silver coin. Ob*: Female head to
right. *Rv*: Figure seated on a prow and
holding a scepter. ΛΙΕΩΝ and ΙΣ.
Donor unknown. Acc. no. 1931.11.6.

928. *Silver coin. Ob*: Head of Posei-
don with trident behind. *Rv*: Aphrodite
riding and holding Eros, who is shoot-
ing. Illegible inscription.
Donor unknown. Acc. no. 1931.11.7.

929. *Silver tetradrachm. Ob*: Beard-
ed head. *Rv*: Eagle with wings folded.
ΔΗΜΗΤΡΙΟΥ; rest of inscription miss-
ing. ΙΕΛΣΠ.
Donor unknown. Acc. no. 1931.11.10.

930. *Silver coin. Ob*: Male head to
right. *Rv*: Crescent. ΠΤΟΛΕΜΑΙΟΥ.
ΔΙΟΝΥΣΙΟΥ.
Donor unknown. Acc. no. 1931.11.25.
This coin may be of Ptolemy XII of
Egypt, who ruled between 80 and 51
B.C.

931. *Silver stater. Ob*: Horseman
with spear ready. ΚΑΣΣ. *Rv*: Baboon
on all fours. ΒΑΣΙΛΕΩΣ. ΑΠΟΛΛΟΔΟ-
ΡΟΥ.
Donor unknown. Acc. no. 1931.11.22.
This coin is probably of the kingdom of
Bactria and northwestern India.

932. Same type as above.
Donor unknown. Acc. no. 1931.11.11.

933. *Silver stater. Ob*: Rider with
spear, astride horse. ΑΖΟΥ. ΒΑΣΙΛΕΩΣ.

ΒΑΣΙΛΕΩΝ. ΜΕΓΑΛΟΥ. *Rv*: Standing figure with branch and scepter. Inscription in Kharosthi. Monogram for Τ, Δ, and Ρ.

Donor unknown. Acc. no. 1931.11.12. This coin is also probably of Bactria and northwestern India.

934. *Silver tetradrachm. Ob*: Head of elephant within beadlike circle. *Rv*: Obscured device. ΒΑΣΙΛΕΩΣ. ΜΑΥΟΥ.

Donor unknown. Acc. no. 1931.11.15.

935. *Silver tetradrachm. Ob*: Young Heracles in lion's skin. *Rv*: Seated male figure holding a dove and resting on a scepter. ΒΑΣΙΛΕΩΣ. ΑΝΤΙΟΧΟΥ. and two monograms: Μ, and one for Δ and Υ.

Donor unknown. Acc. no. 1931.11.17.

936. *Silver coin. Ob*: Bearded head to right. REX. IVBA. *Rv*: Temple. Inscription illegible.

Donor unknown. Acc. no. 1931.11.51. This coin was issued by Iuba I, king of Numidia (d. 46 B.C.), or by his son, Iuba II (about 50 B.C.– A.D. 23).

937. *Silver coin. Ob*: Male head to left. P. DECIVS. *Rv*: Winged Victory with laurel approaching an arch with cupola. COS.

Donor unknown. Acc. no. 1931.11.52.

938. *Silver denarius. Ob*: Female head to right. C. CORNEL. SVPERA. AVG. *Rv*: Standing figure with scepter. VESTA.

Donor unknown. Acc. no. 1931.11.18.

939. *Silver denarius. Ob*: Head of emperor. TITVS. CAESAR. VESPAS. *Rv*: Head. ARRICIDIAE. TITI. VESPA.

Donor unknown. Acc. no. 1931.11.55. This coin is of the reign of Vespasian (A.D. 69–79) or Titus (A.D. 79–81).

940. *Bronze coin. Ob*: Female head to right. Inscription illegible. *Rv*: Woman seated. CONCORDIA. AVG. S. C.

Wulfing Coll. Acc. no. 1926.10.37.

941. *Bronze Byzantine coin. Ob*: Head of emperor. Inscription illegible. *Rv*: The Christian monogram. Inscription illegible.

Johnson Coll. Acc. no. 1919.58.52.

X

Terracotta Lamps

LAMPS, most commonly made of clay or bronze, were used in antiquity not only for illumination but also as votive offerings and as furniture for tombs. Although they are known in Greece in the Neolithic and Mycenaean periods, their use later died out. They were reintroduced from the East into Greece about the beginning of the sixth century B.C., but in Italy they did not become common until the third century B.C. In the main their general features continued unchanged in Greece from this revival down to the fifth century of the Christian era, but their degree of usefulness and artistic qualities varied greatly from period to period. Greek lamps are undecorated and thus in themselves are less interesting than those later types which have reliefs on them. The Roman relief lamps in particular give evidence of religious, domestic, and social customs of the times.

With few exceptions Greek lamps were shaped on the wheel down to the Hellenistic period, when molded types also came into use. This new means of production made it easy to include reliefs on the upper surface, and after 200 B.C. most lamps were manufactured with some form of decoration on them. In the Hellenistic period the center surface was left plain and emphasis was placed on the rim, which was usually adorned with conventional patterns and floral designs. In the Roman period, however, the center, or discus, bears the main relief and the rim is left to serve as a framework. Humans, animals, and other figures and objects appear as decorations on Roman lamps. Apart from their artistic qualities, ancient lamps of all periods are also most important to the archaeologist in establishing chronological sequences in an

excavation. Because the clay lamp was a common object of household use and because it had a relatively short span of life, lampsherds are found in great numbers at almost every Greek or Roman site. Since the lamps of different periods are sufficiently differentiated, the various types help in dating the strata or sites in which they are found.

Olive oil was the chief illuminating fuel of the Greeks and Romans, but animal fats were also occasionally employed, and in the first century of the Christian era mineral oil was being used. In the second century candles were manufactured of flaxen cords covered with pitch or wax, but candles never became popular. Torches of dry twigs soaked in pitch were used for venturing out at night.

The collection of terracotta lamps is mainly interesting because of its comprehensiveness, for almost every period in the history of this class of artifact is represented.

BIBLIOGRAPHY

O. Broneer, *Corinth, Vol. IV, pt. 2: The Terracotta Lamps* (1930).
F. N. Pryce in *Oxford Classical Dictionary* (1949) s.v. "Lamps."
R. J. Forbes, *Studies in Ancient Technology* VI (1958) 119–193.
R. H. Howland, *The Athenian Agora, Vol. IV: Greek Lamps and Their Survivals* (1958).
H. Menzel and J. Elgavish in *Enciclopedia dell' arte antica classica e orientale*, 4 vols. (1958 —) s.v. "Lucerna."
Judith Perlzweig, *The Athenian Agora, Vol. VII: Lamps of the Roman Period* (1961).

TERRACOTTA LAMPS (942–964)

942. *Unglazed lamp of buff clay.* The lamp is in the form of an open shallow dish, with one side pinched in to form a nozzle. Except for the pinched-in side, the dish is perfectly round.

From Cyprus. Sixth century B.C. H, 0.030 m. W, 0.110 m. Wheel-made. Estes Coll. Acc. no. 1902.14.

Salaminia, 279, fig. 274.

Cf. *SCE* III, xxxviii, nos. 4, 5; xciii, nos. 445, 565; clxxiv, nos. 404, 546. The shape of this lamp is that of the earliest type found in Greece of the Archaic period (ca. 600 B.C.). Only later was the body deepened and the top covered.

943. *Black-glazed lamp.* The body is round, the sides nearly vertical. The rim slants inward to a large filling hole, 0.057 m. in diameter. The nozzle, which juts out from the side, is scoop-shaped and has a large wick-hole. The entire upper surface is black-glazed, but the bottom and sides are reserved.

From Attica. About 550–500 B.C. H, 0.019 m. Diam., 0.093 m. Wheel-made except for the nozzle, which was handmade and added separately. Warren Coll. Acc. no. 1930.5.

The lustrous glaze, polished surface, and peculiar shape identify this lamp as Attic ware of the period when the potters of Attica began to dominate the

export market. In shape this lamp is a logical development of the form of No. 942, above. Cf. *Terracotta Lamps*, no. 45, pl. 1; Howland, *Athenian Agora IV*, pl. 32, no. 104.

944. *Black-glazed lamp.* The body is deep and rounded, with an incurving rim and large filling hole. The nozzle is long and thick, and has the wick hole at its tip. At the back the band-shaped handle describes a semicircle at a 30-degree angle above the rim. The lamp was completely black-glazed but is now much worn. The base is offset from the body by a deep groove.

Greek work. Fifth century B.C. H, 0.030 m. Diam. of body, 0.063 m. The body is wheel-made, the nozzle and handle handmade. Gift of Mr. and Mrs. J. Henry HcLellan. Acc. no. 1935.479.

Very few lamps of this type are of Attic workmanship. The clay of this lamp is noticeably inferior to that of No. 943, above. Cf. *Terracotta Lamps*, 135, figs. 58, 65; Howland, *Athenian Agora IV*, pl. 36, no. 212.

945. *Lamp in the form of a sleeping satyr.* The satyr lies outstretched to the right, nude save for a cloak, in which his left leg is entwined. His head rests on his wineskin, the mouth of which serves as the wick hole. His right arm is drawn across his chest and holds his left elbow. His left hand clutches a double flute. The back has a funnel with seven small filling holes in it. The whole figure rests on a small base.

From Tarentum. Second or first century B.C. H, 0.050 m. W, 0.040 m. L, 0.110 m. Mold-made. Warren Coll. Acc. no. 1913.1.

Cf. *Die Typen* II, 392, nos. 3, 4, for similar motives found in vases from Tarentum.

946. *Red-glazed lamp with the figure of a leaping lion in relief.* The body is round, the rim narrow and slanting inward. The discus is encircled by three grooves. The lion leaps to the left. The prominent nozzle is connected to the body by a volute on either side at its base. The wick hole is large and the filling hole is underneath the figure of the lion on the discus. There is no handle. The base is slightly offset from the body.

From Cyprus. First century A.D. H, 0.023 m. L, 0.088 m. Mold-made. Estes Coll. Acc. no. 1902.11.

Cf. *Terracotta Lamps*, no. 425, pl. 7.

947. *Unglazed lamp of reddish clay with gladiators in relief.* The body is round and the wide rim has a decoration of laurel pattern. In the discus on the left a retiarius is armed with a net and a trident. On the right a secutor in full armor carries a shield on his left arm and a short sword in his right hand. The pierced handle has three ridges, and the nozzle, which is set off from the rim, is broken at the tip.

From Cyprus. About A.D. 50–100. H, 0.032 m. L, 0.105 m. Mold-made. Estes Coll. Acc. no. 1902.3.

Scenes of gladiators and gladiatorial combat were very popular on Roman lamps from the middle of the first century onward. There were four main classes of gladiators: the mirmillo and Samnite carried an oblong shield and short sword and wore a visored helmet; the Thracian carried a round shield and scimitar; and the retiarius had as weapons only a net and trident. See F. A. Wright in *OCD*, s.v. "Gladiators," with bibliography. Cf. *Terracotta Lamps*, 85, figs. 41, 42, for this type of nozzle, which helps to date this lamp; Perlzweig, *Athenian Agora VII*, pl. 2, nos. 38, 40.

948. *Brown-glazed lamp with the figure of Eros and a goose in relief on the discus.* The body is round and the discus is surrounded by two grooves. The winged Eros holds the goose over his right shoulder. In front of him is the filling hole. The discus is depressed and

set off from the body by three concentric ridges. The heavy nozzle is sharply set off from the body. The pierced handle is broken. The base is very slightly offset.

Said to be from Pompeii. First century A.D. L, 0.108 m. Diam. of body, 0.068 m. Mold-made. Gift of Miss Ada Munson. Acc. no. 1930.39.

This type of nozzle is an intermediate stage in the encroachment of the nozzle on the rim of the lamp. The figure of Eros was a very popular figure on the lamps of the second and third centuries A.D. Cf. *Terracotta Lamps*, 85, figs. 41, 42, for the shape of the nozzle; Perlzweig, *Athenian Agora VII*, pl. 16, for many scenes with Eros.

949. *Red-glazed lamp*. The body is round, there is no handle, and the prominent nozzle joins the body with volutes on either side. The discus is decorated with a shell design in relief; at its base is the filling hole. On the bottom in raised letters is MΛ. The base is slightly offset and flat.

From Cyprus. First century A.D. H, 0.027 m. L, 0.082 m. Mold-made. Estes Coll. Acc. no. 1902.10.

Cf. *Terracotta Lamps*, no. 420, pl. 7; *SCE* III, xxxviii, no. 555, from Kition and from an identical mold.

950. *Brown-glazed lamp*. The body is round, there is no handle, and the prominent nozzle is joined to the body by a volute on either side at its base. The discus is decorated with a raised shell, in which is a small filling hole. The signature I in a raised letter is on the bottom, which is slightly offset and concave.

From Cyprus. First century A.D. H, 0.029 m. L, 0.074 m. Mold-made. Estes Coll. Acc. no. 1902.5.

The most popular form of lamp in the early Roman Empire is a circular one with decorations in relief on the top or discus. In the later Empire the oval shape is also seen. Cf. *Terracotta Lamps*, no. 420, pl. 7.

951. *Red-glazed lamp*. The body is round with a grooved rim, there is no handle, and the triangular nozzle joins the body with volutes on either side at its base. The discus is decorated with a raised pattern of leaves, birds, and fruit. There is a narrow channel from the discus to the nozzle; the filling hole is in the center of the discus, surrounded by concentric moldings. There is a ring base and the bottom is concave.

From Cyprus. First century A.D. H, 0.030 m. L, 0.093 m. Mold-made. Estes Coll. Acc. no. 1902.9.

Cf. *Terracotta Lamps*, nos. 420 and 425, pl. 7.

952. *Red-glazed lamp*. The body is round, there is no handle, and the prominent triangular nozzle joins the body with a volute on either side at its base. The discus has an impressed shell design; at its base is the filling hole. The bottom is concave and there is no distinct base.

From Cyprus. First century A.D. H, 0.028 m. L, 0.091 m. Mold-made. Estes Coll. Acc. no. 1902.8.

Cf. *Terracotta Lamps*, no. 420, pl. 7.

953. *Brown-glazed lamp*. The body is round and there is no handle. The discus is decorated with many gladiatorial weapons in relief: two daggers, two helmets, two shields, a pair of greaves, and a pick. In the center is the filling hole, with concentric moldings. The prominent nozzle is joined to the body by volutes at its base. The base has a circular groove and is concave.

From Cyprus. First century A.D. H, 0.028 m. L, 0.113 m. Mold-made. Estes Coll. Acc. no. 1902.6.

Lawrence-Cesnola Collection, unnumbered pl. Cf. *Terracotta Lamps*, nos. 418 and 425, pl. 7, for the shape; nos. 427 and 534 have gladiatorial weapons in relief.

954. *Unglazed lantern of gray clay.* The circular body rests on a low base; the sides are pierced irregularly by many small vents. At the bottom there is a broad opening about one fourth the size of the circumference and half the height of the lantern wall for the insertion of a lamp. The moldlike top has four molded ridges and a knob at its peak. The vertical loop handle bridges this knob.

From Cyprus. Of the first or second century A.D. H, 0.225 m. Diam., 0.130 m. Estes Coll. Acc. no. 1902.12.

Salaminia, pl. 20, no. 18.

The ancients had two methods of outdoor lighting: the burning of oil in a lamp or the combustion of some solid such as twigs, tallow, or wax. The present lantern was probably used with a small lamp inside, and its rugged construction suggests that it was designed for use out of doors. Cf. Forbes, *Studies in Ancient Technology* VI, 165, fig. 36.

955. *Unglazed lantern of red clay.* From the high base the body flares out to its full diameter. Its walls are perforated by three rows of regularly spaced vents. On one side is a large opening for the insertion of a lamp or candle. The top rises in three steps to a knobbed peak, over which bridges a vertical loop handle.

From Cyprus. Of the first or second century A.D. H, 0.220 m. Diam., 0.155 m. Estes Coll. Acc. no. 1902.13.

Salaminia, pl. 20, no. 20.

See No. 954, above.

956. *Red-glazed lamp* in the form of a crouching dog. Behind the head is a pierced lug for suspension. The filling hole is in the center of the back, and the nozzle extends from the chest.

From Cyprus. Of the first or second century A.D. H, 0.060 m. W, 0.033 m. L, 0.080 m. Mold-made. Estes Coll. Acc. no. 1902.1.

Salaminia, pl. 20, no. 15; *Lawrence-Cesnola Collection*, unnumbered pl.

957. *Small brown-glazed lamp.* The body is almond-shaped, the sides are angular, and the discus is raised on the rim and depressed in the center, where the filling hole is. The wick hole is set into the body at the tip. Between the tip and the discus are two volutes in relief and two raised bars. There is no handle, and there is a small ring base.

Roman work. Third century A.D. H, 0.030 m. L, 0.074 m. Mold-made. Gift of the Johnson-Chase Estate. Acc. no. 1958.38.

Cf. *Terracotta Lamps*, nos. 1148 and 1155, pl. 16; fig. 49, no. 12.

958. *Unglazed lamp of cream-colored clay with figures of a bear and man in relief.* The body is round and the wide rim has an impressed design of laurel leaf. In relief in the discus are the figures of a bear and a man somersaulting. The filling hole is off-center in the discus. The two-grooved handle is pierced. The nozzle is angular on the inner side and rounded on the outer side; it encroaches on the rim. The base has a circular groove.

From Cyprus. Third century A.D. H, 0.028 m. L, 0.113 m. Mold-made. Estes Coll. Acc. no. 1902.4.

Cf. *Terracotta Lamps*, no. 1243, fig. 185, for a similar scene.

959. *Unglazed lamp of brown clay.* The body is round and the pinched handle unpierced. The rim is decorated with impressed leaves in a herringbone pattern. The discus is encircled by three rows of dots surrounding a raised palmette; at the center is a filling hole. The nozzle protrudes only slightly. On the bottom, which has a hole, is the incised name of the artisan: Ἐρωδ⟨ά⟩-μο⟨υ⟩. The base is slightly offset and has a circular groove.

From Cyprus. Third century A.D. H, 0.040 m. L, 0.098 m. Mold-made. Estes Coll. Acc. no. 1902.7.

K. Herbert, *AJA* 66 (1962) 387, fig. 10.

Cf. *Terracotta Lamps*, no. 1515, pl. 23.

960. *Red-glazed lamp.* The body is round, and the wide rim is without decoration. The concave discus is decorated with an impressed tongue pattern; in its center is a filling hole and near its front edge a small air hole. The small handle is pierced; opposite it is the nozzle with a wick hole. The nozzle is separated from the ridge of the discus by a single groove. The base has a circular groove.

Roman work. Third century A.D. H, 0.027 m. Diam., 0.065 m. Mold-made. Hammond Coll. Acc. no. 1898.3.

Cf. *Terracotta Lamps*, no. 908, pl. 13.

961. *Unglazed lamp of cream-colored clay.* The body is almond-shaped, the sides slant, and the wide rim is decorated with a lattice pattern and dots. The small discus has a filling hole encircled by a band of raised dots. A channel between the discus and the wick hole is decorated with raised lines. There is no nozzle as such, and the base is a raised, almond-shaped line.

From Cyprus. Fifth century A.D. H, 0.070 m. L, 0.095 m. Mold-made. Estes Coll. Acc. no. 1902.2.

Salaminia, 282, fig. 285.

962. *Unglazed lamp of bright red clay.* The body is round, but the heavy nozzle projects from it and has a large wick hole. The wide rim is decorated with a raised pattern of leaves, triangles, and other designs. In the discus in relief is a cruciform monogram with a curved top. There are two filling holes in the discus, which opens into a chan-

nel to the wick hole. There is a small ring base with a ridge leading back to the handle, which is partially broken.

From Carthage. Fifth century A.D. H, 0.038 m. L, 0.125 m. Mold-made. Donor unknown. Acc. no. 1901.2.

This lamp belongs to a category of a distinctly Christian type. The circles, triangles, and three-part leaves used on the rim and in the monogram are all Christian symbols. Cf. *Terracotta Lamps*, no. 1463, pl. 21; Perlzweig, *Athenian Agora VII*, pls. 39–51, for numerous lamps of this period with Christian symbols.

963. *Unglazed lamp of light brown clay.* The body is almond-shaped. The wide rim, which is slanting in profile, is decorated with a raised pattern of lozenges enclosing dots. The discus is almond-shaped and has a raised line down the center, at the end of which is the filling hole. In place of a handle there is a small protrusion at the back. The wick hole is set into the body without a separate nozzle. There is no distinctly shaped base.

Said to be Syrian work. Fifth century A.D. H, 0.035 m. W, 0.075 m. L, 0.100 m. Mold-made. Gift of Mr. and Mrs. J. Henry McLellan. Acc. no. 1935.478.

964. *Green-glazed lamp.* The high, flaring neck is deeply set in the straight-sided body. The vertical looped handle rises above the lip and curves back to join the body. The nozzle projects horizontally from the side, and is broken.

Byzantine work. About the fifteenth century A.D. H, 0.065 m. Diam., 0.065 m. Mold-made. Hammond Coll. Acc. no. 1898.2.

Cf. *Terracotta Lamps*, no. 1560, pl. 24, and no. 1559, fig. 210. The green glaze is a sign of a late date.

XI

Glass

THE earliest wholly glass objects are beads and rods, which date from the middle of the third millennium B.C. and come from Egypt and Mesopotamia. Vessels of glass built up on clay cores were manufactured in Egypt in the fifteenth and fourteenth centuries B.C., and vase-shaped vessels cut from solid masses of glass during the latter part of the second and beginning of the first millennium B.C. appear to be Mesopotamian work. Vases made in the Egyptian manner but imitating the shapes of the smaller Greek terracotta vessels have been found in Greek and Etruscan tombs of the sixth to fourth centuries B.C. and in Cyprus of the Hellenistic period. The manufacturing technique was as follows: after the molten glass was worked over a clay core, threads of colored glass were rolled flush with the still-hot surface. A stylus was then applied to push the colored lines into various patterns.

In Egypt of the Hellenistic period mold-made bowls became popular, and here also the tradition of opaque polychrome glass continued into Roman times in mosaic, or millefiori, vases. In this process glass rods of differing colors were fused into a solid bar, cut into sections, and then set into the hot surface of a dark background glass, producing a mosaic effect. The whole was then molded into the desired shape of bowl. The technique is similar to the modern process by which inlaid linoleum is manufactured, but the effect on the eye is much more striking because of the texture or translucence of the glass. Another process in the same tradition was the casing or sealing of pieces of white glass to a dark blue background and the cutting of the white in the manner of a cameo.

The most famous example of this technique is the Portland Vase of the first century B.C. or A.D., now in London.

The invention of the blowing tube in the second or first century B.C. began a revolutionary advance in glass manufacture which made cheap mass production possible. Under the Roman Empire glassware largely displaced terracotta pottery, and not until modern times was glass again to be so widely used as in this period. Vessels of every size and shape were made in a great variety of processes: plain-blown, blown in molds, millefiori, grooved, spiked, mottled, painted, incised, and with threads of glass plastically applied. The mass-produced type of glass is usually transparent and of a greenish cast.

The following objects and fragments are some of the most interesting pieces in the classical collections: a blue aryballos, the only Greek vase in the collections (No. 965); a seven-handled vase (No. 1000); a delicate blue amphora (No. 1004); a tubular vase with projecting spikes (No. 1007); a vase with double tubes (No. 1008); a ribbed bowl (No. 1003); a miniature bottle with gold encrustation and considerable iridescence (No. 999); a fragment of a dish made by the millefiori technique (No. 1018); and a fragment of the cameo type showing a centaur fighting a Lapith (No. 1017).

Because of the nature of the material and the impossibility of accurate dating in almost every instance, the objects and fragments are collected herein under the names of their donors. Furthermore, since all the glass is of the Roman period or later with but one exception (No. 965), this fact is not reiterated under each object.

BIBLIOGRAPHY

Anton Kisa, *Das Glas in Altertume*, 3 parts (1908).
D. B. Harden, *Roman Glass from Karanis* (1936); *idem*, in *A History of Technology*, ed. Charles Singer and others, II (1956) 311–346.
R. J. Forbes, *Studies in Ancient Technology*, V (1957) 110–231.
R. J. Charleston in *Encyclopaedia Britannica* (1961) s.v. "Glass, History."
Frederic Neuburg in *Encyclopedia of World Art*, 6 vols. (1959 —) s.v. "Glass: Ancient Glass."

GLASS (965–1142)

The following 20 objects belong to the Walker Collection and take their catalogue numbers from those assigned them in the *Descriptive Catalogue* on pages 21 and 38–41 of the third edition (1906), and pages 33–36 of the fourth edition (1930).

They were given in 1894 by the Misses Walker on the occasion of the dedication of the Walker Art Building,

and they are said to derive from three sources: the Lawrence-Cesnola Collection; the excavations of Dr. Max Ohnefalsch-Richter near Limassol, Cyprus; and the vicinity of Tyre in Syria. Some 24 objects in this collection cannot at present be located, and detailed descriptions of them are not available.

965.* *Opaque blue aryballos.* The vase is decorated with horizontal and zigzag lines of yellow and light blue. The handles run from the shoulder to beneath the lip. PL. XLVI

Greek work. About the sixth to fourth century B.C. H, 0.060 m. Diam., 0.045 m. Core-wound; handles applied later. No. 81.

Cf. *Handbook,* 373, pl. 499.

966. *Transparent green bottle* with globular body and very long neck.

From Tyre. H, 0.202 m. Diam., 0.065 m. Plain-blown. No. 83.

Cf. *Das Glas,* pl. a (of forms), no. 54, for the type.

967. *Bottle* with oviform body and long neck. A white encrustation and iridescence cover the entire piece.

From Cyprus. H, 0.177 m. Diam., 0.048 m. Plain-blown. No. 85.

968. *Small oenochoë* with fluted body and trefoil lip. The glass is greenish and the neck is encircled with a spiral thread of glass. The handle is looped at the lip.

From Tyre. H, 0.097 m. Diam., 0.043 m. Plain-blown. No. 90.

Cf. *Das Glas,* 191, fig. 95, for the decoration. The use of encircling threads around the neck is common.

969. *Purple conical vase* with a large mouth. The rounded bottom requires a stand in which to insert the vase.

From Tyre. H, 0.099 m. Diam. 0.043 m. Plain-blown. No. 91.

Cf. Harden, *Roman Glass from Ka-*

ranis, pl. v. This vase may have been used as a lamp.

970.* *Small oenochoë* with cylindrical, fluted body and high neck. The lip flares out, the handle is looped at the top, and the glass is richly iridescent.

From Tyre. H, 0.110 m. Diam., 0.038 m. Mold-blown; handle applied later. No. 92. PL. XLVI

See *Das Glas,* 317–321, figs. 156–158, for over fifty types of handles, including those with loops.

971.* *Small bottle* with cone-shaped body, short neck, and lip with molding. The handle runs from the lip to the shoulder, then continues to the base in a series of undulations. PL. XLVI

From Cyprus. H, 0.087 m. Diam. of base, 0.045 m. Plain-blown; handle applied later. No. 95.

972.* *Globular bottle* with thin neck and flaring lip. PL. XLVI

From Tyre. H, 0.090 m. Diam., 0.053 m. Plain-blown. No. 104.

973.* *Large bottle* with tall neck and bell-shaped body. The lip curves under in joining the neck and the bottom is concave. The glass has a greenish cast and is iridescent in many hues.

PL. XLVI

From Tyre. H, 0.200 m. Diam., 0.085 m. Plain-blown. No. 107.

Cf. *Das Glas,* pl. a (of forms), nos. 16–18.

974. *Long tube* with white encrustations and iridescence.

From Tyre. H, 0.295 m. Diam., 0.018 m. Plain-blown. No. 109.

Cf. *Das Glas,* pl. a (of forms), nos. 2–3.

975. *Large, flat dish* with high rim and small base. The glass is transparent and iridescent. There are two small holes in the base of the rim.

From Tyre. H, 0.048 m. Diam., 0.227 m. Molded. No. 110.

Cf. Harden, *Roman Glass from Karanis*, pl. ii, no. 83.

976. *Bottle* with squat body, long, tubular neck, and flaring lip. The glass has a silver encrustation and iridescence.
From Cyprus. H, 0.143 m. Diam., 0.075 m. Plain-blown. No. 111.

977.* *Large pear-shaped bottle* with high neck. The transparent glass is greenish and iridescent. PL. XLVI
From Tyre. H, 0.172 m. Diam., 0.075 m. Plain-blown. No. 112.

978. *Greenish goblet* with spiral fluted surface.
From Tyre. H, 0.083 m. Diam., 0.075 m. Plain-blown. No. 113.

979. *Small, stout bottle* of greenish color with wide body, thick neck, flaring lip, and handle. There is a silver encrustation and some iridescence.
H, 0.090 m. Diam., 0.070 m. Plain-blown; handle applied later. No. 116.

980.* *Cylindrical goblet* with fluting which is barely perceptible except on the small base. The transparent glass is greenish and there is a double ring of ornamentation on the upper surface of the body. PL. XLVI
From Tyre. H, 0.105 m. Diam., 0.070 m. Mold-blown; ornamentation applied later. No. 117.

981.* *Large two-handled vase*. The handles are green. The body has yellow and silver encrustations. PL. XLVI
From Cyprus. H, 0.098 m. Diam., 0.083 m. Plain-blown; handles applied later. No. 133.

982.* *Green bottle* with bell-shaped body and high neck. The glass is iridescent and is covered in part with a white encrustation. PL. XLVI
From Cyprus. H, 0.119 m. Diam., 0.052 m. Plain-blown. No. 1332.
Cf. *Das Glas*, pl. a (of forms) no. 15.

983. *Goblet* with small base. The glass is green and iridescent.
From Cyprus. H, 0.092 m. Diam., 0.070 m. Plain-blown. No. 1333.

984.* *Two-handled vase* with small neck and wide lip. There is a zigzag decoration applied in green glass around the lower body. There is a considerable silver encrustation and iridescence on most of the piece. The base is concave. PL. XLVI
From Cyprus. H, 0.083 m. Diam., 0.075 m. Plain-blown; handles and decoration applied later. No. 1334.

The following seven objects belong to the Hammond Collection.

985. *Small bottle* with rounded body and long neck with flaring lip. The whole is filled with hardened red sand.
From Beirut. H, 0.095 m. Diam. of lip, 0.030 m. Plain-blown. Acc. no. 1898.11.

986. *Small circular base of a vase* with concave bottom. Diam., 0.050 m. Plain-blown. Acc. no. 1898.12.

987. *Small circular base of a dark colored vase* with a section of the stem attached.
H, 0.030 m. Diam., 0.042 m. Plain-blown. Acc. no. 1898.13.

988. *Small circular base of a vase* with a section of a very narrow stem attached. The glass has a silver encrustation and is slightly iridescent.
H, 0.030 m. Diam., 0.043 m. Plain-blown. Acc. no. 1898.14.

989. *Small circular base of a vase* with concave bottom. Diam., 0.050 m. Plain-blown. Acc. no. 1898.15.

990. *Bottle* with very small body, stepped in profile, and long tubular neck with overhanging lip.

From Ephesus. H, 0.125 m. Diam. of base, 0.025 m. Plain-blown. Acc. no. 1898.16.

991. *Bottle* with short, conical body and long tubular neck flaring at the lip.
From Ephesus. H, 0.115 m. Diam. of lip, 0.024 m. Plain-blown. Acc. no. 1898.17.

The following seven objects belong to the Estes Collection from Cyprus and were formerly in the Lawrence-Cesnola Collection.

992. *Large bottle* with low, spreading body and tall, tubular neck with overhanging lip. The neck was broken near the bottom, but is now mended. The whole has a silver encrustation and some iridescence.
H, 0.240 m. Diam. of base, 0.090 m; of lip, 0.045 m. Plain-blown. Acc. no. 1902.145.

993. *Bottle* with low, spreading body and tall, tubular neck with overhanging lip. There is much silver encrustation and some iridescence.
H, 0.185 m. Diam. of body, 0.105 m; of lip, 0.043 m. Plain-blown. Acc. no. 1902.146.

994. *Small, tubular bottle*, brown and yellow in color and with some iridescence. A slightly depressed line encircles the upper part of the neck and the lip is slightly flaring.
H, 0.100 m. Plain-blown. Acc. no. 1902.147.

995. *Small vase* with oviform body and tall, slender neck with flaring lip. Much of the lip is broken away. There is some silver encrustation and iridescence.
H, 0.150 m. Diam. of base, 0.025 m. Plain-blown. Acc. no. 1902.148.

996. *Tall bottle* with tubular, elongated neck and short body only somewhat greater in diameter than the neck. The lip is missing and there is a small hole in the shoulder of the body. There is some silver encrustation and iridescence.
H, 0.185 m. Diam. of base, 0.020 m. Plain-blown. Acc. no. 1902.149.
Cf. Harden, *Roman Glass from Karanis*, pl. x, no. 834.

997. *Small bottle* with wide body and short, thin neck. The whole has a silver encrustation and some iridescence.
H, 0.065 m. Diam. of base, 0.037 m. Plain-blown. Acc. no. 1902.150.

998. *Small bowl* of brownish color with heavy, rounded rim, standing on small base with curved ribbing. The piece was cracked and mended, but a large fragment is missing from the wall. The glass has a gray encrustation and slight iridescence.
H, 0.065 m. Diam. of lip, 0.105 m; of base, 0.050 m. Molded. Acc. no. 1904.2.
Cf. *Das Glas*, 85, fig. 43. Ribbed bowls of this type are not uncommon.

The following 12 objects and 118 fragments belong to the Warren Collection. Among the vases are some of the most interesting specimens of Roman glassware in the classical collections. The fragments, too, are interesting either for their present iridescence or for their techniques of manufacture. Of these latter three types are well represented: the cameo style, the mosaic, or millefiori, technique, and the mottled type. Many of the smaller fragments are now encased in plastic bindings.

999. *Miniature bottle* with rounded body and high, thin neck. The lip is

thick and overhanging and the glass iridescent with gold encrustations.

H, 0.050 m. Plain-blown. Acc. no. 1908.20.

1000.* *Seven-handled vase* with low, rounded body and tall, thick neck. The handles rise vertically from the shoulder, one of them reaching the lip, the others joining at the middle of the neck. There are horizontal raised lines around the neck and irregular blobs around the lip. The glass is iridescent.

PL. XLVI

H, 0.102 m. Plain-blown; handles and decorations applied later. Acc. no. 1908.21.

1001. *Tall bottle* with low, wide body and thin, high neck. The lip curves outward and the glass is iridescent. There is a large hole in the neck and a chip on the rim.

From Greece. H, 0.160 m. Plain-blown. Acc. no. 1908.22.

1002.* *Small amphora* with wide, flask-shaped body and tall, narrow neck. A handle on either side runs from the shoulder to below the lip, whence it then curves up to the flaring lip. The glass is iridescent.

PL. XLVI

From Syria. H, 0.114 m. Plain-blown; handles applied later. Acc. no. 1908.23.

1003.* *Brown bowl* with wide mouth and vertically ribbed sides.

PL. XLVI

From Trebizond. H, 0.060 m. Molded. Acc. no. 1913.50.

Cf. *Encyclopaedia Britannica* (1961) s.v. "Glass," pl. iii, no. 6.

1004.* *Small blue amphora* with white handles. PL. XLVI

From Syria. H, 0.070 m. Plain-blown; handles applied later. Acc. no. 1915.55.

1005. *Round bowl* with short, offset, flaring lip. Thick threads of glass are looped back and forth between the lip and the shoulder. A piece is miss-

ing on the rim. The glass is iridescent.

H, 0.085 m. Plain-blown; decorations applied later. Acc. no. 1928.18.

Cf. Harden, *Roman Glass from Karanis*, pl. vi, nos. 493, 494, 498, for the type of decoration.

1006. *Small white vase* with two threads of glass encircling the neck. The piece is attractively iridescent.

H, 0.060 m. Diam. of lip, 0.030 m. Plain-blown; decorations applied later. Acc. no. 1930.85.

1007.* *Tall, tubular vase* decorated with projecting spikes. The glass has a white iridescence. PL. XLVI

H, 0.140 m. Diam., 0.038 m. Plain-blown; spikes applied later. Acc. no. 1930.86.

Cf. Neuburg in *EWA*, s.v. "Glass: Ancient Glass," pl. 218, upper right, for a similar vase.

1008. *Small vase* consisting of two tubular units sealed together. There is a handle on each side, and each is broken at the top; another handle may have arched over the two mouths. There are horizontal green threads of glass encircling the middle of the vase.

H, 0.105 m. Plain-blown; handles and decorations applied later. Acc. no. 1930.87.

Cf. *Das Glas*, 41, fig. 18.

1009. *Bottle*, with tall, tubular neck and short, rounded body. The lip is overhanging and the bottom is concave.

H, 0.103 m. Diam. of lip, 0.028 m. Plain-blown. Acc. no. 1930.88.

1010. *Small bottle* with tubular neck and rounded body. The body is much encrusted and the neck has some iridescence.

H, 0.075 m. Plain-blown. Acc. no. 1930.89.

The technique used in the following seven fragments is best represented by

the Portland Vase, a funerary urn of the first century B.C. or A.D. found near Rome in the seventeenth century, and now in the British Museum. The body is a deep violet-blue glass to which white opaque glass was cased and then cut in cameo relief. The figures on the vase may represent Peleus and Thetis, the parents of Achilles, in their courtship.

1011. *Cameo-style fragment of a small bowl* with a flower pattern in white on an iridescent blue ground.
H, 0.055 m. W, 0.085 m. Acc. no. 1908.5.7.

1012. *Cameo-style fragment* with the head of a youth in white on a purple ground. His right arm is raised; there is an unidentifiable object behind it.
H, 0.027 m. W, 0.030 m. Acc. no. 1908.5.11.

1013. *Cameo-style fragment* with two griffins in white facing each other and a monument between them. The ground is dark blue.
H, 0.021 m. W, 0.070 m. Acc. no. 1908.5.12.

1014. *Cameo-style fragment from a cup* with a vase, flower, and leaf in white on a blue ground.
H, 0.050 m. W, 0.052 m. Acc. no. 1908.5.16.

1015. *Cameo-style fragment* with white leaves and buds on a blue ground.
H, 0.062 m. W, 0.032 m. Acc. no. 1908.5.17.

1016. *Cameo-style fragment* with a woman in white bearing a basket on her shoulder and the head of a sheep below. The ground is blue.
Said to be from Egypt. About the second or first century B.C. H, 0.055 m. W, 0.040 m. Acc. no. 1915.58.

1017. *Cameo-style fragment* with the figures of a centaur struggling with a Lapith in white on a dark blue ground. The centaur is at the left with raised hooves and outstretched left arm delivering a blow; the Lapith, at the right, is blocking the blow with his left fist.
About the first century B.C. or A.D. H, 0.045 m. W, 0.063 m. Acc. no. 1923.51.
Cf. *Gr Sculpture*, pls. 142–145, showing centaurs and Lapiths fighting on the metope from the south face of the Parthenon.

The following 15 fragments illustrate the mosaic, or millefiori, technique.

1018. *Mosaic-style fragment of a dish* with flowers in yellow, green, white, brown, and purple.
W, 0.085 m. Acc. no. 1908.5.8.

1019. *Mosaic-style fragment of a thick fabric* with rosettes of green, yellow, and blue on a black ground. H, 0.078 m. W, 0.102 m. Acc. no. 1908.5.14.

1020. *Mosaic-style fragment of a bowl* of yellow, brown, and gray.
W, 0.085 m. Acc. no. 1908.5.20.

1021. *Mosaic-style fragment* with circles in blue, purple, white, and yellow.
H, 0.045 m. W, 0.062 m. Acc. no. 1908.5.22.

1022. *Mosaic-style fragment from a bowl.* The fabric is dark brown dotted with circles of orange, white, and green.
H, 0.034 m. W, 0.048 m. Acc. no. 1908.5.23.

1023. *Mosaic-style fragment from a bowl.* The fabric is dark brown dotted with circles of white and orange.

H, 0.050 m. W, 0.034 m. Acc. no. 1908.5.24.

1024. *Mosaic-style fragment* with flowers in green, yellow, and red, and with a gray and black ground. The reverse is brilliantly iridescent.
W, 0.055 m. Acc. no. 1908.5.25.

1025. *Mosaic-style fragment* of yellow, white, and brown.
W, 0.048 m. Acc. no. 1908.5.27.

1026. *Mosaic-style fragment from the upper part of a bowl.* The colors include green, white, yellow, and purple, and there is now considerable iridescence.
W, 0.065 m. Acc. no. 1908.5.28.

1027. *Mosaic-style fragment from the rim of a bowl.* The fabric is black, speckled with dots of orange and white.
H, 0.038 m. W, 0.065 m. Acc. no. 1908.5.30.

1028. *Mosaic-style fragment* of red and blue lines and yellow dots.
H, 0.020 m. W, 0.024 m. Acc. no. 1908.5.38.

1029. *Mosaic-style fragment* of light green and yellow circular forms on a dark green ground.
W, 0.031 m. Acc. no. 1908.5.52.

1030. *Mosaic-style fragment* of brown, green, yellow, and red.
W, 0.026 m. Acc. no. 1908.5.58.

1031. *Mosaic-style fragment* of green, yellow, brown, and purple.
W, 0.025 m. Acc. no. 1908.5.87.

1032. *Mosaic-style fragment* of green, yellow, and red on a black ground.
W, 0.037 m. Acc. no. 1908.5.96.

The following 22 fragments illustrate the technique in which a variety of colors were blended together in patterns, but less distinct than those of the mosaic type. Cf. *Das Glas*, 421, fig. 204.

1033. *Mottled fragment of a ribbed bowl* in brown, gray, and yellow.
W, 0.065 m. Acc. no. 1908.5.10.a.

1034. *Mottled fragment of a ribbed bowl* in gray, yellow, and brown. The interior is iridescent.
W, 0.057 m. Acc. no. 1908.5.10.b. This piece makes a join with No. 1033, above.

1035. *Mottled fragment* of brown, gray, yellow, green, and orange. The back is iridescent.
W, 0.058 m. Acc. no. 1908.5.29.

1036. *Mottled pencil-like fragment* of black and white.
L, 0.059 m. Acc. no. 1908.5.32.

1037. *Mottled fragment* of gray, brown, and yellow. The underside has a grid pattern.
W, 0.030 m. Acc. no. 1908.5.42.

1038. *Mottled fragment* of green and yellow.
W, 0.053 m. Acc. no. 1908.5.43.

1039. *Mottled fragment* of reddish-brown and orange-brown. The piece is from the lip of a cup.
W, 0.035 m. Acc. no. 1908.5.49.

1040. *Mottled fragment* of green and yellow.
W, 0.025 m. Acc. no. 1908.5.50.

1041. *Mottled fragment* of light and dark green.
W, 0.024 m. Acc. no. 1908.5.54.

1042. *Mottled fragment* of green, gray, and purple.
W, 0.053 m. Acc. no. 1908.5.57.

1043. *Mottled fragment* of green, brown, and gray.
W, 0.032 m. Acc. no. 1908.5.64.

1044. *Mottled fragment* of gray and burnt orange.
W, 0.023 m. Acc. no. 1908.5.69.

1045. *Mottled fragment* of brown, yellow, and gray.
W, 0.032 m. Acc. no. 1908.5.70.

1046. *Mottled fragment* of brown, yellow, and gray.
W, 0.039 m. Acc. no. 1908.5.72.

1047. *Mottled fragment* of green and yellow.
W, 0.030 m. Acc. no. 1908.5.74.

1048. *Mottled fragment* of gray and dark brown.
W, 0.028 m. Acc. no. 1908.5.76.

1049. *Mottled fragment* of light and dark green.
W, 0.032 m. Acc. no. 1908.5.77.

1050. *Mottled fragment* of green, violet, red, and purple.
Diam., 0.033 m. Acc. no. 1908.5.78.

1051. *Mottled fragment* of gray and burnt orange.
W, 0.025 m. Acc. no. 1908.5.84.

1052. *Mottled fragment* of gray and dark purple.
W, 0.021 m. Acc. no. 1908.5.88.

1053. *Mottled fragment* of gray and wine.
W, 0.027 m. Acc. no. 1908.5.91.

1054. *Mottled fragment* of red, yellow, green, brown, and gray. The reverse side is iridescent.
W, 0.060 m. Acc. no. 1908.5.3.

The following 28 fragments are chiefly interesting because of their iridescent or rainbowlike qualities, which are the results of chemical reactions of sand or clay on the glass during centuries of contact.

1055. *Fragment from the base of a bowl.* Two small feet and traces of curved ribbing remain on the fragment, which is brilliantly iridescent.
W, 0.040 m. Acc. no. 1930.92.

1056. *Fragment from the base of a bowl* with iridescence.
W, 0.060 m. Acc. no. 1930.93.

1057. *Fragment from the wall of a glass vase* with much iridescence.
W, 0.080 m. Acc. no. 1930.94.

1058. *Fragment from the wall of a dark purple vase.* The piece is iridescent on both sides.
W, 0.057 m. Acc. no. 1930.95.

1059. *Fragment from the bottom of a dark purple bowl.* Both sides are brilliantly iridescent.
W, 0.088 m. Acc. no. 1930.96.

1060. *Fragment from the edge of a plate.* Part of the ridge on the bottom is preserved and the glass is brilliantly iridescent.
W, 0.070 m. Acc. no. 1930.97.

1061. *Part of the base and side wall of a goblet.* The foot is wide-spreading and the bowl was cone-shaped with curved ribbing. The iridescence is very colorful.
H, 0.065 m. Diam. of base, 0.060 m. Acc. no. 1930.98.

1062. *Fragment from the base of a vase.* There is a colorful iridescence.
W, 0.037 m. Acc. no. 1930.99.

1063. *Base of a vase* slightly concave and iridescent on both sides.
Diam., 0.045 m. Acc. no. 1930.100.

1064. *Circular base of a vase* with wide-angled walls. The underside is concave and the glass is iridescent.
Diam., 0.055 m. Acc. no. 1930.101.

1065. *Fragment from the base of a dish* with brilliant iridescence.
W, 0.064 m. Acc. no. 1930.102.

1066. *Fragment from a wall of a vase,* decorated with band of parallel lines. The glass is iridescent.
W, 0.045 m. Acc. no. 1930.103.

1067. *Fragment from the wall of a glass bowl,* with part of the molded rim. The glass is brilliantly iridescent.
W, 0.040 m. Acc. no. 1930.104.

1068. *Fragment of a vase.* The piece is yellow and iridescent.
W, 0.025 m. Acc. no. 1930.109.

1069. *Fragment of a green cup.* The piece consists of the side and part of the handle. A white encrustation covers part of the surface.
W, 0.073 m. Acc. no. 1908.5.1.

1070. *Base of a greenish vase,* now partly covered with a silver deposit.
Diam., 0.032 m. Acc. no. 1908.5.26.

1071. *Fragment* of brilliant iridescence.
W, 0.030 m. Acc. no. 1930.106.

1072. *Fragment* of brilliant iridescence.
W, 0.040 m. Acc. no. 1930.105.

1073. *Fragment* with tiny circular pits on both sides. The surface is iridescent.
W, 0.037 m. Acc. no. 1930.108.

1074. *Fragment in the shape of a handle* and brilliantly iridescent in purple, violet, and green.
L, 0.055 m. Acc. no. 1908.5.18.

1075. *Fragment of phalluslike shape* beautifully iridescent in blue and green, with a silver encrustation on parts of the surface.
L, 0.118 m. Acc. no. 1908.5.25.

1076. *Fragment of brown and white fabric* brilliantly iridescent.
L, 0.180 m. Acc. no. 1908.5.31.

1077. *Fragment of iridescent white glass from the rim of a cup.*
H, 0.032 m. W, 0.027 m. Acc. no. 1908.5.36.

1078. *Fragment from the rim of a brown cup.* The sides were heavily ribbed and the glass is now iridescent.
H, 0.051 m. W, 0.054 m. Acc. no. 1908.5.37.

1079. *Fragment from the rim of a saucer,* richly iridescent.
H, 0.032 m. W, 0.051 m. Acc. no. 1908.5.41.

1080. *Fragment* of yellow, brown, black, white, and blue. The back is iridescent.
W, 0.045 m. Acc. no. 1908.5.46.

1081. *Fragment* of burnt orange. The underside is brilliantly iridescent.
W, 0.037 m. Acc. no. 1908.5.62.

1082. *Fragment* of gray and wine in a herringbone pattern. The underside is brilliantly iridescent.
W, 0.043 m. Acc. no. 1908.5.73.

The following 47 fragments illustrate a variety of techniques, such as transparent glass painted in a number of colors or opaque fabric in one or more solid colors.

1083. *Painted fragment from the base of a cup.* The glass is colored in lines of green, white, yellow, blue, and red.

H, 0.014 m. W, 0.067 m. Acc. no. 1908.5.5.

1084. *Painted fragment of a vase* of gray, brown, yellow, and green.
W, 0.065 m. Acc. no. 1908.5.6.

1085. *Painted fragment of a small bowl.* The colors are white, blue, red, and yellow.
W, 0.055 m. Acc. no. 1908.5.15.

1086. *Painted fragment* with flowers in green, white, red, yellow, and brown.
H, 0.047 m. W, 0.074 m. Acc. no. 1908.5.21.

1087. *Painted fragment from the bottom of a dish.* The colors are white, blue, red, and yellow.
W, 0.040 m. Acc. no. 1908.5.34. This piece makes a join with No. 1088, below.

1088. *Painted fragment from the bottom of a dish.* The colors are white, blue, red, and yellow.
W, 0.052 m. Acc. no. 1908.5.35.

1089. *Fragment* of solid dark red.
W, 0.019 m. Acc. no. 1908.5.94.

1090. *Fragment* of red chipped on the surface.
W, 0.033 m. Acc. no. 1908.5.90.

1091. *Fragment* of burnt orange.
H, 0.015 m. W, 0.026 m. Acc. no. 1908.5.85.

1092. *Fragment* of dark brown.
W, 0.029 m. Acc. no. 1908.5.71.

1093. *Fragment of a thick solid-blue fabric.*
W, 0.061 m. Acc. no. 1908.5.19.

1094. *Fragment* of burnt orange.
W, 0.030 m. Acc. no. 1908.5.44.

1095. *Fragment* of solid green.
W, 0.041 m. Acc. no. 1908.5.45.

1096. *Fragment* of yellow in battered condition.
W, 0.043 m. Acc. no. 1908.5.56.

1097. *Fragment* of burnt orange with gray dots.
H, 0.038 m. L, 0.051 m. Acc. no. 1908.5.61.

1098. *Fragment* of brown and gray.
W, 0.021 m. Acc. no. 1908.5.95.

1099. *Fragment* of brown with dark parallel lines.
W, 0.019 m. Acc. no. 1908.5.93.

1100. *Fragment* of brown and gray.
W, 0.020 m. Acc. no. 1908.5.92.

1101. *Fragment* with gray dots and green circles on a dark ground.
W, 0.021 m. Acc. no. 1908.5.89.

1102. *Fragment* of dark brown and gray.
W, 0.026 m. Acc. no. 1908.5.86.

1103. *Fragment* with bands of blue, brown, green, and yellow.
W, 0.031 m. Acc. no. 1908.5.83.

1104. *Fragment* of light and dark green.
W, 0.024 m. Acc. no. 1908.5.82.

1105. *Fragment* of white, yellow, and green.
W, 0.026 m. Acc. no. 1908.5.81.

1106. *Fragment* of dark brown, gray, and yellow.
W, 0.030 m. Acc. no. 1908.5.80.

1107. *Fragment* of white, brown, and blue in bands.
W, 0.023 m. Acc. no. 1908.5.68.

1108. *Fragment* of brown and gray.
W, 0.022 m. Acc. no. 1908.5.67.

1109. *Fragment* of dark and light green.
W, 0.038 m. Acc. no. 1908.5.63.

1110. *Fragment* of blue, yellow, and green.
W, 0.035 m. Acc. no. 1908.5.60.

1111. *Fragment* of black, dark green, and gray.
W, 0.040 m. Acc. no. 1908.5.55.

1112. *Fragment* of gray, brown, and yellow.
W, 0.034 m. Acc. no. 1908.5.51.

1113. *Fragment* of blue, green, and brown.
W, 0.038 m. Acc. no. 1908.5.48.

1114. *Fragment* of brownish-red and gray.
W, 0.035 m. Acc. no. 1908.5.47.

1115. *Fragment in the shape of a handle* in blue, black, and brown.
L, 0.055 m. Acc. no. 1908.5.33.

1116. *Fragment* with a wheel of seven red spokes on a ground of yellow.
Diam., 0.018 m. Acc. no. 1908.5.65.

1117. *Fragment of an irregularly shaped bottle* with flower and leaf motives plastically applied. The glass is iridescent.
H, 0.105 m. W, 0.045 m. Acc. no. 1908.5.13.

1118. *Fragment of a dark purple vase.* The main piece has two other sections sealed to it. The first section rises in the manner of a handle; the other is a plastic decoration in the form of a grimacing actor's mask in miniature.
H, 0.102 m. Acc. no. 1908.5.2.

1119. *Fragment of a vase* of elongated shape. The wide, flat base and the lower part of the tubular neck are preserved.
H, 0.095 m. Diam. of base, 0.090 m. Acc. no. 1930.90.

1120. *Fragment from the wall of a vase.* The piece is light purple and slightly convex.
W, 0.035 m. Acc. no. 1930.107.

1121. *Fragment of a decorative tile* glazed in white with a border of flowers in red, yellow, green, and blue.
H, 0.016 m. L, 0.040 m. Acc. no. 1908.5.39.

1122. *Fragment of a decorative tile* with flowers in green, red, and yellow.
H, 0.017 m. L, 0.040 m. Acc. no. 1908.5.40.
Nos. 1121 and 1122 are similar.

1123. *Fragment from the upper part of a large bowl* of a striated fabric in brown, white, and yellow. The outer surface has vertical ribs.
H, 0.070 m. W, 0.120 m. Acc. no. 1908.5.4.

1124. *Fragment* with gray striations on a black ground.
H, 0.023 m. W, 0.029 m. Acc. no. 1908.5.53.

1125. *Fragment* of reddish-brown with two slight striations of blue and white.
W, 0.042 m. Acc. no. 1908.5.59.

1126. *Dark fragment* with striations of gray and blue.
W, 0.024 m. Acc. no. 1908.5.66.

1127. *Fragment* of brown with gray striations.
L, 0.032 m. Acc. no. 1908.5.75.

1128. *Dark fragment* with gray striations.

H, 0.011 m. W, 0.022 m. Acc. no. 1908.5.79.

1129. *Flat fragment* with a white marblelike glaze and a spot of red and green.
W, 0.057 m. Acc. no. 1908.5.9.

The following two objects come from the Johnson-Chase Estate.

1130. *Glass jar* with tall, narrow neck rising from a squat, round body.

The lip flares out. Much of the surface is covered with white clay and there is also considerable iridescence.
H, 0.110 m. W, 0.065 m. Acc. no. 1958.41.

1131. *Fragmentary jar* with relatively thick neck rising from a small, round body. The neck is broken at the top and bottom, and there is considerable iridescence.
H, 0.110 m. W, 0.045 m. Acc. no. 1958.42.

Other items in the collection of glass include the following:

1132. *Bottle* with narrow neck, rounded body, and concave bottom. Around the body are three bands of groups of delicately incised lines. There is much iridescence.
Said to be from Upper Egypt. H, 0.160 m. Diam. of lip, 0.035 m; of body, 0.095 m. Gift of John Hubbard. Acc. no. 1927.26.

The following fragments of glass are of uncertain origin. They may belong either to the Hammond Collection or to the Howe Collection. See *Descriptive Catalogue* [3] (1906) 67, no. 695, and *President's Report 1929–1930*, 65.

1133. *Fragment of iridescent green glass* from the wall of a vase.
W, 0.070 m. Acc. no. 1930.110.

1134. *Fragment of iridescent green glass* from the wall of a vase.
W, 0.055 m. Acc. no. 1930.111.

1135. *Fragment of iridescent green glass* from the wall of a vase.
W, 0.055 m. Acc. no. 1930.112.

1136. *Fragment of green glass* from the wall of a vase.
L, 0.068 m. Acc. no. 1930.113.

1137. *Fragment of iridescent green glass* from the wall of a vase.
W, 0.047 m. Acc. no. 1930.114.

1138. *Thick green fragment of uncertain use, perhaps part of a handle.* It has curved ribbing on one side.
L, 0.062 m. Acc. no. 1930.115.

1139. *Fragment from the rim of a bowl.* The edge of the glass is folded under and brought back against the wall of the bowl to form a hollow rim.
L, 0.060 m. W, 0.025 m. Acc. no. 1930.116.

1140. *Tubular fragment of iridescent green glass*, probably part of a handle.
L, 0.050 m. Acc. no. 1930.117.

1141. *Small fragment of green glass.*
L, 0.045 m. Acc. no. 1930.118.

1142. *Small fragment of green glass* from the wall of a vase.
L, 0.040 m. Acc. no. 1930.119.

XII

Inscriptions

CLASSICAL epigraphy is the study of Greek or Latin inscriptions written on durable materials such as stone or metal. There are other languages the classical scholar might have occasion to study, such as Minoan Linear B, Cypriot, Oscan, Umbrian, and the like, but these are usually the province of specialists. The Assyrian inscriptions in the collections, however, are outside the limits of classical studies altogether, being the proper task of Assyriologists and experts in cuneiform, and even within the area of Greek and Latin there are other exceptions. Coin legends are given over to the numismatist, painted mummy labels and ink-written texts on ostraca to the papyrologist, and painted words on pottery to the student of vases. The study of inscriptions covers an area coextensive with the lands inhabited or ruled by the ancients and a period of time from the early eighth century B.C. to the fifth century A.D. Thus it is that three of the inscriptions at Bowdoin are written in Greek, come from Cyprus, but belong to the period of the Roman Empire.

The texts are examined both as palaeographical problems and historical documents. A comparative study, for example, of the Greek cursive lettering in Cyprus during the Imperial age gives evidence for the dating of the votive tablet (No. 1147) in this collection. The peculiar spelling of Hygieia's name also indicates a late date for this piece. On the historical side, a consideration of the syncretistic developments in later Greek religion shows that this document may have mentioned other goddesses with whom Hygieia was then identified. Similarly, a Latin fragment (No. 1145) is written in a style of the early Empire and its ab-

breviations are those used to describe various offices that a provincial Roman would have held in the course of his career. These small and seemingly insignificant inscriptions are but two of scores of thousands that have been recorded by modern classical scholars, which taken all in all, the lengthy and the brief, the public and the private, have given us a most detailed and accurate understanding of the life and history of antiquity. The historical value of epigraphical documents like the famous Athenian tribute lists or the official autobiography of Augustus in the *Monumentum Ancyranum* is dramatic and readily recognized, and such individual importance cannot be claimed by the thousands of smaller and often battered specimens which have survived. Yet when these lesser texts are collected into groups of sufficiently large numbers they can reveal much that is of real linguistic, legal, historical, or social importance.

In addition to the four Greek and two Latin inscriptions described below, others in the various collections include the cuneiform characters on the Babylonian cone (No. 1) and on the Assyrian reliefs (Nos. 3–7, 9), the hieroglyphics on the Egyptian funerary stelae (Nos. 10, 11), and the Greek inscriptions on the bronze statuette of a bull (No. 421), a scaraboid gem with gorgoneion (No. 486), bronze strigils (Nos. 449, 450, 453), a bronze mina weight (No. 423), a gold ring with a cameo onyx (No. 530), terracotta lamps (Nos. 949, 950, and 959), a sard with intaglio (No. 510), and an agate ring (No. 512). On the pottery there are painted inscriptions (Nos. 157, 159, 160–162, 165, 166, 168, 172, 191, 196, and 200), incised lettering (Nos. 160, 171, 196, and 242), and one example of an impressed signature (No. 247). For letters and legends on coins and tesserae, see the individual items in the collections of coins and miscellaneous objects. Finally, see the unidentified inscription (No. 1197) and the Greek signature on the modern gem (No. 513).

BIBLIOGRAPHY

Corpus Inscriptionum Latinarum (1863 —).
Inscriptiones Graecae (1873 —).
H. Dessau, *Inscriptiones Latinae Selectae* (1892–1916).
W. Dittenberger, *Sylloge Inscriptionum Graecarum* [3] (1915–1924).
J. E. Sandys, *Latin Epigraphy*[2], rev. by S. G. Campbell (1927).
Oxford Classical Dictionary (1949) s.vv. "Epigraphy, Greek," by M. N. Tod, and "Epigraphy, Latin," by R. H. Burrows.
Joyce S. and Arthur E. Gordon, *Contributions to the Palaeography of Latin Inscriptions*, University of California Publications in Classical Archaeology, vol. III, no. 3 (1957).

Arthur E. with Joyce S. Gordon, *Album of Dated Latin Inscriptions*, 2 vols. (1958).
A. G. Woodhead, *The Study of Greek Inscriptions* (1959).

INSCRIPTIONS (1143–1148)

1143.* *Gray marble plaque with alphabetized list of names in Greek, with the first under each new letter extruded into the margin. It is broken on the top and both sides, but is level on the bottom. The back is smooth and apparently the stone once was a revetment. Guidelines so thin as to be almost invisible controlled the placing of the letters.* PL. XLVII

Μητρόδ[- - - - - - - - - - - - - - - -]

Μένανδρ[ος - - - - - - - - - - - - -]

Μάρκος Κλ[- - - - - - - - - - - - -]

Νουμέριος[- - - - - - - - - - - - - - -]

Νυνφόδο[τος - - - - - - - - - - - -]

Νεικίας[- - - - - - - - - - - - - - - -]

Ναύκληρ[ος - - - - - - - - - - - - -]

Πούπλιος [- - - - - - - - - - - - - - -]

Πούπλιος [- - - - - - - - - - - - - -]

From Smyrna. Second century A.D. H, 0.142 m. W, 0.110 m. T, 0.021 m. H of letters, 0.010–.016 m. Hammond Coll. Acc. no. 1898.5.

S. Dow, *AJA* 67 (1963) 257–268, pls. 51, 52.

The letters with their flaring serifs are among the most ornate known and the carefully spaced alphabetic arrangement is remarkable. This inscription provided one starting point for the forthcoming study by L. W. Daly and Sterling Dow, *Alphabetization in Antiquity and the Middle Ages*. Professor Dow offers a full examination of this inscription and related material, now in Leyden, in the *AJA* article cited above.

1144. *White marble fragment with a Latin sepulchral inscription on one side. Face A was once part of a decorative*

relief on a revetment. Its moldings show that it was the earlier face, since they are cut off abruptly at the side which became the top of face B. Architectural decorations are as follows: at the top a flat fascia, below it a two-band guilloche, then a narrow fillet, next an Ionic bud pattern, and finally the beginnings of floral designs, probably a rincean motif. On top of the stone is a hole, apparently bored in order to attach the slab as a revetment to another surface by means of a metal clamp.

Face B. In its later use the stone was cut down to form a small grave stele for Quintus Valerius. About half of its width is preserved. The top and left sides are original. In the rounded pediment is a wreath with part of its streamers and at the left the surviving akroterion. A sunken rectangular band formed a frame for the inscription:

DIS > [MAN(ibvs)]

Q > VAL[ERIVS]

(uncertain number of lines missing)

Provenance unknown. Face A, Augustan period (31 B.C.–A.D. 14) or later. Face B, first or second century A.D. H, 0.165 m. W, 0.104 m. T, 0.033 m. H of letters, 0.017 m, but tall letter I is 0.023 m. Warren Coll. Acc. no. 1913.36a.

K. Herbert, *AJA* 66 (1962) 383–384, fig. 5a, b.

Cf. *CAH* (Plates) IV, 122; G. Moretti, *L'Ara Pacis Augustae* (1938), for reliefs similar to those on face A. On the letter forms of face B, cf. A. E. Gordon with J. S. Gordon, *Album of Dated Latin Inscriptions* (1958) I, 1–3, and pls. 21, 22, 34, 70, 72.

The inscription reads as follows: Dedicated to the Shades of the Underworld. Quintus Valerius (——— lies here).

1145. *Limestone fragment with Latin inscriptions* on both sides. Both faces of this friable stone are encrusted with a yellow-brownish limonite.

Face A text:

Line 1 ⟨hastae⟩

2 [- - - - PRAE]F(ectus) · I(uri) · D(icundo) · C · [(urator) - - - -]

3 [- - - - - · DECVRIO]NAL(ibus) · OR[N(amentis) - -]

The *hastae* of two letters in line 1 are plainly visible. The inscription described the *cursus* of some provincial official.

Face B text is of one line:

rBL

Provenance unknown. First or second century A.D. H, 0.061 m. W, 0.083 m. T, 0.012 m. H of letters of face A, 0.017–0.022 m; of face B, 0.035 m. Warren Coll. Acc. no. 1930.120.

K. Herbert, *AJA* 66 (1962), 384, fig. 6.

For face A, cf. A. B. West, *Corinth: Latin Inscriptions* VIII, pt. 2 (1931) 62–63, nos. 80, 81; 87, no. 107; 128, no. 215, containing similar descriptions of official careers. For the abbreviations, cf. Sandys, *Latin Epigraphy*.

1146.* *Gray marble funerary stele of Gemellos*, complete except for the lower right corner. The edge is trimmed straight on the right and bottom, but not on the left and top. There are traces of red in the letters. PL. XLVII

Γέμελλε
χρηστέ,
χαῖρε.
ἐλαφρά
σοι γῆ.

From Cyprus. Early second century A.D. H, 0.305 m. W, 0.157 m. T, 0.036 m. H of letters, 0.018 m, but the capital phi is 0.034 m. Estes Coll. Acc. no. 1902.22.

Salaminia, 98; K. Herbert, *AJA* 66 (1962) 385, fig. 7.

The first three lines address the deceased with the words: Good Gemellos, farewell. The last two lines are similar to the Latin sepulchral formula *Sit tibi terra levis*. For similar lettering, cf. T. B. Mitford, *Opuscula Archaeologica* 6 (1950) 78–81, no. 43. The modest dimensions of the stone suggest that Gemellos was a person of humble circumstances. On the name, see *RE* XIII (1910) cols. 1022–23; *SEG* VII, 720, 726.

1147.* *White marble votive tablet dedicated to Hygieia*. It is broken away on the right and below. The stone is trimmed smooth in back, with the thickness increasing from top to bottom. PL. XLVII

Ὑγίᾳ Σώτ[ηρι · - - - - -]
Σώτηρα [- - - - - - - - -]
Φιλαδέλ[φου - - - - - -]

From Cyprus. Late second century A.D. H, 0.130 m. W, 0.180 m. T, 0.019 m at top; 0.025 m at bottom. H of letters, 0.024–.030 m. Estes Coll. Acc. no. 1902.21.

Salaminia, 97, fig. 90; K. Herbert, *AJA* 66 (1962) 385–386, fig. 8.

The inscription read somewhat as follows: Sotera makes this thank-offering to Hygieia the Protectress on behalf of herself and her husband Philadelphos.

On the late spelling of Hygieia, cf. T. B. Mitford, *Opuscula Archeologica* 6 (1950) 72, no. 40. On the dating of these cursive letters, *ibid.*, 1, n. 1; T. B. Mitford, *AJA* 65 (1961) 123–125, no. 25, pl. 46. It is possible that either Tyche or Isis or both were also mentioned in line 1, for they were goddesses with whom Hygieia was identified in the later syncretistic movements. Cf. *IG* IV, 1045–46; *RE* XIV (1948) col. 1680, for Tyche; *Lex. Myth.* II (1890–1897) 531–533; *RE* XVIII (1916) col. 2119, for Isis. The honorific of line 1 is

also given these goddesses. Cf. *SEG* XIV, 880, for Isis; *SEG* XI, 442, for Tyche. But line 1 may only have contained an additional honorific of Hygieia. Cf. *SIG*, 1147. On the name Sotera, cf. No. 1148, below; *SEG* VI, 425; and on Philadelphos, *RE* XXXVIII (1938) cols. 2097–98; W. H. Buckley and others, *Monumenta Asiae Minoris Antiqua* IV (1936) no. 361; *ibid.*, VI (1939) no. 219; *ibid.*, VII (1956) no. 217.

1148.* *Limestone funerary cippus of Sotera.* A molding of five projections serves as a capital and the shaft is framed by a half-round at top and bottom. Below the middle another grooved half-round encircles the column. Around the plinth are five grooved lines.

PL. XLVII

Σώτηρα
χρηστέ,
χαῖρε.

From Cyprus. Late second or early third century A.D. H, 0.615 m. Diam. at base, 0.235 m; at top, 0.245 m. H of letters, 0.020–.030 m. Estes Coll. Acc. no. 1902.37.

Salaminia, 96; K. Herbert, *AJA* 66 (1962) 386–387, fig. 9.

The inscription reads: Good Sotera, farewell. The adjective of the second line, however, is wrongly in the masculine gender; it should be feminine.

On the dating of this inscription, cf. T. B. Mitford, *Opuscula Archaeologica* 6 (1950) 13–15, no. 7; 38–39, no. 18; and 41–42, no. 20. For similar cippi, see L. P. di Cesnola, *Descriptive Atlas of the Cesnola Collection of Cypriote Antiquities in the Metropolitan Museum of Art* I, pt. 2 (1885) pls. 146–158; III, pt. 2 (1903) supplement. Although they may have been contemporaries, it is impossible to determine the relation, if any, between the Sotera of this inscription and the dedicatrix of the same name in No. 1147, above.

XIII

Miscellaneous Objects

UNDER this heading are gathered in chronological order a great variety of objects of many materials. The most interesting of these items are the ivory music pipe (No. 1179), the medieval illuminated manuscript (No. 1194), and the medieval fresco painting (No. 1195).

MISCELLANEOUS OBJECTS (1149–1200)

1149. *Limestone coffer.* The sides are decorated with incised bands of zigzags and dots. The top is hollowed out, the bottom undercut to form four short legs.

From Cyprus. Seventh century B.C. H, 0.120 m. W, 0.150 m. T, 0.100 m. Estes Coll. Acc. no. 1902.26.

Salaminia, pl. 10, no. 11. Cf. *Cesnola Collection,* 278–279.

1150. *Upper part of a small limestone amulet.* The figure, which may be a primitive version of the Cypriote fertility goddess, wears a peaked cap. The face and torso are only elementally depicted. The eyes are represented by two black dots. On the left side a short stub curves under the area of the left breast. A hole pierces the figure just below the neck. The back is flat.

From Cyprus. Seventh century B.C.

H, 0.045 m. Estes Coll. Acc. no. 1902. 73.

1151. *Large terracotta die.* There are circular holes to indicate numbers. The flat surfaces on each side have decorations in reddish-brown glaze. Side 1 has a quadruple lotus pattern combined with a dot rosette; 2, a double lotus pattern; 3, several large and small dots; 4, a cross and dots; 5, dots; and 6, four large dots down the center. Each of the holes is encircled by a band of glaze as well.

Greek work. About 650–600 B.C. Sides, 0.038 m. Warren Coll. Acc. no. 1930.33.

Most of the dice made by the ancients were of bone or ivory, but other materials used include bronze, lead, amber, crystal, stones of all sorts, and even terracotta. For the quadruple

lotus pattern, cf. *NC*, 147, fig. 54h, and 148; G. Lafaye in *Dar.-Sag.*, s.v. "Tessera," 126–127.

1152. *Faïence female mask.* Across the forehead are bands of short vertical lines and inset bands of gray and green. The eyebrows, eyelids, pupils, nostrils, lips, and ears are painted black. Below the ears are black horizontal lines to represent hair and underneath the chin a series of dots to represent a necklace. On the neck are two more bands inset in gray and green, and below them another series of dots.

From Cyprus. Sixth century B.C. H, 0.095 m. Handmade. Estes Coll. Acc. no. 1902.25.

Salaminia, 166 and pl. xvi; *Lawrence-Cesnola Collection*, unnumbered pl.

1153. *Plaster head of a boy* (fragmentary). The face is red and the eyes and pupils are incised. Over the forehead in relief is part of a narrow vertical headdress.

From Cyprus. Fifth century B.C. H, 0.080 m. Molded. Hollow. Estes Coll. Acc. no. 1902.129.

1154. *Alabaster flask with separate cap.* The flask is long and narrow; near the top on either side are protrusions on which leather thongs may have been secured. The cap is disk-shaped with a hole in the center and rim on the bottom, which fits into the mouth of the flask.

Greek work. Fifth century B.C. H, 0.200 m. Diam. of top, 0.050 m. Warren Coll. Acc. no. 1927.26.

Cf. *SCE* III, xcviii, no. 63, a similar bottle from a tomb at Vouni in Cyprus of the Classical period. The type is found in many places.

1155. *Small alabaster perfume vase.* The high, narrow neck has a projecting flat lip. Two thin handles join this lip to the shoulders. The body is wide and straight-sided, tapering only at the

bottom, where it comes sharply to a point.

Greek work. Fifth or fourth century B.C. H, 0.060 m. Diam. of lip, 0.027 m. Warren Coll. Acc. no. 1927.21.

1156. *Round clay tessera with figures in relief. Ob*: A wreath. *Rv*: A symbol with the letter lambda, within which is a smaller alpha.

Greek work. Fourth century B.C. or later. Diam. 0.015 m. Warren Coll. Acc. no. 1930.53.

Tokens of this type have been found in bronze, terracotta, and lead, and at Athens they were used for admittance into the theater of Dionysus. The letter(s) on the reverse of some of the Bowdoin tesserae no doubt coresponded to a division of the theater for which they were made. See G. Lafaye in *Dar.-Sag.*, s.v. "Tessera," 130.

1157. *Round clay tessera with figures in relief. Ob*: Female head with pointed coiffure. This figure is identical with that on No. 1159, below. *Rv*: The letter beta.

Greek work. Fourth century B.C. or later. Diam. 0.016 m. Warren Coll. Acc. no. 1930.54.

1158. *Round clay tessera with figures in relief. Ob*: Bearded head facing left. *Rv*: The letter epsilon.

Greek work. Fourth century B.C. or later. Diam., 0.016 m. Warren Coll. Acc. no. 1930.55.

1159. *Round clay tessera with figures in relief. Ob*: Female head with pointed coiffure. *Rv*: A symbol in which a small upsilon is surmounted by a large mu.

Greek work. Fourth century B.C. or later. Diam., 0.017 m. Warren Coll. Acc. no. 1930.56.

1160. *Round clay tessera with figures in relief. Ob*: Perhaps the figures

of two ducks. *Rv*: The symbol for eta and mu.

Greek work. Fourth century B.C. or later. Diam., 0.015 m. Warren Coll. Acc. no. 1930.57.

1161. *Round clay tessera with figures in relief. Ob*: A bird facing right. *Rv*: The symbol for a double upsilon.

Greek work. Fourth century B.C. or later. Diam., 0.016 m. Warren Coll. Acc. no. 1930.58.

1162. *Round clay tessera with figures in relief. Ob*: Two laurel branches. *Rv*: The symbol for tau with a bar above it.

Greek work. Fourth century B.C. or later. Diam., 0.019 m. Warren Coll. Acc. no. 1930.59.

1163. *Round clay tessera with figures in relief. Ob*: Head facing right. *Rv*: The letter psi.

Greek work. Fourth century B.C. or later. Diam., 0.016 m. Warren Coll. Acc. no. 1930.60.

1164. *Round clay tessera with figures in relief. Ob*: Sphinx facing right with the left paw raised. This figure is identical with that on the reverse of No. 1172, below. *Rv*: Two sigmas or mus.

Greek work. Fourth century B.C. or later. Diam., 0.018 m. Warren Coll. Acc. no. 1930.61.

1165. *Round clay tessera with figures in relief. Ob*: Herm facing palm-branches. *Rv*: Two mus.

Greek work. Fourth century B.C. or later. Diam., 0.019 m. Warren Coll. Acc. no. 1930.62.

1166. *Round clay tessera with figures in relief. Ob*: Female head facing right. *Rv*: The letter omega.

Greek work. Fourth century B.C. or later. Diam., 0.016 m. Warren Coll. Acc. no. 1930.63.

1167. *Round clay tessera with figures in relief. Ob*: Bearded head in left profile. *Rv*: The letter omega.

Greek work. Fourth century B.C. or later. Diam., 0.016 m. Warren Coll. Acc. no. 1930.64.

1168. *Round clay tessera with figures in relief. Ob*: Dog walking to the right. *Rv*: The symbol for the letter xi between the horizontal lines at top and bottom.

Greek work. Fourth century B.C. or later. Diam., 0.018 m. Warren Coll. Acc. no. 1930.65.

1169. *Round clay tessera with figures in relief. Ob*: Woman in a chariot drawn by two stags. The scene is identical with those on Nos. 1171 and 1173, below. *Rv*: Dot surrounded by two concentric circles.

Greek work. Fourth century B.C. or later. Diam., 0.020 m. Warren Coll. Acc. no. 1930.66.

1170. *Round clay tessera with figures in relief. Ob*: Wreathed head of a man facing right. *Rv*: Stag running to the right.

Greek work. Fourth century B.C. or later. Diam., 0.017 m. Warren Coll. Acc. no. 1930.67.

1171. *Round clay tessera with figures in relief. Ob*: Horse and rider facing right. *Rv*: Woman in a chariot drawn by two stags.

Greek work. Fourth century B.C. or later. Diam., 0.018 m. Warren Coll. Acc. no. 1930.68.

1172. *Round clay tessera with figures in relief. Ob*: Wreathed head of a man facing right. *Rv*: Sphinx facing right with the left paw raised.

Greek work. Fourth century B.C. or later. Diam., 0.017 m. Warren Coll. Acc. no. 1930.69.

1173. *Round clay tessera with figures in relief. Ob*: Horse and rider fac-

ing right. *Rv*: Woman in a chariot drawn by two stags.

Greek work. Fourth century B.C. or later. Diam., 0.018 m. Warren Coll. Acc. no. 1930.70.

1174. *Small alabastron of a variegated agate of browns, white and gray.* The short, narrow neck has a flaring lip and is offset from the body by two mouldings. The body widens at the bottom, then draws in to a low base.

Greek work. Hellenistic period, H, 0.050 m. Diam. of lip, 0.022 m. Warren Coll. Acc. no. 1927.22.

1175. *Silver ladle with shallow bowl.* Heavy encrustations are everywhere but on the leading edge of the bowl. The handle rises vertically from the bowl and at the top curves inward in a loop, at the end of which is a dog's head.

Roman work. First century A.D. H, 0.165 m. Warren Coll. Acc. no. 1927.11.

Casson, *Catalogue*, 16, no. 136.

1176. *Ivory die.* The numbers 1 to 6 are marked by dots within single circles in the Roman manner.

Roman work. First century A.D. Sides, 0.015 m. Warren Coll. Acc. no. 1930.52.

Dice are the oldest gaming instruments known and have been found in Egyptian tombs dating earlier than 2000 B.C. Gambling with dice was a popular pastime in Greece and though it was nominally illegal in Rome except during the festival of the Saturnalia, there it assumed the proportions of a national vice, especially under the Empire. Two, three, or four dice could be used; the highest throw was called *Venus*, the lowest *canis*. Loaded dice were not unknown. See F. A. Wright in *OCD*, s.v. "Dicing," "Games"; G. Lafaye in *Dar.-Sag.*, s.v. "Tessera" and fig. 6813.

1177. *Grayish chalcedony die.* The sides are slightly convex. Numbers 1 to 6 are marked by dots within single circles in the Roman manner.

Roman work. First century A.D. Sides, 0.015 m. Warren Coll. Acc. no. 1915.59.

1178. Terracotta die with characters and letters incised on all six sides. The characters, which are deeply cut, are as follows: V, V (with a dot at the top of the right bar), CII, R, I, V.

Roman work. First century A.D. Sides, 0.025 m. Warren Coll. Acc. no. 1930.213.

This piece was used in some type of game played on a board, similar perhaps to the popular "Twelve lines" (*duodecim scripta*) and "Robbers" (*ludus latrunculorum*). See F. A. Wright in *OCD*, s.v. "Games."

1179. *Ivory music pipe.* The instrument consists of eight joined sections, with groups of shallow grooves at the points of juncture serving as decoration. On the back are two holes; down the front, eight.

Roman work. First or second century A.D. L, 0.350 m. Diam. of trumpet, 0.030 m; of mouthpiece, 0.018 m. Warren Coll. Acc. no. 1928.2.

The instruments most closely related to the pipe in modern times are the clarinet or oboe. It is uncertain weather the vibrator was a single or a double reed. The longest surviving pipe has 16 holes, the shortest 6. See the excellent discussion with bibliography in J. F. Mountford and R. P. Winnington-Ingram in *OCD*, s.v. "Music: Section 9, Instruments."

1180. *Three fragments of mosaic pavement in opus tessellatum.* The stones are blue, white, orange, and glazed green and are set in a thick mortar base.

Roman work. First or second century

A.D. Hammond Coll. Acc. nos. 1898.32. 1–3.

Mosaic work as architectural decoration occurs at an early date in Mesopotamia. In Greece pavements of this type employing natural pebbles are known from 400 B.C., but it remained for the Hellenistic and Roman periods to fully develop several different mosaic techniques for floors. Of these, *opus tessellatum* used small cubes of uniform size. See F. N. Pryce in *OCD*, *s.v.* "Mosaic."

1181. *Ivory needle.* The upper end is flattened out and pierced by three holes: the central one large and oblong, the other two small and circular.

Roman work. First or second century A.D. L, 0.140 m. Warren Coll. Acc. no. 1930.40.

The use of ivory is known in the earliest historical period. Its excellence as a material for carvings, inlay work, and statuary made it popular among the artisans of Egypt, Mesopotamia, and Crete. In Greece it was most dramatically employed in colossal chryselephantine statues of the gods, in which the drapery was rendered in gold and the skin in ivory. The most famous of these were the Athena Parthenos and Zeus of Olympia by Phidias (fl. 450 B.C.), the chief sculptor of the Parthenon. In the Roman period ivory was used lavishly in a great variety of objects, including the humble domestic implements in the Warren Collection.

The Romans had to depend on needles of bone or bronze, but since their thread was coarse and heavy, fine stitching was impossible. Most garments required some sewing, however. Tunics were made of two stitched pieces and the toga had to be measured, cut, and sewn to fit. Ready-to-wear garments were not unknown, and in the Empire there was a large business in such clothing. See Mary Johnston, *Roman Life* (1957) 201, 209.

1182. *Ivory needle.* The needle is broken at both ends. The upper end is slightly flattened and pierced by three holes. The central one is large and oblong, the other two small and circular.

Roman work. First or second century A.D. L, 0.160 m. Warren Coll. Acc. no. 1930.45.

1183. *Ivory needle.* The upper end is flattened and pierced by a narrow oblong hole.

Roman work. First or second century A.D. L, 0.147 m. Warren Coll. Acc. no. 1930.47.

1184. *Ivory spoon with round bowl.* The handle is thin and the bowl shallow. The end of the handle is missing.

Roman work. First or second century A.D. L, 0.115 m. Diam. of bowl, 0.022 m. Warren Coll. Acc. no. 1930.41.

Cf. Mary Johnston, *Roman Life* (1957) 19, for a spoon of similar shape in silver.

1185. *Ivory spoon with round bowl.* The bowl is shallow and the handle thin.

Roman work. First or second century A.D. L. 0.133 m. Diam. of bowl, 0.022 m. Warren Coll. Acc. no. 1930. 42.

1186. *Ivory spoon with round bowl.* The handle is thin, the bowl shallow. The tip of the handle is missing.

Roman work. First or second century A.D. L, 0.100 m. Diam. of bowl, 0.020 m. Warren Coll. Acc. no. 1930.43.

1187. *Ivory hairpin with carved finial.* The finial consists of two parts, the upper one flat, the bottom one round. They are joined to the pin by a double moulding. The pin is broken at both ends.

Roman work. First or second century A.D. L, 0.078 m. Warren Coll. Acc. no. 1930.44.

Hairpins were made of ivory, silver, or gold, and were sometimes even set with jewels. All were straight, however, like the modern hatpin. In the matter of coiffures the fashions of the early Empire were almost as intricate and extravagant as those of eighteenth century France. See Mary Johnston, *Roman Life* (1957) 205–206.

1188. *Ivory hairpin.* The rather thick pin has one end sharpened to a point, the other finished with a small curved projection about which the hair might be wound.

Roman work. First or second century A.D. L, 0.090 m. Warren Coll. Acc. no. 1930.46.

1189. *Ivory hairpin.* The upper end has a rounded finial. The point is missing.

Roman work. First or second century A.D. L, 0.080 m. Warren Coll. Acc. no. 1930.48.

1190. *Ivory hairpin.* The pin has a heavy rounded finial.

Roman work. First or second century A.D. L, 0.083 m. Warren Coll. Acc. no. 1930.49.

1191. *Ivory hairpin.* The upper end is plain and blunt, and the point is missing.

Roman work. First or second century A.D. L, 0.098 m. Warren Coll. Acc. no. 1930.50.

1192. *Ivory hairpin.* The pin has a heavy rounded finial. The point is missing.

Roman work. First or second century A.D. L, 0.073 m. Warren Coll. Acc. no. 1930.51.

1193. *Limestone fragment of an architectural molding.* Above is a horizontal concave band, below two convex bands of differing widths.

Roman work. L, 0.160 m. W, 0.080 m. Donor unknown. Acc. no. 1930.121.

1194. *Five leaves of an illuminated manuscript in Gothic letters on vellum.* All ten pages contain passages in Latin from a book of hours and handsome floral decorations in the outside margins in gilt, blue, green, yellow, and orange.

Late fourteenth century A.D. H, 0.215 m. W, 0.158 m. Warren Coll. Acc. no. 1914.9.

On the general subject of illuminated manuscripts, see J. A. Herbert, *Illuminated Manuscripts* (1911). One of the tendencies of book illumination in the fourteenth century was to fill the margins completely with sprays of ivy and other floral decoration. On the lettering of manuscripts, see E. H. Minns in *OCD*, s.v. "Palaeography," with full bibliography. For a summary treatment of book ornamentation, see A. Haseloff and H. P. T. Swarzenski in *Encyclopaedia Britannica* (1961) s.v. "Illuminated Manuscripts."

1195. *Three fragments of a fresco painting with scenes from the martyrdom of St. Sebastian, framed.*

No. 1: H, 0.285 m. W, 0.400 m. Upper half of an archer dressed in a green garment looking up toward the right, with an arrow in position on the bow.

No. 2: H, 0.490 m. W, 0.670 m. Upper half of an elderly saint gazing upward to the left, with gray beard and mustache and a fringe of hair and a tuft in the center of the forehead. He is nude save for a purple scarf about the shoulders. Behind him is the entrance to a cave.

No. 3: H, 0.285 m. W, 0.375 m. Upper half of a body dressed in a blue upper garment with long sleeves bloused at the elbows and green trousers. He leans on his left elbow. Level with his shoulders is a bare right foot.

Artist unknown. Said to be from the house of Fra Filippo Lippi. Fifteenth

century A.D. Warren Coll. Acc. nos. 1920.5.1–3.

According to legend St. Sebastian was a captain of a Roman cohort who converted many soldiers. Because of this activity the emperor Diocletian ordered him to be executed by archers. Though he survived this ordeal, he was later beaten to death. As a result of these events he frequently appears in art as a handsome youth wounded by arrows.

In fresco painting, colors of powdered pigments mixed in water are put on fresh wet lime-plaster walls. Both paint and plaster dry together to form a permanent surface of the wall. This technique, especially popular with Italian artists from the thirteenth through the seventeenth centuries, reached its highest development in the monumental series painted on the ceiling of the Sistine Chapel by Michelangelo between May 1508 and the end of 1512. On Italian Renaissance painting, see Bernard Berenson, *Italian Painters of the Renaissance* (1952).

1196. *Circular lock of iron.* The circumference is decorated with a series of perforated triangles. Parts of the mechanism, including the bolt, remain.

Said to be medieval. Diam., 0.084 m. Johnson-Chase Estate. Acc. no. 1958.21.

1197. *Two clay disks.* The bottom disk is flat on both sides. On the top is embedded a thin wire post over which the upper disk is fitted through a perforation in its center. The top of the upper disk is also hollowed out at the center and bears an inscription: ℲYVZVN. Around the edge there are six scallops.

Provenance unknown. Diam. of each, 0.052 m. Johnson-Chase Estate. Acc. nos. 1958.40a, b.

All the letters except the final one are similar to characters in the Etruscan alphabet. See M. Pallottino, *The Etruscans* (1955) 357–280, and fig. 6.

1198. *Iron tweezers.* They are of the overlapping type which are opened by pressure on the handles. The join of the two handles has been fashioned into an elaborate star pattern.

Provenance unknown. L, 0.110 m. Warren Coll. Acc. no. 1930.31.

1199. *Two irregular flakes of limestone from Mt. Sinai.* Johnson-Chase Estate. Acc. nos. 1958.39.1–2.

1200. *Terracotta tile.* The top, the two slanting edges, and a flat edge are glazed and intact. The other edge is broken and the underside is roughly finished. The color is light yellow.

Provenance unknown. H, 0.155 m. W, 0.145 m. T, 0.045 m. Warren Coll. Acc. no. 1927.25.

Appendix I

ADDENDA

THE following two pieces came to light during the removal of objects to the new storage facilities in the Walker Art Building in October 1961.

1201. *Cypriot plate with horned handles.* It is decorated with concentric circles of varying width in black. The sides are grooved and in black. The underside is black except for the area within the base, in which is a geometric wheel pattern on a reserved ground. The hub consists of outer and inner circles in black bounding a large band in red.

About 1200–1000 B.C. H, 0.025 m. Diam., 0.185 m. Estes Coll. Acc. no. 1902.18.

Cf. *Cesnola Collection*, 72, nos. 560, 561; 57, no. 469.

1202. *Roman terracotta relief of a winged Eros.* He stands to the left, holding fruits on his back and looking to the right. There are traces of white on the figure and of blue in the background. The original edge is preserved at the top, where there is a groove.

First century A.D. H, 0.155 m. W, 0.130 m. Warren Coll. Acc. no. 1913. 44.

This is a replica of a plaque in Berlin. See *Tonreliefs* I, 187–189, pl. 59, no. 2.

Appendix II

THE problems of detection resulting from faking and forgery have beset the student of ancient art since the time of the Renaissance, with its renewal of interest in all aspects of antiquity. So compelling was the urge in that period for "redoing the antique" that, according to the tradition, no less a person than Michelangelo made a marble Cupid which he buried for a time to give it the sheen of age. Later the work was sold as a genuine piece of ancient art. Since fakes follow the laws of supply and demand, there is always a great amount of activity in counterfeits after important archaeological excavations. For example, the work at Pompeii and Herculaneum in the latter half of the eighteenth century set in motion the production of the first spurious Roman paintings, and in the late nineteenth century the market was flooded with forgeries of the popular terracotta figurines found at Tanagra in Boeotia. Perhaps the most notorious single examples of forged classical art in recent times have been the so-called Tiara of Saïtaphernes in the Louvre, exposed in 1903, and the three colossal terracotta figures of Etruscan warriors in the Metropolitan Museum of Art, exposed in 1961.

The false pieces at Bowdoin include marble reliefs, terracotta figurines, and pottery. Of these only three of the figurines were made with an order of skill that could for long deceive. Ironically, however, all of these objects can now serve a function for which their makers never intended them. By the very falseness of their nature, they can help the student to sharpen his vision and thereby grow in the knowledge of the true and the beautiful. The famous words of Lactantius are appropriate to the matter: "Primus autem sapientiae gradus est falsa intelligere; secundus, vera cognoscere."

BIBLIOGRAPHY

Fritz Mendax, *Art Fakes and Forgeries* (1955).
D. Mustilli in *Enciclopedia dell' arte antica classica e orientale*, 4 vols. (1958 —) s.v. "Falsificazioni."
Licia V. Borrelli in *Encyclopedia of World Art*, 6 vols. (1959 —) s.v. "Falsification and Forgery: History of Falsification, etc."
Sepp Schüller, *Forgers, Dealers, Experts: Strange Chapters in the History of Art* (1960).

X1. *Marble fragment from a low relief with an eagle, altar, and a kneeling woman playing a lyre.* The eagle to the left stands on the ground with his wings spread and his gaze to the right. The altar in the center is decorated with a diagonal lozenge pattern and has a fire on its top. The woman on the right is nude and faces right. Above her head is part of a laurel branch and in front of her the leg of a standing figure.
H, 0.150 m. W, 0.215 m. Acc. no. 1898.9.

X2. *Marble fragment from a low relief with a maenad.* She is nude save for an animal skin draped off the shoulders. She looks to the left and holds a thyrsus in her left hand.
H, 0.143 m. W, 0.085 m. Acc. no. 1898.61.

X3. *Terracotta figurine of a standing woman with fan.* Clad in chiton and himation, she stands with her weight on the right leg. Both arms are under her outer garment, the right raised to her throat, and the left held at the side with the hand protruding to hold a fan. The hair is worn in the melon coiffure, atop which is a wide-brimmed hat. She stands on a thin, rectangular base, and the back is unworked and has a crudely cut rectangular vent. The figure is covered by a white slip and the upper left side is stained by what appears to be iron rust.
H, 0.180 m. W, 0.042 m. Acc. no. 1898.4.

X4. *Terracotta figurine of a standing woman.* Clad in chiton and himation, she stands with both arms enveloped in the outer garment. The right arm is raised to the throat under it and the left arm is at her side with only the hand protruding, in which is held a fan. The hair is parted in the middle and knotted at the back. The back is roughly worked and has a round vent. There are traces of white, red, and blue on the figure, which stands on a low, rectangular base.
H, 0.190 m. W, 0.060 m. Acc. no. 1911.1.

X5. *Terracotta figurine of a standing woman.* She wears chiton and himation and places the weight on the right leg. The right arm is akimbo, the left hangs at her side. The hair is parted in the middle and knotted behind. The hair is reddish-brown, the chiton blue, and the himation red. The back is roughly worked and there is a square vent. She stands on a thin, rectangular base.
H, 0.220 m. W, 0.080 m. Acc. no. 1911.2.

X6. *Terracotta figurine of a standing woman.* She stands on a low, rectangular base with her weight on the left leg. Proportionately she is extremely tall, her legs being overly long. Her right arm is bent at the elbow and is otherwise hidden by the drapery. Her left arm is undraped and raised to her bosom. Her hair is parted in the middle and arranged in a melon coiffure. She

wears a long undergarment as well as a chiton and himation. The back is unworked and has a large, square vent. Traces of red, blue, brown, and white cover the figure.

H, 0.260 m. W, 0.077 m. Acc. no. 1911.3.

X7. *Small cup.* It has a red glaze and a zigzag motive surrounds the lip. There are two handles.

H, 0.035 m. Diam. of lip, 0.053 m. Acc. no. 1898.8.

X8. *Small kantharos.* The vase has an olive glaze but is otherwise without decoration. It has two handles and a small foot.

H, 0.055 m. Diam. of lip, 0.063 m. Acc. no. 1906.6.

X9. *Small kantharos.* It has a red glaze but is otherwise without decoration. It has two handles and a small foot. There is a heavy encrustation of lime.

H, 0.065 m. Diam. of lip, 0.072 m. Acc. no. 1906.7.

X10. *Cup with vertical handle.* The handle is decorated with parallel lines in red. On the shoulder is a band in which lattice lozenges alternate with groups of vertical stripes, and the lower part of the body is completely red.

H, 0.095 m. Diam. of base, 0.045 m. Acc. no. 1906.11.

Plates

The objects illustrated are identified by their catalogue numbers. Plate numbers are noted in the catalogue.

PLATE I

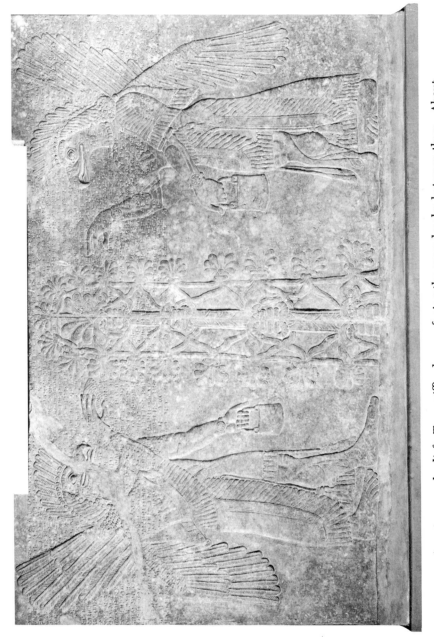

Assyrian mural relief. Two griffin demons facing the sacred palm between them. About 885–860 B.C. (Cat. no. 3)

PLATE II

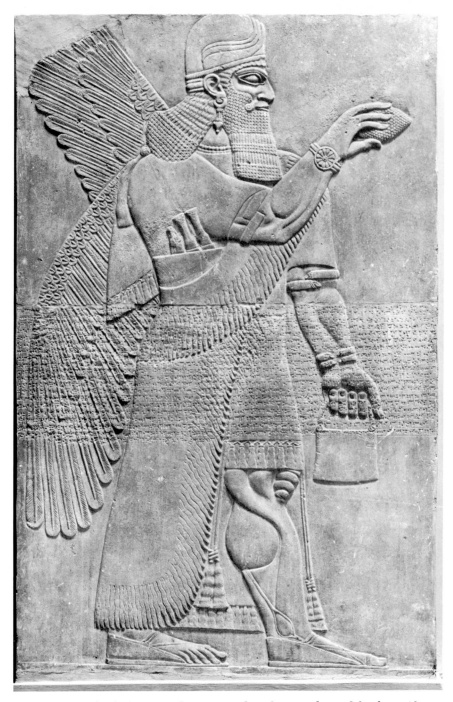

Assyrian mural relief. Winged genius with a date spathe and bucket. About 885–860 B.C. (Cat. no. 4)

PLATE III

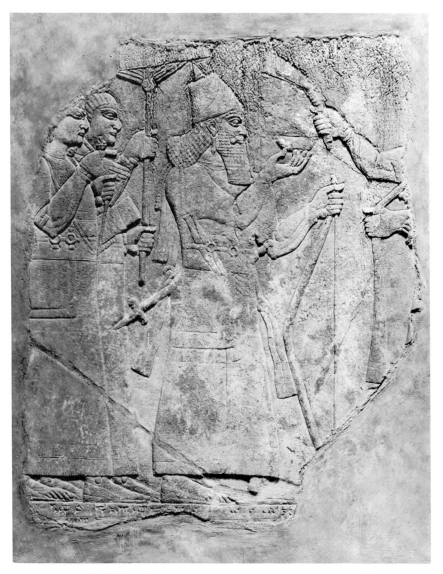

Assyrian mural relief. King and attendants at the hunt. About 885–860 B.C.
(Cat. no. 7)

PLATE IV

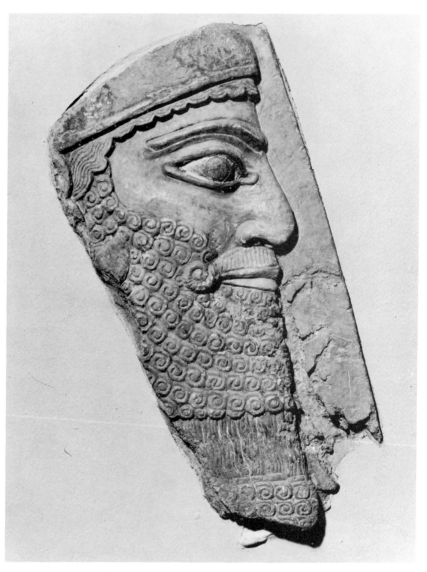

Assyrian portrait relief. Head of King Ashurnazirpal II. About 885–860 B.C.
(Cat. no. 8)

PLATE V

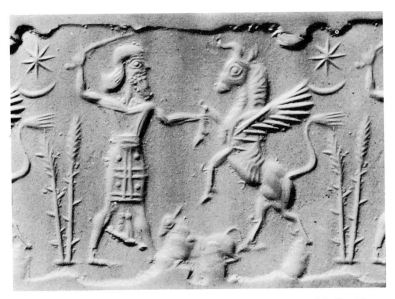

Assyrian chalcedony cylinder seal. Hero fighting a winged bull. About 900–700 B.C. (Cat. no. 2)

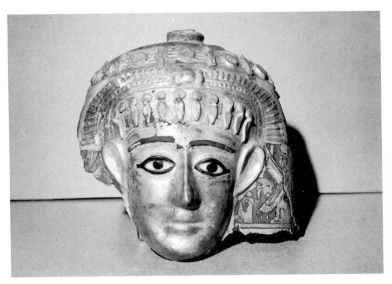

Egyptian mummy cartonage. Face in gilt and a deep headpiece. New Kingdom or later. (Cat. no. 12)

PLATE VI

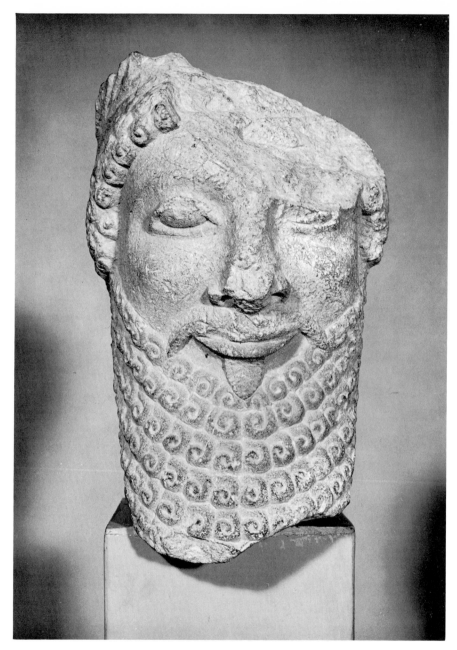

Cypriot limestone bearded head. From a statue. About 550–500 B.C. (Cat. no. 68)

PLATE VII

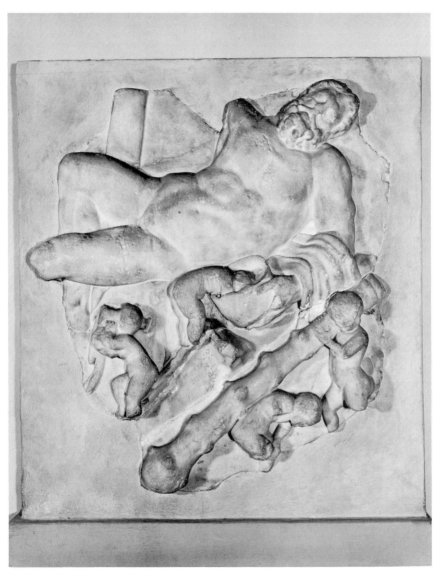

Greek marble mural relief. A sleeping Heracles surrounded by playful Erotes.
Hellenistic period. (Cat. no. 75)

PLATE VIII

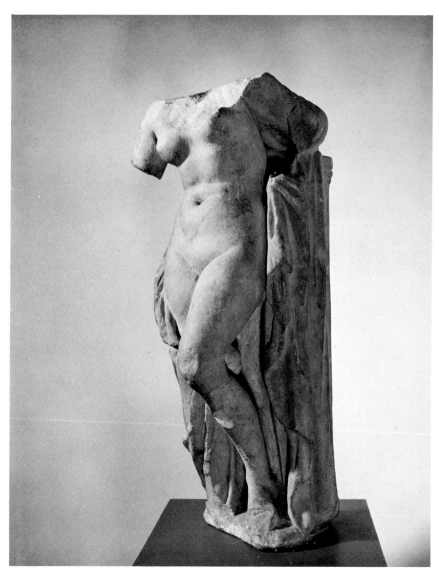

Greek marble female torso. From a statuette of Aphrodite. Hellenistic period.
(Cat. no. 76)

PLATE IX

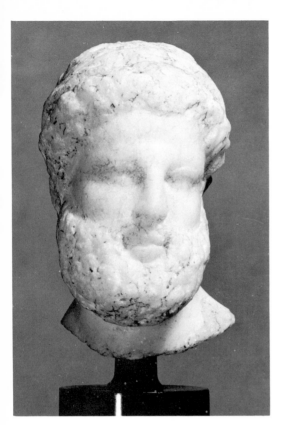

Greek marble head. From a statuette of Zeus or Heracles. Hellenistic period. (Cat. no. 78)

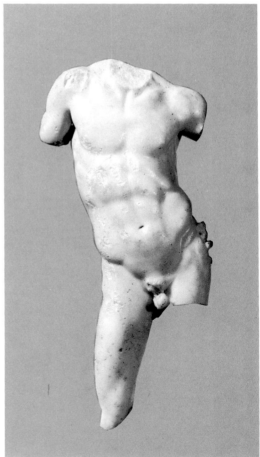

Greek marble male torso. From a statuette of a god or youth. Hellenistic period. (Cat. no. 77)

PLATE X

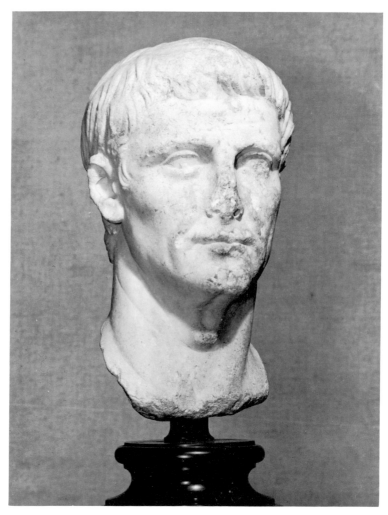

Roman marble portrait head. Perhaps of the emperor Claudius. Mid-first century A.D. (Cat. no. 83)

PLATE XI

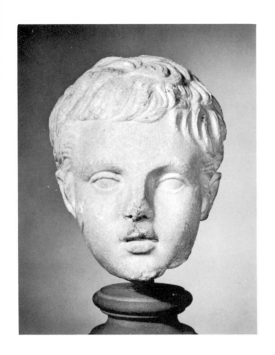

Roman marble portrait head. A young unknown boy. Augustan period or later. (Cat. no. 84)

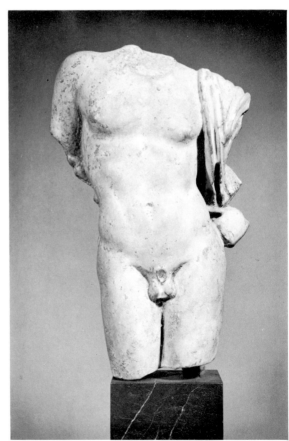

Greco-Roman marble male torso. From a statuette of Hermes. First or second century A.D. (Cat. no. 92)

PLATE XII

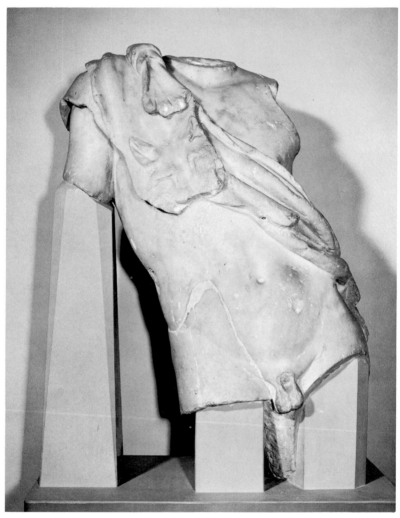

Greco-Roman marble male torso. From a copy of the Leaning Satyr by Praxiteles. First or second century A.D. (Cat. no. 86)

PLATE XIII

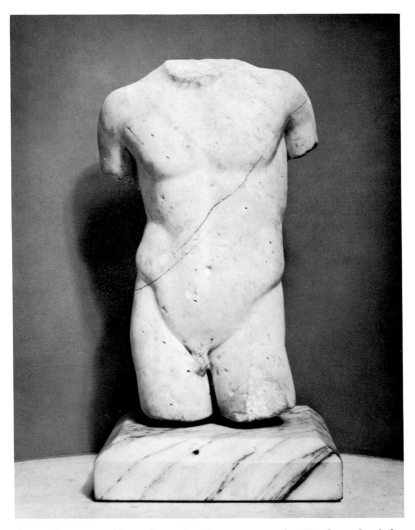

Greco-Roman marble male torso. From a copy of a Greek work of the
late fifth century B.C. First or second century A.D. (Cat. no. 87)

PLATE XIV

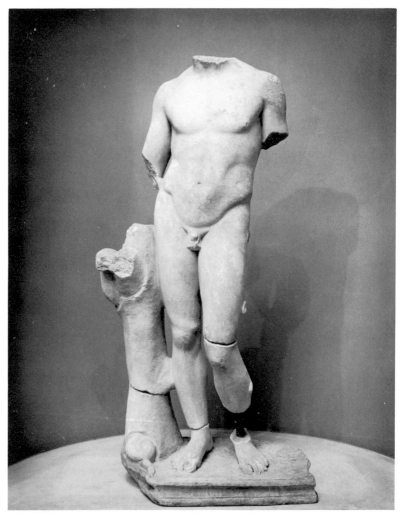

Marble statue of an unidentified god or youth. Possibly Greco-Roman
work of the second century A.D. (Cat. no. 97)

PLATE XV

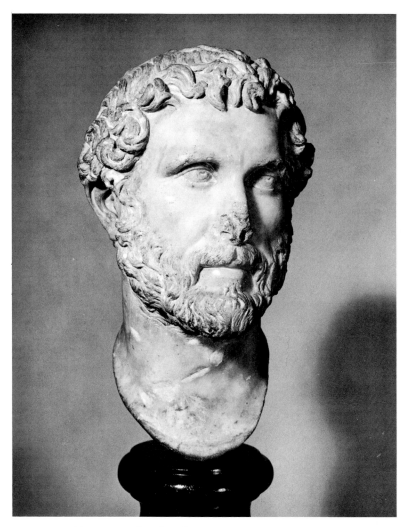

Roman marble portrait head. The emperor Antoninus Pius. About A.D. 138–150. (Cat. no. 100)

PLATE XVI

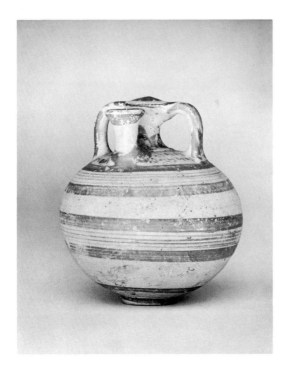

Cypriot stirrup vase. Levanto-Helladic ware. About 1200–1050 B.C. (Cat. no. 111)

Cypriot oenochoë. Black-on-Red II (IV) ware. About 700–500 B.C. (Cat. no. 117)

PLATE XVII

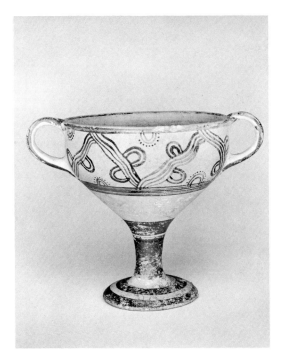

Mycenaean tall-stemmed cup. Late Helladic III
ware. About 1350–1300 B.C. (Cat. no. 128)

PLATE XVIII

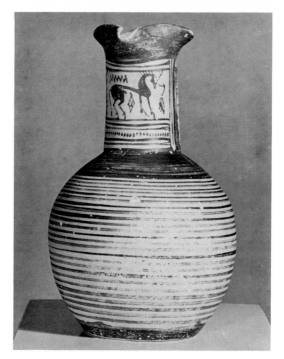

Attic Geometric trefoil oenochoë. Horse on neck panel. Late eighth century B.C. (Cat. no. 132)

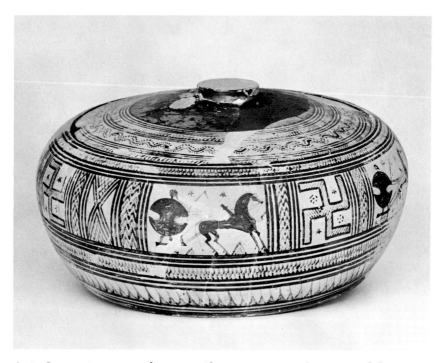

Attic Geometric pyxis with cover. Charioteers in panels. Late eighth century B.C. (Cat. no. 131)

PLATE XIX

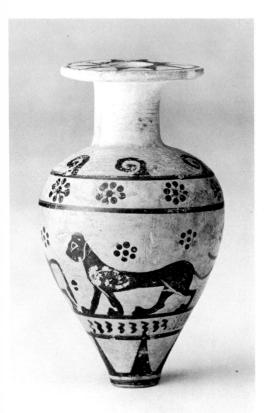

Late Protocorinthian Black-figure pointed aryballos. Two lionesses and a bull in the scene. About 650–640 B.C. (Cat. no. 134)

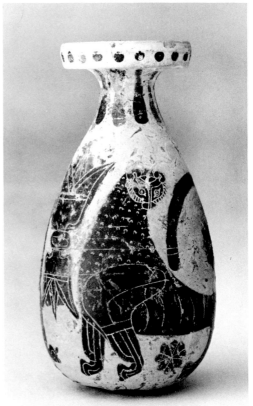

Early Corinthian Black-figure alabastron. Two panthers and a lotus bud in the scene. By the Dolphin Painter. About 625–600 B.C. (Cat. no. 135)

PLATE XX

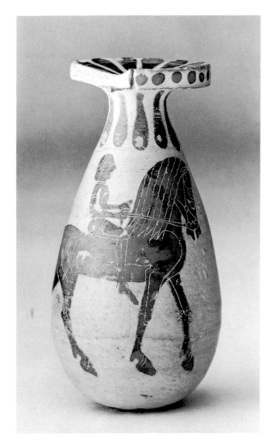

Corinthian Black-figure alabastron. Youth on a horse in the scene. About 625–600 B.C. (Cat. no. 136)

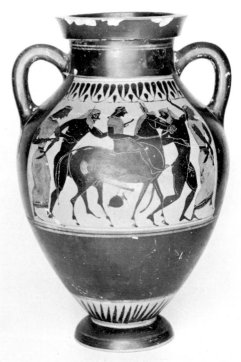

Attic Black-figure panel amphora. Bacchic procession in scene A. By the Painter of Berlin 1686. About 550 B.C. (Cat. no. 143)

PLATE XXI

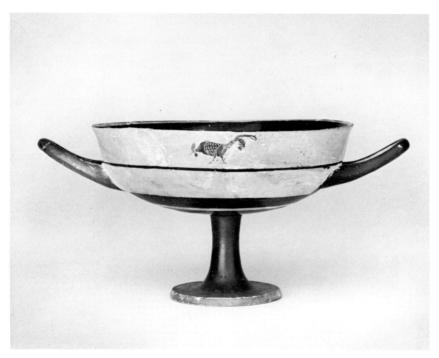

Attic Black-figure Little Master lip cup. Cock on one side. About 550–540 B.C.
(Cat. no. 144)

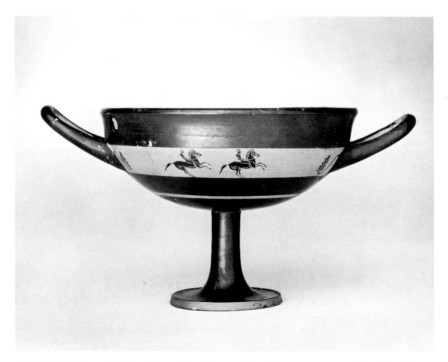

Attic Black-figure Little Master band cup. Two horsemen on each side. About
550–530 B.C. (Cat. no. 146)

PLATE XXII

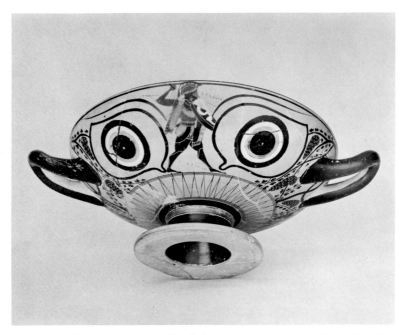

Attic Black-figure eye cup. Fully clad warrior in scene A. About 530–520
B.C. (Cat. no. 148)

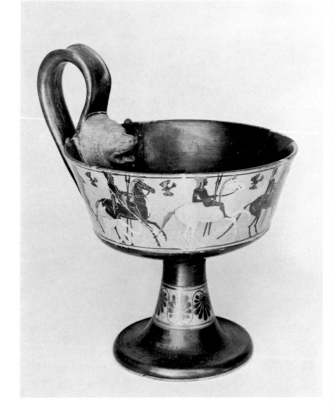

Attic Black-figure one-handled
kantharos. Seven horsemen ac-
companied by two dogs in the
scene. About 510–490 B.C.
(Cat. no. 152)

PLATE XXIII

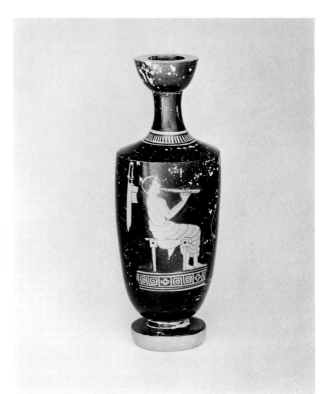

Attic Red-figure lekythos. A boy playing the double flutes in the scene. By the Bowdoin Painter. About 490–480 B.C. (Cat. no. 167)

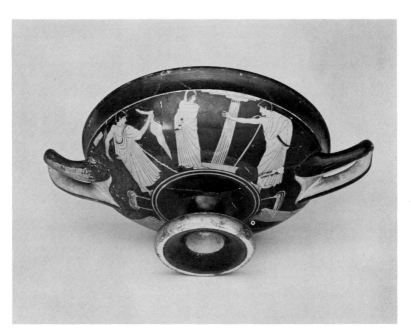

Attic Red-figure cup. Two youths addressing a boy in scene A. By the Briseis Painter. About 480–470 B.C. (Cat. no. 175)

PLATE XXIV

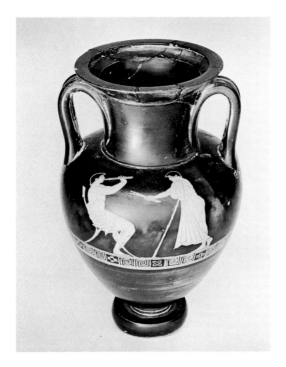

Attic Red-figure Nolan amphora. Two youths, one playing the flute, in scene A. By the Pan Painter. About 460 B.C. (Cat. no. 185)

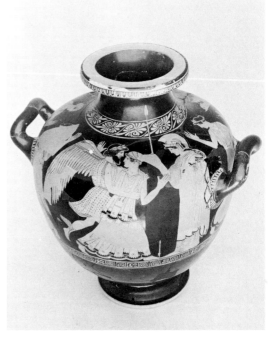

Attic Red-figure hydria. The rape of Oreithyia by Boreas in the scene. By the Niobid Painter. About 460–450 B.C. (Cat. no. 186)

PLATE XXV

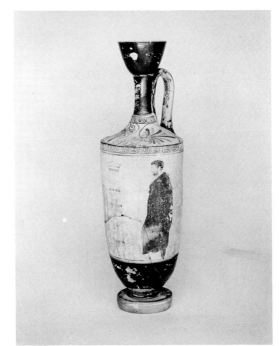

Attic white-ground lekythos. Grave stele, before which stand a woman and a man in mourning in the scene. From the school of the Achilles Painter. About 450 B.C. (Cat. no. 188)

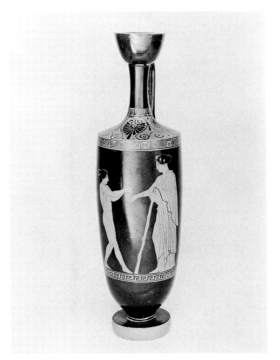

Attic Red-figure lekythos. Nude dancing girl and dancing mistress in the scene. By the Painter of the Boston Phiale. About 430 B.C. (Cat. no. 195)

PLATE XXVI

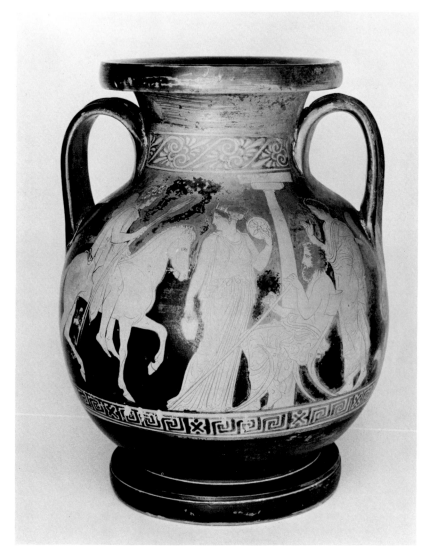

Attic Red-figure pelike. Mounted youth approaching a woman and a seated man in scene A. By the Dinos Painter. About 425–420 B.C. (Cat. no. 202)

PLATE XXVII

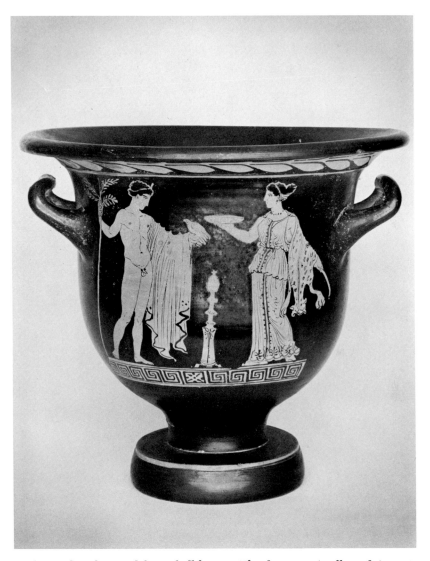

Early South Italian Red-figure bell krater. The divinities Apollo and Artemis facing a thurible between them in scene A. By the Tarporley Painter. About 420–400 B.C. (Cat. no. 213)

PLATE XXVIII

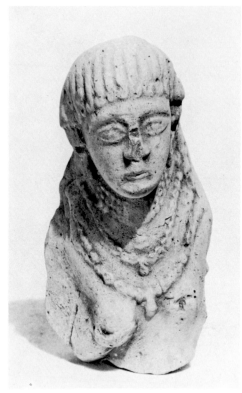

Cypriot terracotta figurine. Fragment of
a fertility goddess. About 650–550 B.C.
(Cat. no. 255)

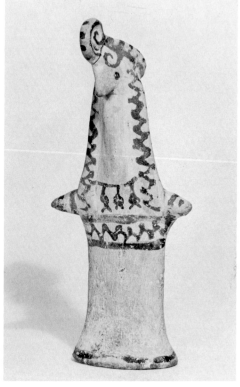

Boeotian terracotta figurine. Standing
idol with birdlike head. About 650–600
B.C. (Cat. no. 271)

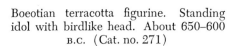

PLATE XXIX

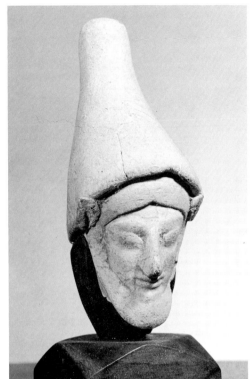

Cypriot terracotta head. From a figurine of a warrior. Sixth century B.C. (Cat. no. 279)

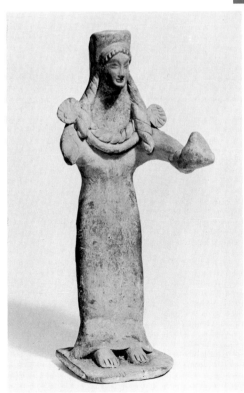

Boeotian terracotta figurine. Standing woman, perhaps a votary. About 550–500 B.C. (Cat. no. 287)

PLATE XXX

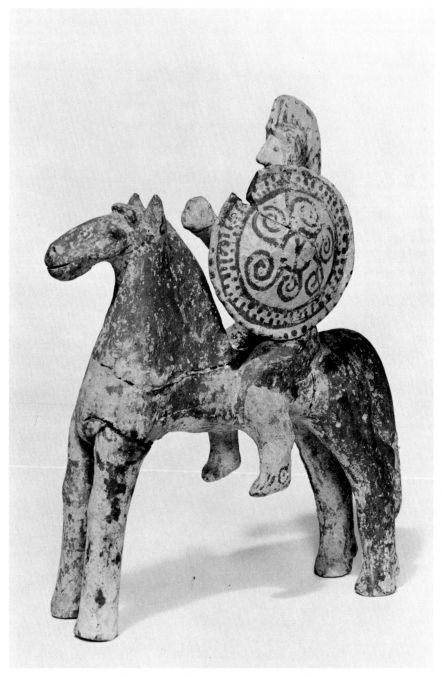

Boeotian terracotta figurine. Mounted warrior with shield. About 550 B.C.
(Cat. no. 277)

PLATE XXXI

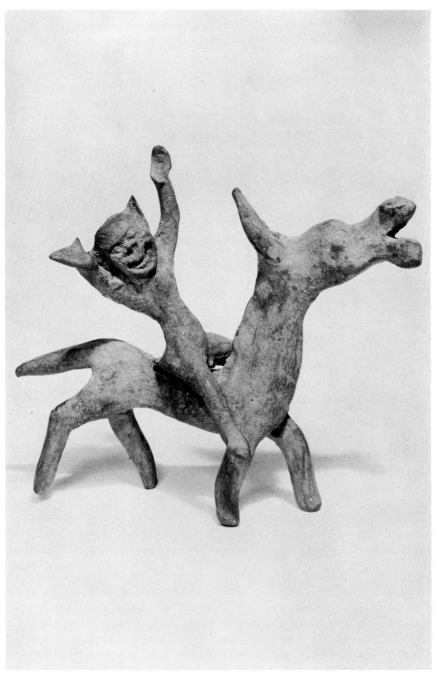

Terracotta figurine from Tanagra, Boeotia. Comic figure on a donkey. About
525–500 B.C. (Cat. no. 288)

PLATE XXXII

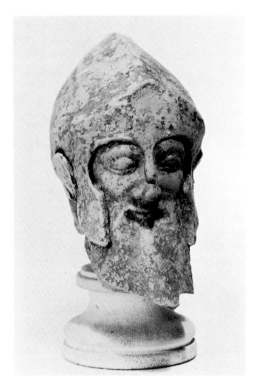

Terracotta head from Medma, South Italy. From a figurine of a bearded warrior. Early fifth century B.C. (Cat. no. 295)

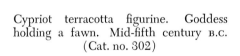

Cypriot terracotta figurine. Goddess holding a fawn. Mid-fifth century B.C. (Cat. no. 302)

PLATE XXXIII

Greek terracotta figurine. Jointed female doll holding rattles. Mid-fourth century B.C. (Cat. no. 339)

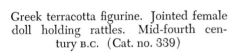

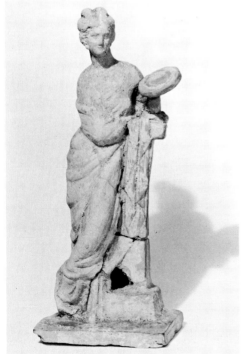

Terracotta figurine from Tanagra. Woman leaning on a pillar. Late fourth or early third century B.C. (Cat. no. 353)

PLATE XXXIV

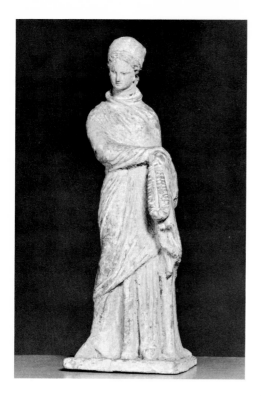

Terracotta figurine from Tanagra. Woman holding a chaplet. Late fourth or early third century B.C. (Cat. no. 354)

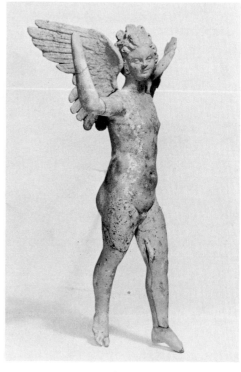

Terracotta figurine from Myrina, Lydia. Nude flying Eros. Second or first century B.C. (Cat. no. 367)

PLATE XXXV

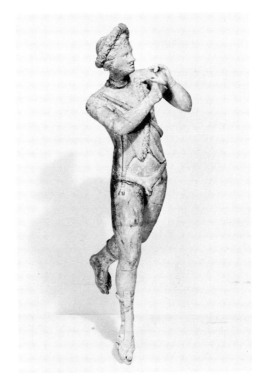

Terracotta figurine from Myrina. Male Bacchic flute player. Second or first century B.C. (Cat. no. 369)

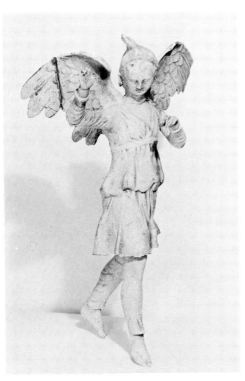

Terracotta figurine from Myrina. Flying Eros in Phrygian garb. Second or first century B.C. (Cat. no. 370)

PLATE XXXVI

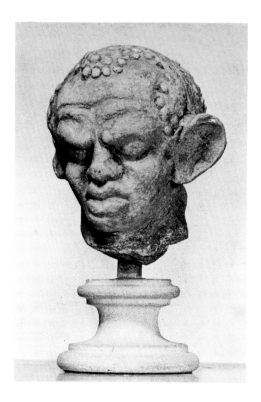

Terracotta head from Medma. From a figurine of a grotesque Negro. Third or second century B.C. (Cat. no. 363)

Cypriot terracotta miniature mask. Satyr with ivy wreath. Hellenistic period. (Cat. no. 382)

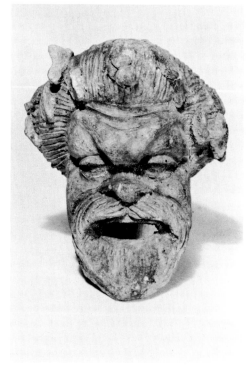

PLATE XXXVII

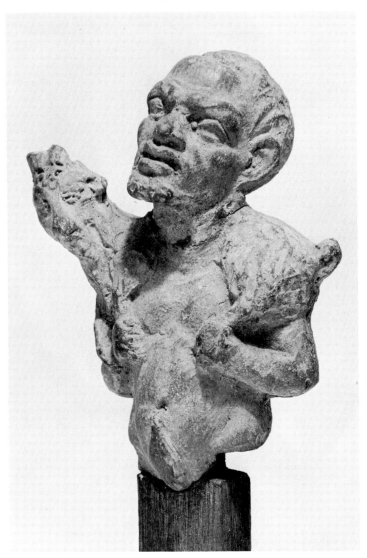

Eastern Greek terracotta figurine. Dwarf carrying a kid on his shoulders. Second or first century B.C. (Cat. no. 374)

PLATE XXXVIII

Melian terracotta reliefs. 393: Winged woman holding a hare and a dish of fruit. About 470–460 B.C. 394: Crouching sphinx. About 470 B.C. 395: Cock. About 450 B.C. (Cat. nos. 393–395)

Roman terracotta revetment plaque. Fragment with head of Ammon. First century A.D. (Cat. no. 408)

Roman terracotta cresting. Fragment with two satyrs treading grapes. First century A.D. (Cat. no. 412)

PLATE XXXIX

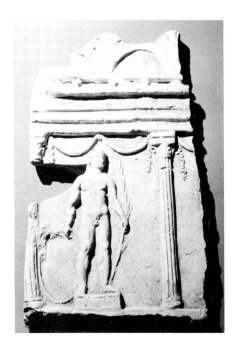

Roman terracotta cresting. Fragment with statue of an athlete in the colonnade of a palaestra. Second century A.D. (Cat. no. 413)

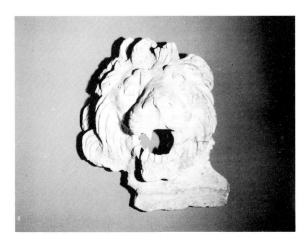

Terracotta rainspout in the form of a lion's head. Provenance unknown. (Cat. no. 414)

PLATE XL

Greek bronze figurine. Geometric horse. About 725
B.C. (Cat. no. 416)

Greek bronze decoration. Griffin protome from the shoulder of a cal-
dron. About 620–600 B.C. (Cat. no. 417)

PLATE XLI

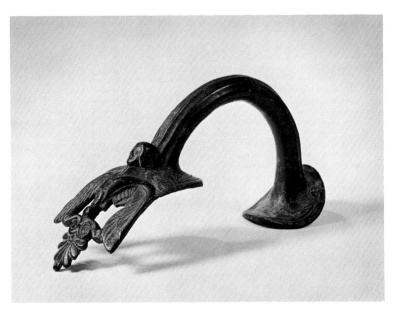

Peloponnesian bronze decoration. Back handle of a hydria. About 470–460 B.C. (Cat. no. 420)

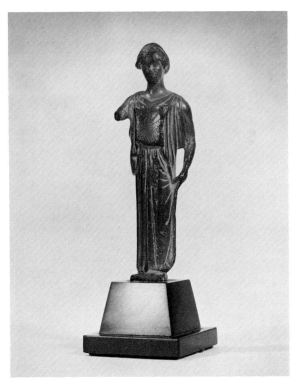

Peloponnesian bronze figurine. Woman wearing peplos with napkin. About 470–450 B.C. (Cat. no. 422)

PLATE XLII

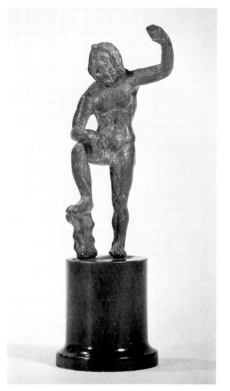

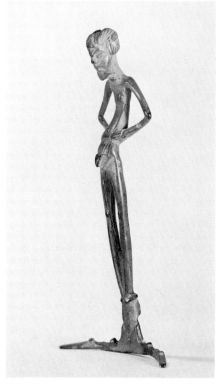

Greek bronze figurine. Poseidon with right leg propped up on a rock. About 250 B.C. (Cat. no. 425)

Italian bronze figurine. Nude Priapus. First century B.C. (Cat. no. 427)

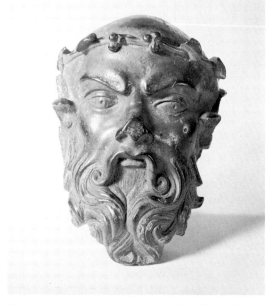

Greek bronze miniature mask. Head of Silenus. Hellenistic period. (Cat. no. 426)

PLATE XLIII

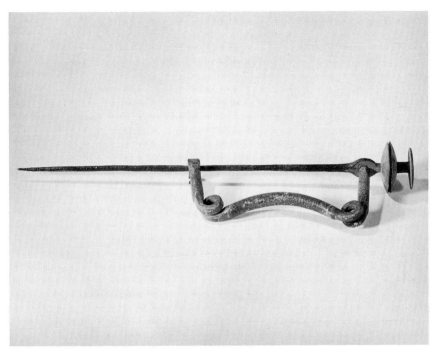

Italian bronze fibula. About 700–500 B.C. (Cat. no. 439)

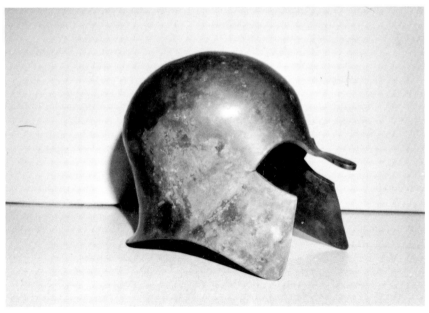

Greek bronze helmet. Of the Corinthian type. About 600–500 B.C. (Cat. no. 445)

PLATE XLIV

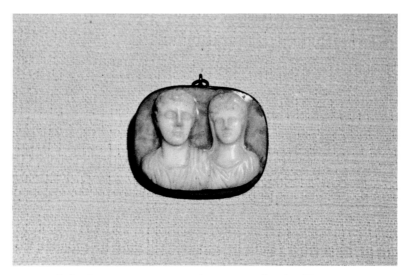

Roman chalcedony cameo. Busts of a man and wife. First century B.C.
(Cat. no. 507)

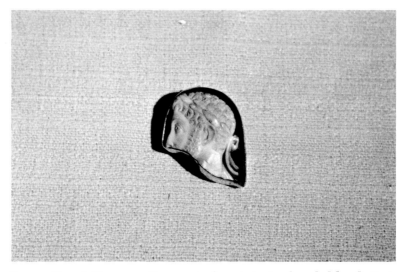

Roman blue-shell cameo. Fragment of an Antonine bearded head. Late
second century A.D. (Cat. no. 511)

PLATE XLV

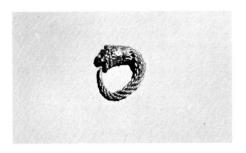

Greek gold earring. Terminal in the form of a lion's head. Third century B.C. (Cat. no. 523)

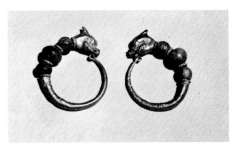

Greco-Egyptian gold earrings. Terminals in the form of houndlike heads. Late Ptolemaic period. (Cat. no. 529)

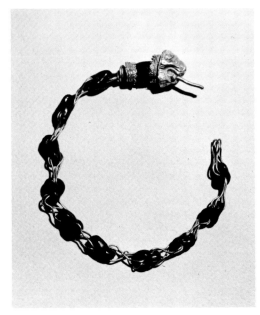

Greek necklace. Gold links and pear-shaped sards. Third century B.C. (Cat. no. 525)

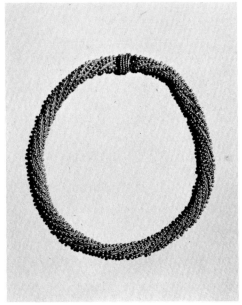

Greek bracelet. Gold cable and pellets. Hellenistic period. (Cat. no. 528)

PLATE XLVI

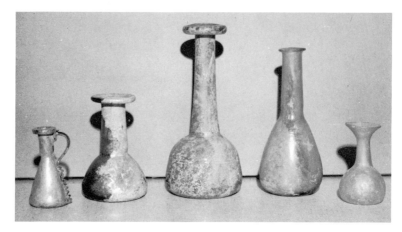

Glassware. 971: Cone-shaped bottle from Cyprus. 982: Bell-shaped bottle from Cyprus. 973: Tall-necked bottle from Tyre. 977: Pear-shaped bottle from Tyre. 972: Globular bottle from Tyre. (Cat. nos. 971, 982, 973, 977, 972)

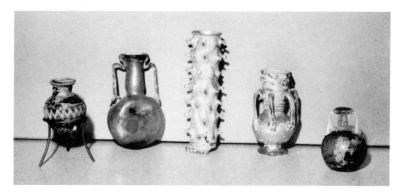

Glassware. 965: Greek opaque aryballos. About the sixth to fourth century B.C. 1002: Amphora from Syria. 1007: Tubular vase with projecting spikes. 1000: Seven-handled vase. 1004: Blue amphora from Syria. (Cat. nos. 965, 1002, 1007, 1000, 1004)

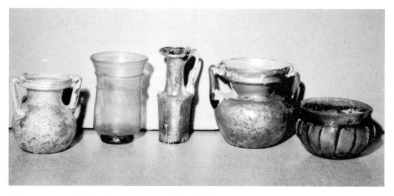

Glassware. 984: Cypriot two-handled vase. 980: Cylindrical goblet from Tyre. 970: Small oenochoë from Tyre. 981: Cypriot two-handled vase. 1003: Bowl with ribbed sides from Trebizond. (Cat. nos. 984, 980, 970, 981, 1003)

PLATE XLVII

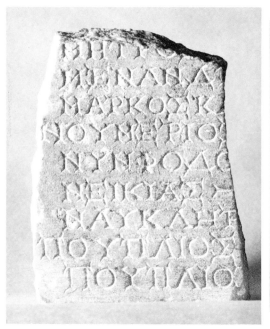

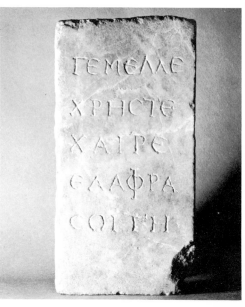

Cypriot marble funerary stele of Gemellos.
Early second century A.D. (Cat. no. 1146)

Marble plaque with alphabetized list of
names. From Smyrna. Second century A.D.
(Cat. no. 1143)

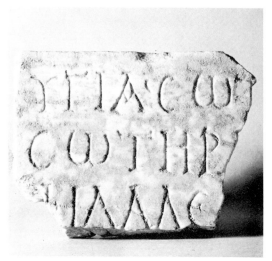

Cypriot marble votive tablet dedicated to
Hygieia. Late second century A.D. (Cat.
no. 1147)

Cypriot limestone funerary cippus of Sotera.
Late second or early third century A.D.
(Cat. no. 1148)

PLATE XLVIII

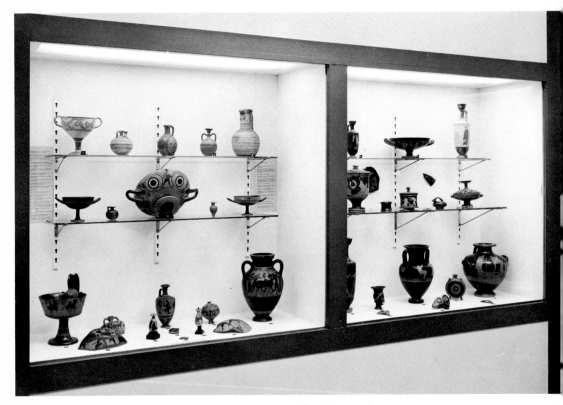

Pottery cases in the Walker Art Building.